Villa Air-Bel

Villa Air-Bel

WORLD WAR II, ESCAPE,
AND A HOUSE IN MARSEILLE

Rosemary Sullivan

HarperCollinsPublishers

An extension of this copyright page appears on page 477.

FIRST EDITION

Designed by Sarah Maya Gublein

Library of Congress Cataloging-in-Publication Data
Sullivan, Rosemary.
Villa Air-Bel : World War II, escape, and a house in Marseille / Rosemary Sullivan.
p. cm.
Includes bibliographical references.
ISBN-13: 978-0-06-073250-9
ISBN-10: 0-06-073250-4
1. Villa Air-Bel (Marseille, France) 2. World War, 1939–1945—France—Marseille.
3. Escapes—France—Marseille. 4. Rescues—France—Marseille. 5. France—
History—German occupation, 1940–1945. 6. Artists—Homes and haunts—France—
Marseille. 7. Intellectuals—Homes and haunts—France—Marseille. 8. Marseille
(France)—History. I. Title.

D802.F82M3775 2006
940.53086'9140944—dc22 2006046495

06 07 08 09 10 NMSG/RRD 10 9 8 7 6 5 4 3 2 1

For Arlene Lampert,
my dearest friend and most exacting reader

And in loving memory of my father,
Michael Patrick Sullivan

They cannot imagine that the things they lived for could disappear. They cannot believe . . . that something essential could disappear, that a whole spiritual realm is threatened. They do not believe in major historical upheavals that obliterate all traces of previous generations and entirely transform continents. They do not believe that what seems to them unjust is possible.

ANTOINE DE SAINT-EXUPÉRY

There is no escape from yesterday because yesterday has deformed us, or been deformed by us.

SAMUEL BECKETT

CONTENTS

ILLUSTRATIONS

Villa Air-Bel

THE ROAD OUT

It was slightly after 4 A.M. on the morning of September 25, 1940, when Lisa Fittko opened the door of the inn in the seaport town of Banyuls-sur-Mer and looked apprehensively up avenue Puig del Mas. After seven years on the run, she had grown adept at controlling her panic. She looked across at the harbor and listened for the sound of the waves beating on the shore. She tried to match her breathing to that calming rhythm. She glanced at the mayor's office on the central square. The gendarmes would not be arriving for hours yet. Up the avenue to the right, she noted that the vineyard workers had already begun to come out of their houses. It was time to leave.

She turned to the two people behind her and told them to put on the espadrilles they would need for the rough climb up the mountain. She gestured for them to follow her and reminded them again not to speak. Their German accents would betray them. The woman was a stranger to her, but Lisa believed she could be trusted not to lose her nerve. The boy, just sixteen, had been through enough to know the danger they were in. The two had understood immediately when she told them there was always someone watching and they must

carry nothing but a small knapsack in order not to draw attention to themselves. Not that they had anything to carry. They had already lost everything.

The three walked slowly up the avenue, the women first, the boy trailing behind. In the waning moonlight, Lisa could make out the silhouette of the church tower. Only the previous week she had sat in its garden, contemplating the autumn butterflies gorging on the last sweet tastes of life. On that day, the Spanish simplicity of the church's façade with its three bells consoled her and the gothic mausoleums lined up like sentinels in the graveyard had made her think, then, of sanctuary. Now, though, the idea of the dead witnessing this flight through the blackness made her shudder.

She thought of her husband, Hans, who was still in Marseille. He'd sent her these strangers to guide over the mountains to freedom. For a moment she was almost angry with him. Why was it always they who had to risk their lives to save someone else? They'd been fighting Fascism since 1933 when Hitler first came to power and they'd fled, distributing anti-Fascist tracts as they ran across borders, first Czechoslovakia, then Switzerland, and now France. She knew that Hans was constitutionally incapable of abandoning his convictions. They were young, he said, and someone had to stay and fight.

She turned left at the railway bridge and her companions quietly followed. Now came the precipitous climb up stone steps into the vineyards. She could feel the cold wind, the *tramontane*, against her cheeks, bringing the exhilarating smell of the sea and lifting her courage. They mingled amid the vineyard workers who were moving casually through the darkness, their spades slung over their shoulders, their *cabecs* for carrying earth swinging with the motion of their footsteps. The workers were pointedly ignoring them. It was not the first time they had seen worried strangers slipping over the mountains. A year ago the refugees had been pouring into France because of the Spanish Civil War. Now the flight was reversed, back into Spain, away from the Gestapo and the French police, away from a country trapped in the totalitarian vise of irrational hatred. Lisa knew the vineyard

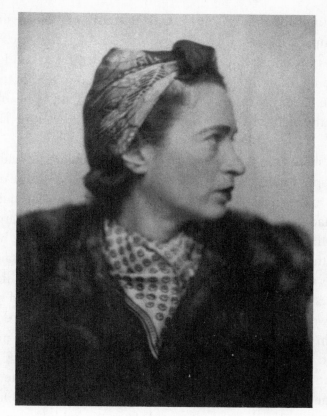

Lisa Fittko.

workers, so accepting of life's patient seasonal pace, would not betray them.

She could smell the mature grapes hanging from the vines and felt their weight. The ritual of the harvest was about to begin. It shocked her to think about how life continued, oblivious to her fear. The light was lifting, and she glanced up at the hills to see if the border patrols, the *gardes mobiles*, were already on duty. If the three of them were spotted, she could offer no explanation for the presence of two women and a boy making their way through the alleys of vines up into the mountain. They would be arrested as *apatrides*, stateless people, without the papers that gave them the right to be walking on this an-

cient ground. It would mean immediate transportation to an internment camp.

They moved up, still unnoticed, into the foothills. Lisa looked at the crude chart on the paper she held in her hand. She noted they'd passed the empty stable marked on the map. They were obviously going in the right direction. Then they reached the huge landmark boulder.

Now she was looking for the old man. Yesterday she had wanted these people to see the climb they were in for and so she'd walked them up to the meadow. The daytime hikers were not suspicious and no one had stopped them. The old man had insisted on carrying his black leather briefcase. In frustration, she tried to dissuade him. She was sure the heavy briefcase would give them away, but he said it contained his new manuscript, which he valued more than his life. Then, to her shock, when they'd reached the meadow, he refused to return to the town. He was halfway, he said. He could not climb down and start again from the bottom. He was going to sleep on the mountain overnight. He would meet them in the morning.

In the distance she saw his body stretched out on the ground, there, where she had left him. She ran to him. Her first thought was that he had died in the night, probably from the cold. He had nothing to cover him. Wild bulls and other animals roamed the mountainous terrain. And smugglers. But he opened his eyes and smiled up amiably at her. Clearly in pain, he stood up slowly. It was then she noticed that his eyes were rimmed with dark red spots. Responding to her shock, he took off his glasses: "It's the dew," he reassured her. "See, the rims of the spectacle frames. The color rubs off when they get wet."[1]

She stared down at Walter Benjamin. He was only forty-eight, but he looked frail and old. He had already survived so much. She and Hans had known him in Berlin and they had met again in France where he had immigrated in 1933. But in September 1939, as soon as war was declared, the French government rounded up all German nationals as enemy aliens, and Benjamin and Hans Fittko found themselves imprisoned together in the Vernuche internment camp. Benjamin had a serious heart condition, and Hans helped him survive through the

long agonizing months until they were both released. Once the Germans advanced toward Paris in June 1940, Benjamin made his way to Marseille. With the help of American sponsors, he managed to get an emergency visa for the United States from the American consulate, but then the problem was that there was no legal way of getting out of the country. Benjamin and a friend once even tried to disguise themselves as French sailors and bribe their way aboard a freighter. With the scholarly Benjamin carrying his black briefcase, they hadn't gotten far and luckily hadn't been arrested. That's when he ran into Hans. Hans knew Benjamin was trapped. No one could leave France without an exit visa. And Vichy officials weren't about to give a visa to someone as famous as Benjamin, who was, in any case, probably on the Nazis' black list. No one on that list could even bribe his way out of France. Benjamin had to be smuggled out. Hans sent him to Lisa.

It was presumptuous, yet astute, of Hans to count on her. In fact, she had indeed found a secret route over the Spanish border. He knew she would. It had happened so fast. She had made friends with the dockworkers in the port, who directed her to a sympathetic man named Azéma, the mayor of the town of Banyuls. When she arrived at his office, Azéma immediately understood the purpose of her visit. Locking the door, he drew her the map of a secret escape route across the Pyrenees and spent hours with her explaining the details. He told her that if she and Hans wanted to help refugees escape over the border, he would find them a house in Banyuls. In the meantime, she should stay at the local inn and learn the habits of the townspeople.

When Benjamin had arrived on her doorstep, she had been shocked to see him. How could Hans think this old man could possibly make the grueling trek over the mountains? Nevertheless she told him about Azéma's escape route, warning him that it was risky and had not yet been tested. "No matter, as long as the route is safe. . . . Not to go. That would be the real risk," he said.[2] Then, apologizing for his intrusion, he asked if he could bring two other friends along. Frau Gurland and her sixteen-year-old son, José, were also in danger. "The world is falling to pieces," she thought, "but Benjamin's courtesy is unshakeable."[3]

Lisa looked at the mayor's sketch of the route. He'd drawn it from memory, and she hoped it was accurate. As soon as Benjamin composed himself, they began the climb. Benjamin established their rhythm. He could walk for ten minutes and then had to rest, but his pace was constant and methodical. He said he had calculated the pace out during the night before. "I can go all the way to the end using this method," he said. "I stop at regular intervals—I must pause *before* I'm exhausted. One must not completely overspend one's strength."[4]

Lisa and the boy took the briefcase from Benjamin. It was agonizingly slow, but she noted they passed the workers' hut that was marked on the map. They were on the right track. Then suddenly in front of them was another signpost, a high plateau with seven pines. Now they moved slowly along the rocky path concealed by the cliff overhang. She told the others not to speak. They might be heard by the border guards patrolling just above their heads. Next there was a near impossible, almost vertical climb through a vineyard. This was the only moment Benjamin faltered. Steeling himself, he tried his best to climb, but it was clear he wasn't going to be able to make it on his own. Lisa and José each took an arm and dragged him as well as his briefcase to the top of the ridge of rock. They rested for some time and then began the final climb. Benjamin had been walking seven hours, but somehow he kept his pace, and at last they were on the crest of the mountain. There they stopped. The view was magnificent. They could see both the French and Spanish coasts. The sun was overhead now, turning the sea into a dazzling white and turquoise blur. Below them was the Spanish border post and the town of Portbou.

Lisa knew that it was time for her to turn back now, but she continued to accompany them down the mountain. The canteen of water she had brought had long been emptied. They approached a scum-covered pool. Benjamin stooped to drink. When Lisa cried out in panic that the water was polluted, Benjamin replied that he had no choice. "You must understand," he said. "The worst thing that could happen is that I might die of typhoid fever—*after* I have crossed the border. The gestapo can no longer arrest me, and the manuscript will have reached safety. You must pardon me, please, gnädige Frau."[5]

It was 2 P.M. when they reached a cliff wall. The town of Port-bou lay in the sleepy valley below. Lisa was now in danger. She had no authorization to be in Spain. She told Benjamin and his companions that they must go on alone. They had made it through. All they needed to do now was to register with the Spanish border guards. They had all the necessary travel documents and their Spanish and Portuguese transit visas. It was well known that the Spanish were willing to overlook the absence of French exit permits. She assured the nervous Benjamin that he would be given an entry stamp and would soon be on his way to Lisbon. She watched the trio descend. From the back, Benjamin looked stooped over and exhausted carrying his now reclaimed briefcase.

Lisa began the climb back up the mountain, confident that she had just guided one of the twentieth century's greatest intellectuals to freedom. The ascent over the crest had taken ten hours, but young and fit, she managed the descent in two.

Disastrously, when Benjamin and the Gurlands reached the Spanish border post to request their entry stamps, they were informed that "a few days earlier a decree had been issued that prohibited people without nationality from traveling through Spain."[6] Though he had lived in France seven years, Benjamin did not have French citizenship and, with the Nazis in power, no longer held a valid German passport. In fact, all three of them were stateless people. An hour of begging and showing their various papers and letters of recommendation proved useless. They were brutally told that they would be escorted back to the French border in the morning. José and Benjamin would certainly end up in a German concentration camp.

The three friends were allowed to spend the night, under guard, at the Hotel de Francia near the Portbou police station. Frau Gurland reported what happened next. At 7 A.M. Benjamin called her to his room. He told her he "had taken large quantities of morphine at 10 the previous evening" and that she "should try to present the matter as an illness."[7] He then handed her a letter.

When Frau Gurland called a doctor and asked that Benjamin be taken to hospital, the doctor diagnosed "a cerebral apoplexy" and

"refused to take any responsibility, since Benjamin was already mori-
bund." Terrified for herself and her son, she spent a frantic day trying
to get his death certificate signed. She then bought a grave for Benja-
min. After significant amounts of money changed hands, she and her
son finally received their entry stamps and were allowed to proceed
through Spain.

Frau Gurland read the letter. "It contained five lines saying that
he, Benjamin, could not go on, did not see any way out."[8] Since Ben-
jamin had advised her to hide his suicide from officials, she destroyed
the letter.

In the death register at Portbou, among the personal items left be-
hind by the deceased was listed a black leather briefcase, and within it
"unos papeles mas de contenido desconocido — with papers of unknown
content."[9] The briefcase and papers were never recovered.

THE PHOTOGRAPH

In the photograph a man and a woman sit like birds in the branches of a tree and look down at the camera. Despite the danger of their perch, they look comfortable. The tree is a plane tree, huge, with branches the thickness of trunks. The day is warm. The man has rolled up his shirtsleeves and the woman is wearing slacks and a light sweater. He stretches out on a branch, embracing it with his right arm, and reaches down with his left hand to touch her shoulder. She sits on a lower branch, one leg extended, the other bent at the knee. She leans back, bracing herself with her right hand as if she were posing on a comfortable couch rather than twenty feet up in the air. It is impossible to tell how they got up there. If they used a ladder it has been taken away. It is probably early spring. The tree is naked without a single leaf to obscure its beautifully mottled bark. The sun pours down in drifts and the sky in this black and white photograph is obviously a perfect cerulean blue. The man and the woman are hanging paintings from the branches of the tree. They smile down on us as we look up with concern. The caption reads: "Varian Fry and Consuelo

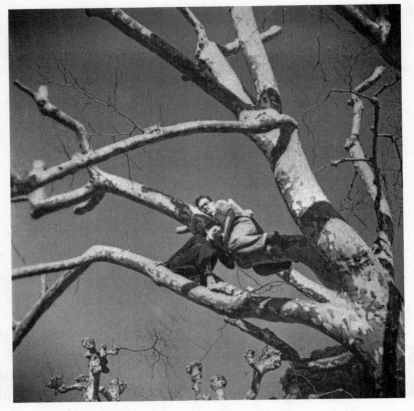

Varian Fry and Consuelo de Saint-Exupéry.

de Saint-Exupéry in the branches of a tree at Villa Air-Bel, outside Marseilles, 1940 or '41."

Varian Fry is familiar to me. As a young man in his early thirties, he traveled to Marseille as the representative of the American Emergency Rescue Committee. In June 1940, after the Germans invaded France and the fall of the country seemed imminent, the committee had been hastily assembled in New York with the express purpose of saving European artists and intellectuals. European émigrés who had already escaped to the United States knew that the Nazis kept a secret list of political and intellectual enemies who had stood against them during the 1930s. The Nazis would now be searching for them. It was imperative to get them out of France. Then, alarmingly, at the end of June the new Vichy government blindly signed an armistice that

included an article whereby France agreed to "surrender on demand" all German nationals requested for extradition by the Third Reich. If there had been any doubt before, it was now clear. The hunt was afoot and the Nazis had murder in mind.[1]

The image of the beautiful young El Salvadoran Consuelo de Saint-Exupéry conjures up the memory of her dashing husband, the pilot Antoine de Saint-Exupéry, author of *The Little Prince*. Sometime later, in 1944, his plane disappeared over the Mediterranean on a reconnaissance flight.

But what is the Villa Air-Bel where the photo was taken? In my mind I see the villa, a large nineteenth-century home, multishuttered with an extensive terrace sheltered by plane trees. In that house certain individuals gathered against the onslaught of war. What moves me about the uncannily beautiful photograph is the contrast between the frivolity of the adventure—hanging paintings in tree branches— and the world outside its frame. The world had been edging slowly toward total conflagration and, by the time the photograph was taken, had turned deadly.

Villa Air-Bel was the residence of a group of artists and intellectuals waiting to escape France—some waited for up to two years—and also of the young Americans who decided to risk their lives to rescue them. The photograph poses so many questions.

Wars build slowly, cumulatively, often years before the history books date their beginnings. Who were the artists at the Villa Air-Bel, and how did they get caught in the deadly web? How did they not see the war coming and escape in time? Did they refuse to believe war could happen, or did they believe that, if it did come, it could only touch others? Nameless, abstract others.

Long before the bombs fell and soldiers and civilians died, long before extermination camps did their work of horror, there was the war of nerves, the propaganda war being fought for people's minds. Despite the stories that are told in retrospect where everything is clear and predictable, it is never easy to decipher where the real enemy is or who will be the victim. In France the illusion of normalcy was sustained for years. And then, in a moment, the world collapsed like a

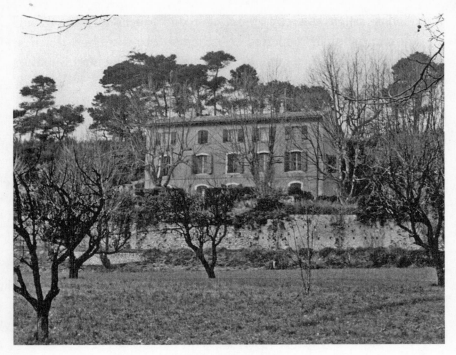

Villa Air-Bel.

burnt husk. Millions of people were blindsided. Despite the ominous signs, they could not believe a world war could happen. Not a second time.

And who were these young rescuers at the Villa Air-Bel? What convinces young people to risk their lives saving others? Is it a matter of temperament, or does this transformation happen gradually, by a series of spontaneous decisions, until there is no other choice, until the risk has already been taken? As in every war, there are victims and there are rescuers. And there are the murderers and those who stand by passively and watch.

"Why did you not leave France in 1939?" I once asked the artist Leonora Carrington, then the lover of the surrealist painter Max Ernst, who, though he had lived in France seventeen years, had not become a French citizen. The French imprisoned him in September 1939 as an enemy alien.[2] "We should have left France after Max was arrested the first time," she said. "But we couldn't imagine a world

other than Paris. You must remember what Paris was in those days, before the war. Paris was wonderful. Paris was freedom."

In France people soon learned how quickly everything could change. Suddenly destinies ceased to be a matter of personal control. The life and death of any individual became merely something to be haggled over in bureaucratic ministries: who was an alien, who should be imprisoned as an enemy alien, who should be deported to certain death. Not chance, not contingency, but someone else, a stranger, arbitrarily decided who lived and who died.

I want to ask what it feels like to move from freedom to occupation: to feel threatened, administered, restrained? Suddenly bits of bureaucratic paper control one's life and death. The words *prohibited, investigated, imprisoned* enter one's vocabulary and everything is uncertain—life, home, children, lovers. All can be taken away or left behind.

Villa Air-Bel sat like a stone interrupting the stream in a handful of lives. It was their unexpected destiny. Multiple trajectories brought individuals who would otherwise never have encountered one another to a villa in the South of France. Over the course of many months they waited through the terrors and deprivations of war. And then they scattered in different directions, some unchanged, others changed forever. This book is their story.

THE DINNER PARTY

Late October 1940

It is hard for me to put into words what I felt at this time without surrendering to hyperbole: I can still see myself standing on Air-Bel's terrace in the late afternoon sunshine, the great golden leaves of the plane tree drifting down around me. I knew that this was a moment of rare privilege. Somehow through a strange confluence of chance encounters and unlikely coincidences, I had been swept into a place where grief, consternation, disillusionment, and anger had become the gentle servants of justice. That space had now been expanded to accommodate delight.

MIRIAM DAVENPORT[1]

Sometime in the early eighteenth century a prominent bourgeois family named Castellane bought an eighty-five-acre property outside the city of Marseille. The estate called La Castellane was mostly farmland, with fruit trees and wild herbs scenting the meadows. The Huveaune River ran through it and to the south the limestone escarpment of Saint-Cyr rose like a gray monolith covered with a stain of thin scrub. In the distance it was possible to catch just a glimpse of the turquoise-blue sea.

In the mid-nineteenth century, the estate was sold to the Thumin family, who built an imposing villa on its highest hill. They called it

Villa Air-Bel because of the fresh breeze carried in from the sea. A second residence, a traditional two-story modest house, La Castellane, was named in memory of the property's ancient ancestry. Sliced in two by the new railroad in 1858, the estate came to include two tenanted farms and three market gardens. By 1915 the surviving Thumins, Dr. Thumin and his two sisters, had come down in the world and resorted to renting out the Villa Air-Bel on weekends and summers. The suburbs of Marseille by then encircled the property, and the villa could be reached by the local tramline.

It's not clear whether Dr. Thumin and his sisters ever occupied Villa Air-Bel. They seemed to have preferred the cramped quarters of La Castellane. Unable to find renters in the depressed economy of the 1930s, they had let the villa deteriorate. By 1940 Air-Bel had already stood vacant for a number of years, its gardens overrun and its hedges untrimmed.

To reach the Villa Air-Bel, which stood several hundred yards to the east of La Castellane, one climbed a long steep laneway between plane trees interlaced with giant cedars and then passed through an entranceway framed by imposing red brick pillars capped with white stone. On a large terrace rose the rectangular three-story stone building with double-paneled iron shutters covering the large windows on the ground floor. The eighteen-room villa was now a slightly faded image of its original self, but it still gave the impression of reserved elegance.

A graveled terrace ran the length of the house, shaded by three magnificent plane trees, and, on the west side, a greenhouse was tucked in among the palms. To the left and right of the terrace were stairs leading down to a small French garden, its overgrown flower beds framed by boxwood hedges and alleys of rosebushes. The centerpiece of this garden was a pond in which stood a lovely stone fountain.

It is late October 1940. Twelve adults and two children are seated around the table in the gloomy dining room. Little light penetrates

the room's dark corners, so that the tattered condition of the torn mock leather walls and leather-backed chairs is obscured. An over-varnished landscape of the French countryside hangs above the ornately carved sideboard. The room gives an impression of old world elegance. In the center of the table, camouflaged by branches and green leaves, are two large triangular-headed insects. They are praying mantises. The male has just mounted the female and she has turned back and begun slowly to eat her mate.

The people around the table are laughing. Or at least some of them are. The entertainment is a substitute for food. Even though everyone has contributed ration stamps, the meal Madame Nouget, the cook, has managed to cobble together is still meager. But there is plenty of cheap red wine and a polenta pudding made palatable with *grapo* sweetener.

There are two masters of ceremony at this table. At one end sits André Breton, the poet who invented surrealism. It is he who brought the praying mantises in from the garden. He is "one of those men whose almost unbearable radiance provokes (try as he might to soften the shock) a sudden disequilibrium, the feeling the ground is crumbling beneath one's feet."[2] So a young female friend remembered him. But Breton's magnetism is equally seductive to men and to women. His style is one of irony: a quality of reserved self-assurance. Everyone notes his remarkable head, almost too large for his body, with the mane of hair that cascades back from his high forehead, still chestnut-brown though he is now forty-four. (He carries his imposing head "like a chip on the shoulder," his friend Man Ray said.[3]) But it is really the mouth, the lower lip, prominent and fleshy, that makes him so seductive. And the jade-green eyes. It is impossible to imagine a more willful and yet inviting face. Breton is an artist in exile in his own country, trapped, like the others at this table, and hoping to leave. Attacks against his work in the right-wing collaborationist press have been increasing. France has become a dangerous place.

Beside him sits his wife, Jacqueline Lamba. Only thirty, with a leonine blond mane every bit as impressive as her husband's, she is nicknamed "Bastille Day" for her tempestuous personality. She is an

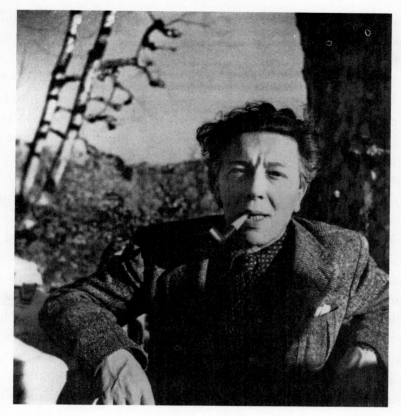

André Breton.

intelligent woman, both a painter and a writer, who had been making her living as a nude underwater dancer at the Coliséum music hall in Montmartre when Breton first met her. He always says that at their first meeting at the Café de la Place Blanche he felt her presence before he saw her—"she gave the illusion of moving about, in broad daylight, within the gleam of a lamp" and was "scandalously" beautiful.[4] On the other side of him sits their daughter, Aube, on whom he dotes and who, though she is only five, often serves as his intermediary when things are not going well with his young wife. When she was only eight months old, he wrote his daughter an outrageous letter: "For a long time, I thought it was the gravest insanity to give life. In any case I held it against those who had given it to me."[5] This was more than a pose. Breton has spent half a lifetime fighting against

the conventionality of his impossibly correct lower-middle-class child-hood. He detests correctness. His ambition is to reinvent the human mind.

The other master at the table, diametrically opposite, is Victor Serge. If, for Breton, finding himself in peril because of his writing is a new experience, for Serge it is all too familiar. He is almost a pro-fessional refugee—this is his fourth exile, his seventh flight in twenty years.[6] Now he is cornered, and awaiting his final escape at the villa. Born in 1890 in Belgium and on his own from the age of thirteen, he saw Russia, the country of his ancestry, for the first time in early 1919 when he arrived to participate in the Russian Revolution. All his Bolshevik comrades are now dead, having been exterminated in the Stalinist purges. Writing in French, he has become a noted novel-ist and historian. He is a mild-looking professorial figure, with steel-rimmed glasses and disheveled gray hair that he attempts to control under a French beret. Listening to him talk, say the others, is like reading a Russian novel. At the age of fifty, he is as clear-eyed as any-one at the table about what is happening to France.

Next to Victor Serge sits his companion, Laurette Séjourné. She is dark-haired and quiet, and can be flirtatious when she wants to be. Twenty years younger than Serge, she is tiny and very beautiful. She is reserved and has reason to be so. Unlike anyone in the room except Serge himself, she understands the full dimensions of the danger he, and therefore she, is in. She would later say that she had been too young to marry him—"his life too full of tragedy and darkness" for her to understand.[7]

On his other side sits his twenty-year-old son, Vlady. Already a gifted painter, he mostly keeps to himself sketching in the garden. He is a survivor, along with his father, of Siberian exile, and is adept at improvising. He will endear himself to his fellow refugees at the villa by making rolls from dried fruits and nuts collected in the garden, which will ameliorate their hunger in a period of near famine. Serge is desperate to leave France but refuses to do so without his son, who is of an age to be vulnerable to imprisonment or forced labor. And so they both wait anxiously, hoping for visas to America.

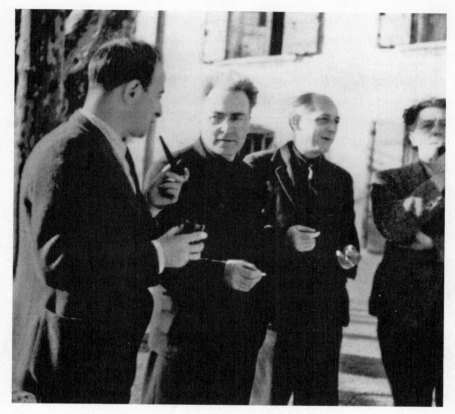

From left: Charles Wolff, Victor Serge, Benjamin Péret,
and André Breton on the terrace at Villa Air-Bel.

In a few months' time, several other artists will take up residence at the Villa Air-Bel. After his release from prison a second time, the painter Max Ernst will find shelter here, joined briefly by Peggy Guggenheim. And also the French poet Benjamin Péret and his lover, the Catalan painter Remedios Varo. Their wait for rescue will be the most harrowing and most protracted of all the villa's inhabitants.

For these artists, life before the war had mostly been comfortable. They spent their days working in their Paris rooms and their evenings in fashionable cafés. In short, they were France's elite artists. Now they live in fear, fleeing for their lives.

At the same table are a motley crew of young people ranging in age from twenty-five to thirty-three, people who, perhaps even to their

own surprise, find themselves among those willing to put their lives at risk to save the lives of others.

An American heiress named Mary Jayne Gold is one of the most compelling. Aged thirty-one and single, Gold is willful and used to doing things her own way. At the beginning of the war in September 1939, the American ambassador, William C. Bullitt, had called on all Americans to return to the United States, but Gold stayed on.[8] She describes herself as an upper-class WASP born in Chicago, educated in New York, and finished at private school in Italy. She has spent the last ten years living off her trust fund in Europe, dividing her time between Paris, London, the Riviera, and fashionable ski resorts in Switzerland. Beautiful and blond, in her designer clothes, the owner of a Daimler car and Vega Gull airplane, she might easily be taken for simply frivolous, but underneath she has a great sense of humor, loves danger, and is deeply generous. She has been pulled into the war by helping some friends leave Paris and she is still helping.

Seated beside her is Miriam Davenport, age twenty-five, a tiny, feisty young woman. In physical appearance she is plain, almost schoolmarmish, dressing conventionally and wearing her long hair in braids, which she winds around her head. She grew up in New Rochelle, New York. Shortly before her graduation from Smith College in 1937, her father and then her mother died suddenly. The shock was brutally painful. In addition, she found herself in debt and in charge of her ten-year-old brother. She decided on a master's degree in art history, which she hoped would then allow her to get work and reestablish her family. The summer of 1938, after asking an uncle to take care of her younger brother on his farm in North Carolina, she headed to France on a Carnegie scholarship. She was halfway through a *licence libre* and about to write her exams when the Germans invaded France in June 1940 and the University of Paris closed down. She headed south, only to be caught up in the exodus of people fleeing the German advance. While she waits in Marseille for a visa to Yugoslavia, where she hopes to be reunited with her boyfriend, she has decided to make herself useful by working for refugees.

Varian Fry sits opposite. He has just turned thirty-three. Though he trusts Miriam Davenport completely and has come to depend on her, he still thinks Mary Jayne Gold is a dilettante. Even so, her money, generously given, is quietly supporting much of his operation. For the moment, Fry is the most important person in the room. He is the reason they are all here.

Varian Fry had arrived in Marseille on August 14 intending to stay three weeks. He had been sent by the Emergency Rescue Committee, which was just that—an American committee hastily put together by European exiles and New York liberals who suddenly understood that the Nazis were hunting down artists and intellectuals in France. Fry had been given a list of two hundred people he was meant to save. Assured that things could be handled expeditiously, he'd taken a month's leave from his job. He knew little about social work or clandestine activity. In fact he was a classical scholar, but he spoke French and German and was devoted to art. The idea of saving artists in danger appealed to his sense of adventure and justice.

The day he walked out of Marseille's gare Saint-Charles in his Brooks Brothers suit and Homburg hat, he looked out of place—a Harvard boy, slightly self-righteous, publicly unflappable, and deeply out of his depth. Yet now, two and a half months after his arrival, the forthright gaze behind his tortoiseshell glasses inspires confidence. It is his American directness and cordiality that people find reassuring. And in late October here is Fry at the Villa Air-Bel, having set up Marseille's most impressive clandestine escape route out of France.

And then there is Daniel Bénédite. Twenty-nine years old and a committed Socialist, he had been working in the Préfecture de Police in Paris before the war. Refugee organizations knew he was the one to go to when they needed help. He was the one who could cut through the red tape. Indeed, it was through him that supporters had been able to get a residence permit for Victor Serge in 1936 after he was released from Siberian exile and was left stateless. Danny Bénédite is in Marseille because he could not imagine staying in Paris and working for the Germans. Although he has just been hired by Fry, he has al-

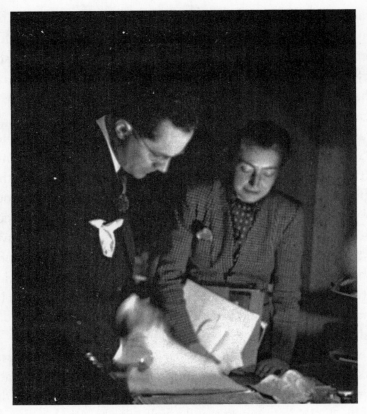

Varian Fry and Miriam Davenport.

ready become Fry's right hand. He is a methodical, sober young man, always ready to scathingly dismiss those he thinks are drawn to the "cloak and dagger" romance of rescue work. He detests "uncalculated risks."[9] He sits with his British wife, Theo, and their two-year-old son, Pierre, whom they affectionately call Peterkin.

There are two other ERC workers living at the villa. Jean Gemähling is a young, blond, blue-eyed Frenchman from Strasbourg who speaks perfect English, having been sent to a British public school by his professor father. He is very shy and is soon to fall in love with one of the villa's most dramatic and frequent visitors, Consuelo de Saint-Exupéry. Gemähling is Bénédite's friend, a fellow survivor of the battle at Dunkerque. He is waiting to get to Britain, where he hopes to join

the forces of General Charles de Gaulle fighting for a free France. And lastly, there is Marcel Verzeano, whom everyone calls Maurice, a young Romanian just out of the Paris Faculty of Medicine, whom Fry hired to help his fleeing refugee clients, some of whom were ill or on the verge of mental breakdown but too frightened to show their faces in a doctor's office.

Despite the good humor, the games being instigated by André Breton with his macabre praying mantises, and the astonishing conversation led by Victor Serge that covers decades of cultural and political history, there is fear in this room. Outside, the French police and even the Gestapo are circling. No one knows—not if, but when—the police will knock. What is initiated from this room—the saving of innocent refugees from deportation and death—is no longer legal. Each person here is aware that the police are keeping files on them all. The situation is very unstable. At any moment their rescue activities could become a treasonable act, punishable by imprisonment and possibly worse. The young Americans believe that being U.S. citizens protects them, but the others have no such illusions. It is the not knowing that is most unnerving.

The gathering poses multiple questions. Who becomes a refugee? Who becomes a rescuer? How did each person in the room come to decide on which side he or she stood? Was this a choice, or was it, like so many human acts, simply the unforeseen result of a sequence of choices, involving more chance than decision?

And how is it that a peaceful country, committed to principles of freedom and democracy, suddenly finds itself not simply invaded by a foreign army, but ruled by an authoritarian regime with its own Fascist ideology? The greatest threat to the people in this room is, for the moment at least, not the German enemy but their own fellow citizens, supporters of the collaborationist Vichy government.

It has taken more than seven years of cumulative events for these twelve men and women to arrive at this table. For them, it might seem that there is no logic to this forward momentum. Events simply unfolded as everyone looked blindly the other way. In retrospect, however, the momentum appears inexorably unstoppable—like iron

filings drawn to a magnet. There was only one possible outcome: this culture of death.

The twelve people around the table momentarily look at one another in amazement, shocked to numbness at the terror in which they find themselves caught. No one could have imagined it, and though they would never wish to return to this horror, they understand its significance. They are being forced to define who they are and what they are capable of. Now they have to decide what they will refuse to lose.

THE HEIRESS

There is a photograph of the young Mary Jayne Gold with her girlfriends aboard the S.S. *President Harding* in 1929. She's nineteen and on her way to finishing school in Italy. She is seated in the front row, her large, rather masculine hands resting on one silk-stockinged knee. Perhaps it's the way the light falls on her face that spotlights her, picking her out from among the others who look dated, lost in the past in a charming sepia photograph. But she seems immediately present. She looks directly into the camera, her expression challenging, as if she would speak with you. She's lovely without the least trace of coquetry, and yet there's a certain vulnerability to her gamine gaze.

Anyone on that ship might have dismissed Mary Jayne Gold as just another of those *modern* rich American girls whom Europeans found so fascinating—so flamboyant in their advanced ideas about sex. She would have laughed and said she had advanced ideas, but a Protestant conscience. Mary Jayne was the daughter of a manufacturing magnate, Egbert Gold, who could trace his New England ancestry back to a signatory of the Connecticut colony charter in the seventeenth cen-

tury. By selling steam heating equipment for railway cars, Gold had built the family business into an international empire worth millions.

The Gold family lived in Chicago and usually spent their summers at Marigold Lodge, the family's splendid thirty-four-room mansion on Lake Macatawa, Michigan, or aboard the family yacht, the *Marigold*. The year Mary Jayne turned nineteen, however, her parents decided to send her abroad. They had found an appropriate finishing school in Gazzolo, Italy, run by the Contessa Livia Lazzizi della Rovere-Casey. The contessa housed her *exclusive* collegio in her family villa, which she had only just managed to salvage by selling the surrounding land and most of the valuable antique furniture. As Mary Jayne boarded the S.S. *Harding* on her first visit to Europe, America was collapsing into the Great Depression. Shrewd investments, however, had left the Gold family fortune secure.

The curriculum at Collegio Gazzolo was not particularly oner-ous. There were classes in art, deportment, and languages. There were trips to nearby Verona, Rome, Venice, Florence, Umbria, Na-ples, and Sicily. Invitations for luncheons and dinners were extended to the sons of appropriate families. They would play the Victrola and dance under the scrutinizing gaze of the contessa. The girls attended operas in the royal box with the King and Queen of Italy and worried over the latest fashions.

Mary Jayne loved much of it, but her intelligence was certainly underchallenged. She was a complex young woman with a good mind and a sense of high principles. She was also a bit wild and loved a good time. So far nothing would have led one to expect anything particularly exceptional from this rich young girl.

November 3, 1928, Mary Jayne received a deep blow. Her father had died after a four-month illness. He was only sixty. He had been the difficult parent, distant and forbidding, so that memories of sailing with him down the Mississippi in the family yacht or making bon-fires in the Michigan woods were carefully and perhaps disproportion-ately treasured. Mary Jayne was devastated. But unexpectedly, with his death, the women in his household were suddenly free. Certainly her mother's life altered irrevocably, and Mary Jayne herself would

not likely have become the woman she was had her father lived. She would never have had the freedom (or the substantial annuity) to invent herself.

After two years at the collegio, Mary Jayne told her mother she wanted to take courses at the Sorbonne. Having just restarted her own life after twenty-four years of marriage, Mrs. Gold was more than compliant. Through friends, she found her daughter a respectable Parisian family with whom to board.

Madame Bénédite lived with her three children on rue du Douanier near the Parc Montsouris in Montparnasse. She'd had to resort to taking in two or three students, usually Americans, to supplement her income after her divorce.

Mary Jayne arrived in Paris like any young ingénue. It was the city she had been reading about since childhood. Everything was exotic and yet exactly as it should be: the smells of medieval brick churches, of mildewed books in stalls along the Seine; of rank cheeses and wine kegs in street markets where hawkers were shouting their wares. The pavements had been worn down by generations of walkers and the stone steps were indented and polished. The sky of Paris was almost translucent, as though the light were traveling through stained glass windows. The juxtapositions were also marvelous: old women bending over their braziers of roasting chestnuts, and then the legs of men peeing in the *pissotières* scattered strategically along the boulevards. Unlike life in Chicago or even Italy, there were no taboos here. The most outrageous behavior would earn only a passing glance. Mary Jayne became a passionate Francophile, immersed in what she liked to call the "warm whirlpool bath of French culture." She boasted it gave her a "certain nimbleness of mind and morals."[1]

The Bénédites became Mary Jayne's second family. Despite their strained circumstances, their house was in the affluent bourgeois section of the artistic district. Rue du Douanier-Rousseau was a small street that ended abruptly at the back of the Church of St. François, which towered over it with an austere authority. The painter Georges Braque lived across the street. The famous cafés Le Dôme and La Coupole were close by. From the very first meal at rue du Douanier, Danny

Bénédite took on the role of Mary Jayne's teasing younger brother. He was studying philosophy at the Sorbonne and engaged in a long-distance romance with his British fiancée, Theo. His two sisters also became Mary Jayne's good friends.

Mary Jayne walked the fifteen minutes to the Sorbonne to attend lectures in French history, art, literature, and law, but she was dabbling. She was only twenty-two, and with the wealth her father's trust fund now afforded her, she was preparing her assault on the world of fashion. She headed for the Place Vendôme.

Napoleon stood on his stone column in the center of the place, encased in the bronze of 1,250 cannons captured at the battle of Austerlitz in 1805. The façades of the *petits palais* and town houses, commissioned by Louis XIV, now discreetly fronted the shops of some of the most famous names in fashion. There was Coco Chanel's salon on the rue Cambon directly behind the Ritz, and nearby the Houses of Lanvin and Vionnet. Mary Jayne's favorite was the House of Schiaparelli on rue de la Paix. (It would be a few years before Schiaparelli would move up the rung to occupy the very classy address—21 Place Vendôme).

Determined to be *à la page*, Mary Jayne had selected the designer with a penchant for the outrageous. Schiaparelli was already known for her sportswear (swimsuits with fish motifs), leather unisex flying suits (airplanes were all the rage), and peasant sweaters in art deco patterns. Her colors were black and white, a fanciful touch of Italian *morbidezza*. But she would not become really infamous until the mid-thirties when Dalí became her collaborator, designing a dress for her with trompe l'oeil drawers and bone handles, a handbag shaped like the newly pervasive telephone, and, most outrageously, an evening gown with orange lobsters crawling their way from hemline to bodice, specially created for the notorious Mrs. Wallis Simpson, mistress to the Prince of Wales.[2]

Mary Jayne loved Schiaparelli's risqué style, which managed to be both elegant and playful, and which had the essential virtue of making one *noticed*. She chose a Schiaparelli *robe sirène*, a slinky affair that made her tall figure even taller. The fitting was hellish, what with

young women with pins sticking out of their mouths crawling all over her, but the result was spectacular.

Mary Jayne decided to test out her glamorous new wardrobe that summer of 1931 at the fashionable Hôtel du Palais in Biarritz. She'd brought in tow the youngest Bénédite daughter, Zabette, as a kind of shield to fend off importuning lovers. The Hôtel du Palais, originally La Villa Eugénie, was built by Napoleon III as a summer palace for his wife. The last word in sophisticated elegance, the palace had housed every sort of European royalty and had lost none of its glitter and ostentation when it became a hotel in La Belle Époque. When Mary Jayne arrived, there were still royals seated in the Imperial Ballroom, now converted into a dining room. On April 14 that year, Spain had been declared a republic, and King Alfonso XIII had gone into exile. Many of the dukes and duchesses who had followed him now filled the tables of the Hôtel du Palais, impatiently awaiting their imminent return to Spain.

When the maître d' escorted Mary Jayne and Zabette to their table that first evening, they were immediately spotted by Ramón Maura. He was the nineteen-year-old son of the Duke of Maura who had been premier to King Alfonso. Mary Jayne's points of reference were romantic novels and movies, and so to find herself surrounded by royalty was seductive. When Zabette returned to school in Paris and she was suddenly unchaperoned and unfettered, she allowed the flirtation with Ramón to continue.

Life in a luxury hotel was certainly pleasant. She loved the way the maître d' singled her out with his charming greeting: "Mademoiselle, the little duke is waiting for you."[3] It was a summer of horseback riding and dinner parties, polo and dancing. There might have been a civil war brewing just over the border in Spain (though it wouldn't break out for another five years), but politics was a matter about which Mary Jayne showed only a cursory interest. Certainly dinner conversation included vitriolic attacks on the Republican and Communist hordes destroying the great Spanish institutions, but Mary Jayne was not taking sides. She was an "American democrat."

Ultimately the flirtation petered out when Mary Jane told the

young duke she wouldn't sleep with him. Back in Paris in the fall, her life of professional tourism continued. Although she kept up with her courses at the Sorbonne, the rest of the time she could be found on sightseeing junkets throughout Europe. Certainly part of this was the nomadism that comes with being young and rich and full of enthusiasms. But she also felt an aimlessness that she couldn't exactly put her finger on. She wanted to get her life started but couldn't figure out how. Certainly she had no desire to return to the United States.

Then, unexpectedly, she received a telegram from her mother informing her that she was coming to France. Initially Mrs. Gold set up at the Hôtel Meurice, an elegant early-eighteenth-century building on the rue de Rivoli with the luxury shopping bazaar of Place Vendôme just around the corner. She soon found an apartment on the rue Beethoven right by the Seine, from where, if one leaned far enough out the window, one could see the Eiffel Tower. Mary Jayne moved in with her. Her elder brother, Dick, was also visiting Paris. In the evenings the family would climb into a rented limousine and head out to taste the glamorous nightlife at Paris's *boîtes de nuit* like Bricktop's and Le Boeuf sur le Toît where everyone came to dance to the new rhythms of the black jazz scene.

Paris was officially conservative, the town where Jean Chiappe, the *préfet de police*, was famous for once having arrested Marlene Dietrich for wearing trousers in public.[4] But among the bohemian underground and in the heady world of haute chic, the nightlife was as wild as it could get.

Bricktop's cabaret in Montmartre was named after its proprietress, Bricktop, the red-haired mulatta who was by then a reigning doyenne of the show business scene. F. Scott Fitzgerald was one of the club's devotees. Bricktop was known to confiscate his wallet for safekeeping when Fitzgerald got so drunk he began to scatter banknotes to the musicians and customers. Bricktop's was also a rendezvous spot for the Prince of Wales and the stylish Mrs. Simpson. Duke Ellington and Cole Porter often stopped by. Cole Porter wrote "Miss Otis Regrets" for Bricktop. The club engaged Louis Armstrong and other celebrity musicians to keep the dance floor rocking. Josephine Baker,

the "ebony Venus," was still the rage in Paris in the early thirties. She could usually be found at Bricktop's when she wasn't dancing at the Casino de Paris, where thousands flocked to see her strip down to her garter belt of bananas singing *"J'ai deux amours."*[5] Mary Jayne would look back on this time with nostalgia: "Everybody was in evening clothes, and jewels, and the headwaiters recognized you."[6]

Her mother took up with a nightclub singer, a White Russian called Michel (Mischa) Thorgevsky, one of the many Russian émigrés who had fled the revolution in 1917 and were surviving by their wits. A Russian count (real or bogus) could often be found driving a taxi or singing in a *boîte*. Many of them were looking for American heiresses, preferably older, to help recoup their fortunes.

Perhaps Mrs. Gold was recovering her own lost youth, for she was living as if she were in a Scott Fitzgerald novel. She, Mischa, and her son, Dick, used to go out to the cabarets, drink too much, and then the fighting would begin. To Mary Jayne, the endless parties in the apartment on rue Beethoven were upsetting. They violated the memory of her father who had been such a sober and forbidding man. After a Christmas spent skiing in St. Moritz, her mother returned with Mischa to the United States, where they were soon married.

Now that she was once again on her own, Mary Jayne took a suite at the Hôtel Prince de Galles, a new art deco hotel on avenue Georges V, whose garden-side restaurant Le Jardin de Cygnes and Regency Bar were the pinnacles of modern elegance. The gold-leaf chandeliers and marble floors in its elegant lobby shut out the world, reminding its guests that they were Paris's elite. Almost immediately Mary Jayne also took her first lover. Her timing was interesting. Perhaps having watched her mother with her own new lover, she had decided to assert her independence. But it was likely more complex. To friends, the young French lover remained nameless. Mary Jayne would look back on him and remark that he was the first in a line of unfortunate choices.

The luxurious life charmed her, but what was a young girl to do with herself? She was a bit bored. There was always skiing in Switzerland, though she soon abandoned the trendy resort town of St.

Moritz for the less fashionable Davos. Here she met a young woman who was to become one of her closest friends. Yola Letellier was the wife of an investment tycoon who owned the popular daily *Le Journal*, considered the most Parisian, most literary, and most *boulevardier* of the newspapers of Paris. The newspaper was the chief sponsor of the exclusive Automobile Club of France located on the Place de la Concorde. The Letellier family ran hotels and casinos in Normandy and counted among their friends the owner of the famous restaurant Maxim's. Henri Letellier was a wealthy older man very much in love with his young wife. In French high society it was standard for a man to maintain both wife and mistress—it ensured marital stability—but it also worked both ways. A method of sustaining the loyalty of a much younger wife was to allow her to take lovers. Yola expertly balanced three separate relationships—one with her husband; one with her official lover, Étienne de Horthy, son of Admiral Horthy, dictator of Hungary; and a secret affair with Lord Louis Mountbatten. There was a famous story that Louis Mountbatten had a pullout double bed installed in the back of his 1931 Phantom II Rolls-Royce to entertain his lovely mistress. Yola managed to maintain all three relationships with affection and high spirits as only a Frenchwoman could. Mary Jayne envied her guilelessness and thought of herself as a mess of Protestant repression and neuroses. Which was, of course, selling herself far too short. She hadn't had to resort to the reflected glory of a famous husband or lover to give herself status or emotional security. She was negotiating dark waters on her own.

In selecting her female friends, Mary Jayne picked those who were daring and outrageous. Personally, however, she thought of herself as a loner. Looking back she would say: "I wasn't a very good mixer. Actually I spent a lot of time alone, reading, or just moping."[7] She enjoyed the high life and knew how to be gracious and polite but she was detached, on the periphery of the social whirl. She preferred intimate friendships to glamorous connections, adventure to propriety. Some said she was aloof. They said she was something of an enigma.

THE YOUNG CLERK AT THE PRÉFECTURE DE POLICE

Paris, 1933

You might have called Danny Bénédite an archetypal Frenchman. He was tall and thin, and wired with a nervous intensity. He wore horn-rimmed glasses and a thin brush mustache that left him looking rather austere, but he actually had a teasing sense of humor. He was a man you could depend upon but never predict. An intellectual in temperament, with a surprisingly sensual passion for gardening, he had an entertaining manner of speaking, mixing slang and familiar expressions with an erudite vocabulary. It was disconcerting but fascinating. It was as though his instinctive impulse toward formality was continually being sabotaged by a stronger desire for camaraderie. He came across as very passionate. His emotions were not to be toyed with.

His father was from a rich industrialist family named Ungemach whose estate in Alsace was called the Château de Honcourt. Alsace and Lorraine had been surrendered to Germany after the defeat of 1870, but the Ungemachs always thought of themselves as French. It was a standing family joke that the no-nonsense Madame Ungemach sang the "Marseillaise" as she gave birth to each of her children.[1] On

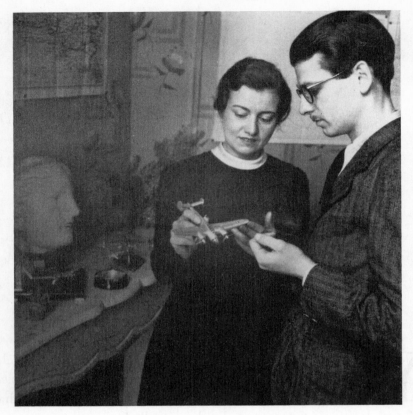

Danny and Theo Bénédite.

the Bénédite side, the family came from a line of art bureaucrats and critics. Danny's maternal great-grandfather had been a *conservateur* of the Louvre. His grandfather was *conservateur* of the Luxembourg. At the time of her divorce Danny's mother, Eva Bénédite, reverted to her maiden name, and so did her three children. Danny claimed to prefer his French name, associated with many excellent books on art, to his German name, which appeared on cans of food produced by a factory in Schiltigheim. Perhaps more significant to his preference was paternal neglect. Eva Bénédite had had to take in what she referred to as "paying guests" to augment the feeble support she received from her ex-husband. The family's favorite "guest" was Mary Jayne Gold.[2]

Danny was intensely political, describing himself as a militant Socialist of the extreme Left. He'd joined the Students' Socialist and

Republican League at university and then was on the executive commission of the Young Socialists of the Seine, where he was involved in producing left-wing publications like *Masses* and *Spartacus*. All had tiny circulations and brief life spans.

Once he completed his studies at the Sorbonne, Danny married Theo, his English girlfriend. She had been secretary to the director of IBM and was a good match. Through the influence of an uncle who was director of the Department of Health, he soon landed a job at the Préfecture de Police.

His job was to oversee the medical files of Paris's wet nurses, as well as to determine exceptions to the mandatory one-day-per-week closing of Paris shops. Not exactly scintillating work for a young leftist. Much to his relief, in 1934 at the age of twenty-three, he was assigned the position of personal secretary to Roger Langeron. Langeron, *un grand commis de l'état* (or senior civil servant), was affable, cultivated, and a liberal (though he would later collaborate with the Germans). Danny wrote speeches for him and organized his cabinet correspondence.[3]

Because he'd been hired through a relative, Danny had managed to avoid a background police check. When one was finally done and his radical politics came to light, his boss decided to indulge him. He was too good an assistant to lose. Langeron told him that he would count on his prudence and discretion—he didn't want to find his young secretary giving fiery speeches in public or getting arrested at antigovernment demonstrations.

Since he had nothing to do with actual police enforcement or the judiciary, Danny never felt there was a contradiction between his employment and his political activities. And with access to important figures in public administration, he believed he could be of service to his *camarades*. Often he was asked to expedite naturalization papers or a residence permit for a leftist political refugee. A note sent on the stationery of the Office of the Préfet carried weight. Eventually, when Léon Blum, leader of the Popular Front left-wing coalition, was elected premier of France in 1936, the Socialists came to think of Danny as their man at the prefecture. Discretion was Danny's highest

virtue. His superiors never had occasion to reproach him for failure of duty and no one ever suspected him of playing a double game. It was good training for the undercover life he would one day find himself leading.

By 1933 Paris had changed. The U.S. stock market crash of 1929 had emptied the city of many of its most famous American expatriates. Gertrude Stein was still holding court in her apartment on rue de Fleurus, but there were only a few new American arrivals. Henry Miller could be found at his favorite table on the terrace of the Dôme. (When he couldn't afford a cheap hotel, he was known to have slept on the sawdust floor of the Dôme's washroom.[4]) But even as the bohemian set continued to frequent Bricktop's and the Casino de Paris, the giddy pleasures of the Jazz Age were giving way to the growing anxiety of the Depression. France's governing class had thought they would be immune, but the crash hit France too, and the effect was catastrophic. Unemployment rose to 20 percent and industrial production declined by 80 percent. Governments seemed to be playing a game of musical chairs. The average longevity of the government in power was six months. Right-wing movements flourished in the countryside and wildcat strikes organized by the Communists disrupted factory production in the cities. It was clear that a clash between extremists of the Right and the Left was building. At the same time, the rise of Nazism in Germany was creating a new refugee class heading for France.

As soon as Adolf Hitler assumed the chancellorship of Germany on February 28, 1933, the Nazis began their attacks on German dissidents and Jews, provoking a "massive exodus of Jews, trade unionists, Communists, Socialists, and leftists of all kinds." In collaboration with Hitler, the Soviet Union immediately closed its borders to all German political refugees, even to known Communists.[5]

With no alternative, the refugees turned west, with France their destination of choice. Paris may have been used to refugees, but these people were in particularly desperate straits. Many of them were political exiles who had had their passports and documents confiscated and were consequently stateless. Now they were fleeing for their lives.[6]

Initially the refugees were well received. They were allowed into the country without much difficulty and numerous relief committees were set up to aid them. But as their numbers reached twenty-five thousand, right-wing newspapers like *Action Française* inevitably began to refer to them as "German invaders who were taking the bread out of French mouths." Anti-Semitism was on the rise. Rumors were spreading that Jewish refugees would seek Hitler's pardon by spying for him. The last straw was when the refugees began monopolizing the cafés of Montparnasse, which were intended to be "cosmopolitan, not German."[7]

Watching from police headquarters as the tide of refugees poured in, Danny Bénédite was clearly worried. Throughout the 1920s young militants like Danny had always thought of Germany as the country where the next revolution would begin. The German working class was meant to rise up against the unjust terms imposed on their country by the Treaty of Versailles at the end of World War I, particularly the impossibly harsh reparation payments that were impoverishing its citizens. How then was it possible that the German working class, the best-educated proletariat in Europe, was so mesmerized by Hitler? In the elections of April 1932, Hitler's National-sozialistische Deutsche Arbeiterpartei received 47 percent of the national vote. "Traumatized by street unrest, food shortages, assassination attempts, and unprecedented unemployment," Berlin had become "Europe's most dangerous city."[8] Now Hitler was spitting out Germany's most talented citizens. Using his power at the prefecture, Danny made the cases of refugees fleeing Germany his priority and countering anti-Semitism his personal concern.

The case of Albert Einstein was typical. In February 1933, when Hitler was elected chancellor, Albert Einstein had been away from Berlin on a trip to the United States. As a Jew he was dismissed, in absentia, from his university post. His Berlin apartment and his summer cottage were raided and sealed. Shaken and dejected, Einstein renounced his German citizenship. At the age of fifty-four the world's greatest physicist was suddenly a man without a home or a country.[9]

Offers of refuge poured in immediately. Chairs were awaiting him in Belgium, Spain, Jerusalem, France, and the United States, and, in his distraught state, he seems to have accepted quite a few of them. Eventually he accepted a position in the United States. But the Collège de France was under the impression he had accepted its own offer as well. The anti-Semitic right-wing press was furious. Who was this Jew to snub France? They raged against his *goujaterie* (his scurvy trick).[10] The emotional brutality of such contempt was unnerving.

In his private travel diary Einstein meditated on the profound shock of forced exile:

Well, then, a bird of passage for the rest of life. Seagulls accompany our ship, constantly in flight. They will come with us to the Azores. They are my new colleagues, although God knows they are happier than I. How dependent man is on external matters. Compared with the mere animal . . . !

I am learning English, but it doesn't want to stay in my old brain.[11]

AN EVENING AT THE APARTMENT
OF ALEXANDER WERTH

1934

It was 1934. Although Mary Jayne had lived with the Bénédites for only a year before moving out on her own, she and Danny remained close friends and she continued to think of the Bénédites as her French family. Affectionately, they called her Naynee. To Danny, Mary Jayne seemed to have everything. She was beautiful, rich, and intelligent, and at the same time, kind and generous. She was so prodigal with her wealth that he sometimes thought she was asking pardon for being so rich. He loved to tease her, but he also took on her political education as his personal responsibility. One evening he phoned her to say that he and Theo were going to Alexander Werth's the following evening and invited her along. "It will be a change from your lousy milieu."[1] Danny's insults only amused Mary Jayne. She'd heard of Werth and thought it would be interesting to tag along.

Danny had many friends on the left, and these young men and women used to meet in one another's apartments to plan political strategies and prepare their various amateur publications. It was a measure of the range of his contacts that he knew Alexander Werth,

the Paris correspondent for the *Manchester Guardian*, who was celebrated, even then, as one of the keenest and most thoughtful observers of French and European politics.

In fact Werth was an interesting character. He was only thirty-three at the time and had lived the first sixteen years of his life in Russia. His family came from a line of well-to-do industrialists and had immigrated to Britain in 1917, soon after the start of the Russian Revolution. After attending Glasgow University he earned his living as a journalist and a translator of Russian fiction. Certainly his intimacy with things Russian would have made him attractive to Danny's group of young Socialists.

Near the Santé prison, beyond Montparnasse, Werth lived in an artist's studio with a splendid library in four languages: English, French, Russian, and German. He had a journalist's gift for anecdote, and that night in his apartment he regaled Danny, Theo, Mary Jayne, and other friends with stories. As a Brit, he watched French politicians with fascination. He could recount hobnobbing in 1933 with Pierre Etienne Fladin, leader of an opposition party in the Chamber of Deputies, at his home in the boulevard Malesherbes. "It's a nuisance of course, having a lunatic asylum next door," Fladin had remarked to him about the current situation in Germany. "But we are not unduly worried . . . we have still a certain military superiority over Germany." Or he could describe having chatted with the politician M. Franklin-Bouillin, in the garden of the Inter-allied Club in the Faubourg St. Honoré. Franklin-Bouillin had told him that Hitler's atrocities against the enemies of Nazism were nasty, but they were all to a good end. They would teach the British how dangerous Hitler was and they might take him seriously. "Nothing affects the English public more than atrocities, for the English are sentimental and humane. They are sorry for cats and dogs, for Jews, and Socialists, and some are even sorry for the Communists."[2] That Werth was English and might have been repelled by such xenophobic nonsense seemed not to have occurred to the politicians.

Werth was disgusted by the absurd disconnect of such comments. He'd been in Berlin in February and March 1933 to cover Hitler's in-

duction as chancellor and had witnessed the beginnings of Germany's military buildup. He knew German war ambitions were very real.

But the French remained complacent. Although the sight of German Brownshirts goosestepping across the screens in French newsreels was certainly alarming, Hitler himself was the butt of jokes. People said that he looked like "a second-rate French hairdresser," or that only the Boches could choose a "joli coco" like Hitler as their leader.[3] French newspapers called him a "straw man of the rich German industrialists who would soon throw him to the winds."[4]

The evening in Alexander Werth's apartment was animated but also sobering. The subject uppermost on people's minds was whether there would be another European war. Werth told everyone that the military experts he interviewed assured him war was at least two years off. "The democratic forces in Europe will have to pull themselves together," he said. He loved to quote Voltaire: *"Personne ne peut avoir perdu sa liberté que pour n'avoir pas su la défendre."* ("No one can have lost his liberty except by failing to know how to defend it.")

As she sat and listened, Mary Jayne was suddenly afraid. She tried but she couldn't even generate the imagination necessary to visualize a city like Paris under attack, let alone contemplate hundreds of thousands dead. "Would there be war? Could there be war?" she asked. When she made an effort to think of war barreling down on them, she felt paralyzed, like an animal trapped in the headlights of an oncoming truck. The French politicians were dithering. The Left were as corrupt as the Right. A pox on both their houses, she thought.

The only Germans she ran into were the skiers in Davos, and everyone made fun of them. They would hobble their way down the slopes breaking their falls with sticks and she and her British friends would shout: *"Stockreiten verboten."* The young Germans would obediently put away their sticks and go careening down the hill. Hitler's master race indeed![5]

Mary Jayne found Werth compelling. He was a large, handsome man and totally charming. He had an amusing characteristic gesture. While thinking intensely, he stood on one foot, his elbow crooked above his head and his hand occasionally dipping down to rub his

eyes with his knuckles. He looked like "a big bird trying to hide its head underneath a wing."[6] He was brooding and intense and brilliant, and it did not surprise Mary Jayne to discover he was also a gifted pianist. There was something intoxicating about him—perhaps it was the spontaneity of his friendship. He also had a wife and daughter waiting in London.

Mary Jayne listened intently as the conversation turned to the recent riots in Paris. When she had gotten back from her skiing expedition in Davos that March, the owners of the fashionable shops on the rue de Rivoli and the Place Vendôme were buzzing with horror stories of lootings and killings. What had happened at the beginning of February while she'd been away? A riot of such magnitude in Paris! It hardly seemed possible.

THE PARIS RIOTS

February 6, 1934

Alexander Werth had a crucial story to tell. According to his publishers, his book *France in Ferment* would be a *succès de scandale* because it was a firsthand account of the riots that had broken out in Paris that February. Already dubbed "Bloody Tuesday," February 6, 1934, had almost pulled France into civil war. The year wasn't even over and Werth's book was being rushed into print.

France certainly was in ferment. Fear of social revolution was in the air. There had been one scandal after another and the government was reeling. A flamboyant financial swindler named Alexandre Stavisky, who had links to government officials, had perpetrated a huge bond fraud involving hundreds of millions of francs. Although he was reported to have committed suicide when under investigation by police, rumors circulated that the police had forced him to take his own life. With the scandal mounting, the government was compelled to resign, and Radical Socialist leader Édouard Daladier took office. (*Radical* was somewhat of a misnomer; the party was actually slightly left of center.) Daladier promised an investigation, but then, as often occurs, only minor provincial officials were scapegoated and jailed. The

popular right-wing prefect of police, the same Jean Chiappe who had arrested Marlene Dietrich, was dismissed. The comedy was complete when Daladier fired the veteran director of the Comédie-Française theater for putting on the mob-inciting play, Shakespeare's *Coriolanus*, and replaced him with the head of the Sûreté, the French secret service. Politicians had become so unpopular that signs were posted in cafés and restaurants saying: "We don't serve deputies here!"[1]

On February 6 Daladier was making his first appearance before the Chamber of Deputies. Right-wing extremist groups like the royalist Camelots du Roi, the Croix de Feu, and Action Française, and Fascist organizations like the Leagues and Jeunesses Patriotes saw this as their chance. It was time to eject the Left from power. A call went out for a public demonstration against government corruption. Thousands gathered in the Place de la Concorde, intending to march across the Concorde Bridge to the Chamber of Deputies. Police guarded access to the bridge on the Right Bank and encircled the chamber on the Left Bank. Six police vans pulled up on the bridge to serve as barricades.

As an accredited reporter for the *Manchester Guardian*, Alexander Werth had spent the afternoon in the Chamber of Deputies. Hearing the rioters, he went outside. In *France in Ferment*, he described what happened next:

> I went down to the bridge about 7:30 just as the mobile guards were beginning to retreat. It was an unforgettable sight.
>
> The Place de la Concorde was black with people. Mounted guards, flourishing their sabers, careened round the flood-lighted obelisk in a desperate endeavour to disperse the crowds. They were pelted by a hailstorm of stones and pieces of asphalt. The pavement on the Tuileries side had been smashed up for that purpose. To the left of the obelisk a bus was on fire, filling the air with the stench of burning rubber. . . . On the bridge, behind the barrier of six police vans, the injured policemen and horse-guards—many of them were terribly injured—were being packed into police cars and rushed to the Chamber infirmary or to the hospitals. A few demonstrators, mostly young men,

with blood streaming down their heads, were being pushed into the same vans. Two of the guards were in charge of the injured horses that were being brought through the barrier. Some of them, dripping with blood, had their bellies slashed half-open by razor-blades attached to walking sticks—another of the weapons used by the "peaceful" demonstrators.[2]

"It was inevitable," Werth explained, "that shooting would break out." Even though numerous witnesses later confirmed that the first shots had come from the street agitators and that the first man struck was a mounted policeman, the crowd shouted hysterically at the police: "Assassins! Assassins!"

The number of people massed in the Place de la Concorde that night was later estimated at between forty thousand and sixty thousand, with hundreds of thousands more behind the Madeleine, down the rue de Rivoli, up at the Étoile, and across on the Left Bank. The paving stones of the Tuileries gardens were broken to pieces and the ground was littered with bricks, smashed chairs, and iron fence rails, which the crowd used as projectiles to attack the *gardes mobiles*. The battle in the streets of Paris lasted seven hours. In the Place de la Concorde, a mounted guard and fourteen rioters were killed, and 1,325 people were injured—770 guards, policemen, and gendarmes, and 555 rioters and spectators. A stray bullet killed a woman leaning out to watch the spectacle from the windows of the elegant Hôtel Crillon. She was later identified as a thirty-three-year-old cleaning woman who worked at the hotel.[3]

The right-wing press the next day announced that the guards on the bridge were tools of the left Republican regime and murderers of defenseless patriots who had only gathered peacefully to give vent to their indignation. "That," said Werth, "was patently a lie. There were armed and vicious professional provocateurs in that crowd."

However, he was equally skeptical about the claims of those on the left who said that "there was a definite plot on February 6th to overthrow the Republic."[4] Such claims, he added, should be "taken with a grain of salt."

It was clear to Werth that there were thousands of people of all classes and all political persuasions out on the streets during the riot. People were fed up with all the political parties and all government. They felt used by years of high taxes, financial corruption, and state-protected swindlers. "À *bas les voleurs!*" ("Down with the thieves!") was the chant he'd heard on the bridge that night.

The next evening the streets were quieter but the situation seemed even more sinister. "The streets were completely dark," Werth explained. "There were no police anywhere; the atmosphere was one of complete anarchy, which was more terrifying than the loud rioting of the night before."[5] Vandals, out to take advantage of the disorder, did most of the looting. In the rue Chambon, Werth ran into a "crowd of tough-looking youths with bulging pockets [who] turned hurriedly into a side street and disappeared." The police, their numbers decimated by the previous night's riots, gathered around the Madeleine district. The area was filled with people. Charges on the crowds were savage and five people were killed by the police. In the rue de Rivoli the looting was systematic and highly organized. From Concorde to the Palais Royal, every shop window not protected by metal blinds was smashed. The fashionable tourist district of St. Honoré was a scene of devastation.

On the third night, the eighth of February, the Communists called for a mass demonstration in the Place de la République against what they were calling the "Fascist coup" of February 6. Warned in advance, the police cordoned off the square. The cafés were closed; the Hôtel Moderne, usually a blaze of lights, was dark, and all electric signs in the area had been extinguished. As the crowds gathered in the side streets, the police charged. A police van drove through one group of rioters, kicking at the faces of those standing nearby. The crowds responded by erecting barricades. The clashes were violent and lasted past midnight. Six demonstrators were killed and the official number of wounded was put at sixty-four, twenty of whom received bullet wounds. The police claimed 141 policemen were injured, four shot.

Alexander Werth doubted these official numbers of police casualties. He believed the police vented their rage that night on an easy

target: the Communists. The police behaved with more savagery than he had ever witnessed before. "The wounded continued to pour in all evening into the Hôpital St. Louis," he remarked. "It was a ghastly sight."[6]

It was clear that the three days had been a horrendous ordeal for the city of Paris. In the immediate aftermath of the riots, there had seemed to be only two options: a coup d'etat by the Right or a military dictatorship with martial law imposed by the government of the Left. Either would probably have led to a complete Left-Right polarization and civil war of the kind that was soon to break out in Spain.

But the long tradition of democracy in France held. In the face of such unprecedented unrest, Premier Édouard Daladier resigned. A sigh of relief went up in the country when a former president of the republic, Gaston Doumergue, was called out of retirement and named to replace him. It was an inspired choice, acceptable to both sides.

Many on the left might have disputed the origins of the riots of February 6, 1934, but most would certainly have agreed on their lasting impact. The riots gave new hope to the Fascist parties in France. Antagonism between the Left and the Right had become so extreme that a terrible precedent was being set: those on the right would seek alliance with German Fascism as a way to wreak vengeance on their own compatriots.

UP IN THE CLOUDS

1935

Mary Jayne Gold happened to be in London one day in June when she ran into her old friend Giangi Murari. He was the son of the Conte and Contessa Murari whom she had known in Verona when she was at the Collegio Gazzolo. Giangi was on his way to Heston airport for a flying lesson. By the mid-thirties, flying had become a recreational sport, and light airplane clubs had opened up all over Britain. There were a lot of planes left over from World War I that could be bought at a bargain. Giangi suggested Mary Jayne join him, which, of course, appealed to her sense of adventure. She loved it and immediately signed up for the flight-training course.

Mary Jayne soon discovered that flying required a great deal of skill and physical dexterity. One had to have a built-in consciousness of wind and weather, and to understand engine pressure and cables. Compass pressure had to be checked constantly, propeller speed controlled, and oxygen levels maintained. Though the planes themselves were surprisingly rugged, they were almost as dangerous on the ground as in the air. They were tail draggers. This meant that a pilot couldn't see over the plane's nose and had to weave from side to side

to check the ground ahead. Takeoff was especially tricky as the plane had to be clear of any gust-generating trees, and there was a tendency for the low-winged monoplane to weathercock in the wind. Taxiing was almost like sailing. Strapped down and with goggles on, the pilot eased up into the slipstream of wind.

Once she got her pilot's license, Mary Jayne bought herself a Vega Gull, De Havilland's new low-winged four-seater monoplane. It was a Gull that New Zealander Jean Batten, the "Garbo of the Skies," had flown that year to set a world record—she was the first female pilot to fly from West Africa to Brazil across the South Atlantic, beating her male rival's record by a full day.[1]

The beauty of the Gull was its glass roof, which gave a clear vision of the sky overhead. There was a splendid exhilaration in being alone in the sky and then looking down to see the projected shadow of one's own wings skimming over the ground. Little could compare to the feeling of power in the throttle beneath one's hands and the strength it took to control it. And then to ride the lip between life and death put an edge on things.

Still, if Mary Jayne had guts and a desire for adventure, she remained rootless. She felt she had no special skills or qualifications. She had never *done* anything. Her own family neither shared her interests nor approved her way of life. In Chicago her mother was now living nostalgically in another century with her conservative White Russian husband. Mary Jayne decided to stay in Paris. She would make her life here.

Her first commitment was to move out of her suite in the Hôtel Prince de Galles. Paris was already terribly overcrowded with foreigners fleeing to the metropolis to escape the burgeoning Fascism in Germany, Italy, and Spain. People came to Paris because France had always offered itself as a country of asylum.

After an exhausting search, Mary Jayne finally found an apartment on avenue Foch off the Arc de Triomphe. She also found a cook and a housemaid. Her chic new home was in the haughty 16th Arrondissement, near the Bois de Boulogne with its lovely old trees, its meadows and riding paths. She bought a black poodle, which she called Dago-

bert after a character in a French nursery rhyme, and she took to walking in the Bois.

She furnished her apartment in Louis XV furniture. The decor was exhuberantly ornate and rococo, rather sumptuous in fact, quite appropriate to what Danny called her "lousy milieu." She'd learned her periods. She had the right gilded cabriole leg fauteuils and tables with elaborate scrollwork and lovely shell and foliate motifs. The guest room was furnished in Directoire with coverings in tapestry and needlework and the inevitable striped weave.

Though she enjoyed her first experience of antique hunting, Mary Jayne soon lost interest. This was typical of her. Periodically she had to leave the cocoon of wealth to get her fix of reality. She described her life as "gyrating among several different worlds in a series of interludes all interwoven."[2] Even as she was becoming aware of what was happening in France, she was still drawn to living extravagantly. She found her own life irresistible, as a rich person does, and felt protected from the menace. Of course this wouldn't last.

THE CONGRESS AND THE CASE
OF VICTOR SERGE

Paris, 1935

*In their country as in any other, the men who think and the men who kill are not the
same. And in their country, as everywhere else, when the men who kill are the masters
they begin by killing and gagging the men who think.*

VICTOR SERGE[1]

O n the evening of June 14, 1935, André Breton was walking
with his wife, Jacqueline, and several friends along the bou-
levard Montparnasse toward the Closerie des Lilas. Breton
was in a state of high excitement, though, as always, he concealed it.
He'd always despised familiarity, informality, and lack of restraint. He
was thinking about the upcoming First International Congress of Writ-
ers for the Defence of Culture that was being organized as a resistance
to the rise of Fascism in Europe. Writers from fourteen countries were
expected to attend. He had his speech ready, and he intended to make
a splash. When he spoke before a crowd, he knew he could always
"make sparks fly and start fires."[2]

He was dressed as usual in a black suit, with the dark green shirt
and slightly eccentric red tie he favored. His tallish figure was robust

but lithe, his gait controlled. He seemed to glide. His mane of hair was russet, slightly wavy, and he wore it long for the times. His blue-green eyes were attentive, even mocking. Friends remarked: "he was always present, never distracted."[3] The effect he created was one of power. He exuded authority, he believed he had a mission to accomplish.

The group of friends was heading to their ritual aperitif gathering, a permanent part of Breton's life. At whatever café was his favorite of the moment, he would arrive around noon and then again at 7 P.M., with the efficiency of a businessman going to his office. And he liked to find his people there when he arrived. Assiduously attended, these daily get-togethers were ceremonies of allegiance to the artistic movement he had founded called surrealism—he had already been dubbed its pope. Here issues were discussed and new surrealists were inducted. During these sessions, Breton could be intimidating, but he was also a generous man. Though he was himself indifferent to luxury and security and was always poor, he was attentive to the financial situations of his friends. Anyone low on cash would find Breton had discreetly taken up a collection and covered his bill.

As they walked toward the café, someone pointed out Ilya Ehrenburg, who was just leaving the Closerie des Lilas.

Breton turned white. He felt his face harden and his eyes dim with tears. He was shaking with a violent anger. This was shocking to his friends, for Breton rarely allowed his anger to explode all at once. A lifetime habit of aloofness and restraint had taught him that sarcasm and humor were more intimidating. Rage had to be managed sparingly. But hearing Ehrenburg's name, he ran forward to accost the man.

Ehrenburg was the Paris correspondent for the Soviet newspaper *Izvestia*, for which he wrote hard-line orthodox articles, even though he had the reputation of a bon vivant. Most evenings he could be found at the bar of La Coupole, regaling friends at his favorite table near the entrance. The Communist Party enjoyed considerable favor among Paris intellectuals because they saw it as the only serious force combating the rising tide of European Fascism, and, as a Russian Communist, Ehrenburg was a popular man. He was also an astute

political operator, "one of the few Soviet writers of his reputation, one of the only Jewish writers, to survive the Moscow purge years." It was said of him that "when his peers were in detention camps, he was receiving Stalin Prizes."[4]

The previous year he'd published *Vus par un écrivain d'U.R.S.S.* (*As Seen by a Writer from the U.S.S.R.*), a widely read book in which he berated French authors for selling out to capitalist interests, but he'd saved his fiercest invective for the surrealists. He mocked them as "busy studying pederasty and dreams" while "spending their inheritances or their wives' dowries."[5] They preferred "onanism, pederasty, fetishism, exhibitionism, and even sodomy," he wrote, and "the Soviet Union disgusts them because people work in that country."[6] They had the nerve to call the rag they published *Surrealism in the Service of the Revolution*.

To be accused of political dilettantism and sexual deviance was too much for Breton. He accosted Ehrenburg.

> "*I've come to settle a score with you, sir,*" *he said. . . .*
> "*And who are you, sir?*" *Ehrenburg replied.*
> "*I am André Breton.*"
> "*Who?*"
> *Breton repeated his name several times, each time adding one of the epithets that Ehrenburg had used. . . . Each of these introductions was followed by a slap. . . . Ehrenburg did not even defend himself. He stood there, protecting his face with his hands.* "*You're going to be sorry for that!*" *he blurted out.*

Jacqueline Breton stood by in amazement. "It was the first time I had ever seen such an act of personal violence provoked by indignation and disgust," she would later remember. "It took André several hours to calm down."[7]

Ilya Ehrenburg did get his revenge. He was a member of the organizing committee of the International Congress of Writers, and he demanded that the surrealists be stripped of their right to speak. If not, the entire Soviet delegation would walk out. To go ahead with-

out the Soviets was unthinkable. The committee voted to censure the surrealists.

Breton was furious. And then events took a tragic turn. His friend the poet René Crevel had tried desperately to get the committee to lift its ban, but Ehrenburg refused, saying that Breton had behaved like a cop. Crevel attempted to convince Breton to make a conciliatory gesture. Breton flatly rejected the idea.

On the seventeenth of June, just days before the congress, Crevel went home, swallowed sedatives, and turned on the gas. He left a note pinned to his lapel: "Please cremate me," it read. "Disgust."[8] Clearly a man doesn't commit suicide over a petty political skirmish, but Breton was horrified and felt at least partially responsible for his friend's suicide. Knowing his enemies would blame him for Crevel's death, however, toward the public Breton turned a face of stone.

The congress was one of the most important intellectual events of the mid-1930s. Throughout Europe, Fascism was on the offensive. Italy was under Mussolini's firm thumb and Germany was expanding its Fascist agenda throughout Europe. Spain was unstable, and in France, no one had forgotten "Bloody Tuesday" of the previous year. Sides had to be taken. International solidarity in the face of Fascism was the only answer. What was needed was a broad coalition of writers and intellectuals from all countries united as defenders of justice and humanity. Unexpectedly and in ways no one could have anticipated, the congress that resulted would come to serve as a microcosm of the tragic ideological battles then raging in Europe.

The congress organizing committee included the poet Louis Aragon, the novelist André Malraux, the Dadaist Tristan Tzara, and Ilya Ehrenburg. André Gide, who had recently proclaimed his sympathies with the Communists, was honorary chairman. He was at that time the darling of the Western intelligentsia. Many of the stars of the Left Bank intellectual community turned out, as did writers from the international community. E. M. Forster and Aldous Huxley came from England. Robert Musil, Julien Benda, Bertolt Brecht, Anna Seghers, Lion Feuchtwanger, Alexei Tolstoi, Henri Barbusse, and Paul Nizan were there. Arthur Koestler spoke for the anti-Fascist exiles. Heinrich

Mann represented the German resistance to Hitler. (Mann, the older brother of Thomas Mann, was the author of the satirical novel that became the Marlene Dietrich movie *The Blue Angel*.) Ernest Hemingway, Theodore Dreiser, and James Joyce sent greetings.[9]

But equally important was the number of writers who had been excluded. As the official chair of the congress, André Gide wanted to take in the full spectrum of French opinion, indeed, all writers prepared to unite in an anti-Fascist stance, including the nonpolitical poet Paul Valéry, the Catholic novelist François Mauriac, and the conservative Henry de Montherlant. But Ehrenburg insisted that outspoken opponents of unity of action with the Communists were in principle to be excluded or made to feel unwelcome. Their presence would only give the Right the chance to disrupt the congress.

It became clear that the Soviet Union was the principal organizing force at work in the shadows. While appearing to take a backseat, the Communist Party machine worked aggressively to retain control. Stalin himself had summoned Ilya Ehrenburg back to Moscow to talk about preparations for the event. However, when Ehrenburg arrived there, the leader was busy. Sergei Kirov, the popular secretary of the Communist Party of Leningrad, had just been assassinated. Historians would later conclude that Kirov had probably been murdered on Stalin's own orders since his death marked the beginning of Stalin's campaign to purge all potential rivals to his power.

Ehrenburg did not get to see Stalin. Instead it was the Central Party that gave him his orders and selected the Soviet writers who would attend the conference.

The congress opened on June 21 in the Palais de la Mutualité, an art deco building in the Latin Quarter that served as the headquarters of an insurance association. Its auditorium was designed to seat two thousand, but the nightly audience at the congress numbered between two and a half and three thousand. Loudspeakers relayed the speeches into the lobbies and people stood listening in the street. National and international newspapers gave the congress full coverage. Even Hitler took notice: "Bolshevist writers represent the murder of culture," he sneered.[10]

Paris was experiencing one of the worst heat waves in memory. The weather was exceptionally torrid—the days were close and the nights were interrupted with continuous thunderclaps and sheet lightning. In the packed hall there was hardly any air to breathe. Men worried fussily at their neckties and bow ties. Women removed their gloves and fanned themselves. Whispers of complaint at the heat fanned through the room. Speakers and spectators sweated through the five days the congress lasted.

As honorary chairman, Gide was expected to open the congress. He had been fussing for weeks. He wrote in his diary: "When I think of this Congress at which I am expected to make a speech, it makes my head spin."[11]

Opening night it seemed to take hours to seat the 250 official delegates who attended. Late into the evening, Gide stepped to the podium: "In my opinion," he said, "we must begin with the idea that this culture which we seek to defend is the sum of the particular cultures of each country, that this culture is our joint possession, that it belongs to us all, that it is international."[12] He later spoke admiringly of the Soviet Union as a country that respected people's language, customs, and culture where the individualist could best fulfill himself. Over the next days speeches followed on "The Role of the Writer in Society," "The Individual," "Writers and Propaganda." The atmosphere was feverish, sometimes uplifting, and often confusing. Heated conversations followed late into the morning at the Deux Magots and other Left Bank cafés.

But no one at the congress had any idea that the real story of the congress was percolating behind the scenes and that it involved the Soviet participants.

The Russian writer Maxim Gorky had been expected to attend the congress, but withdrew at the last moment. As one of the chief organizers, André Malraux had been furious. How could the congress proceed without Gorky, who alone matched the stature of the other foreign participants and who was needed to speak out against Fascism? What Malraux did not know was that, by the time of the congress, Gorky was virtually a prisoner in Moscow. He would be dead within

a year. His death would eventually serve as the pretext for another trumped-up treason trial. His doctor and the head of the secret police would be executed for his murder, even though he was likely killed on Stalin's orders.[13]

The Soviets selected Boris Pasternak and Isaac Babel to replace Gorky. Their function was to serve as official mouthpieces, and, while in Paris, they were under constant surveillance by Soviet secret police. The charade was impressive. When the Jewish writer Isaac Babel walked onto the stage of the Palais de la Mutualité, he seemed totally at ease. Speaking with humor in eloquent French, "like a storyteller in an Eastern town," he told stories of village life in the shtetels and talked of the Soviet people's love of literature.[14] Isaac Babel would later disappear as Stalin's purges continued.

One of the most important moments of the entire event came when Boris Pasternak mounted the podium. The irony was that no one in the audience understood it to be so. Pasternak told his listeners: "Poetry will always exist down in the grass. It will always be too simple a thing to discuss in meetings. It will remain the organic function of a happy creature."[15] For so important an occasion, this sounded like nonsense. But Pasternak's handlers were watching. By saying nothing, he made the only statement he could make and live. Years later he would look back and interpret his own remarks: "Only personal independence matters."

The editor of *Pravda*, Mikhail Koltsov, also attended. When he spoke, he recalled the first international meeting of writers in Paris in 1878 attended by Victor Hugo and Turgenev. He claimed that "today Russian writers could speak to their Western fellows very differently: the convict prisons, the general illiteracy . . . despotic governors no longer overshadowed them."[16] In 1938 Koltsov was arrested and shot as a spy.

André Breton was perhaps one of the few writers who had even a clue about the sinister backdrop. Having been officially excluded from participation in the congress, he sat in the back of the hall each night and occasionally heckled. Shocked by Crevel's death, the congress had finally come up with a last-minute compromise. The poet

Paul Eluard was allowed to speak on behalf of the surrealists. At twenty minutes past midnight on the fourth day of the congress, Eluard stepped to the microphone to address the nearly empty hall and read a statement written by Breton. Breton attacked the organizers as academic, bureaucratic, and conservative, but he saved his fiercest invective for the new Soviet doctrine of "Socialist Realism." Breton insisted that art could follow no dictates but freedom of expression and "must resist all falsification from the right and from the left." He had always thought that the enemy was the tainted bourgeoisie. Now that he had been censored from speaking, he understood that "the Soviets could be just as conniving as any Western power."[17] After this episode, he would sever all ties with French and international Communism.

Something huge and very important underlay these debates. Art had become a linchpin to political ideology. Both Stalin and Hitler and their ideological henchmen sought to control the artist and to dictate what was acceptable. The potentially tragic fate of the artist became clear on the last day of the congress when a number of members in the audience brought up the name of Victor Serge.

The organizers knew that the so-called *l'affaire* Victor Serge would come up, and that it would have to be dealt with discreetly. In the mid-1930s there was a reluctance to criticize the Soviet Union and the Communists because such criticism would only feed the propagandists on the right. But some were beginning to question this logic. Should the Soviet Union be able to duck all scrutiny? For them the dissident Socialist Victor Serge, reportedly incarcerated in a Soviet jail for his outspoken opposition to the Communist state, was a cause célèbre. It took guts for leftists to buck the accepted orthodoxy. When the young French philosopher Simone Weil had previously brought up the case of Victor Serge at a convention of the United Federation of Teachers, she had been shouted down with cries of "Viper!" She would have been physically attacked had not friends formed a protective circle around her.[18]

Geatano Salvemini was a professor and former member of the Italian parliament who had been forced into exile in the mid-1920s as Benito Mussolini consolidated his power. At the congress, Salvemini stood up to speak for persecuted intellectuals and freedom of thought

and then asked what had become of the Belgian-Russian writer Victor Serge. Rumors held that he had been arrested, imprisoned, and then sent into forced exile in the Ural Mountains.

Next, a group of young Parisian leftists who had made Serge their cause, demanded the floor. Still somewhat naïve, André Gide was amazed to find that fierce efforts were being made by Ehrenburg and others to hush up the dispute. As honorary chair, he insisted on ventilating the matter. André Malraux, who was chairing the session, finally allowed a young writer, Magdeleine Paz, to take the floor. Invoking the congress's focus on the issues of "dignity of thought . . . freedom of expression, censorship and exile," she demanded the writers address the fate of Victor Serge.[19]

The previous year, Serge had managed to smuggle a message to Paz and other friends in France. In it he defined Russia as a totalitarian state (he later remarked in his *Memoirs* that he may have been the first person to do so). He told them: "I sometimes begin to wonder whether we are not bound to be murdered one way or another in the end, for there are plenty of ways of going about the job."[20] He asked his friends to publish the message in the event of his disappearance.

The official Russian version stated that Serge had participated in the Trotskyite counterrevolutionary agitation that led to the murder the previous year of Sergei Kirov, the murder that Stalin himself had most likely staged. Serge had been sent into exile, where he received a stipend from the state. It mattered little that Serge had already been arrested a year before the murder and had been deported to the Ural Mountains. Nor did it matter that Serge was starving on his official stipend.

The truth was that Serge had been arrested in 1933 and, after eighty days of solitary confinement with lengthy interrogations in the infamous Lubianka prison, headquarters of the secret police in Moscow, he was sent under armed guard in a convoy of detainees to the town of Orenburg on the Ural River, a metropolis on the steppes at the border between Europe and Asia. He was guilty of the crime of nonconformism. He had done nothing except refuse to recant his criticisms of Stalin and the Soviet system.

Serge arrived in Orenburg in the middle of a terrible famine. A government campaign against religion had led to the destruction of

all the churches. The rubble of the dynamited Orenburg cathedral filled the central square. According to the terms of his exile, Serge was forbidden to leave the town. His wife, Liuba, had had a series of mental breakdowns under the pressure of persecution, in particular when she had stood trial with her father as a counterrevolutionary. Both were acquitted. She was eventually allowed to join Serge, as was his thirteen-year-old son, Vlady.

During the two years of his exile in Orenburg, Serge's persecution continued. Serge and his son were alone now. His wife, having had another breakdown, had been sent to Leningrad for psychiatric treatment. At his school, Vlady was berated by the Communist senior staff for not breaking off relations with his father. The political police (GPU) had cut off Serge's correspondence with France and so he was not receiving any royalties from his books. Unable to work, he and his son nearly starved to death.

If there was one significant achievement of the First International Congress of Writers for the Defence of Culture, it was the freeing of Victor Serge. After the congress was over, André Gide went to the Soviet embassy on the rue de Grenelle to deliver a letter asking for an explanation of Victor Serge's case. "It is important," he wrote, "that [the USSR's] most ardent and devoted defenders not feel themselves morally disarmed and distressed when they have to defend it."[21] At a time when Soviet policy was to seek support from left-wing intellectuals in Europe, Serge was an embarrassment. If he hadn't become such a noted author in France, matters for him would have taken a much bloodier turn.

Shortly after the congress, the French novelist Romain Rolland visited Moscow and had a meeting with Stalin, who, realizing there was much to lose by holding on to Serge, offered his personal assurance that Serge would be authorized to leave the Soviet Union in the company of his family.

It would take almost a year for Serge's exit to be effected, in part because it wasn't easy to find a country willing to take him in. Though he was a respected writer and intellectual, his background still made him suspect to the mostly anti-Communist European governments. The

French Foreign Ministry refused the entry permit for which Serge's friends pleaded. Approaches to London were fruitless. Denmark and the Netherlands also refused a visa. Finally the government of his native Belgium offered a residence permit for three years. The Russian government gave Serge three days to get ready to leave for Moscow.

Serge was released along with his son on a freezing day in April 1936. Sitting across from two guards, he watched the white plains of the steppes flee past the train window and, like all exiles, wondered if he would ever see his country again. In Moscow he marveled at the luxurious new metro with its granite paving and huge platforms and noted there were no benches for weary travelers. He had hoped to collect his manuscripts but was told by a friend: "Go this very evening. Don't press for anything."[22] The secret police were already reviewing his case.

Serge's wife was allowed to join him. As soon as he and his family arrived in Belgium, he began his campaign to publicly expose what was happening in the Soviet Union. This made him a target of the Right because he was still considered a left-wing revolutionary, and also of the Communists, who considered him a "Trotskyite-Fascist."

André Gide had long since been invited to Russia, where his books were being translated. After the experience of the congress, he was anxious about being manipulated and determined that one thing he would talk about with Stalin was the "plight of Soviet homosexuals." His concern was naïve. Serge published an open letter to Gide in the left-wing newspaper *Esprit*, in which he warned him:

> We are building a common front against Fascism. How can we block its path, with so many concentration camps behind us? Let me say this to you: one can only serve the working class and the U.S.S.R. by seeing absolutely clearly. And let me ask this of you in the name of those over there who have every kind of courage: have the courage to see clearly.[23]

Serge was warning Gide that, seen up close, the new Russia was not what it appeared to be from abroad. Even if Europe was facing the

triumph of Fascism in Germany and Italy (and Spain would soon follow), lying about Soviet totalitarianism in the name of solidarity would prove no route to peace. Serge had seen the repressive regime that Russia had become and called it what it was: "a concentration camp universe." He had great respect for Gide. Remarkably, all he was asking of him on his trip was to keep his eyes open. Not to be duped.

In June 1936 Gide finally went. As it turned out, his nine-week trip to the Soviet Union was a public relations disaster for Stalin. Gide came back deeply critical of the government he had naïvely admired. In *Retour de l'U.R.S.S.*, the book he published on his return, he criticized the privileged bureaucracy that had created a new elite class and the cult of the leader under Stalin's ruthless control. The Communist press said Gide was a "victim of anti-Soviet agents and a kind of Judas."[24]

That very August 1936, the first of Stalin's infamous Moscow show trials began. Sixteen well-known Communist officials were summarily tried and executed, beginning a nightmare of killings that would last almost two decades. As the number of executions mounted, Victor Serge, now in Belgium, continued his campaign of exposure, but he could get almost no one to see the truth. His foresight was absolutely useless. He protested that Western party leaders swallowed it all: "the killing, the nonsense, the cult of the Leader, the democratic Constitution whose authors are promptly shot!" With secret police surveillance, trumped-up trials and executions, slave labor camps and starvation, Stalin had indeed turned Russia into a concentration camp universe. "Nobody was willing to see evil in the proportions it had reached," Serge raged. This was turning into "a tragic lapse of the whole modern conscience."[25]

Serge's courage was astonishing. He watched most of his comrades murdered within Russia and abroad, and yet he still spoke out, decrying "the wilful determination to wipe out the rebellious intelligence without mercy." "What is terrible when you seek the truth is that you find it," he wrote. "You find it, and then you are no longer free to follow the biases of your personal circle, or to accept fashionable clichés."[26] There would prove to be few who could look at the truth like this without flinching.

FRIENDS FOR LIFE

It was November 1936. Danny Bénédite was sitting at his desk at the Préfecture de Police when Paul Schmierer, a physician and one of the people who brought him individuals in need of visas, entered his office. With him was a man in his mid-forties. He had finely drawn features with a sharply sculpted nose and square jaw. His face carried little of his experience: the skin was taut, the mouth controlled. His manner was almost courtly. But behind steel-rimmed glasses, his eyes were shrewd and incisive. They had a searching, attentive look that took your measure immediately. There was little possibility of dissimulation before eyes that had seen so much. Standing in front of Danny was Victor Serge, the man whose case was so infamous. He had just arrived from Belgium and had come to Danny in the hope of obtaining the *permis de séjour* (residence permit) foreigners required to reside in Paris.[1]

The mild-mannered man who greeted Danny was a surprise. Danny knew immediately who he was. From the late 1920s Serge, writing in French, had built a reputation as an historian, political analyst, and novelist. What moved Danny was that despite his clear per-

ception of Stalinism and Fascism, despite everything, Serge was still battling for the ideals of social democracy.

Danny was familiar with Serge's novel *Men in Prison*, which had been published in Paris in 1930. It had the kind of opening one couldn't forget:

> *All men who have experienced prison know that its terrible grasp reaches out far beyond its physical walls. There is a moment when those whose lives it will crush suddenly grasp, with awful clarity, that all reality, all present time, all activity—everything real in their lives—is fading away, while before them opens a new road onto which they tread with the trembling step of fear. That icy moment is the moment of arrest.*[2]

Danny examined, with frank astonishment, the man who stood before him. Serge had experienced prison, exile, starvation, the death of friends, and yet his manner was mild and he spoke with humor and equanimity. The anger must be there, Danny thought, the rage at human perfidy. Perhaps that's why Serge wrote so much—to purge himself of hatred. Danny was thrilled to be in the presence of this man who had become one of his heroes and who would prove to be one of his best friends.

In his long conversations with Serge, Danny began to understand the roots of Serge's moral courage. Beneath the surface idealism, there was something profoundly pessimistic, even fatalistic, about Serge's temperament. He himself explained: "Even before I emerged from childhood, I seem to have experienced, deeply at heart, that paradoxical feeling which was to dominate me all through the first part of my life: that of living in a world without any possible escape, in which there was nothing for it but to fight for an impossible escape."[3]

His family history was one of flight and rootlessness. As a cavalry officer in the Russian imperial guard, his father had been on the far reaches of the anti-tsar movement, and when Alexander II was assassinated in 1881, he had had to flee Russia. Serge was born Victor Lvovich Kibalchich in 1890 and grew up with stories of how his father

had swum to safety across the Austrian frontier under a hail of police bullets. During his childhood, the family lived in abject poverty in Belgium. He watched his younger brother die of starvation at the age of eight and a half. Owing to the estrangement of his parents, he lived on his own from the age of thirteen. In 1919 he traveled to Russia to fight for the Revolution, but, by 1927, was expelled from the Communist Party for criticizing it as antidemocratic. This was the same year Leon Trotsky was arrested and later exiled. Serge always said that he felt like he was a member of a tribe of the condemned whom it was his responsibility to champion.

With much effort, Danny was able to get Serge a *permis de séjour* and found him a place to live on the outskirts of Paris. Serge's bitter protest against the Moscow show trials had not gone unnoticed. In retaliation, the Soviet government engineered a slander campaign by Soviet agents in France. Soon Serge found himself under a boycott that was practically total. Most left-wing publications were suddenly closed to him. Censored by the French trade unions, he couldn't even find work. The few allies he had on the left were themselves under boycott and powerless to help him.

At last he found a job as a proofreader at the Croissant printing factory. The neighborhood reminded him of his working-class childhood in Belgium—the pubs, the small hotels servicing the love life of factory workers, the little restaurant where the independent Socialist Jean Jaurès had been murdered in 1914. The dilapidated nineteenth-century buildings of the Croissant suited him, along with the incessant noise of the printing machines, and the intermingled smells of ink, paper, and dust. At the end of each run, he loved the way "faces would relax and trade-jokes would pass back and forth over the 'stone.'" When the workday ended, the workers would catch a last drink as they waited for the final edition.[4]

In France, Serge did not stop his political activities. He gave endless speeches—in Socialist halls, at trade union meetings, at the League for the Rights of Man. He met André Breton and, with him and a few others, set up a Committee for Inquiry into the Moscow Trials and the Defence of Free Opinion in the Revolution. They had no

money and used to meet in the back rooms of cafés, first in the Place
de la République, then in the Odéon. It was Serge who insisted on the
lengthy name. Everything he had experienced in the Soviet Union
had taught him that civilization had to be grounded in freedom of
thought and the right to criticize.

He railed against Stalin's show trials:

> *The most shameless lying conceivable blazed out . . . In* Pravda,
> *I could read the accounts (all of them mangled) of the Trials.
> I picked out literally hundreds of improbabilities, absurdities,
> gross distortions of fact, utterly lunatic statements. . . . The Brit-
> ish Intelligence Service blended with the Gestapo; railway acci-
> dents became political crimes . . . ; crowds of defendants whose
> trials were pending disappeared forevermore into the shadows;
> the succession of executions went into the thousands.*[5]

The situation was urgent now. The Spanish Civil War had broken
out that summer of 1936. Stalin had secret agents operating in Spain.
Serge was worried that these agents would use the same tactics of slan-
der and assassination that had been used in Russia to purge dissidents
within the Communist and Socialist ranks. He was afraid that among
the thousands of anarchists and anti-Stalinists who were now fighting
against Franco on the Republican side, many would be targeted for
liquidation. Heartbreakingly, his prediction would prove to be deadly
accurate.

THE PARIS EXPOSITION

1937

The place to be in the summer of 1937 was the Paris International Exposition dedicated to Art and Technology in Modern Life. Europe might have been edging toward world war, but thirty-one million people attended the exposition. Paris was partying. There were motorboat races on the Seine, horse races, boxing matches, international sporting events, and dance festivals. *A Midsummer Night's Dream* was staged in the Bagatelle gardens in the Bois de Boulogne. The exposition was billed as an enactment in the City of Light of "a ritual of Peace and Progress," a great lesson in international cooperation.[1]

The previous year, Léon Blum's Popular Front had been elected to power, bringing France its first Socialist government with a platform of social reform. Many Parisians thought that a Socialist government had no business spending millions on something as frivolous as an exhibition when the country was still in the midst of the Depression and hundreds of thousands were out of work. But as soon as one stepped out of the Trocadéro Metro and entered the exhibition gates, it was impossible not to be impressed. The old Palais du Trocadéro from the

Exposition of 1878 had been completely dismantled. In its place stood the Palais de Chaillot, an imposing if rather ugly neoclassical structure with colonnaded wings curving around a garden. In the center of the garden was a tower called the Tower of Peace, flanked by bronze sculptures, ornamental pools, and fountains. Across the Seine, the Eiffel Tower provided the backdrop.

On the exposition's central esplanade, the German pavilion stood directly across from the Soviet pavilion, as if the two were engaged in a "dramatic architectural confrontation."[2] The German building was the larger and loomed ominously over the Soviet structure, facing it down. On its roof a bronze eagle, its talons curled around a huge swastika, spread its wings threateningly.

The rumor was that Hitler's architect, Albert Speer, had stolen onto the Soviet site to get a premature look at blueprints. Fearing his Führer's rage, he had to be sure the German pavilion was taller than its rival.

A guidebook instructed the audience about the German pavilion's symbolic meaning: "The great hall creates the effect of a unit . . . the individual departments are not in competition with each other . . . [but] are all housed under the same roof, organized according to the will of one man, united in the ideal of the community of the German people—witnesses of the new Germany and its Führer."[3]

Perhaps the German penchant at the time for mythomania—the cult of the leader, the myth of the master race—is clear only in retrospect. The mainstream Paris newspaper *L'Oeuvre* called the Deutsches Haus pavilion "an imposing manifestation of the civilizing energies of Germany, of a Germany which has cast off its warrior gear and is speaking to the world through the voices of its scholars, engineers, and artists."[4] Ironically, many of those artists and scholars were already refugees hiding from the Nazis in Paris.

That Hitler took the symbolism of his pavilion very seriously was clear three years later when he marched into Paris. On the morning

of June 23, during the three hours he spent in the newly defeated city, he had himself photographed on the esplanade of the Palais de Chaillot.[5]

But the visiting public was indifferent to the symbolic confrontation between the two totalitarianisms. They only laughed at the giant male and female nudes, embodiments of racial purity, in front of the German pavilion and had themselves photographed in suggestive poses leaning against the formidable loins.[6] And they took a certain joy in scribbling anti-Communist notes in the visitors' book of the Soviet pavilion.

What interested them was the Palais de l'Air, the most visited pavilion at the exposition, for the public in the 1930s was in love with flying. The Palais was certainly impressive. Its major feature was a vast gallery that resembled an airplane hangar. At intervals on pedestals, airplane engines were displayed as if they were abstract sculptures by Georges Braque. Parachutes like giant mushrooms hung from the ceiling.

The centerpiece of the exhibition was a Ponteix 63 fighter plane suspended in the air and surrounded by gigantic aluminum rings like the rings of Saturn. Amid the thrill of the exposition, it probably occurred to few that what they were really looking at was the future of warfare. The new day would soon come when bombs and troops would fall from the sky.

PICASSO AND THE DRESS REHEARSAL

April 1937

> *And one morning everything was burning,*
> PABLO NERUDA[1]

The dress rehearsal for the new type of warfare was already under way. Most visitors to the Palais de l'Air, marveling at the grandeur of the airplane, were oblivious to the fact that a few short weeks before the pavilion opened in May, a small town in the north of Spain was the first to experience the terror that airplanes could inflict. Though planes had been used in World War I, the saturation bombing of civilian targets was an entirely new concept.

The Spanish Civil War had erupted the previous July when a coordinated group of army chiefs in Spanish Morocco and on mainland Spain staged a military uprising to overthrow the democratically elected Republican government. By late July the right-wing insurgents controlled one-third of the country. By November Hitler and Mussolini had recognized the Nationalists (as they called themselves), led by General Francisco Franco, as the official government of Spain. Léon Blum's Popular Front government had agreed to send artillery and air-

craft to support the Republicans, but, under pressure from Britain and the more conservative members of his own cabinet, Blum withdrew his support. Wary of starting a wider European conflict, the Western democracies opted not to intervene. Only the Soviet Union (certainly for its own cynical reasons) and international left-wing organizations openly sided with the beleaguered Republicans. They organized International Brigades of volunteers to help fight against Franco.

The flagging Republican government of Spain was determined to use its pavilion at the Paris Exposition to assert its political legitimacy on the world stage. A young Catalan architect named Josep Lluis Sert was assigned to design the pavilion. Having already ensured the participation of the artist Joan Miró and the filmmaker Luis Buñuel, he approached Pablo Picasso in January to ask him to paint the central mural.

The government considered Picasso Spain's greatest living painter. In September 1936, at the outset of the civil war, they had nominated him honorary director of the Prado Museum. They needed his international credibility. The assignment proved tragic. As the civil war intensified, Picasso's sole function was to preside over the hasty evacuation of the Prado's masterpieces, first to Valencia and then to safety in neutral Switzerland.

Back in Paris, Picasso was known to be working on a group of grotesque cartoon etchings called *Dream and Lie of Franco* in which he expressed his unlimited contempt for the dictator, portraying him as the embodiment of evil.

To accommodate the enormous canvas the pavilion organizers were requesting, Picasso rented a two-floor studio in the rue des Grands-Augustins. Surviving sketches suggest that he'd decided on a subject—a portrait of the artist in his studio—an image to celebrate creativity.

Then on the afternoon of April 26, an act of chilling barbarity affected the painter profoundly. The small northern Basque town of Guernica was bombed and totally destroyed. It was initially thought that it was Franco's Nationalist pilots who had carried out the bombings. The next day the *New York Times* described the destruction:

*Fire was completing today the destruction of Guernica, ancient
town of the Basques and center of their cultural tradition, which
was begun last evening by a terrible onslaught of General Fran-
cisco Franco's Insurgent air raiders.*

*The bombardment of this open town far behind the lines
occupied precisely three and one-quarter hours. During that
time a powerful fleet of airplanes consisting of three German
types—Junkers and Heinkel bombers and Heinkel fighters—did
not cease unloading bombs weighing up to 1,000 pounds and
two-pound aluminum incendiary projectiles. It is estimated that
more than 3,000 of these projectiles were dropped.*

*Fighting planes meanwhile plunged low from above the
center of the town to machine-gun those civilians who had taken
refuge in the fields.*

*Virtually the whole of Guernica was soon in flames. . . . At
2 A.M. today, when the writer visited the town, the whole of it
was a horrible sight, flaming from end to end. The reflection
of the flames could be seen in the clouds of smoke above in the
mountains from ten miles away. Throughout the night houses
were falling, until the streets were long heaps of red, impenetra-
ble ruins.*[2]

In fact, the raid was planned and executed by German pilots of the
Condor Legion. Guernica was simply an occasion to test new planes
and the effectiveness of incendiary bombs. It was also a dress rehearsal
for the strategy of blitzkrieg (the lightning strike) with which Hitler
and his generals expected to win the Big War.

The news of the bombings first reached Paris on April 27 in a
Radio Bilbao broadcast. With mounting outrage, the Basque presi-
dent, José Antonio Aguirre, initially blamed Franco's Nationalists for
the bombings. But then it became clear that the German Condor
Legion, acting with Franco's cooperation, had carried out the raid.
Radio Nacional, which supported Franco, claimed that no German
planes had been in the air that day and, more outrageously, that no
German troops were even in Spain. Radio Seville (also pro-Franco)

Guernica.

reported that Guernica had been intentionally "destroyed by extremist elements among the retreating 'Reds' who first dynamited and then set fire to the town."[3]

Reading of the attack in *Ce Soir*, *Le Journal*, and *Le Figaro*, Picasso at first was horrified by the bombings, and then appalled by the lies. Over a period of two months he poured his rage and grief onto the canvas, completing the three-hundred-square-foot *Guernica* in June, in time for it to be hung in the Spanish pavilion.

Guernica is a terrifying work, a grotesque jumble of faces and limbs, massacred animals and human beings, with a brutal sun or eye presiding above, unblinking before the horror of it all. It is impossible to contemplate without heartbreak. Set apart from all the glitter of the Paris Exposition of 1937, this painting was a prophetic testament to the coming disintegration that was about to engulf the whole of Europe. If people could only have comprehended it.

But there were some who understood. In the wake of France's decision to stay neutral in 1936, thousands of British, European, and North American civilians had flocked to Spain to join the International Brigades on what they thought of as the first barricade against European Fascism. The surrealist painter Max Ernst offered his services to the Republican authorities.[4] George Orwell was fighting for the Republicans in Barcelona, as were Antoine de Saint-Exupéry and Simone Weil. Weil had managed to join a small commando group of

French, Italian, and German volunteers fighting on the Ebro River. She was the only woman. She lasted only a week before an accident she suffered at the base camp forced her to quit the front.[5]

And many writers were writing about the war. Ernest Hemingway was using the Ritz Hotel in Paris as a base while he made forays into Spain to report on the progress of the war for the wire service NANA (North American Newspapers Alliance) and also organized a rescue committee to get sick and wounded American volunteers out of Spain. Even Gertrude Stein had to look up from her work: "All the time I am writing the Spanish revolution obtrudes itself. . . . I know it all so well . . . all the places they are mentioning and the things they are destroying."[6]

Mary Jayne Gold felt the same tragic sense of recognition. She knew Spain well. She had lived there for some months in the mid-thirties and had even fallen in love with a young Catalan. Now there was brutal fighting on the streets of Barcelona where she had walked with her lover. And she wondered about Ramón Maura. Had the Duke of Maura returned from his exile in Biarritz? Was Ramón now fighting with Franco's insurgents? Was he still alive?

Even though the fighting was at a distance, the sense of a country devouring itself was unsettling. Still, most people said it was a "civil war" after all, happening elsewhere. Not yet THE WAR.

DEGENERATE ART

Munich, 1937

"Why are totalitarian minds afraid of art?" I asked.
"Because it gets inside," Leonora Carrington replied. "It can terrify you or give you joy."
LEONORA CARRINGTON[1]

It was July 19. The day was hot and yet several thousand people were lined up waiting to enter Munich's Institute of Archaeology. The paleontology exhibits had been cleared out and its tiny rooms were now hung with "degenerate" art. The master of ceremonies, Adolf Ziegler, offered opening remarks: "All around us you see the monstrous offspring of insanity, imprudence, ineptitude, and sheer degeneracy. What this exhibition offers inspires horror and disgust in us all."[2] People were obviously titillated. What would they see?

When the doors finally opened on the exhibition, Entartete Kunst, the expectant viewers found themselves climbing a rickety staircase and entering a dimly lit, low-vaulted room. In the narrow space, only thirteen feet wide, paintings were crowded together on the walls, some unframed, others pasted on burlap, most hung crookedly. As the crowds shoved forward to get a look, the effect was one of appalling claustrophobia.

Hitler visits Entartete Kunst, the exhibition of "degenerate" art.

There were nine rooms, each bearing a thematic label. On the first floor were "Insolent mockery of the Divine under Centrist rule" and "Revelation of the Jewish racial soul." Upstairs the smaller rooms had titles like "An insult to German womanhood," "The ideal — cretin and whore," and "The Jewish longing for the wilderness reveals itself — in Germany the negro becomes the racial ideal of a degenerate art." On the walls under many of the paintings were hand-lettered labels indicating how much money German museums had spent acquiring them. The amounts were ludicrously inflated. Red stickers bore the words: *"Bezahtl von den Steuergroschen des arbeitenden deutschen Volkes"* — paid for by the taxes of the German working people.[3]

The walls were also plastered with graffiti: "Crazy at any price," "Nature as seen by sick minds." The sick minds included Marc Chagall, Max Ernst, Wassily Kandinsky, Lyonel Feininger, George Grosz, Paul Klee, the Dadaists, Oskar Kokoschka, Käthe Kollwitz, Otto Dix. In all, there were 650 works by 112 artists, among whom were six Jewish painters. The damning epithets — Jews, Bolsheviks, criminals — were used interchangeably; they were synonymous.

Didactic messages from speeches by Hitler were also pasted on the walls: "It is not the mission of art to wallow in filth for filth's sake, to paint the human being only in a state of putrefaction, to draw cretins as symbols of motherhood, or to present deformed idiots as representatives of manly strength."[4]

The public responded with the expected outrage. "The artists are making fun of us," they said. These so-called artists could neither draw nor paint. Surely there had been a conspiracy of degenerate art dealers, museum directors, and critics to bamboozle them. They wanted their money back.

Schoolchildren were bused into Munich to see the exhibit: "Go and see how degenerate the world has become," they were told. And the lesson was clear. Modern art was threatening, dangerous, outrageous. The artists were bent on the destruction of the German people, and this exhibition was to be their funeral.

Some historians see Hitler's attack on modern art as personal. As a young aspiring artist, he had been spurned by the artistic establishment, and now, as the Führer, was wallowing in revenge. But others see something more sinister.

Joseph Goebbels, Hitler's minister for public enlightenment and propaganda, was using modern, experimental art to marshal public hatred. He recognized that people could easily be made to feel afraid of art, especially art they didn't understand. He realized the value of a propaganda campaign against *degenerate* art. He could locate the enemy, harvest the public's anxiety and fear of the unfamiliar, and get to be the defender of public morality. Calling the exhibit degenerate was a brilliant propaganda stroke. *Entartet* (degenerate) is "essentially a biological term, defining a plant or animal that has so changed that it no longer belongs to its own species."[5]

Degenerate was one of Hitler's favorite words. At the end of World War I, lamenting the defeat of Germany, he wrote in his diary: "Hatred grew in me. Hatred for those responsible for this deed, the degenerates and miserable criminals. In the days that followed my fate became clear to me. I resolved to go into politics."[6]

Meanwhile those artists on the Nazis' hit list had reason to be

afraid. At the opening of the House of German Art on July 18, the previous day, Hitler had warned: "We are going to wage a merciless war of destruction against the last remaining elements of cultural disintegration . . . all those . . . cliques of chatterers, dilettantes and art forgers will be picked up and liquidated."[7]

A photograph of Hitler at the Entartete Kunst shows him standing in front of a painting by Max Ernst titled *La belle jardinière* (*The Beautiful Gardener*). Over it is the caption "A Slur on German Womanhood." The painting disappeared and has never been found. It is thought to have been burned.

The exhibition Entartete Kunst toured Germany and Austria for more than four years and was seen by over three million people. It was the most successful art exhibition in German history.

Throughout 1938, the Nazis continued to seize works of modern art from private collectors and German museums. In March 1939, once Hermann Göring, "the self-styled art connoisseur of the Nazi Party," had selected what he wanted for his private hunting lodge, at least four thousand stolen works were burned on a huge pyre in the courtyard of Berlin's main fire station.[8] Except for more than seven hundred items, considered the most valuable examples of modernism. These the Nazis were quietly selling off at auctions in Switzerland. The profits from the sale of pilfered works by Gauguin, Chagall, Klee, Matisse, and others went directly into Nazi Party coffers.

THE ANSCHLUSS OR MERGING

March 1938

On Friday, March 11, Hertha Pauli and her friends were sitting in Vienna's most famous café, the Herrenhof. Like everyone else, they were discussing the plebiscite that was scheduled for Sunday. Austrians were finally being asked to vote yes or no for a free, independent Austria. Austrian chancellor Kurt von Schuschnigg had called for the plebiscite as a last-ditch effort to stave off Adolf Hitler's pressure to annex Austria, his first move to realize his vision of a Greater Germany. The young political activists in the café never doubted the outcome of the vote. It would be an overwhelming yes for Austrian independence.

Vienna was in turmoil. Young Austrian Nazis who supported the Anschluss (the reunification of German-speaking regions with the German Reich) raged through the streets bellowing "Heil Hitler!" and those for an independent Austria shouted back the colors of the Austrian flag: "Red, white, and red to the death." That Friday evening the twenty-eight-year-old Pauli visited her parents' house, where, shortly after seven, the family gathered around the radio.

The chancellor of Austria was speaking. He reported that forty thousand German troops were amassed on the Austrian border:

> *The Government of the German Reich has presented to the Federal President an ultimatum with a time limit demanding the formation of a Government according to German proposals, with the entrance of German troops into Austria at this hour to be envisioned. . . . The Federal President has instructed me to announce to the Austrian people that we are yielding to force. Determined at all costs and even in this grave hour to avoid shedding blood, we have instructed our armed forces to withdraw without resistance.[1]*

The chancellor said that the referendum was to be postponed to April and announced his resignation.

In a state of profound shock, Hertha Pauli left her parents' home and made her way back to her apartment through streets filled with Austrian Nazis shouting, "One folk, one Reich, one Führer!" Overhead, planes were still dropping propaganda leaflets in support of the yes vote in what should have been Sunday's plebiscite. Pauli knew she had to reach her friend, the German poet Walter Mehring. He was in grave danger. His name was on Goebbels's list of banned writers and the Gestapo would be hunting for him. In her attic apartment, she waited for Walter Mehring and for her business partner, Carli Frucht, with whom she ran a literary agency called Austria Correspondence.

When Frucht arrived, he embraced her and, looking at the manuscripts scattered all over the apartment floor, said calmly: "We will have to get rid of the dangerous ones." Mehring arrived at 9 P.M. in a state of nervous collapse and almost incapable of action. Bands of rioters had surrounded his cab. The driver had managed to escape only by speeding down a dark alley. "Walter," Pauli said, "we'll have to put you on the next train."

Mehring and Pauli sat through a sleepless night phoning friends for help while Frucht tramped through the streets trying to get rid of the agency's anti-Nazi manucsripts. At dawn Frucht went to Mehring's

hotel to collect a few of his belongings, and there learned that the German Gestapo, already active in Vienna, had indeed inquired after the poet. The three headed for the Westbahnhof station.

When he saw the German guards patrolling the main entrance, Mehring lost his nerve. "I can't," he said. But they managed to slip into the station through an unguarded side entrance. In lieu of his German passport, which had been confiscated, Mehring had a French travel pass. He boarded the Vienna-Zurich-Paris Express just as an SS officer approached. The officer demanded, "Who was that?" "Just the French teacher," he was told.

But Hertha Pauli and Carli Frucht were also in danger. They had refused to represent Nazi authors at their literary agency. Pauli had written a biography of an Austrian peace activist, Bertha von Suttner, and it had caused an uproar. Once, when she'd read a chapter of the book on the Vienna radio, young Fascists had thrown stink bombs at the station. Her book was banned in Germany.

On Sunday Hitler himself arrived in Vienna. While he drove in his black Mercedes through the city streets, now clogged with Austrians waving swastika flags, Pauli and Frucht reached the train station. They found it guarded by German troops. Loudspeakers announced Germany's triumph from the vaulted ceiling.

Frucht insisted it would be safer if they left separately. To avoid rousing suspicion, Pauli bought a round-trip ticket to Paris. She would need the money she could get from cashing in the return fare since Austrians were allowed to take only ten schillings, or about three dollars, out of the country whenever they traveled.

At the border, instead of the usual Austrian customs officials, SS men boarded the train. The doors were locked, passports confiscated, and suitcases opened, their contents ransacked. An SS man sat in the empty seat beside Pauli. "Brazen it out," she told herself.

The cross-examination went in circles—why, where from, where to, how, with whom, what for. I felt the noose tighten round my neck until I could hardly breathe. The S.S. man's eyes almost drove me out of my mind; I stared back. They were grey-

greenish werewolf's eyes that never left mine . . . Why did you
leave last night? . . . He kept asking and I kept answering. . . .
I never moved, never took my eyes off his. . . . Why particularly
last night?

"I wanted to wait for the Führer's arrival." . . . He blinked.
All of a sudden my fingers held a passport. My passport.[2]

After five hours, the train was allowed to move. Sunday the thir-
teenth, the day the referendum should have secured Austrian inde-
pendence, was almost over. It had taken only three days for Hertha
Pauli to lose her country and become an exile. She now owned noth-
ing but what she carried in her small suitcase.

By Monday, Carli Frucht joined Pauli in Zurich. He hadn't waited
for her telegram announcing her safe arrival, but instead decided to
leave immediately when he'd realized a Nazi, sporting a swastika in his
lapel, had followed him out of the station. Luckily his pursuer turned
out to be one of his own authors turned collaborator who warned him
the Gestapo was watching him.

When Pauli and Frucht boarded the express to Paris the follow-
ing week, they found the train almost empty. The French border with
Switzerland had already been officially closed, but it opened briefly as
their train crossed. Amazingly, Walter Mehring, who had already ar-
rived in Paris, had managed to call a friend of his, Monsieur Comert,
at his government office at the Quai d'Orsay, the French Foreign Min-
istry. He explained his friends' plight and, to his great relief, Comert
had agreed to open the border for one hour. When the three friends
later met with Monsieur Comert, he congratulated them on being so
prompt. France was now demanding special visas from those entering
the country from Switzerland. He told them they had gotten out just
in time.

THE CLIENTS OF VARIAN FRY

You lose one home after another, I say to myself. Here I am, sitting with my wanderer's staff. My feet are sore, my heart is tired, my eyes are dry. Misery crouches beside me, ever larger and ever gentler; pain takes an interest, becomes huge and kind; terror flutters up, and it doesn't even frighten me anymore. And that's the most desolate thing of all.

JOSEPH ROTH[1]

Wherever they burn books they will also, in the end, burn human beings.

HEINRICH HEINE[2]

In April 1938 the Austrian novelist Joseph Roth sat at his favorite table at the Café Tournon on the corner of the rue de Tournon across the street from the Hôtel Foyot and just off the Luxembourg Gardens. The table was the farthest from the door. He liked to sit with his back to the wall and be within easy reach of the public phone booth. He could always be found at his table, day and night, writing articles in his meticulous script, taking steady sips from his glass of slivovitz that looked as innocent as water. The *patronne* kept Roth's personal bottle behind the bar and cared for him tenderly, locking up his manuscripts at night if he was too drunk to carry them back to the Hôtel Foyot where he had a room.

Well-known exile artists and political figures came to Roth's café table, as did a beautiful black woman called Manga Bell, said to be married to a chieftain of French Cameroun still patiently awaiting her return to Africa.

In the morning Roth would arrive with a red rose that he would ceremoniously present to Manga Bell, after which he hardly ever left his table, except to make mysterious telephone calls. His table was like a nerve cell connected by the thinnest of tissues to the centers of power. Even in exile he always knew the latest news. And he had been in exile five years now.

When Hitler was appointed chancellor in February 1933, Roth had been in Berlin. His books were among those burned in the streets, and then they were officially banned. He packed his bags that same day and took the train to Paris. He severed all ties with Germany and thus lost his German publishers, his newspaper outlets, his German-speaking audience. His highly successful career as a journalist was over. In despair and fury, he scratched together a living writing articles for exile journals in Paris and Prague.

Roth had spent many weeks of the spring of 1938 watching workmen who were finally razing the derelict Hôtel Foyot where he'd lived on and off since his first trip to Paris in 1925. As the building turned slowly and surely into rubble, he sat writing, a sentence and then a drink and then another sentence, recording the demolition.[3]

The final morning of the demolition, only a single wall of the Hôtel Foyot was still standing. The workmen had erected scaffolding against it and were dismantling it piece by piece. As he sat there looking, Roth could make out the sky-blue wallpaper in what had once been his room. At the end of the day when the workers were finished, he invited them to join him for a drink. "It is gone now, your wall," they said. They joked about the wallpaper. Over the top of the first page of his manuscript Roth wrote the title: "Rest While Watching the Demolition." For him, the hotel's demolition was a perfect metaphor for the demolition of Europe itself, which he was witnessing. Like all forced exiles, Roth felt that something profound had been stolen from

him. The idea of home. Years of precious memories were lost to him because he had never been allowed to live them.

The Austrian refugees fleeing from the Anschluss always ended up at Roth's table at the Café Tournon. They came to him because he had written *Radetzky March*, the greatest Austrian novel of the decade, and had become a well-known literary fugitive. They came because he, a Jew, had long seen what was going to happen. In 1934 he had written in a Prague newspaper: "Europe is possible only without the Third Reich. Germany should be quarantined."[4]

To Roth's table came Walter Mehring, Hertha Pauli, and her partner, Carli Frucht. Pauli asked Roth's advice about whether she should return to Austria to cast her vote in the long delayed plebiscite. Hitler had cynically rescheduled the plebiscite for April 10, by which time the outcome was a foregone conclusion. Roth sat drawing scores of tiny crosses. Then with small strokes, he broke them into swastikas. He said to Pauli: "Go and try. By now the outcome is presumably in print."[5] She didn't go. When the vote was finally counted, 99 percent of Austrians favored unification with Germany. Hitler and his allies within the Austrian government had always intended to sabotage the plebiscite and annex Austria.

Not many thought as clearly and consistently as Roth. When he was asked to explain the world's failure to resist or even respond to German aggression, Roth replied that "the Germans have always had the gift of killing to music":

> *People have gotten used to viewing the shameful theatrical scenes that are produced in Germany from time to time through the same opera glasses they take to Wagner productions. . . . The present rulers of Germany . . . know exactly how best to exploit it. They put up some Wagnerian scenery and give foreigners an operatic song and dance of their politics of vulgar expediency. . . . there is something in human nature that would prefer to take brutality for a game. Then you either close your eyes to it or, almost as effective, you interpose a pair of opera glasses.*[6]

Immobilized by the clarity with which he saw the world, Roth drank all day and late into the evening. Tragically, in 1939, after receiving the news of the suicide of his close friend, the revolutionary playwright Ernst Toller, who had escaped to New York only to hang himself in his apartment, Roth collapsed at his café table. He was rushed to the hospital, where he died of pneumonia and delirium tremens. He was forty-four years old. When the Germans invaded the Netherlands in the spring of 1940, they took the time to destroy the entire Dutch stock of Joseph Roth's last novel, *The Tale of the 1002nd Night*, which had just come off the presses in Holland.

Roth had advised Hertha Pauli, Walter Mehring, and Carli Frucht to get out of Europe at all costs and as quickly as possible. They duly joined the lineup of refugees at the U.S. embassy. It was endless; it went around blocks. In any event their effort was pointless. Embassy officials informed them that American immigration quotas were filled and that visitors' visas were issued only to persons able to return to their countries of origin. But a political refugee is by definition someone who can't go back.

As they waited in line, Pauli and Frucht bantered that their situation was "hopeless but not serious," an old World War I joke from the Austrian trenches. Looking back, Pauli would say: "Home was inseparably tied to me but lost forever. I was not travelling; I was in exile. I could not, must not go home again. This was the difference, and it was not to be bridged."[7]

THE SHADOW CITY

1938

In order to get through, one had to learn to slip through the cracks and loopholes, using every trick and stratagem to slither out of this labyrinth, which was continually taking on new configurations.

LISA FITTKO[1]

B eginning in 1933, Paris had slowly become two cities. By 1938 there was the plainly visible Paris and then there was the shadow city, filled with colonies of refugees subdivided by linguistic groups.[2] There were the Russian, the German, the Italian, the Spanish, and now the Austrian exiles. Some refugee émigrés were well-off individuals. Some had financial support from friends or relatives. Disgusted by the rise of totalitarian and Fascist regimes in their own countries, they sought asylum in Paris because of the city's long tradition of welcoming foreigners. But there were others, often artists, banned intellectuals, or political dissidents, who arrived penniless. Their goods had been confiscated and they now lived in cramped quarters or shabby hotels in the delapidated *arrondissements* of the city. These "marginals" were labeled SDFs (*sans domicile fixe*, no per-

manent address) and were subject to random arrests for violations of
the Code Civil.[3]

To stay in the country, the refugees had to show proof of financial
independence. Most had been unable to bring any money out of their
own countries and were unable to work in Paris. To do so, a *permis de
travail*, or work permit, was required, and this was almost impossible
to obtain. Irmgard Keun was a young novelist forced into exile when
her work was branded anti-German. She recalled that the forty-odd
refugees of the exiled German literary community passed around a
single thousand-franc banknote. Each émigré would produce it when
it came time to visit police headquarters to prove he or she was not a
drain on the public coffers. When it was Keun's turn to present the
tattered note, the commissaire remarked: "Seems to me I've seen that
bill before."[4]

The Popular Front government of Léon Blum had finally fallen
that April 1938, bringing a backlash against Socialists, Communists,
and all leftists. Because Blum was Jewish, his defeat also gave license
to latent anti-Semitism. In May, Premier Édouard Daladier, a sup-
porter of appeasement with Germany, was now back in power. After
the Anschluss, which brought an influx of between six thousand and
eight thousand Austrian political refugees to France seeking asylum,
Daladier turned his attention to the "refugee question." His govern-
ment called for a report on the situation of refugees in France. Their
endlessly growing numbers were a drain on social security and the
economy, and they posed a threat to public order. "The *étrangers clan-
destins*," Daladier declared, "were not worthy of French hospitality."
New restrictive measures were needed to control them. He assured
the public that these measures would not affect political refugees, but
only "illegals" without documents. But it was precisely the political
refugees who had no documents. For the most part, the Nazis had
confiscated their passports and documents before they fled. Soon dis-
cussions began about closing the French borders to refugees. Finally
all foreigners already resident in France were required to carry iden-
tity cards.

More ominously still, on November 12, 1938, the French govern-

ment, distinguishing between "*les bons éléments*" (the good elements) and "*les indésirables*" (the undesirables), passed a decree (*décret-loi*) that provided the legal basis for the internment of refugees. Measures were now in place to open internment camps in France.[5] The right-wing press began a xenophobic campaign to demonize foreigners: foreigners were responsible for the economic and social ills of France; they were a threat to public order. They should be interned.

REALITY UP FOR GRABS

Summer 1938

German propaganda has worked brilliantly, like those teams that produce special effects for Hollywood films. The German propaganda teams were faced each time with the following problem: Germany, in order to expand, must absorb a given territory. How could they present this new demand to the world in such a way as to disturb its common sense and confuse its conscience? So the teams launched slogans. The slogans contradicted each other, but, as advertising agencies know, crowds have no memory.
<div align="right">ANTOINE DE SAINT-EXUPÉRY[1]</div>

Mary Jayne Gold put on her bomber jacket, leather pants and boots, and a white silk scarf, and drove to the airport. She had the requisite maps and charts, and had studied the fuel consumption rates. She was ready for the flight to Verona. In her pocket she carried her pilot's license and her American passport.

Flying was not nearly as romantic as some people thought. It was dirty, greasy, and noisy and required dexterity and concentration. It was also dangerous. But Mary Jayne loved danger. The male flyers looked askance at female flyers, but she'd never let traditional notions of what a girl was supposed to do stop her. When they teased her, she bantered back that the airplane didn't care who was flying it. She

climbed onto the wing of her Vega Gull and eased herself into the pilot's seat. Strapping herself in, she looked up through the glass roof at a cloudless sky. She adjusted her goggles and taxied down the airstrip.

It was the summer of 1938. Her plan was to fly to Verona to visit the Murari family. She'd known Giangi Murari since she was nineteen. In those days he had been proud to be one of the first to join the Italian Fascist Party's youth movement. He and his young friends had tried to convert her. Fascism was a modern idea, courageous and antibourgeois, they said. *"Better one day as a lion than a thousand years as a sheep."*[2] It had been heady stuff—the uniforms, the parades, and the slogans, and yes, she'd been a little taken in by the glamour. But in the eight years since she'd made Paris her home, she'd become less naïve. Still, she claimed not to be interested in political change or current events. Her own passion was reserved for sightseeing. She told Giangi to get ready to pop into some of the old towns in northern Italy. It would be fun to arrive in her Vega Gull.

Mary Jayne reached Verona, but at the airport, discovered all British-registered planes were being grounded. Mussolini was touring the north and was scheduled to speak there.

The Murari family had lived in a palazzo near the old Church of San Fermo in Verona since the 1450s so it was not surprising when the conte and contessa and their friends were invited to watch from a balcony in the Piazza Brà close to where Mussolini was speaking.

A number of entrances to the piazza had been roped off as if the police were expecting violence. The square was only half-filled when Mussolini appeared on the adjacent balcony. Mary Jayne had to admire his rhetorical control. As he paced the balcony, she watched his minister of propaganda scuttle behind him raising his arms for applause whenever Il Duce paused for effect, and then dropping them quickly when his leader turned to go in the opposite direction. *"Duce, Duce, Duce,"* the small group of black-shirted supporters occupying the center of the piazza shouted while some people milled about casually on the edges of the crowd. She found it all rather uninspiring.[3] In the old days she would have been impressed. At the collegio, she and her roommate had written to Mussolini asking him for a picture,

as she had once done with movie stars. Two *carabinieri* later arrived at
the villa to check out potential assassination plots.

But now it was easier to take Mussolini less seriously. He was a
standing joke in the Montmartre cabarets; the satirical papers like *Le
Canard Enchaîné* called the Fascists *les fessistes* (a word play on *fesse*,
or backside) and suggested that their black shirts were an Italian in-
vention to save on laundry bills.[4]

The next day, however, when Mary Jayne looked at the local
newspaper, the front-page photograph showed a piazza jammed with
people cheering madly. When she examined the photo closely she
could see that many of the heads were of different sizes and some of
the people were facing in the wrong direction. The photo montage
brought a queasiness to her stomach. It suddenly occurred to her that
the world was changing. Reality now belonged to whoever had the
power to manipulate it.

Clouds rolled in over the Alps. Although Mary Jayne was a li-
censed pilot, she had no experience with instrument flying, and so
she and Giangi remained grounded. But being stalled in Italy wasn't
a hardship. There were always trips to nearby Vicenza. She loved the
intimacy of Palladio's theater. In Padua there were Giotto's frescoes.

It was already well into September and Mary Jayne was still in
Italy. One morning, reading the Italian newspaper, she asked Giangi
in astonishment why Daladier, Chamberlain, Hitler, and Mussolini
were meeting in Monaco. She had misread the Italian. "Not Monte
Carlo, *cara*," he replied, "Munich."[5] He explained that the heads of
state were meeting in Munich, and that this might mean war. She
thought for a moment of her airplane. The Italians would certainly
confiscate her plane if war broke out. It disgusted and enraged her to
think that these men had the fate of all of Europe in their hands.

It was September 29, 1938. Hitler was demanding the right to
self-determination for the three million "ethnic" Germans in the Su-
detenland, a collar of territory around the western reaches of Czecho-
slovakia. Italian radio stations carried the sounds of Nazis barking:
"Like our folk comrades everywhere, we demand justice!"[6] Over the
next few days the leaders of Europe agreed to allow Hitler to annex a

large part of Czechoslovakia, accepting his specious argument that, after all, it was really German Bavaria. Chamberlain had already met privately with Hitler in his mountain retreat at Berchtesgaden (the same room in which Hitler had sworn to the chancellor of Austria to respect Austria's independence). Hitler had pledged that this was his "last territorial demand," and Chamberlain assured the world that the Führer was "a man whose word can be relied upon." On his return to France after the peace conference in Munich, Premier Daladier was shocked that the craven haste with which the Western alliance conceded the Sudetenland to Hitler had won him a hero's welcome on the tarmac of Le Bourget airport. He'd expected to be denounced, not celebrated as an appeaser. Instead the French public was relieved that the war everyone feared had been put off yet again. Within six months Hitler occupied and dissolved the rest of the Czechoslovakian state.

By the time Mary Jayne was able to fly her plane back to Paris, the government posters calling for general mobilization of the French army against Germany, which had been pasted on walls and kiosks throughout the city, were being taken down.

Years later she examined the cycle of escalating violence and the measure of self-deception that blinded people: "Hitler always made his moves in the spring: the Rhineland, the Anschluss, and all the rest. Something was going to crack, sometime, but not now, not yet. . . . The menace of war came every year with the spring snow, but we chose to slide over both, ignoring the avalanche that was forming just beneath the surface."[7]

AM I MY BROTHER'S KEEPER?
THE FRENCH BORDER

February 1939

There has never been anything in modern history like the recent flight of the Catalonian army and civilian population into France.

JANET FLANNER[1]

In February 1939 rumors reached the Préfecture de Police in Paris that an influx of people was streaming over the Pyrenees from sunny Spain. Danny Bénédite had been expecting this. For months the sick and wounded from the International Brigades in Spain had been arriving at the gare d'Austerlitz aboard the dawn train from Barcelona. He had heard about men with their intestines hanging out of their stomachs and others with limbs blown off. Franco was winning the Spanish war.

Now 450,000 people—soldiers of the Spanish Republican army and civilians, including women and children—were reported to be amassing at the Spanish frontier with Franco's army in pursuit.

On February 1 and 2 the newspaper *Le Populaire* reported that demonstrations were being organized in the Paris region to demand that the Franco-Spanish border be opened to the refugees who had

been "chased from their homes by the horrors of war and the threats of retaliation from the Spanish generals who had betrayed their country." The headline read: "The threat of Franco is a direct threat to the security of France."[2]

The French government decided that there was, after all, no way to drive the Spanish refugees back. The border was opened and the refugees swept down into the Pyrénées-Orientales, quickly outnumbering its two hundred thousand inhabitants. To contain the refugees, the government constructed large camps. On the sandy wastes of the beaches of Saint-Cyprien and Argelès, two hundred thousand people were interned, another sixty thousand in the resort town of Amélie-les-Bains, and the remainder in smaller camps.[3]

It was February. Bitter, driving winds swept the snow down from the mountains. There was no shelter. Men wearing blankets like shawls paced the compounds under the eyes of the garde mobile or sat or slept in holes dug in the wet, filthy sand. Everyone was hungry. Some of the Spaniards had brought cows and horses, which they slaughtered. The government allotted each group of twenty-five people two pounds of bread. Sympathetic villagers brought rice and beans, which men cooked in wash buckets and iron pots. The local vineyards were decimated as people ripped up whatever wood and underbrush they could find to burn.

France was totally unprepared to receive hundreds of thousands of people in a few days, but the government had already passed the laws making internment a legitimate solution. The refugees lived for weeks in conditions of horrible filth and many died. But doctors and nurses came to help and refugee assistance committees were established. The committees sent sleeping bags to the refugee camps.

The French chapter of the International Association of Writers for the Defence of Culture was able to set up a Reception Committee for Spanish Intellectuals, sponsored by, among others, Pablo Picasso.[4] Within a month, they had found homes for five hundred people, including the poets Rafael Alberti and Antonio Machado, considered among Spain's greatest poets. Having crossed the Pyrenees on foot with his frail mother and brother, the sixty-four-year-old Machado had

become ill on the journey and, though he was moved to the town of Collioure, he died shortly thereafter.

Danny followed the debate about the fate of the Spanish refugees in the French press. By February 15 *Le Populaire* was protesting against the hunger and privations of the tens of thousands of Spanish refugees still being held in French relocation camps. They demanded that army cots and mobile kitchens be sent to the camps and that the government cease its "scandalous propaganda" inside the camps by which it was attempting to force people to be repatriated against their will. The names of missing children being sought by parents were published in columns. But the newspaper also reported that Paris schoolchildren were collecting food and clothing in their schools and generous aid was coming from all social classes.[5]

On February 15 *Le Figaro* reported the return to Spain of 38,000 Nationalist Franco supporters. Meanwhile 150,000 refugees had been dispersed throughout France, and General Besson had been sent from Paris to inspect the camps where the remaining refugees still languished.[6]

The right-wing newspaper *Le Matin* wrote that France must not allow herself to be blackmailed with pity (*le chantage à la pitié*), while *Gringoire* published a grotesque cartoon of a burglar, with a large sack of stolen art treasures on his back, slipping across the border into France, saying: "I'll find plenty of work here."[7]

The right-wing press greeted Franco's military victories and the "*débâcle des rouges*," the debacle of the Reds, with hoots of joy. With a creeping sense of anxiety, Danny understood that those who found common cause with Franco could not be counted on to fight against Hitler.

For Danny, as for many, the Spanish Civil War had been a political *bouleversement*, a turning upside down. Because of what was happening in Spain, he and his wife, Theo, turned from pacifists to militants, shocked by the refusal of the French government and the international community to come to Spain's aid in the fight against Fascism. As for the Spanish refugees fleeing Franco's armies, only the government of Mexico offered substantial help by granting asylum to

up to thirty thousand people.[8] Now, sitting in his office at the Préfecture de Police in Paris, Danny made a commitment to offer whatever help he could to the Spanish refugees.[9]

On April 1, 1939, Franco announced his victory. It became a catchphrase in France that all Spanish refugees should be repatriated to Spain as soon as possible, with the exception of those who might be shot on their return. But how to tell who would be shot? The government demanded that Franco declare a generous amnesty for all refugees. Franco was not interested. Why should he be intimidated by French demands when the warplanes of his German allies were now within three hours' striking distance of Paris? Meanwhile he was busy signing decrees defining what "political acts by the Red element" would be considered treasonous and what sentences would be applied to those found guilty.[10] A large percentage of the Spanish Republican soldiers who had fled to France for refuge would find themselves languishing in detention camps for years.

DESPERATE TO PARTY

Paris, Summer 1939

In most of France, daily life continued as before. The tourists arrived, and it was almost impossible to find a table in the sidewalk cafés. People stayed out on the streets, seeking comfort in crowds. The *New Yorker* society columnist Janet Flanner reported to her American readers that Paris was having "a fit of prosperity, gaiety and hospitality." The summer of 1939 was "the first good time since the bad time started at Munich."[1]

Propelled by an unacknowledged anxiety, the public was determined to party. The gossip columns described aristocrats on a binge: that summer the Comte Étienne de Beaumont threw a costume party at which the guests were attired in the manner of the seventeenth century. Maurice de Rothschild wore his mother's famous diamonds on his Ottoman turban. And the British hostess Lady Mendl ordered three elephants to entertain her 750 guests at her garden party at Versailles.[2] The government reported the franc was strong. The Depression was over. As the Germans were massing tanks on the frontier of Poland, yo-yos became the craze in France. A few doors down from

the Ritz, the fashion house of Cartier was selling yo-yos made of gold. "The sophisticates were spinning these trinkets in public as if counting prayer beads against disaster."[3]

The news that was being followed assiduously that summer was not of war, but rather of the sensational trial of a German mass murderer. Eugene Weidmann had killed an American tourist and buried her remains in the basement of his modest rented villa outside Paris. He then proceeded to murder five other people. In a special for *Paris-Soir*, the novelist Colette wrote about the quiet, darkly handsome Teutonic Bluebeard. She made a point of insisting that the fact he was German did not prejudice her against him, but he was clearly guilty. On the night before he was to be guillotined, cafés were given all-night license extensions. Impatient to witness the spectacle, men, women, and children stormed the gates to the prison yard at dawn. Weidmann was the last criminal in France to lose his head in public. To deter such morbid voyeurism, the Ministry of Justice soon passed a decree that all future executions were to be carried out behind prison walls.[4]

The summer of 1939, the Louvre opened its doors with an exposition called Ballets Russes de Diaghilev 1909–1929, featuring stage curtains and costumes designed and painted by the most famous modernists, including Max Ernst, Picasso, Giorgio de Chirico, Modigliani, and Matisse. The exhibit harkened back nostalgically to *les beaux jours*, the golden days of the 1920s after the First World War, the war to end all wars, when a new age of modern art and culture was going to change civilization forever.

August 23, Hitler signed a ten-year Non-Aggression Pact with Stalin, and the self-serving fiction that his territorial ambitions were modest was finally shattered. Everyone understood that the point of the pact was to ensure that Russia remained neutral in the coming war. And that there would be war in Western Europe was eminently clear. For signing the pact with Hitler, Stalin got half the spoils of Poland. Russia was proving itself an imperial power like any other. This put French and European Communists in a particularly difficult position.

The Fascists were now their allies. Though it was now evident that Stalin didn't give a damn about the proletariat of Europe, there were still those who managed to blind themselves to the fact.

The rich in France continued their frenzied partying, but most others were beginning to face the truth. Simone de Beauvoir recorded what it was like to be in Paris in August 1939. The restaurants, theaters, and shops were closed, as they were every August when the whole of the city shut down for the *congés annuels* (the annual closings). The city felt dead:

> *The mixture of braggadocio and cowardice, hopelessness and panic, that we smelled in the air made us feel highly uneasy. The hours passed slowly. There was nothing for us to do, and we did nothing, except traipse through the blank streets and seize every edition of the daily papers. In the evening we went to the cinema . . . As we fell asleep each night our last question would be: "What will happen tomorrow?" And when we woke it was to the same mood of agonized anxiety. Why had we been landed in this position? We were scarcely over thirty, our lives were beginning to take shape, and now, brutally, this existence was snatched from us. Would we get it back? And if so, at what cost?[5]*

Hitler was preparing once more to test Europe's resilience. Would he be allowed to gobble up Poland as he had Austria and Czechoslovakia? He needed a pretext to justify invasion. On the Führer's orders, prisoners were taken from German concentration camps, drugged, dressed in Polish uniforms, and shot. The bodies were strewn around a German signal station near the Polish border. On September 1, 1939, in retaliation for this "attack," the German army invaded Poland.[6] On the third, England and France declared war, and the world suddenly turned into a Kafka fiction.

THE CALL

September 1939

L'Européen—c'est presque fini. *(It's almost done for.)*
<div align="right">ANDRÉ BRETON[1]</div>

The posters for general mobilization, *appel immédiat* (immediate call), which had been taken down the previous summer after the Munich crisis, went back up. And this time they stayed up. Paranoia was rampant. To ensure that enemy agents would not be able to calculate the number of French troops being mobilized, government officers either phoned or sent private messengers to the residences of all eligible males. This was absurd, of course. All the "enemy agents" had to do was count the recruits who queued at the Gare de l'Est and the Gare du Nord, with kit bags and army boots slung over their shoulders, waiting for trains heading to the northeast. They milled about saying good-bye to wives, girlfriends, and mothers, some with eyes glassy and red-rimmed, some sobbing. It was obvious who had passed the night in passionate lovemaking and who in nervous exhaustion. Preparing to board the troop trains were not just the young but also the middle-aged who had fought in World War I and

had not forgotten the grimness of war with its burden of separation and death.

On September 1, 1939, André Breton was at his parents' home in Lorient, Brittany. His wife, Jacqueline, had taken off at the end of July to stay with Dora Maar and Picasso in Antibes. To maintain her own creative independence, Jacqueline periodically made bolts for freedom. Their daughter, Aube, had been sent to join her mother in August, and Breton felt alone and bitter. He was anxious. This wasn't the time to be separated from his family. Like everyone, he was expecting war to break out. But not, of course, when it did.

The very next day, September 2, Breton was mobilized by the army and headed to Vincennes to join the medical corps. He hadn't practiced medicine for twenty-one years, not since he had served as a medic in the last war.

In his barracks on September 3, he listened as the French radio enthusiastically counted down the hours to the start of hostilities: "Only an hour left, only five minutes." He was disgusted by the elation. No one seemed to acknowledge the enormity of the situation. The rising din among the soldiers around him was "reminiscent of a school recess."[2]

For him, it was all happening again. In 1915 in the early days of World War I, he had been called up for basic training. Just nineteen and with only a few months of medical school under his belt, he worked as a nurse in Nantes, and then in the neuropsychiatric hospital at Saint-Dizier in northeastern France, where he assisted the director with a new category of war victim—shell-shocked soldiers. Breton was astonished by the images that emerged from his interviews with them. One particular case of clinical insanity caught his attention: that of a young soldier who had been sent back from the front because of "recklessness."

During bombardments the soldier had stood exposed on the parapets reaching up for the grenades flying by and redirecting them with his fingers. He said the "make-believe" shells could do him no harm. He believed the injuries on the bodies of his fellow soldiers were makeup and the corpses were made of wax. He believed the

whole spectacle of World War I had been staged for his personal entertainment.[3]

Breton was aghast but also fascinated to watch the minds of his shell-shocked patients invent their own realities. It sparked his fascination with the phenomenon of psychic automatism. He began to read Freud and his French counterparts, and eventually took a post under Joseph Babinski, then famous as a clinical neurologist. Among his psychiatric patients, Breton found "the route-map for the great artistic journey of the coming century: the journey to the interior."[4] Psychic automatism would be the basis for the artistic process he would later call surrealism.

But back then Breton himself had not escaped personal horror. In November 1916 he was sent to the front near Verdun as a stretcher bearer and spent four weeks under constant bombardment in a "blood-soaked fog," able to rescue the wounded only under cover of darkness while dodging enemy shells. He performed triage duties in a cave by the light of a single acetylene lamp. It was a terrifying scene: "We had to go through a horrible crossroads in blackest night. At intervals the rocks lit the shattered trunks, the festoon of ruin, then back once again to the treacherous potholes."[5]

Breton found himself, twenty-three years later, awaiting a repetition of the old nightmare; he was being flung back again into the "cesspool of blood, mud, and idiocy."[6]

Daniel Bénédite had been called up on the twenty-fifth of August, ten days before war was actually declared. Both he and his wife, Theo, managed a brave parting, but both felt a terrifying anxiety about the fate of their son, Peterkin. Theo never imagined she would be raising her child alone in a wartorn Paris without his father.

Danny headed to Lorraine. As *sous-officier* of an artillery regiment, he was stationed near a muddy little village called Haute-Vigneulles on the French border with Germany in a fortress in front of what was thought to be the impregnable Maginot Line.

In construction since 1930, the Maginot Line was a defense system of "fortified regions." The French general command boasted it was the most impressive system of permanent fortifications since the Great Wall of China.

The line was 87 miles long and stretched from Basle on the Swiss frontier up to Longwy on the frontier with Luxembourg. It included 62 miles of tunnels and 279 miles of roads and railways. French engineers had set up hundreds of miles of antitank obstructions and barbed wire. Deep antitank ditches came next, and then staggered at two- to three-mile intervals were massive forts built deep into the earth. Marvels of military engineering, these were called earthscrapers. Like an underground city, each fort held headquarters, barracks for up to fifteen hundred soldiers, movie theaters, gymnasiums, and recreation areas. Miniature trains traversed the interconnecting tunnels.[7]

France's frontier with Belgium remained unfortified. There had been discussions of moving the line along the Belgian frontier up to the Channel, but the waterlogged terrain would have made this expensive. It was assumed that the German attack would come, as it had in 1914, through north and central Belgium. Though France and Belgium had signed a military alliance in 1920, Belgium had by now declared itself neutral and was totally unprepared to fight. Still, the French comand had stationed troops at the border and was confident that they were ready for the enemy.

Just north of the Maginot Line stretched the Ardennes, much of it consisting of steep hills covered by thick forest. Its western extremity was protected by the River Meuse, which was wide and had precipitous banks. Transporting a massive army across this area, with its limited roads, would be a logistical nightmare. No tanks would be coming through the Ardennes forests. And even if they did, there would be time to reinforce the sector before the Germans were ready to cross the river. Caught up in the Maginot mentality, beneath the earth thousands of men slept, trained, and waited for the battle to start.[8]

When Danny arrived at the line, he was unnerved by the complacency of his commanding officers. They seemed most concerned about their own comfort, "drinking and playing cards in their officers'

mess sumptuously furnished with the spoils requisitioned from houses in the evacuated zone."[9] On the twenty-second of September, nineteen days into the war, he headed out to inspect a small village in the border area that had been designated no-man's-land.

He was shocked to discover the village houses abandoned, their doors kicked in and windows torn out. All portable furniture had been removed, and the walls were covered with graffiti. A local gendarme still in the area told him what had happened.

On September 1 police had ordered an immediate evacuation of the area. Forced to quit their houses carrying only what they could stuff into valises, the villagers were herded onto trucks that were to take them to safety. For twelve days nothing happened. Then French officers returned to inspect the village. They raided the houses for furniture, wine, and liquor. Then soldiers arrived and emptied the houses of any remaining furniture. Finally another wave of soldiers, enraged that nothing was left, savagely and methodically reduced the houses to shards.

Danny waded through stacks of broken glass and shattered marble. Soldiers had "defecated on the floor and used the drapery for toilet paper." He was shocked. "Where were the officers?" he wanted to know. "Drinking in their fortresses," was the reply. His shock turned to a deep sense of shame. This was the French elite that was showing such rapaciousness and contempt for their own countrymen.[10]

He immediately requested a transfer from his unit. Because of his proficiency in English, he was assigned as a translator and cartographer to the British forces that had already landed in France. The British Expeditionary Force (BEF), as it was called, had been stationed farther north at Bersée near Lille.

LA DRÔLE DE GUERRE

Autumn 1939–Spring 1940

There's a gorgeous moon rising above Saint-Germain-des-Pré, making it look like a country church. Everywhere, underlying everything, a feeling of unfathomable horror. You can't foresee anything, or imagine what it will be like, or grasp the situation at any point. . . .

An obstinate voice still whispered inside my head: "It can't happen to me; not a war, not to me."

SIMONE DE BEAUVOIR[1]

Paris was in a state of profound shock. How many times could the Germans come back? They'd won in 1870; lost by a hair in 1918 with ten million dead; and now they were attacking again. It wasn't logical. It was a nightmare. Until war was actually declared at 5 P.M. on September 3, 1939, people wanted to believe that a miracle would save them. Then the headline "C'EST LA GUERRE" appeared in fat black letters on the front pages of all the evening newspapers. Everyone who could leave was ordered to evacuate the city immediately.

The children were evacuated to the countryside. (Some 16,500 children were enumerated.) A mass exodus began along the quais. Cars and taxis, their roofs piled high with luggage, bedding, and food, formed in long processions. Soon the south and west highways were clogged with people hoping for safe harbor in Brittany or the Midi.

Posters warning of gas attacks appeared on public walls. Those who remained in the city lined up at dispensing centers to collect gas masks. Metro stations were turned into air-raid shelters, as were basements in restaurants, hotels, and apartment buildings. Blaring sirens shattered the silence that fear had imposed upon the city.

With the men mobilized and the parks emptied of children, the city was caught up in a siege mentality. Civil Defense called for a general blackout, or blue-out, as the newspapers called it. The ornate streetlamps in the parks and on the broad avenues were veiled or coated with a navy-colored paint, and all public and private windows were painted black or covered in thick cloth. At night cars were permitted to use only one headlight, which was painted blue. Negotiating the narrow back streets at night was suddenly like finding one's way through dark caves. There was as yet no curfew, but cafés closed at 11 P.M. and nightclubs and theaters were shut down.

In the next few days, trucks from the city's sanitation department dumped piles of sand outside apartment buildings and the concierges were ordered to carry up bucketsful to the roofs and attics to help prevent the spread of fire from incendiary bombs. Public monuments, including Napoleon on his column in the Place Vendôme, were sandbagged at the base and reinforced with wooden scaffolding. The museums were closed and their collections crated and sent to the provinces. The rarest animals in the zoos were evacuated.[2]

Everyone was on the lookout for spies. Crossword puzzles were banned in newspapers in case they contained coded information. To use a public phone, a person had to show an identity card. To collect a telegram at the post office, it was necessary to have the notice countersigned at the police station, which in turn required a certificate of residence. Any light leaking from a window was a sign of espionage and might warrant a bullet through the shutters. People constantly reported

German reconnaissance aircraft over Parisian skies. Paranoia spread like poison gas. Soon detention camps were being set up for resident aliens.

Propaganda replaced fact as the government proudly boasted of France's inherent strength. So far, they said, the Germans hadn't really been tested. They hadn't come up against the Maginot Line. Newspapers printed maps showing the vast resources of the French and British empires. But who really believed them? People cowered and waited for the bombs to fall.

Slowly, however, it became evident that hostilities were not breaking out at the front. German radio broadcasts into France were conciliatory. They said the war was England's fault. *Why should French boys die for England?* It was rumored that German soldiers on the front lines were sticking up notices: "We have nothing against the French; we won't shoot unless you do."[3]

This was turning into the most insubstantial and elusive of wars. In time, people began to speak of it as a new kind of war—one to be solved by diplomacy. Jean-Paul Sartre made his famous remark to Simone de Beauvoir: "This will be a modern war, without slaughter, just as a modern painting has no subject, modern music no melody, and modern physics no solid matter."[4]

A little more than two weeks into September, theaters and dance halls opened again. People began to filter back into the city. Shopgirls started tying silk bows to their gas masks. On the Place Vendôme, the mannequins in the windows were wearing them and on the avenue de l'Opéra, one confectioner sold boxes of chocolates shaped like masks. Schiaparelli came out with a line of parachute-shaped dresses. At the Casino, Maurice Chevalier sang: *"Paris sera toujours Paris."*[5]

Still, despite the brave front, people were increasingly fearful. Rumors filtered through the city. Poles were being slaughtered and their country divided between Germany and Russia. There was talk of offensives, of the French army attacking Russia. No one had any precise information. Simone de Beauvoir, who proved such a compelling witness, wrote in her diary that "Hitler announced in the beginning of April that he would enter Paris on June 15th, but no one took this piece of braggadocio seriously."[6]

SHAME

September 1939

B ut there were those for whom the *drôle de guerre*, the phony war, was all too real. Eric Sevareid, a twenty-seven-year-old American journalist who would later make a career for himself as national correspondent for CBS News, was living in Paris, working at the *New York Herald Tribune* by day and the United Press at night. A North Dakotan of Norwegian extraction, he had befriended the European exiles who had fled the Nazis. In his apartment in Paris late into the night over innumerable bottles of Cognac, Sevareid would listen to Hertha Pauli and her friend Carli Frucht trying to describe to him what was happening in Fascist Germany. Sevareid was dumbfounded. He believed them of course, and yet "no effort of will or imagination could bring me all the way into [their] world."[1] When Joseph Roth died in the hospital, he shared the Austrians' grief.

By September 5, just two days after the war had been declared, Sevareid noticed that Hertha Pauli and Carli Frucht had disappeared, as had all his other political refugee friends. He guessed that the police had picked them up, but inquiries he made at the prefecture produced no results. Soon word leaked out that after September 3, the

French government, like their British allies, called for the arrest of all German nationals (which now included Austrians and Czechs). Whether they had lived in France for decades, or had recently arrived seeking asylum from the new Germany, all suddenly found themselves "enemy aliens." To most of them, the label would have seemed ridiculous. Until the police knocked on the door.

The government had decided it was most efficient to arrest all German aliens. The *criblage*, or screening of pro-Nazi sympathizers, who might prove to be enemy spies, and of anti-Nazi exiles, who had the right of asylum, could be worked out afterward. Over several days, it is estimated that between fourteen thousand and eighteen thousand *ressortissants de nations enemies* were rounded up and isolated in Paris sports arenas and other centers.[2] People were ordered to go to the collection centers at their own cost (some took taxis), and were told to bring forks and knives. Many complied.

The poet Walter Mehring, who had escaped from Vienna with Hertha Pauli and Carli Frucht, was arrested, but released through the intercession of the French PEN Club. Carli Frucht was held in the Stade Colomb, where the posters still announced the last football and tennis matches.[3] After a week, he was transported to an "assembly center"—in effect a detention camp. Simone de Beauvoir recorded in her diary that her Austrian friend Billiger was picked up coming out of the café Rotonde. He was taken to the local police station, where a "furious" inspector tore up his Austrian passport and sent him to the prefecture for processing. There, to his astonishment, he met a group of Spanish refugees. In a spirit of bureaucratic thoroughness, the police were also picking up Spanish exiles.[4]

Refugees' accounts of being rounded up contained the same details. They were arrested without any chance of getting in touch with friends; they were not allowed to bring extra clothes with them; they were herded into a sports coliseum or some such civic building where they slept on the ground.

In the detention camp to which Carli Frucht was transported, people were forced to sleep on raw barn floors or in mud and straw for weeks until chicken wire pallets were constructed. There was one

water spigot for seven hundred men. It took two hours in line to get a meal. Until the men dug their own latrines, there were no toilet facilities. Some had visas to America but were unable to get out of the camp to make use of them. They requested to be formed into labor battalions for the French army but their entreaties were ignored. Those with a bit of money had it stolen by the guards.

During the *drôle de guerre*, there may have been no fighting of any consequence at the front, but censors and the military press waged their own war behind the lines. The secret of the internment camps within French borders was fiercely protected. The camps were off limits to all national and foreign reporters.

Then rumors of their existence began to surface in the international press. A U.S. article appeared in the *New Republic* on January 15, 1940, titled "France Copies Hitler." It referred to "the shocking treatment the French are now giving to foreign refugees on their soil . . . They are herded into concentration camps [*sic*] . . . Although nearly all these people can readily prove their implacable hatred of Hitler and all his works they are being treated as though they were loyal Nazis."[5]

The propaganda office of the French Ministry of the Interior was particularly sensitive to the opinion of neutral countries like the United States, and immediately justified the existence of the camps on the grounds that they had no alternative. *German* political refugees were a danger to national security. They could not serve as soldiers — they would either prove traitorous or the Nazis would shoot them on sight. Nor could they be left in the cafés of Paris, where their presence would be an affront to French soldiers on leave.[6]

Pointing out the bad impression France was making in America, Eric Sevareid requested to be allowed to inspect a camp for central European political refugees. To his surprise, the Ministry of Information sent a lieutenant to give him a guided tour. The experience seared itself on his mind:

> We climbed broken steps into what had been the hayloft of a
> great barn. Men of all sizes and ages, in shapeless coats and

trousers, lay on their backs, their sides and stomachs on low pallets made of chicken wire. For pillows they had rolled bundles of old clothes. . . . I noticed a man of about forty, a stout, pale man wearing only corduroy trousers and a filthy undershirt, who appeared at my elbow, trying to catch my eye. . . . [I] saw that his jaw was quavering, as he tried desperately to find courage to speak. . . . Tears suddenly poured from his eyes. . . . He was an Austrian who had been Vienna correspondent for the Amsterdam Telegram. *His name was familiar; he was a journalist of some distinction. Suddenly he stepped to his pallet, found a stub of pencil and a piece of paper. He scribbled the name and the address of a friend in Paris and put it into my hands. His fingers closed over mine for a moment, and he tried to say something more, but could not, and broke into sobs and turned away. . . .*

When I stepped from the barn into the yard, I was immediately surrounded by dirty and bearded men. They all began talking at once in English, French and German. I was the first man from the outside they had seen since their arrest, nearly four months before. Each was desperate to be heard. . . . Some began to cry and others, red with anxiety and rage, demanded that I stop. They had the appearance of human animals, and they were: a cinema producer from Prague, a well-known novelist from Vienna, the leading tenor of the Vienna Opera; they were journalists and poets, doctors and lawyers and university students. They were all the things that civilized, aspiring men become in civilized Europe.

When the lieutenant got me to the last barracks barn, my coat pocket bulged with scraps of paper, playing cards, and torn bits of handkerchief on which they had written the names of friends in Paris, London, New York, and Washington—friends who could help them. . . . It was growing dark in the winter afternoon. As I began to make out more figures on the wire cots, I heard a choking voice call "Sevareid! Sevareid!" In the short, fat and ragged body before me I recognized Kurt Dosmar, a jour-

nalist from the Saar, who had covered the Weidmann trial with me for the Chicago Tribune. The sound of his voice brought hurrying footsteps on the board floor, and in a moment Carli Frucht was beside me.

It was his beard, I suppose which gave him a certain Christ-like appearance. The beard somehow made his soft and gentle eyes more noticeable than ever. His cheeks were drawn in a little, and his wrists were very thin. It was curious; he could utter only polite formalities, and I knew my voice was sounding cold and strange. French officers were waiting in their car for me at the gate. We had a date for dinner in the best place in the village, the tavern where they served duck with orange — which, they assured me, was rather remarkable considering the town. Carli walked toward the gate with me, and there was nothing we could say. When we were a few yards from the group of officers, he slipped one arm over my shoulder, and I turned away from him and began to cry. I was filled with shame and self-loathing. But I could not help it; I stood still in the mud, dressed in my fake French uniform, before my officer hosts, and cried into my handkerchief.

I got back to my squalid hotel room in Le Mans and fell asleep in my clothes and boots. I had bad dreams and awoke just before dawn. I was sweating and my side hurt, where I had been lying on the thick bulge in my coat pocket — their wadded-up words, their silent cries for help.[7]

Years later, Carli Frucht would recall how Sevareid had stopped at the gate and, without a word, had handed him his topcoat before climbing into the car of his impatient French escorts.[8]

ONE MAN'S NIGHTMARE

September—December 1939

The artists Max Ernst and Leonora Carrington stood outside their farmhouse in Saint-Martin d'Ardèche and admired their own sculptures obtruding from the walls. Leonora had sculpted a bas-relief of a horse's head, while Max had created a relief of a naked female with delicate breasts holding a bird in one hand and extending the other in a gesture of calm. Beside her stood a gigantic bird-man, his hands thrown up in the air and his magnificent beak open as if he were crowing. The walls and lintels inside and outside the house carried a fantastic bestiary: there were animals in various stages of metamorphosis, bird-lizards, a mermaid, women with the heads of fowl. Standing there admiring their home (the work of reconstruction had taken a year), they made a remarkable couple.

Women used to say that Max Ernst looked like a fallen angel. He was "exquisitely made."[1] Forty-nine years old, thin and naturally elegant, he had pure white hair, huge blue eyes, and a sharp nose that resembled a beak. He claimed to have an alter ego that he called Loplop, the Bird Superior. Leonora Carrington was equally beautiful. She had black wavy hair that swept over her shoulders, alabaster skin,

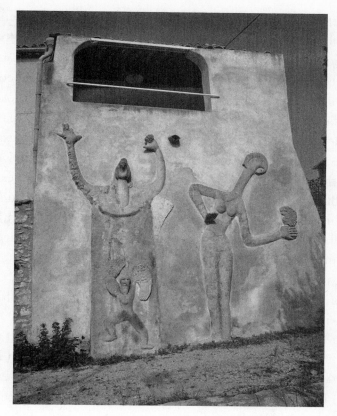

Sculptures by Max Ernst and Leonora Carrington
on their house in Saint-Martin d'Ardèche.

and exquisitely dark eyes. There was something ethereal about her. A friend remarked: "I always said she could slip through a crack in the door, as if she had one finger and one toe less than the rest of us, her physical self was so narrow."[2] The child of upper-class British parents, she had been presented at court, but had long ago decided not to be *decorative*. She dressed in clothes bought in secondhand shops, or wore jodhpurs and boots, and was wild and exotic, like the spirited horses she painted in her self-portraits. Max called her his "bride of the wind."

The lovers had met in London during his one-man show at the Mayor Gallery in 1937. The encounter had been *un choc amoureux* (a love shock). They fled to the Cornish coast, and then to Paris. Max

had never owned anything, but in 1938, with Leonora, he bought the derelict farmhouse in Saint-Martin d'Ardèche (the date on the lintel above the door was 1735), and they set about making it a surrealist palace dedicated to passion. Already the object of curiosity because of the disquieting creatures sculpted on their house, he and Leonora became infamous in the village when they put on a surrealist play in the local café. "Dyeing their hair blue, Max played a surgeon extracting kilometers of Leonora's intestines (using an inner tube) . . . and she danced the dance of the Hindu cockroach on the café tables." They were indifferent to clothes and would often work in the nude, after which they would descend toward the river, only putting on bathing suits as the first house became visible. The scandalized villagers took to watching from the bushes.[3] For the lovers, 1939 was a summer of enchantment. Max was in the midst of painting A Moment of Calm. It depicts a neobotanical forest whose inhabitants seem suspended in a benevolent carnival of green.

That September, Max answered a knock on the door. It was the local gendarme come to arrest him. As Leonora watched in helpless tears, he was taken away in handcuffs and interned as "a citizen of the German Reich." Though he had lived in France for seventeen years, he was suddenly an enemy alien.

The morning of his arrest, Max was taken to a long-disused prison in nearby Largentière, serviced by two captains, two lieutenants, and ten noncommissioned officers, all there to guard the prison's twenty-five internees. Learning that Ernst was a painter, the camp commander made a bargain. If Ernst would paint him a landscape of Largentière with the prison in the middle, he would give him three hours of freedom a day. He knew the painter was not a risk. Max had "excellent testimonials" to his loyalty to France, which he carried on his person.

Leonora rented a room in a nearby inn and took daily walks with Max outside the prison walls. She brought him paint and canvas so that he could work, and, on one occasion, one of his finished paintings that she had found in Saint-Martin d'Ardèche. It would have been a work in his usual surrealist style. When Max showed this to the

camp commander, he was outraged. This was not painting, he said, and revoked Max's three hours a day "walking privileges." After six weeks, Max was transferred to Camp des Milles, just outside Aix-en-Provence, where his real ordeal began.[4]

On the thirty-first of August 1939, in preparation for the war that everyone knew would soon be declared, the mayor of Aix-en-Provence requisitioned an abandoned tile and brick factory just outside the town of Les Milles to serve as an internment camp for German aliens.[5] It was an ideal location in that the railway ran next to it and prisoners could be transported there with a minimum of inconvenience. Its twenty dilapidated buildings, hastily enclosed by barbed wire, were meant to house a thousand internees.

During the fall of 1939, about eighteen hundred inmates lived behind the barbed wire of Camp des Milles. Thirty officers and 130 soldiers of the 156th Regional Regiment ran the camp as a military installation. The inmates were told they were only *rassemblés* (assembled), not prisoners.

The prisoners slept on straw pallets, one beside the other, between two hundred and three hundred men to a room. There were no chairs or tables. Every ten yards a twenty-five-watt bulb hung from the ceiling, insufficient for reading or writing. At about 5 P.M. prisoners were shut up for the night in the buildings.

Max Ernst was able to find a small, cavelike space that had once been in the area of the yard housing the ovens. This he shared with his friend Hans Bellmer, the German-born French surrealist painter. Broken bricks littered the yards and brick dust invaded everything. It penetrated the scant food rations; it even penetrated the pores of the skin. "One had the impression," Max said, "that one was destined to become broken brick."[6]

Prisoners were permitted to receive packages from family, and Leonora again brought paint and canvas for Max. He and Hans Bellmer were allowed to paint out in the yard. To control both their anger and their hunger, the two men painted as much as they could. Painting was a way of asserting self-control when the self was totally violated. Bellmer painted a portrait of Ernst in a mosaic pattern as though his

Camp des Milles.

face were a brick wall. Ernst's drawings depicted scenes of panic and terror: raving monsters stalking figures in flight in moonlit forests, people walled up in situations too vague to decipher precisely. He also painted tragic images of his lost beloved.

In November 1939 Ernst's nineteen-year-old son, Jimmy Ernst, who was working in the mail room of the Museum of Modern Art in New York, received a tattered pencil-written postcard dated October 27 with the address: Camp de les Milles, Les Milles, France. It read:

> *My dear Jimmy,*
>
> *Thank you for your letter. I'm being detained here. You can help me (in my liberation) through your excellent connections. Do something. Ask important people.*
>
> *I embrace you, your father, Max.*
>
> *ps. (I am writing a postcard because letters are prohibited)*[7]

Jimmy had no such influential contacts, but he braved the intimidating office of Alfred Barr, the museum's director, the pathetic post-

card in hand, and asked him for help. Barr said he would do what he could. Meanwhile, Leonora was working incessantly for Max's release. The poet Paul Eluard came to her aid and proved a faithful friend. When he and Max had first met in Paris in the early twenties, they discovered they had encountered each other before. In February 1917, during the First World War, they had fought at the front in the same battle, Eluard on the French side and Ernst on the German side. They had probably fired their guns at each other.[8] Through the intervention of Eluard, Max was eventually freed in December after three months' incarceration.

At Camp des Milles, Max Ernst had excellent company. His fellow prisoners included the poet and dramatist Walter Hansenclever; the novelist Lion Feuchtwagner; the dramatist Wilhelm Herzog; and the son of Thomas Mann, Golo Mann, who had been working as a history professor at Rennes University before he was arrested. Also interned were Dr. Otto Meyerhof, winner of the Nobel Prize for Medicine in 1922, and Dr. Thadeus Reichstein, who would discover cortisone and win the Nobel Prize for Medicine in 1950.

With so many artists and intellectuals in Camp des Milles, some internees organized conferences and painting workshops. Murals painted by prisoners covered the walls of the guards' refectory—these were comic portraits of elaborate feasts.[9]

But nothing diminished the horrors of incarceration: the black racketeering, bribery, blackmail, sexual predation by fellow prisoners; the dehumanizing labyrinth of official dossiers and interrogations; the work squads and endless boredom, interminable lineups for food and latrines and roll call; the dysentery and disease. It was soul-searing, hardly to be borne.

By late December, the French administration had finally begun to organize the sorting of prisoners in the detention camps. Before the end of January, seven thousand of the fifteen thousand "enemy aliens" held in internment camps throughout France were released.[10] Among these were prisoners who, through outside connections and influential friends, could prove that they were anti-Nazis and would remain loyal to France. Other prisoners escaped the camps by joining the *compagnies de travailleurs étrangers*, government organized work

parties of foreigners attached to the French army, who were assigned to labor on defense. Even if actual fighting hadn't broken out yet, everyone knew it wouldn't be long before it did, and the *prestataires*, as they were called, were assigned to dig trenches. Those prisoners left behind in the camps were still thought to pose a threat of collaboration with the Germans when they came, as they surely would.

L'HUMOUR NOIR

I believe that a rather interesting time could be starting, on condition, of course, that one can live through it.

ANDRÉ BRETON[1]

When war was declared in September 1939, André Breton found himself back in his medic's uniform, promoted to second lieutenant, part of the 401st Antiaircraft Division stationed at the Noisy fortress in Romainville, in Paris's northeastern suburbs. He had sworn, after the First War, that he would never allow himself to be drafted again. But he had a daughter to take care of now and he didn't want to spend the war in jail.

As the phony war stalled, he was granted frequent leaves and was a familiar sight at the Deux Magots on boulevard Saint-Germain. One of his preoccupations was the publication of his long-delayed *Anthologie de l'humour noir*. He had invented the term *black humor*. He wrote to his editor Jean Paulhan at Gallimard: "It seems to me that this book would have a considerable *tonic* value."[2]

Breton's attitude toward war was fatalistic. Wars were started because someone believed they could be won. He saw the war as a pathological outburst made inevitable by the monotony and constraints of bourgeois life. Incompetent octogenarian generals led the French military, and the populace, brainwashed, behaved like sheep.

At the beginning of January, the flight training school to which he was attached as a doctor was relocated to Poitiers. Cut off from his family and totally without any source of funds, he was dispirited. He had little to do at the airfield, and Poitiers itself held few mysteries. He was annoyed that he couldn't find his books in the bookshops. He did strike up a friendship with a young nineteen-year-old student, Maud Bonneaud, whom he had met in one of the city's hotels during a blackout. The young woman had been reading Alfred Jarry's surrealist play *Ubu Roi* with friends when the lights went out. To meet Breton when the lights were restored indicated to her that the finger of destiny had prepared the encounter. Breton spent much of his free time with Maud in daily intense conversations.

For young Maud this encounter with Breton was a total *bouleversement*. She felt it changed her life. The secret of Breton's power, she would say in retrospect, was that he taught her "ecstasy, delirium." "He was like a wind levelling the sandcastles of the normal . . . a typhoon devastating the small island of comfortable life. Yet the desolation was beautiful, moving."[3] With infinite patience, he directed her through what she called strange roads, an extraordinary "scenic railway" of the mind. He was a verbal enchanter, and she felt deliciously caught in his snare.

Clearly, she'd fallen in love. But Breton was only interested in mental eroticism. He berated his fellow surrealists, like Paul Eluard, who were drawn to affairs, to libertinism, brothels, or group sex. Such indulgences, he cautioned, were detrimental to the exclusive dedication the artist owed to his muse.[4]

Breton was faithful to Jacqueline Lamba. For Maud he painted a portrait of his wife as "adorned in jewels in a Rousseau forest of the marvellous." Of course Maud too now wanted to be this idea in the mind of a man. But she would always think of Breton as a personage of "extraordinary nobility, directing others with a hand of friendship through sombre corridors out into the free air."[5] She felt it was a privilege to have met him.

While Breton was at Poitiers, Jacqueline and Aube stayed with Picasso and Dora Maar, who were now living in the Atlantic coastal

town of Royan, only one hundred miles away. At least Breton was able to spend his leaves by the sea with his family, renewing his friendship with Picasso. Seeing how destitute the family was, Picasso gave Breton one of his works to sell. Even in wartime there were still buyers. On returning to his post, Breton wrote him: "I have to tell you how happy I was to spend some time with you, how all things considered it gave me back my taste for life. And thank you, THANK YOU again, for having offered to help so spontaneously, in the most seductive form possible."[6]

Breton was worried about his friends. Max Ernst had finally been released from Camp des Milles, though he was in a very poor state of health. But his closest confidant, the poet Benjamin Péret, was now in prison in Rennes for making defeatist statements and trying to organize a Trotskyite cell. As the phony war dragged on, Breton focused his attention on his anthology. He had changed publishers, and now the book was due at the printers in May and was to be released on June 10. What he didn't know was that his *Anthology of Black Humor* was scheduled to appear on the very day Paris fell to the Germans.

RETREAT: OPERATION DYNAMO

May 26–June 4, 1940

We must . . . we must . . . I would so like to be rewarded before it's too late, to have the right to love, to know and acknowledge for whom I am dying.

ANTOINE DE SAINT-EXUPÉRY[1]

When France and Britain declared war on Germany, the U.S. ambassador, William Bullitt, called on all American citizens to return to the United States. Americans in the luxury trade on the Place Vendôme closed up their shops. Tourists, students, and expatriate artists alike headed for the western ports where the offices of the passenger liners were flooded with people desperate to get out.

Back in Paris after spending the month of August in the Vosges, Mary Jayne Gold realized she had to make a decision. She had lived in France for eight years, and it was more her home than the United States. She still had access to her trust fund. "If the French can take it," she told herself, "so can I."[2] Her first gesture to confirm her decision to stay was to offer her Vega Gull to the French air force.

Mary Jayne was on her own in Paris. The city was bleak. Passersby on the desolate streets looked dazed and anxious. The blackouts and

the air-raid drills were taking their toll on people's nerves. Most of her friends had abandoned Paris—Yola Letellier was in Bordeaux, Zabette was in New York, and Danny's other sister, Hélène, was in Normandy.

Concluding her family would be safer outside Paris, Theo Bénédite had moved with her mother-in-law and her one-and-a-half-year-old son, Peterkin, to Châteauneuf-sur-Loire, two hours south of Paris. She had found shelter in a small guesthouse on the property of an old friend, the illustrator Camille Roche. In the pleasant autumn weather of the Loire, so much warmer than Paris, she waited for news of Danny at the front.

Mary Jayne decided to close up her apartment on avenue Foch and join the Bénédite family. Taking a last glance at the elegant decor over which she had labored so studiously, she gathered Dagobert in her arms and, turning the key in the lock, wondered if she would ever see her apartment again.

She managed to rent a peasant's cottage in the tiny village of Le Mesnil just outside Châteauneuf-sur-Loire. It had been owned by the schoolmistress and had a miniuscule bedroom, kitchen, and sitting room. She had brought her cook and housekeeper with her and found them rooms in a nearby village, but they soon tired of the countryside and headed back to Paris.

Truly alone, perhaps for the first time in her life, Mary Jayne found she loved the solitude. She learned to cook in a rudimentary fashion and kept the house heated by stoking the fire in the porcelain stove in the sitting room. The only way to take a bath was in a shallow tin tub, placed for warmth in front of the fireplace. When she bathed, she imagined she was in a Renoir painting.

The winter was extremely cold, in fact one of the coldest in nearly half a century. Heavy snow was falling all over Europe as far south as Rome. At midnight, New Year's Eve, the French president's official message was broadcast: "1940 will be a happier year for all humanity."[3] People had grown accustomed to the "phony war," choosing to believe in the impregnability of the Maginot Line.

But the winter, if brutal, was short and spring came early, dazzling the countryside with splashes of hyacinths, daffodils, and crocuses.

Mary Jayne set to work and planted a garden, wondering whether she would see it flower. Amid such beauty, it was hard to believe in war.

Everyone was waiting for Hitler to make his usual springtime move in the deadly game he was playing. On April 9 the German army launched an attack against Norway, which had no air cover and was easily defeated. The same day it invaded Denmark. Hitler delivered an ultimatum, and the weakly armed Danes gave in with hardly any fighting at all. "They took us by telephone," said the Danish prime minister.[4] Britain and France sent troops to Norway, in an ill-conceived attempt to drive out the Germans. They were badly supplied and their forces barely managed to evacuate in time to avoid slaughter.

A month later, on the evening of May 10, when Mary Jayne bought her evening paper, the headlines were in huge black letters: "This morning," she read, "in the early hours, Germany invaded Holland and attacked Belgium and Luxembourg." The airport at Lyon had been bombed. Planes could be heard over Paris though the city itself was not hit. "It's begun," she thought. Her fear was mixed with an unexpected sense of relief. At last the intolerable waiting was over.

The aviator and poet Antoine de Saint-Exupéry, author of *The Little Prince*, sat at a Paris café table on the boulevard Saint-Germain, writing in a large ledger. He looked tough and scarred, his eyes hard and cold. When asked about the German advance, all he would say was: "From the air, the war is a frieze. You see the black dots which are the tanks and the trucks and the veil of dust. There is no movement when you see it from 20,000 feet. It is a still life."[5]

His refusal to speak out came from disillusionment and disgust. Since mid-March, he had been posted to 2/33 Reconnaissance Squadron, and had been flying observation missions over enemy territory. He'd brought back photographs of German engineers throwing pontoon bridges across the middle Rhine. Well in advance, it had been clear to him that the German plan was to invade France through the reputedly impenetrable Ardennes forest. But the Allied high command couldn't imagine that the German army would have the capability to travel with its tanks and equipment through the rough mountainous

terrain of the Ardennes and so they had deployed the bulk of their forces much farther north at what seemed to them a more vulnerable part of the Franco-Belgian border.

On May 13 the assault on France began. The German armored column, over 80 miles long, stretching back to the other side of the Rhine, easily penetrated north of the Maginot Line at the French town of Sedan near the Meuse River. The battle began with an eight-hour aerial bombardment by about one thousand Stuka bombers with their sirens screeching. The noise alone was unnerving and the explosions were terrifying. Then German soldiers crossed the Meuse in rubber dinghies carrying bridging equipment. Panzer tanks by the thousands poured across the makeshift bridges onto French soil, and within four days the Germans were 93 miles from Paris. Knowing they could trap the majority of the defending French army, instead of proceeding to Paris, they shifted their advance north, driving swiftly toward the Channel ports.[6]

The French First Army and the British Expeditionary Force had been outwitted. Now the German army was on their flank and the Allied forces found themselves pressed back toward the French town of Dunkerque on the English Channel.

Each morning at the Ministry of War in Paris, the information officer, with a schoolteacher's pointer, marked the advance of the German "pocket," never failing to mention the heavy German losses. The *London Daily Mail* carried headlines: "1,000 German Tanks Lost." But the truth was otherwise.[7] The French army was stunned. With their Maginot Line, they had prepared to fight a defensive war, but the Germans had invented a new and ruthless tactic: blitzkrieg, the German Luftwaffe making lightning strikes against targets that included civilian populations, while Panzer divisions moved swiftly across the difficult terrain below.

Danny Bénédite was serving as a translator with the First Division of the British Expeditionary Force. With the German breakthrough at Sedan, the BEF was ordered to move south to defend the border garrisons. When his division reached the Belgian-French border not far from Lille, he was immediately sent back north to collect maps of

the region. Absurdly, the BEF had no up-to-date maps of France. The Germans weren't supposed to be in France.[8]

Commandeering the Austin mini of his company's Anglican chaplain, Danny and his cockney chauffeur, Luthwaite, drove against the human tide of soldiers moving south to meet the German attack. They headed back toward Dunkerque. The road had turned "into a flood of khaki: Belgian, English, French soldiers, military trucks, motorcycles with sidecars, even a tank followed by a horse-drawn cart." When Danny asked an MP, attempting to direct the chaos, for directions to Dunkerque, the soldier pointed to the northern horizon where a column of black smoke was pouring into the sky: "You can't possibly miss it, sir."

The German planes, Messerschmitts and Stukas, strafed the route. Like a scar, the bombardment seared itself on Danny's mind, and more than forty years later he could reproduce its details with brutalizing immediacy. In his memoir he worte:

> The violence of the explosions filled the air with bricks and wood and human debris. . . . From their curved wings Stukas unloaded bombs that produced a terrifying howl before they shattered the landscape. Fresh blood pooled on the asphalt and mangled corpses littered the ground. Outraged medics, responding to desperate cries from all sides, could not free their ambulances from the bottleneck of vehicles. Abandoned trucks were scattered in fields, some plundered by soldiers, others burning despite the rain that, from moment to moment, fell in sudden floods. . . . [On the whole route to Dunkerque] I didn't see a single civilian. They had been piteously driven back from the roads reserved for the army in retreat. People who hadn't yet left their houses were forced to hide in caves.[9]

In six hours, Danny and Luthwaite had covered only 25 miles; again and again they had been forced to abandon the car and head for the ditch to shelter from the bombings. When they finally reached Dunkerque the city was a disaster. Wind squalls had trapped the black

smoke rising from burning oil reserves in the port. Waves of bombers flooded the skies.

Danny asked himself what he was doing hunting for maps in this inferno. No one was in control and he was being sent into danger, and to his death, for no other reason than that the command had not been issued the right maps and needed to execute its futile orders. But Danny's sense of the absurd kicked in. With everything falling apart and the end clear, what was the point of concerning himself too much with risk?

Threading their way through the ruins of houses and streets pocked by shell craters, they found an abandoned surveyors' office. The houses on either side of the building were in flames but Danny leaped out of the car, sprinted up the stairs, and searched through cluttered desks until he found what he was looking for. He fled just as the building's roof caught fire. Noticing that Danny had lost his helmet, Luthwaite motioned to five or six dead British soldiers lying on the side of the road. "Help yourself," Luthwaite said.[10]

Again moving against the human tide, this time of refugees fleeing west to escape the Germans, they stuck to the back roads where enemy fire was less ferocious. Eventually they found their division. The British general's first question to Danny was: "How's the embarkation going?" "What embarkation?" Danny asked. He did not know that the British and French forces had accepted defeat and were attempting to evacuate.

Now Danny's division had been ordered to turn around and march north, back to Dunkerque once again where he had just risked his life for the useless maps. His division's new role was to provide cover for the BEF's northern retreat. From the office of the new British prime minister, Winston Churchill, a call had gone out to every seaworthy vessel in the Channel ports and the North Sea. A flotilla of troopships, ferries, small craft, and pleasure boats of all sizes was on its way to Dunkerque. Between May 26 and June 4, they would evacuate 198,315 British and 139,911 Allied (mostly French) soldiers, transporting them across the Channel to safety in England.[11]

During the indescribable confusion on the northern beaches, Danny was separated from his unit. Exhausted from lack of sleep,

hunger, and thirst, he too was finally picked up and evacuated by boat to Dover.

This was a momentary victory in the midst of the debacle of total defeat. In 1942 the film industry would turn this daunting rescue effort into one of the most successful propaganda films of the war: *Mrs. Miniver*. But as Churchill famously said: "Wars are not won by evacuation."

In Yorkshire, with his unit waiting to get back to France, Danny tried desperately to send word to his wife and mother that he had survived Dunkerque and had not been captured. Between thirty thousand and forty thousand French soldiers who had managed to survive the battle were left behind on the dunes of Dunkerque. Prisoners of war, they were transported to internment camps inside Germany. It would be four years before their families would see them again.[12]

THE FALL OF PARIS

June 10, 1940

When Paris ends, the world ends; useless to see the truth, how could one bear to acknowledge it?

VICTOR SERGE[1]

On June 4, 1940, a reception was taking place at the French Ministry of the Air. In attendance were military officers, politicians, and foreign diplomats. The American ambassador William Bullitt was standing at the buffet, cocktail glass in hand, when a bomb came through the roof, pierced each successive floor, and landed at his feet. No one moved. Luckily, it did not go off. But German intelligence was obviously very good. The Luftwaffe also bombed the Citroën works on the Seine, and odd bombs landed around the avenue de Versailles.[2]

Now caught like the northern refugees in the debris of war, Parisians began to understand that this might be the end. Warplanes droned over the rooftops; the houses shook, the plaster cracked, the plates and glasses slid from the tables. Powdered glass piled in small crystal mounds on the sidewalks and the acrid smell of cordite from the bombs thickened the air. It felt like Paris was dying.

The city streets were covered with posters: "We will win because we are the strongest." Amid the wail of air-raid sirens and the cackle of antiaircraft fire, people, moving like automatons, descended into the subways and into the makeshift trench shelters dug in the public parks. Thick smoke rose above the city as officials at the quai d'Orsay threw files out the windows to bonfires on the lawns below. The Foreign Ministry didn't want sensitive documents falling into German hands.

No one knew what to expect. Right-wing writers in newspapers like *Action Française* claimed that the Communists of the industrial suburbs would use the occasion to seize Paris. They would loot, murder, and burn. Even German occupation, they said, would be preferable to a Communist revolution. But where were the Communists? Most were either in prison or had fled to escape the arrests that had begun the previous November when the government, having outlawed the French Communist Party, passed a decree to intern all people deemed dangerous to national security.[3]

Thanks to the intervention of Danny Bénédite, who had obtained a residence permit for him, Victor Serge had joined the ranks of foreign refugees in Paris and was now living in the working-class district of Pré-St. Gervais. Though he was ill and isolated, by luck and his ability as a *débrouillard* (one skilled at slipping somehow through the cracks), he had been spared the hazards of internment.

Paris was experiencing one of the loveliest Junes on record. On the morning of the third, Serge and his companion, Laurette Séjourné, stood on their apartment balcony listening to the sounds of distant bombs and antiaircraft fire.[4] A feeling of revulsion swept through them even as the sun danced against the glass windowpanes that trembled behind them. All of Paris was in a state of panic. Just beyond the eastern suburbs, people knew that German motorized columns were amassing to enter the city.

Disillusioned by the Spanish tragedy, by the Soviet Union's betrayal, by the nihilism that seemed to hold Paris in a vise, Serge was in agony. The newspapers were full of lies—phrases about American sympathy, last-ditch resistance, the memory of Jeanne d'Arc, the ene-

my's fatigue. It was all nonsense, hiding the real terror. He knew the Allied forces could not match German armaments.

Fellow Belgians who had made it into France had told him of the massacre of French cavalry in the Ardennes—a cavalry against tanks! They also said that, while the French border police were letting in the flood of civilians with passports or visas, all *apatrides*, stateless people without documents, were being turned back. These people had no documents precisely because the Nazis had confiscated them. Serge was disgusted. French bureaucracy was still functioning efficiently— turning back the enemies of its own enemy. *Apatrides* got across the border only once the French guards had fled their posts.

Gardes mobiles, their rifles loaded, were raiding the student cafés in the Latin Quarter. All foreigners whose papers were not in order were packed into trucks and taken off to police headquarters. The last country of asylum on the continent seemed to be losing its sanity.

Serge was determined to put off leaving Paris until the last minute. He still had some vague hope that the world might be righted, and anyway, he had practically no money. He was not alone. Many Parisians had delayed their departure, hoping for a last-minute reversal in the war.

On the tenth of June as he rode the metro, he saw men and women in tears, hands clenched, violently scrunching up the newspapers that reported Mussolini had broken his pledge of neutrality. Italy had entered the war on Hitler's side. "We're betrayed at every turn," an old man said and staggered out of the metro, muttering: "*Ah! nom de Dieu! nom de Dieu!* Two wars in one lifetime."[5]

Serge set out on what he believed would be his last walk ever through his beloved Paris. "Seen for the last time, objects take on an unprecedented relief," he wrote in his notebook. "The empty chairs along the balustrades in the Tuileries cast shadows like surrealist tracery on the gravel paths. Not a single child was sailing a boat in the fountain." Nearby a sign read: "Shelter 80 Persons." What a deception, Serge thought. There was never any shelter. He stopped for a last look at the Seine where a few "fishermen were still dragging their lines between the flat colourless stones and the dreary water" while Europe

collapsed above their heads. "A great immobile panic hung over the quays, the equestrian statues and the blind windows." The stores had their iron shutters closed. As he looked down the Champs-Élysées, the Arc de Triomphe appeared "like a monument in a cemetery."[6]

By noon dark smoke obscured the sun. It crept along the Champs-Élysées and obliterated the top of the white dome of the Sacré Coeur. Rumors were flying. Some said the French army had set fire to oil reserves to create a smokescreen for their retreat. Others said that the gasoline tanks at Rouen were burning to cover the German advance on Paris.[7] All day people sat beside their radios waiting to be told what to do. Would Paris be defended or not? Should they leave or stay? They waited for gestures of courage or defiance from the government.

But the government was itself paralyzed. In March Premier Daladier had resigned after a no-confidence vote over the way he was conducting the war and had been replaced by the conservative politician Paul Reynaud. But Reynaud proved equally ineffectual. His government seemed unable to make any decisions or give any directions, except to say *restez tranquilles*.

As the German mechanized juggernaut pushed relentlessly toward Paris, Reynaud announced in a radio address to a populace desperate for direction: "If I were to be told one day that only a miracle could save France, I would say, 'I believe in that miracle, for I believe in France.'" Reynaud, accompanied by his generals, attended High Mass at Notre Dame Cathedral to pray for a miraculous deliverance.

Behind the scenes, the French War Committee was meeting and the atmosphere was rancorous. Reynaud wanted to commit the government unanimously to resistance. They would carry on the war from Africa. But he vacillated, and the word *armistice* floated menacingly in the air. One of his generals, General Maxime Weygand, raged that France was paying for "twenty years of blunders and neglect." "It is out of the question," the general said, "to punish the generals and not the teachers who have refused to develop in the children a sense of patriotism and sacrifice."[8] The idea of requesting an armistice from the Germans moved to the head of the agenda. The generals said that France should get out of the war.

On the tenth of June, the French government, after announcing that it was leaving Paris in order to save France, began its ramshackle retreat to Tours, where its ministers were scattered among the châteaux in the Loire Valley. Before leaving, they declared Paris an open city—it would not be defended. The Germans could take it without firing a shot.

Hypnotized by the swiftness of the German advance, France had already accepted defeat. When the British prime minister Winston Churchill flew to the Loire Valley to meet Reynaud on June 11 to try to invigorate the French war effort, he spoke dramatically of defending Paris street by street. "The French perceptibly froze," he reported.[9] The thought of mounting a fight in Paris was inconceivable to them.

Ignorant, like everyone else, of the goings-on in the corridors of power, Serge also decided to abandon Paris that evening of June 10. With Laurette and his son, Vlady, he set out for the gare de Lyon, but immediately he sensed violence in the air. Restless crowds milled around the outside of the station. There was no more room inside, and in any case there were no more trains. By astonishing luck, he found an empty taxi for himself, Laurette, his son, and a Spanish friend who had joined them. The driver, also fleeing Paris, was willing to take them south, away from the German advance. "That's how salvation comes when it comes," he thought. "Simply." You have to "trust in chance, but with a rational tenacious will."[10]

The taxi nosed into a silent caravan making its way down the avenue de Vincennes, its camouflage lights squeezed against the bumper of the car in front. The night was so dark that only the sound of shuffling feet or the occasional cough betrayed the presence of hundreds of thousands walking past the car. It seemed the whole of Paris was fleeing. The taxi drove through the Fontainebleau woods under a barrage of shells, and along the clogged highway heading south, following the fugitive tide.

Strangely, along with dread, Serge felt a kind of euphoria. Even though he had lost all his possessions once again—books, personal objects, manuscripts—he experienced a sense of release. Europe had been living in a "suffocating blind alley," and everyone knew it

couldn't last. He wrote in his memoirs: "The leap into the unknown has been made. It will be black and terrible, but those who survive will see a new world reborn."[11]

Serge was, for a moment, back in his childhood when he had lived among Russian revolutionary exiles. They were idealists waiting for the necessary cataclysm. They waited patiently through brutal persecution for half a century. And the revolution had come. For a moment Serge held on to the old faith, briefly forgetting how almost as soon as the revolution occurred, it was corrupted.

Not finding anyplace to stop, the taxi driver simply drove off the road into the darkness, and the family slept in the open field. They awoke at dawn, in the middle of farm country, a thin drizzle of rain falling on their faces. The highways were still filled with the fleeing French army, with Parisians, with refugees from Alsace, Lorraine, Belgium, Holland, and scores of other places. It was a scene of unbelievable chaos. Every type of vehicle had taken to the highway: trucks, cars, horse-drawn hay wagons, dung carts, any box on wheels, piled high with family belongings wrapped in bedsheets, often covered by a mattress to protect from aircraft fire. There were hearses carrying elderly patients evacuated from nursing homes and patients from mental institutions.

"What's happening?" people asked the soldiers as they passed. The soldiers were leaderless, without orders. Many of their officers had fled. "*Nous sommes foutus,*" they said. ("We're done for.") "*Nous sommes vendus.*" ("They've sold us out.") Village after village emptied, the villagers taking their places in the procession, following the doomed caravan. Livestock, freed from barns lest they starve to death, roamed the countryside, trampling the ripening grain. Rumors spread like a slow burn: the Americans had entered the war; the Russians had bombed Berlin; the pope had committed suicide; England had been invaded. People were beyond astonishment. Telephone lines had been cut. There was no way to know.[12]

The refugees often found scant welcome in the towns. They were viewed with suspicion—they gobbled up the food supply and sent prices soaring. They stole bicycles. They might even be enemy sus-

pects, especially if their accents were foreign. There were stories of groups of nuns on the highway who turned out to be German agents in disguise.

Enterprising farmers set up roadside stands, some even selling water. But there were also farmers who opened their barns to shelter the homeless and who fed the children fresh milk. And shop owners who fled leaving their doors unlocked, with the invitation: "Take what you want."

Beginning in mid-May, it is estimated that between six million and eight million people abandoned their homes and took to the roads toward the south and west.[13] This mass migration would be called *la pagaille* (the great turmoil). Entire towns became ghost towns overnight. The highways were littered with cars abandoned when they ran out of gas or broke down. Often the cars were pushed into adjacent fields, and there they lay like skeletal remains, some burned hulks, others overturned, their wheels spinning. The Germans were bombing the roads to prevent the advance of the French soldiers and to terrorize civilians. People scattered to find any shelter. After the bombings, the planes swooped down in a leisurely fashion, machine guns spitting bullets to kill any survivors.[14]

Everything had broken down, except for French bureaucracy. In central France, two thousand graves had been dug and instantly more than a million burial forms, with blanks for names, dates, and cause of death, were printed up. If France hadn't been prepared for battle, it would certainly be prepared for death.[15]

Victor Serge and his family looked for some place of sanctuary. He had the addresses of Socialist and anarchist friends, but at each door they were turned away. One former Socialist colleague said: "Take my car, but get out quickly. They're coming this way." The man explained that he had changed. He now believed in strong government and was in sympathy with Hitler.

On one occasion Serge and Laurette were arrested, but the police soon let them go. It seemed that the arrest was simply perfunctory—everyone was getting arrested. Serge and his family followed the flood heading for the southernmost port of Marseille. There was no logic to

this movement except to get as far away as possible from the advancing Germans. Marseille had become the spout of a horrifying human funnel; half of Europe seemed to be pouring into its clogged quarters, hoping to escape the fighting.

On June 14, at 5:30 A.M., the victorious army of the Third Reich marched into Paris. It was a warm June day. Dabbled clouds scattered across the sky and the air was filled with birdsong. German Panzer tanks and armored cars, heavy and dark and in rigid formations, rumbled through the northern and eastern boulevards of the city. As part of the open city stipulations, French police lined the sidewalks of the Champs-Élysées with batons drawn to maintain order. But there was only a solemn scattering of crestfallen Parisians lining the streets. Most who were left in the city stayed indoors and witnessed the humiliating spectacle through closed shutters. As a small gesture of defiance, the elevator to the Eiffel Tower had been dismantled to prevent the Germans from taking down the French tricolor. German soldiers diligently climbed the steps to the summit and hung the swastika.

In a stiff ceremony at the American embassy that lasted only ten minutes, Ambassador William Bullitt, serving as a neutral mediator between France and Germany, accepted the treaty outlining the terms for the occupation of Paris. These included the assurance that no "enemy action" would take place, or "immediate reprisals would be visited on the civilian population." He was to hand the treaty to the French military commander.[16] Washington had ordered Bullitt to follow the French government to Tours, but he had refused on the grounds that no American ambassador had ever quit Paris. (In an absurd gesture he had cabled Washington on June 6, asking for twelve submachine guns). President Roosevelt was livid, believing Bullitt had cost the Allies the chance of convincing Reynaud not to surrender. The ambassador was hastily recalled to the United States.[17]

By June 16 the French government had retreated yet farther. Abandoning the Loire Valley, they reassembled in Bordeaux. That day Premier Reynaud, in what was thought in retrospect to be a strategic move to stall the vote for an armistice with Germany, offered his resignation. Much to his shock, it was accepted. Marshal Henri Philippe

Pétain, who had rallied the troops in the crucial battle of Verdun in World War I and was the nearest thing France had to a national hero, was appointed the head of government. The octogenarian soldier would assume absolute power and prove to be the puppet of dark forces bent on collaboration. Under his leadership, the parliamentary democracy of the Third Republic was soon voted out of existence and replaced by an authoritarian, antidemocratic regime dedicated to working hand in glove with the Nazis.[18]

FEAR

People had forgotten that it's just as natural for the human animal to wait for the massacre, flee along the roads, hide in forests as to be born, grow, struggle, and die of old age.

VICTOR SERGE[1]

For Mary Jayne Gold, one of the most vivid memories of the war would always be the melancholy parade of nomads fleeing through the Loire Valley, their cars and farm wagons piled high with household goods—first the Dutch, then the Belgians, and finally the French. The curé of Châteauneuf-sur-Loire and local farmers organized a canteen at the roadside, and she helped to distribute food to the refugees while the young farmhands found them places where they might rest. Cycling home at night, Mary Jayne watched the passing carts drawn by the powerful Percherons. Despondent and weary travelers headed into the fields to set up campsites. Against the summer stars, the sparks of the multiple bonfires were an oddly beautiful sight.

But soon car license plates carried the number 75, the code for Paris, and the panic increased. And then military vehicles and wounded soldiers joined the flood south.

Keeping up with the progress of the war by shortwave radio, Mary Jayne, Theo, and Eva pored over maps, tracing the German victories. General Rommel's Panzer division advanced from the north, Reinhardt provided the central thrust, and Guderian pressed from the east. When the Germans entered Paris on the fourteenth of June, the women couldn't bear to talk about it. Silently they piled their suitcases into a small cart they had attached to the Citroën and joined the flight to the sea.

By the fifteenth the front had almost reached Chartres, south of Paris, and German divisions were heading west to the Atlantic ports of Brest and Cherbourg. On the same day, the Germans also pushed south past Dijon and were moving toward the city of Lyon. A great wave of civilian refugees preceded them. It felt like the disintegration of a whole civilization.

Mary Jayne, Theo, and Eva decided to head south and then west toward the port of Bordeaux, where they hoped to find ships evacuating civilians to Britain and America. But they were on the north side of the Loire River and needed to get across. Negotiating the dirt roads, Mary Jayne guided the Citroën to the nearest bridge in the town of Sully. Above them they could see German planes flying in the direction of nearby Orléans. When they reached the bridge, it was a complete bottleneck, automobiles bumper to bumper with military vehicles. The French army was continuing its retreat west to make a last defensive stand on the Loire River. When Theo asked the soldiers what was happening, she was told: "France is lost. We're going to have to fight from Africa."[2] The news was stunning. It had been only four weeks since the invasion.

It was getting dark. Civilians were being allowed to cross only intermittently. Just as Mary Jayne's Citroën reached the end of the bridge, they heard a loud, low-pitched buzzing noise as a fighter plane dropped its bomb. The whole bridge shuddered. But the French responded with antiaircraft fire and the plane moved on.

A fine drizzle was falling and the blackout headlights barely penetrated the darkness. They stopped at the first barn they came upon,

and climbing into the loft, found it filled with dozens of refugees. They made their way gingerly around the sleeping bodies and collapsed in the straw, too exhausted to give more than a moment's thought to the terrible realization that their world was collapsing.

As they fled southwest the next day, they began to see soldiers traveling in small groups. They passed abandoned tanks and trucks and saw piles of rifles and machine guns that had been thrown carelessly into the ditches. That night they knocked on the door of an isolated farmhouse, and the farmer's wife offered them shelter for the night. No one had any news to offer of what was happening.

Around 1 P.M. the next day, they arrived at Guéret on the edge of the Auvergne. They stopped in the central square for lunch. But something was very wrong. People were milling about, talking nervously. Voices were raised. A young woman was crying. Someone remarked that the French fleet was set to sail to England. When they walked into a café and asked what was wrong, a waiter told them that Marshal Pétain, the commander-in-chief of the French army, had become the head of government. "France has surrendered," the bar owner said.[3]

Mary Jayne and Theo looked at each other in dismay. They both wanted to cry. What to do? Anything could happen. It was "like the end of the world, that everything that one believed in was being overrun by this evil thing . . . but on the other hand you felt that it couldn't be . . . nothing like that could win, and you'd have to just carry through and hope for the best."[4]

They decided to go on, but without their small trailer. As she packed a few final things into a single suitcase, Mary Jayne was "suddenly and incomprehensibly stricken by a panic, a low, craven fear."[5] All she could think of was turning her back on her friends and fleeing for all she was worth. Her panic was so intense, she was shaking all over. The danger earlier had been much greater, but then she had been running on fear. Now the full shock of the horror they had been through hit her. She could think only of escaping, of abandoning everyone. "It was an ugly thing." Just as suddenly the wave of fear passed and she felt deeply ashamed.

No one had noticed her panic. She managed to discuss quite sensibly the best possible route to Brive on the way to Bordeaux. Theo had still not heard from Danny, but was hoping he had been evacuated to England. What she did not know was that he was already back in France. On the ninth of June, eight days earlier, he had sailed back across the Channel and landed in Cherbourg. He was trying desperately to get a telegram to his family. But where to send it?

THE CAPITULATION

D anny had been evacuated to England at the end of May. Landing at the English port of Southampton, he was sent north to Yorkshire for regroupment. The battle at Dunkerque had been horrible—the French Mission attached to the British Expeditionary Force had lost more men proportionally than any other French unit.

The French and their British allies wanted to get the survivors of Dunkerque back into the war as quickly as possible. On June 9, along with about six hundred men from his old division, Danny was repatriated by troopship to Cherbourg on the northwest coast of France.

As soon as Danny's unit landed, things went from bad to worse. He and his fellow soldiers were shuffled from train station to train station in a convoy of cattle cars, moving peripatetically across the landscape from Caen to Angers, then to Périgueux, back to Limoges and down to Millau, crossing the west and Midi. Danny had come back to fight, so this vagabond wandering was deeply galling. One comrade suggested they were being kept from the Germans because their losses

had been so high at Dunkerque. Danny replied that this was no way to fight a war.

Instead, they were eyewitnesses to the debacle: the panic and misery of civilians fleeing the invasion, detachments of demoralized soldiers abandoned by their officers, and the bottlenecked traffic fleeing south. The worst part was that Danny hadn't had any news of his wife and son.

Leaderless, the men simply organized themselves into their own groups. With seven other Dunkerque survivors, including his friend Jean Gemähling, Danny found himself stuck in a siding at Niort station, near Poitiers, eating sardine rations and resting in the sun. It was midday, June 17. As they listened to the music from the signal post radio, a quavering voice suddenly interrupted the broadcast. It was the octogenarian Marshal Pétain, who had assumed the head of the government. Pétain was addressing the country:

> *At the request of the President of the Republic, I assume the leadership of the government of France starting today. Certain of the affection of our admirable army, which has fought with a heroism worthy of its long military traditions against an enemy superior in numbers and in arms. . . . Certain of the confidence of the entire French people. . . . I put my trust in the people and I give myself to France to relieve her pain. . . . It is with a heavy heart that I say to you today that it is necessary to cease fighting. I have . . . approached the enemy to ask if he is ready to try to find, between soldiers, with the struggle over and in honour, the means to put an end to the hostilities.[1]*

Danny turned to his friends. All more or less leftists, they had built up a fraternal bond. They had known the worst of the debacle and had suffered irremediable losses. Now to discover that France was capitulating to the Germans was profoundly shocking. They looked at each other, appalled, almost in tears. Yet around them they heard jubilation. People congratulated one another: *peace at last.* Soldiers and

civilians cheered the courage of Pétain, who had stopped the useless butchery.

Truthfully, given the swiftness of the German advance, Danny had known there could be no other outcome than defeat. When Paris had been declared an open city and the Germans simply walked in, he'd recognized that everything was over. But he'd thought, vaguely, that a resistance might be mounted from Africa. Something would be done. He resented from the depth of his soul the soldiers' jubilant reaction to the downfall of France.

At that moment, standing on the train siding in Niort listening to Marshal Pétain's radio broadcast, Danny made a decision. He could see ahead the barrage of lies and demagoguery that Pétain's right-wing regime would bring and the brutally repressive measures they would take against all left-wing sympathizers. He immediately understood that the enemy to combat was not only the German occupiers, but also the spirit of Fascism itself, "its partisans and accomplices whoever and wherever they were to be found, starting with those closest at hand."[2] He decided then and there that if the French ruling classes had become collaborators, he would become a resister.

POSTCARDS FROM THE ZONE LIBRE

On June 17, when Marshal Pétain made his radio broadcast announcing that the French government would approach the German enemy to stop the fighting, the pervasive sentiment throughout France was one of enormous relief. The swiftness of the German advance had left people traumatized. After less than six weeks of combat, between fifty thousand and ninety thousand French soldiers were dead.[1] Still fresh in the collective memory was the Great War when much of the fighting had been on French soil; 1.3 million Frenchmen had died and one million survivors were invalided. Another bloodletting on that scale was unthinkable.

Most French troops took the marshal at his word and, believing an armistice was imminent, tens of thousands threw down their weapons: why get killed when the war was effectively over? The roadsides and ditches of northern France were strewn with abandoned rifles. Entire regiments sat in their barracks waiting for the Germans to arrive.

French soldiers who wanted to continue the fight found themselves spurned and even attacked by civilians. Women shouted at the troops: "The war has got to stop. Do you want them to massacre us

with all our children . . . why are you still fighting?" Civilians were said to be stoning soldiers.[2]

People were terrified of the consequences of resistance. When the German front moved to Angers in the Loire Valley on June 18 and German planes bombed the train station, the townspeople begged the defending soldiers not to fire on the Germans. On the twentieth the mayor of Angers announced in the local paper that "all resistance and all armed opposition is formally prohibited and will be severely punished by the French authorities. The prefect and the mayor appeal for calm, coolness, and discipline on the part of the population."[3]

At Nantes, the occupation went smoothly. The German troops streamed in on trucks and motorcycles while the townspeople crowded the pavements. The curé of the town of Sainte-Croix described people hanging out of their windows as the Germans entered. German soldiers filmed the scene for propaganda purposes and then in the evening invaded the shops buying jewelry and silk stockings. "There seemed to be an atmosphere of festivity rather than of mourning."[4]

The day following Pétain's speech, headlines blazed across the front page of Le Monde: "Parliament and Senate Dissolved." The Courrier du Centre reported: "The Destiny of France Is in Pétain's Hands."[5] Pétain intoned: "At least our honour is safe." But he had made a tactical error. By calling for a premature halt to the fighting, he had given away any bargaining power he might have had with Hitler. When the armistice was finally signed on June 22, the Germans imposed the terms by diktat, to be accepted without negotiation.

Pétain had sold out the soldiers of France. One and a half million French soldiers had been taken prisoner, at least half of them after Pétain's June 17 broadcast. They had allowed themselves to be rounded up by the Germans, believing they would be demobilized and returned to their families. But by the terms of the armistice, the French government agreed that French prisoners would remain in German hands. They were shipped off in freight cars to labor camps in Germany. For four long years they served the Germans as a bargaining tool to keep the French in order.[6]

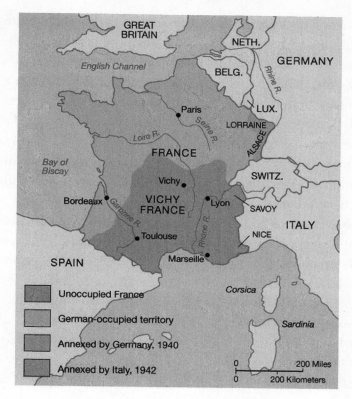

Map indicating the border between
German-occupied France and Vichy France.

Hitler made sure the signing of the armistice was as humiliating and symbolically painful to the French as possible. It took place in the same clearing in the woods at Compiègne where the Germans had capitulated to the Allies in 1918. Hitler ordered the railway car used at that time to be removed from the Musée de Compiègne, and had it delivered to the exact spot. The ceremony of the signing was filmed for its propaganda value. The image of Hitler exiting the car and slapping his thigh in a gloating gesture of triumph would later play on newsreels in cinemas throughout France.[7]

By the terms of the armistice, France was divided into occupied and unoccupied zones. A black line snaked from the French-Swiss

border near Geneva to Tours in the west and then headed south to the town of St. Jean Pied de Port near the Spanish border.

Germany held two-thirds of the country, including Paris, the industrial north, and the whole Atlantic coast with its valuable ports. The remaining third—the south-central provinces, with access to the Spanish border over the eastern Pyrenees, and the single port of Marseille, remained under Pétain's control. Obviously Hitler considered total occupation unnecessary. It would be an administrative drain on German manpower, and anyway he had confidence that Pétain's government would toe the Fascist line.

The armistice also required that France bear the cost of its own occupation; from now on 60 percent of its national income would go to the German Reich.

On July 1 the new French government moved from Bordeaux to the spa town of Vichy in the Massif Central. Meeting in the Vichy casino on July 9, Parliament voted almost unanimously to accept a proposal to revise the constitution. On the next day, Marshal Pétain was granted the authority to do so. He immediately issued a number of constitutional acts that in effect gave him absolute power, and adjourned Parliament until further notice.

At Vichy, Pétain and his new leaders immediately set out on an "ideological crusade" to remake France. Rebaptizing the disastrous defeat a "National Revolution," Vichy ideologists claimed France had authored its own tragedy. It was intellectualism and the cosmopolitan cities, those repositories of vice, that had undermined traditional values. The motto of the Republic: *Liberté, Egalité, Fraternité* was replaced with the phrase *Work, Family, Fatherland*. One Vichy propaganda documentary blamed the French defeat on "the English weekend, American bars, Russian choirs, and Argentinean tangos."[8]

Vichy had to find an enemy to blame for the humiliation of France. One of the regime's first acts was to set up a tribunal to investigate the defeat. Among the defendants were former Socialist premiers Léon Blum and Édouard Daladier.[9] The right-wing press began violent attacks on the old Socialist Popular Front. In right-wing papers like *Gringoire*, Blum was ridiculed. One cartoon depicted him as a

bearded, hook-nosed Pied Piper attracting Communist and Socialist rats into France. It was clear where this was heading. The enemy was not the Germans. It was the traitors within the gates: the Socialists, the Communists, and the Jews. Particularly targeted as enemies of France were all foreigners and all refugees.

By the terms of article nineteen of the armistice, France agreed to "surrender on demand" all German nationals requested for extradition by the Third Reich. This included refugees from conquered countries like Poland, Austria, and Czechoslovakia that had been absorbed into Greater Germany by the war. Intellectuals, artists, politicians, in fact any individual who had publicly expressed criticism of the Nazi Party and who had fled to France seeking asylum, could no longer expect protection from the government of France. Nor could they easily leave the country. The French borders were closed. Anyone wishing to leave the unoccupied zone, and this included French citizens, now needed an exit permit from Vichy to get out of France.

Almost immediately upon assuming power, Pétain's government set up a commission to redefine French citizenship. They targeted a 1927 law that had liberalized the naturalization of foreigners. All citizens naturalized since 1927 were to be examined, and "undesirables" would be stripped of their nationality. Subsequent legislation "forbade the offspring of immigrants to hold licenses as medical doctors or lawyers or to join the civil service." This refusal to recognize the rights of "second-generation assimilation" was "a dramatic departure from French tradition."[10] French Jews were particularly vulnerable. Of the 350,000 Jews residing in France, at least half were foreign born. The Marchandeau Law of April 1939, forbidding attacks in the press on persons or groups because of race or religion, was revoked. At the beginning of September a new law was passed authorizing prefects to intern, without trial, individuals deemed a danger to public safety. The unoccupied zone had effectively become a police state.

Passage across the heavily guarded demarcation line that now split France into occupied and unoccupied zones was as controlled as at any international checkpoint. To be found crossing the line illegally could be fatal. Communications were restricted. The only private

mail permitted across were the "interzone cards," which were "printed multiple-choice postcards that allowed senders to transmit only standardized messages." One such interzone card invited the sender to tick off one of the following choices: "in good health/tired/slightly ill/ seriously ill/wounded/dead."[11]

SAVE THE CHILD

June 18–July 15

Mary Jayne Gold drove into the main square of Brive, still several hundred miles from the seaport of Bordeaux. It was June 18. Seemingly overnight, the population of Brive had gone from thirty thousand to one hundred thousand.[1] The city was choking with panic-stricken refugees, mad with fear and with only one word on their tongues: *evacuation*. In the café on the square, people were clustered around the radio. In the streets, groups were milling about nervously. Angry men were shouting. Mary Jayne had run out of gas, and Eva Bénédite got out with the gas can to stand in line. From where they sat in the car, Mary Jayne and Theo could see her engaged in a fierce argument with a man. She shouted: "Me surrender? Never."[2] He hit her across the breast. Theo ran to rescue her mother-in-law before things had a chance to escalate further. The gas attendant announced the pumps were empty. There would be no more gas.

"My god, what is it?" Theo asked. In tears Eva replied: "It's the armistice. They're fighting over whether there should be an armistice."

Without gas they were trapped. There was nothing to do but look for a hotel. Despite all the chaos they managed to find lodgings and even a meal. Over dinner, Eva Bénédite remarked that she had bumped into a woman she knew called Madame Leduc, an "archre-actionary"[3] who was on her way to Bordeaux where the new French government had retreated. All the upper crust was heading to Bordeaux. Eva was sure Madame Leduc must have inveigled extra gasoline rations for herself.

That night Eva and Theo arrived at Mary Jayne's door in their nightclothes. Theo's eyes were swollen with crying. They asked to come in. As they sat on the edge of Mary Jayne's bed, Theo blurted out that she wanted Mary Jayne to take Peterkin with her. She could continue the journey with Madame Leduc. Mary Jayne was an American and could get out. Theo and Eva had no chance of escape since this would involve getting U.S. visas and they would certainly be turned down. But Mary Jayne would have no trouble being repatriated.

Theo was certain that even if the French government had already accepted defeat, there would be resistance within France and from French soldiers based in the colonies. There would be war and it would be bloody. Mary Jayne was dumbfounded.

It was a heartbreaking decision to give up her child in order to save him, but Theo was adamant. Mary Jayne could take Peterkin to his relatives in the United States.

Reluctantly Mary Jayne agreed. However, the moment was so painful, she could not look Theo in the eye.

The next morning Madame Leduc agreed to take Mary Jayne and the child. Since she was not noted for her generosity, the gesture was probably self-serving. Neutral Americans like Mary Jayne might turn out to have influence.

The departure was agonizing. Loaded down with baby clothes and diapers, Mary Jayne tried to look efficient. She accepted the child from Theo's arms; Theo could barely disguise her despair. Eva said they would go to the Vaucluse and wait to find out what had happened to Danny.

Mary Jayne sat in the passenger seat with Peterkin, while Madame Leduc's maid sat in the back beside a mound of luggage. She assumed the role of navigator, and when Madame Leduc remarked on her map-reading skill, Mary Jayne let it drop that she had flown her own plane. She knew the game of one-upmanship she had to play; though she hated it, she was good at it. Madame Leduc must be made to feel impressed. Mary Jayne brimmed with charm and distinction.

As they drove, Madame Leduc ranted on about the Spanish refugees who had spread syphilis all over France and about the evils of the old Popular Front government with their disgusting social security and paid vacations. She raged at her maid for failing to get the license plate number of a vehicle that had tapped them from the rear, which meant that she would be unable to collect the insurance. "Hitler will bring order, you'll see," she told Mary Jayne.[4]

French soldiers had set up so many roadblocks on the route to Bordeaux that it soon became clear the city was essentially closed to civilians. The women decided to proceed to Biarritz instead. While Madame Leduc joined friends in a château on the outskirts of the city, Mary Jayne, delighted to be rid of her, headed by bus to the Hôtel du Palais.

When she arrived at the reception desk, disheveled and carrying a child, she was directed to the servants' entrance. Nonplussed, she scanned the lobby for friends and finally spotted the maître d'. It had been nine years since she'd spent the summer there, romanced by the young Duke of Maura, but after a few moments the old man recognized her. Courteously he escorted her across the lobby and informed the desk clerk that Mademoiselle Gold was a distinguished guest and must be given anything she needed.

Stepping out onto the main street of Biarritz with Peterkin, Mary Jayne was thrown by the calmness of the scene before her. When she'd offered to take the child to America, they had all anticipated that even the smallest seaports would be in a terrifying state of chaos: French soldiers everywhere, last-minute evacuations, rumors of the intervention of the American or British fleet coming to pick up stranded na-

tionals. The order she encountered was unnerving. The stores in the fashionable district were still open. The first thing she did was to buy a pink linen suit. Now, she thought, the performance can begin.

Suitably dressed to impress, she set out on her mission. She went first to the American consulate, where an official informed her that the United States would not accept a child without a legal visa on a regular passport. She must speak to the French authorities. The French official at the prefecture informed her that of course, as an American she herself could have an exit visa any time, but not the child. When she blushed appropriately and told him the child was a "love child," her illegitimate son, he informed her that she would have to prove it. She got up and left.

Now she was in a dilemma. How to contact the Bénédites, who were on their way to the Vaucluse searching for Danny? She had the address of their destination and sent a telegram explaining that the plan to send Peterkin to America had failed. Meanwhile she waited in her hotel, hoping her message would eventually find them.

One night she was awakened by the sound of marching feet and of engines revving. She ran to the window. The Germans had arrived in Biarritz. Hastily putting on her coat, she slipped down to the lobby, where she found only the doorman on duty. The two of them stood impassively and watched as the helmeted enemy rose out of the blue darkness. The motorcyclists came first, wearing necklaces of cartridges and armbands with swastikas like sinister black spiders on white circles. Then came the roar of the tanks moving over the cobblestones sounding like drills boring into rock.

The porter offered Mary Jayne a Gauloise. They smoked in silence. The grotesque parade seemed to go on endlessly. "They're occupying the whole coast," he remarked, and spat on the sidewalk. "*Merde alors,*" she responded. There was nothing more to say.[5]

When she descended to breakfast the next morning, the German generals had moved into the hotel. She watched as they strolled through the ballroom where she and Ramón Maura had danced. It was June 23, the day after the armistice, and she discovered she was now stranded in occupied France.

For almost two weeks Mary Jayne waited impatiently at the Hôtel du Palais for word from Theo and Eva. She and Peterkin spent their time strolling along the Promenade de la Grande Plage. She was repelled by the proprietary air of the German officers casually window shopping or sitting in the cafés drinking beer.

Then, around July 5, she at last received an answer to her telegram, which had somehow miraculously reached Theo and Eva in the Vaucluse. They warned her that they would have to meet up somewhere safely inside the unoccupied zone and suggested Toulouse. But suddenly travel had become very complicated. Mary Jayne and the child would need official permits to leave occupied France. Biarritz was not an *administrative* center. They would have to get the necessary permits in the nearby town of Bayonne.

When they arrived in Bayonne, it was easy to find the Kommandantur—the building was draped with a large swastika flag. In his tidy office under a portrait of Adolf Hitler, a Nazi official stamped her and Peterkin's travel permits without hesitation—the Nazis were happy to evacuate foreigners from the coast. As Mary Jayne and Peterkin crossed by train through the demarcation line, their papers were stamped again. Unoccupied France had become another country.

Theo and Eva were waiting on the platform in the Toulouse station as the train pulled in. When Mary Jayne descended the steps, Theo swept her son up into her arms and held him close. No words were necessary. Two people were standing with the Bénédites. Eva introduced them to Mary Jayne as Charles Wolff and Miriam Davenport.

Toulouse was a disaster zone. The city had been designated a center for Belgian and Polish refugees, and the population had quadrupled in a fortnight to about a million. Hotels were so full that people were sleeping on or under dining tables and in lobby chairs, or outside in automobiles and in public parks. Everyone was looking for someone. Advertisements appeared in newspapers searching for lost husbands, wives, and children. "Mother seeks baby daughter, age two, lost on the road between Tours and Poitiers in the retreat" or "Generous reward for information leading to the recovery of my son, Jacques, age ten, last seen at Bordeaux, June 17th."[6] Messages were left on city

hall billboards until there were so many, they fluttered in the wind like white flags.

When Charles Wolff had run into Eva and Theo by chance in the street and found they had just arrived in Toulouse, he immediately insisted that they take his hotel room. He said he could find a bed at one of the refugee centers.

Charles Wolff was an Alsatian journalist and musicologist, and an old friend of Danny's. A fellow Socialist and militant anti-Communist, he had often approached Danny at the prefecture in Paris for help in sheltering German and Spanish political refugees. He was a frail young man, rather tubercular, with a bald patch that was exposed only when he removed his Basque beret, which he did rarely. His appearance didn't suggest that he had fought in the Spanish Civil War.[7]

He brought his friend Miriam Davenport along to the station to meet the young American woman who was bringing Danny's son from Biarritz. Theo had spoken of her with such deep affection that he was curious. He and Miriam Davenport had met in Paris when he'd come to inform her neighbor that the French army was surrounded in the north and that they had no more than a week to ten days to leave before the Germans entered Paris.

Everyone warmed immediately to Miriam Davenport. She was testy, amusing, and down-to-earth. Twenty-five years old, she liked to call herself a dishwater blond and said she wore her Phi Beta Kappa key "as a kind of dog tag."[8] She'd been about to complete her master's degree in art history at the University of Paris when the war started.

"The war seemed a poor excuse to drop everything," she explained.[9] Signing out at the local police station and packing all her belongings into four suitcases, she took the night train to Toulouse, where she'd arranged to write her exams at the university. Hers was the last train to run on that line; the next day the tracks were bombed. In Toulouse she discovered her American passport had expired, and when she approached the American consulate to renew it, she was told her plan to stay in France was frivolous. Her passport could be renewed only for immediate repatriation to the United States via the port of Bordeaux. She didn't mention that her real reason for wanting

to stay in Europe was to rendezvous with her Yugoslavian fiancé, Rudolph, who was ill and stranded in Ljubljana. Though the Germans would not invade Yugoslavia until the spring of 1941, travel to that country was exceedingly difficult, as Miriam well knew.

Miriam and Charles Wolff met again on the crowded Place du Capitole where he and his friends gathered in a small café. Miriam took to spending most of her days there, reading the newspapers. In the evenings she listened to their discussions about the baroque complexity of politics in Europe. "Their table became for me a kind of political seminar where I quickly lost my American innocence," she later remarked.[10] Still, they were young and there was lots of fun to be had. Charles was particularly good at ribald French folk songs. He and a cartoonist from the satirical weekly *Le Canard enchaîné* kept them in stitches.

One evening Charles took Miriam to the Cinéma Pax movie theater in Toulouse. The seats had been removed and the floor strewn with straw for bedding. It was now a dormitory for refugees. Suddenly the political and intellectual refugees she had been hearing about had human faces. She met Hitler's unflattering biographer, Konrad Heiden; Katia Landau, whose Communist husband had been murdered in Spain by the Stalinists and who herself had been jailed in Barcelona; and Justus Rosenberg, a fifteen-year-old boy who was the son of Danzig Jews. He had cycled down to Toulouse from his *collège* in Paris. She immediately nicknamed him Gussie. She also briefly met the German poet Walter Mehring who, she learned, was not only one of Germany's finest poets, infamous for the anti-Nazi songs he'd written, but was also high on the list of the Nazis' most wanted.

After taking the Bénédite family back to the hotel, Charles headed with Mary Jayne and Miriam to the Place du Capitole. The cafés were full on this warm summer evening. As they sat at Tortoni's, Charles and Miriam brought Mary Jayne up to date.

Thousands of French refugees from the north were already on their way back home. Charles said that now that the armistice had been signed and France was out of the war, the government was sending freight trains back north in an effort to repatriate people as soon

as possible. But Toulouse harbored a small number of foreigners who did not want to be repatriated to the occupied zone. They were artists, intellectuals, and political activists who had every reason to be terrified of falling into Nazi hands. Miriam was desperate to find a way to help these people whom she considered her new friends.

The next morning Mary Jayne boarded a freight train for La Bourboule. She wanted to collect her dog, Dagobert, whom she'd had to abandon on a farm in the care of strangers. Everyone now needed a *sauf-conduit* (safe-conduct pass) to travel, even in the so-called *zone libre*, but being an American with all her papers in order, she had no trouble obtaining the pass. Before leaving she had a coffee with Miriam at Tortoni's. When she heard of Miriam's plans to join her fiancé in Yugoslavia, despite the resistance of his unfriendly family who thought of her as a penniless American unworthy of their brilliant son, Mary Jayne remarked that she was a rich woman, and that should Miriam run out of cash, she would love to help out. To back up her offer, she gave Miriam the address of her *homme d'affaires* in Chicago.[11] As the train pulled out, she shouted to Miriam: "See you in Marseille." They had made plans to meet up at the American consulate.

MARSEILLE I

July 1940

The Nazis opened up a forbidden door in the soul. I suppose if you have to stake out this little idea, this little bit of ground that says you are the superior race and then you have to defend it, something horrible always happens . . . when you claim certainty, when you say that you know.

LEONORA CARRINGTON[1]

Marseille sat like a crescent on the edge of the Mediterranean. The gare Saint-Charles and the Church of Notre-Dame de la Garde stared down from adjacent hills into the harbor. Refugees arriving by train, by car, and on foot poured into the city and down its embankment following the lure of the sea smell carried on the wind. Some of the most famous artists and intellectuals of Europe had climbed down the magnificent stone staircase of the railway station to the boulevard d'Athènes below.

Those with money stopped at the elegant Hôtel Splendide, where a doorman greeted the new arrivals. But most continued down the boulevard and turned into the Canebière, the broad avenue that led to the harbor. Everything branched off from this artery. A flood of poor exiles at the end of their tether poured into the obscure little hotels tucked away in the back alleys.

At the harbor, the Canebière met the quai des Belges where the port stretched out in a rectangular basin magnificently sheltered from the open sea. On the left side was the quai de Rive Neuve (the new bank) that led eventually to the lighthouse and to fort Saint-Nicolas, where the French garrison was housed. On the right was the quai du Port. There stood the Hôtel de Ville and also the seventeenth-century quarantine house, which had once served as a forced refuge for cholera sufferers. Then, finally, came fort Saint-Jean, now the central depot of the Foreign Legion in France. Sixty English soldiers from the British Expeditionary Force were still being held in the fort. They had managed to escape the Germans at Dunkerque, only to be interned by the French. They could sometimes be found in the port out on a day pass.[2]

Standing on either side of the harbor were two huge pylons. An iron staircase led to a high footwalk that hung in the void. Suspended by cables, a broad platform below carried freight and people across the harbor. The locals called the bridge the *transbordeur*. It was meant to facilitate the entry and loading of large ships in the harbor but all vessels now sat immobilized in the port. Only the small fishing boats had freedom of movement, leaving at dawn and returning to dump the day's catch onto the docks.

Behind the right bank of the harbor reaching up into the hill was the Vieille Ville with steep steps leading into narrow alleys and tall buildings that leaned into each other. Washing lines stretched across the alleys, though the buildings were so close that the sun shone only stingily. A gutter filled with rank sewage ran down the middle of the streets. The Vieille Ville was a dangerous place where the criminal underground flourished and houses of prostitution serviced the city clientele. It was literally an underground. Tunnels interconnected the cellars of the houses. Smugglers had used them for centuries to evade customs and to hide stolen goods. Warehouses that showed up on no city plan were used to store contraband, illegal drugs, and even the occasional Degas. It was known that even the police were reluctant to enter the Vieille Ville.

Most of the houses had trapdoors, hidden behind commodes

Vintage postcard—Vieux-Port.

or under rugs, which led to cellars. Some, more caves than cellars, opened into ancient catacombs where the dead had been buried thousands of years past. Eventually the labyrinth of tunnels led out to the sea and to jetties where a dinghy hidden among the fishing boats could provide a quick escape and where booty was brought in.

Marseille had not escaped the violence. On the first and second of June, the German air force had brought the war to the city. Thirty people were killed in bombing raids, and at least seventy were injured as the bombers targeted the harbor and adjacent factories. On the twenty-first of June, the Italians bombed Marseille in a raid that seemed to have no objective other than terror. One hundred and forty people were killed.

Three days after the armistice was signed, the Vichy government declared a national day of mourning for the defeat of France. All the shops of Marseille were closed. Black flags were hung from windows, the courts were suspended, and people flocked to the churches to pray. Horrified by the bombings, much of Marseille cheered Pétain as their savior, and the cult of Pétain grew.

The official line at Vichy was that an international conspiracy of

plutocrats and Socialists, inspired by Jews, had been responsible for France's defeat. Streets named for "Socialists" like Rousseau, Anatole France, and Jean Jaurès were rechristened. And foreigners were demonized. On July 8 it was declared that no "resident alien" was allowed to travel or move from his actual domicile. A city ordinance was passed preventing refugees from living in a hotel for more than five days.[3]

In *Paris-Soir*, now printed in Marseille, a story appeared with the title: "The Marshal and the Peasant—A Modern Legend." Supposedly Pétain had invited an old peasant to Vichy for a "hearty man-to-man talk." When the peasant left he was reported to have said of the general: "*C'est un homme*, an honest peasant like myself." Pétain was quoted: "This interview has convinced me that I have the entire confidence of the peasant class."

The same issue of the newspaper had an editorial endorsing the new decree "making knee-length, two piece bathing-costumes compulsory for men and women at Nice." "No more shorts, no more French women disguised as men—*La Revolution Nationale marche*."[4] Franco-German propaganda newsreels began to appear in local cinemas. French audiences watched the ladies of the German Red Cross distribute food. A soothing voice intoned: "German employees and their French comrades undertake the restructuring of France."[5]

In the name of its paternalistic revolution—*Work, Family, Fatherland*—Vichy abolished divorce and decreed the death penalty for abortion. Family legislation rewarded the birth of children. Then food rationing was instituted on August 6. Soon there would not be enough food to feed those new babies that Vichy was encouraging its citizens to conceive.

That summer in Marseille, crowds of refugees replaced the tourists. Some 190,000 displaced persons had suddenly augmented the city's population, estimated at 650,000 in 1939.[6] The numbers were staggering. Everyone knew that few ships were sailing, yet the refugees still came to the port. They had nowhere else to go. They sat in taverns like the Bar Mistral and waited for rescue. Many of them had been released from internment camps, or from the French army

where some had chosen to work as *prestataires* to escape detention. Others remained in hiding to avoid the roundups of illegal aliens.

The refugees lived in constant fear. Rumors traveled through the narrow streets: the Germans were about to occupy Marseille; to apply for a residency permit was a ticket to a concentration camp; the Gestapo were in Marseille disguised in civilian dress. The refugees understood that Vichy was cooperating with Hitler.

Their main focus was to go unnoticed; to blend into the populace while avoiding close contact with anyone; to be mistaken for French natives in a city that had almost doubled its size in a matter of weeks. One hundred and ninety thousand refugees needed to apply to the prefecture for *permis de séjour* (temporary residence permits) to stay in the city legally. But to get the permits, they needed to prove that they had every intention of leaving; they needed to obtain international visas to another destination. Without them, they could be sent to internment camps. As often as they dared, they took the trolley to a château in Montrédon on the outskirts of Marseille where the visa office of the U.S. consulate was housed. They might have saved themselves the trip. The signs posted outside the visa office: "Applications from Central Europe Closed," "Quota Transfers from Paris Discontinued" made it clear that the embassy was issuing few American visas.[7]

Since all newspapers and radio stations had been taken over by the "New Order," the refugees had only rumor to fall back on. By the end of July, one such rumor had solidified into fact. The Vichy government was going to keep to the terms of article nineteen of the armistice to "surrender on demand" all Germans named by the Reich. For these people, it was now imperative to get out of France. But who was on the Germans' list and how were they to get out? The armistice had put all shipping, whether in occupied or unoccupied France, under German control, and the German navy was patrolling the Mediterranean. The number of ships departing from Marseille dwindled to almost nothing. Because Portugal remained a neutral country, there were still international sailings from the port of Lisbon, but the paperwork required to get there had multiplied exponentially. One needed a valid passport, a safe-conduct pass to the French border, a French

exit permit, Portuguese and Spanish transit visas, and an international overseas visa.

Everyone understood that it would take no time before any of these documents could be bought on the black market—Vichy officials would soon be conducting a brisk trade in exit permits and even stateless refugees could always buy a forged passport.

But who, except the privileged few, had any money? The penniless refugees certainly didn't. It seemed they had only one consolation left. It would take months before Vichy would become efficient enough to round them all up.

Soon international aid groups began arriving in Marseille. The American Friends' Service Committee run by the Quakers under Miss Holbeck; the YMCA under Dr. Lowrie; the Unitarian Service Committee; HICEM, the international Jewish relief agency; the Oeuvres de Secours aux Enfants (OSE), the children's aid committee. There were the French Red Cross, the Belgian Red Cross, and the American Red Cross, Russian and Czech organizations, the Mennonites, and the American Emergency Rescue Committee. Enough organizations to keep the refugees prisoners of hope.[8]

THEY GATHER

Here is a beggar's alley gathering the remnants of revolutions, democracies, and crushed intellects. . . . In our ranks are enough doctors, psychologists, engineers, ed-ucationists, poets, painters, writers, musicians, economists and public men to vitalize a whole great country. Our wretchedness contains as much talent and expertise as Paris could summon in the days of her prime; and nothing of it is visible, only hunted, terribly tired men at the limit of their nervous resources.

VICTOR SERGE[1]

The family of the thirty-one-year-old French philosopher Si-mone Weil, who had once taken upon herself the case of Vic-tor Serge, had been out shopping on the thirteenth of June when Simone's father saw a notice stating that Paris had been declared an open city. Open to the Nazis. He knew what this meant for Jews. Without returning to their apartment for clothes or belongings, the Weils made their way to the gare de Lyon. Luckily Dr. Weil had taken to carrying a large amount of cash on his person. Although national guardsmen surrounded the station, refusing to admit anyone, Ma-dame Weil was able to convince them her husband was in charge of a medical convoy. The three managed to squeeze into the last packed car heading south. The Germans entered Paris the next day.

After spending two months in Vichy, the family made it to

Marseille, where Dr. Weil found a spacious apartment on rue des Cat-
alans with a view of the harbor. Before the demarcation line between
occupied and unoccupied zones was sealed, they were able to send
for several trunks of belongings from their Paris flat, including their
daughter's manuscripts. The Weils were hoping to get visas to Portugal
or even North Africa. They waited eighteen months.[2]

The novelist Lion Feuchtwanger was one of Germany's most
widely read authors, with works translated into a dozen languages. But
in his 1930 novel *Erfolg* (*Success*) he had had the temerity to satirize
Hitler and his increasingly popular National Socialist Party. In 1933,
when the Nazis assumed power, Feuchtwanger's citizenship was re-
voked for "disloyalty to the German Reich and the German people."
He immediately went into exile in France.

It was the middle of May 1940. Lion Feuchtwanger was lying on
his couch thinking of the novel he was working on. Dusk had over-
taken the little room where he kept his radio on the ground floor of
his house in Sanary-sur-Mer on the French Riviera. He was alone,
lying with his eyes closed, listening vaguely to the news reports when
he heard: "All German nationals residing in the precincts of Paris,
men and women alike, and all persons between the ages of seventeen
and fifty-five who were born in Germany but are without German citi-
zenship, are to report for internment."[3] He lay there controlling his
panic. Probably this will apply only to Paris, he assured himself. Not
the South of France. Not here in the village of Sanary on the shores
of the Mediterranean where he had lived for seven years. This region
isn't threatened by war, he thought, and anyway, he had been investi-
gated so many times and it had been ascertained that he was a sworn
enemy of the Nazi government. Perhaps the French government was
just trying to give the public the sense that something was being done.
But an inner voice was telling him such rationalizations were absurd.
"From the first days of war, it's one's worst fears that come true," he
reminded himself.[4]

He picked himself slowly up from the couch and walked out into
the garden. He strolled among the flower beds, gently touching the
blossoms. The salt smell of the sea poured through his nostrils, scram-

bling his thoughts. The landscape was filled with a vast silence. The cat scampered at his feet. He bent over to stroke its back and in the warm night, felt suddenly chilled. He turned back to tell his wife. At least it was warming up. "The frosts are over," he thought.

A week later they came for him. A knock on the door. Transport to Camp des Milles. He already knew the place. He had been interned there the previous September during the *drôle de guerre*, though he had been quickly released. This time he would spend one month in the camp. When the German army advanced toward the south, the French administration released the prisoners at Camp des Milles to fend for themselves. Now he and his wife were in Marseille, trying to orchestrate their final escape.

Victor Serge was now living with Laurette Séjourné and his twenty-year-old son, Vlady, at the Hôtel de Rome. He'd been caught in several street roundups and was once listed for the concentration camp, but his papers were in order and he was let go. For the moment. He wrote in his memoirs:

> *Marseilles, flushed and carefree with its crowded bars, its alleys in the old port festooned with whores, its bourgeois streets with lattice-windows, its lifeless wharves and its brilliant seascapes . . . selling, buying and selling back documents, visas, currency, and tasty bits of information . . . [all of us exiles] running through numberless varieties of terror and courage, anticipating every fate that we can imagine lying ahead.*[5]

Max Ernst had talked endlessly with Leonora Carrington about leaving France. But to live in New York? America seemed like a primitive, Wild West place. He couldn't imagine giving up Paris. Anyway the term *enemy alien* struck him as ridiculous. He was sure there would be somebody he could talk to, somebody who could make special arrangements if anything went wrong. In France, nothing was final.[6]

But Ernst was wrong. He was denounced in May by a village resident who alleged that he was a German spy and had sent light signals

to the enemy. At the time, the enemy was still six hundred miles away near Dunkerque. He was again handcuffed like a common criminal and taken by the local gendarmes to Camp Loriol and then back to Camp des Milles. By this time the number of prisoners at the camp had increased to thirty-five hundred. Ernst managed to escape once, but was soon recaptured.

On June 22, the very day the armistice was being signed, the German army reached Andance-sur-Rhône. The French commander of Camp des Milles announced that a train was being made available to all prisoners at risk at the hands of the Nazis. It was to take them to a southern port from where, rumor had it, they would be shipped off to work as forced laborers on the Trans-Sahara Line in France's North African colonies. Ernst was one of the twenty-five hundred prisoners who boarded that train.

The prisoners called it the "ghost train." Soon most of the guards disappeared, leaving a prisoner in charge of each carriage to make sure no one escaped. As they approached Carcassone, Max Ernst considered flight, but he remembered the words of his friend Joë Bousquet: "Impossible to hide even a mouse in Carcassone." There was not much point to escaping. Without proper identification papers and ration cards, life outside was impossible.

The ghost train shuttled back and forth across the South of France, only stopping to reverse directions. The prisoners were advised to burn all papers that would prove compromising, especially affidavits of loyalty to the old France.[7]

When the train unloaded its prisoners on the twenty-seventh of June at an isolated camp at Saint-Nicolas near Nîmes, where the inmates slept in tents with no sanitation and plenty of lice, Ernst effected his escape. He made his way on foot to the village of Saint-Martin d'Ardèche, only to discover that Leonora Carrington was gone. Terrified and alone, she had suffered a breakdown. She herself described her experience after Max's arrest: "I wept for several hours, down in the village; then I went up again to my house where, for twenty-four hours, I indulged in voluntary vomitings induced by drinking orange blossom water and interrupted by a short nap. I hoped that my sorrow

would be diminished by these spasms, which tore at my stomach like earthquakes."[8]

Knowing she had no access to money, the owner of the local bar had allowed her to drink freely. When the bill came, he suggested she sign over to him Max's house, which was in her name. It would be safer in his than in German hands, he said.[9] Fearing for her sanity, friends encouraged Leonora to join them in the exodus to the Spanish frontier.

When Ernst arrived in the village, he discovered the owner of the bar had seized his property. He was forced to break into his house in the middle of the night to reclaim his canvases. Hungry and alone, he lived in hiding in Saint-Martin d'Ardèche until he could make his way to Marseille.

André Breton found himself in the Gironde after his flight-training school was evacuated. He was demobilized in the unoccupied zone, a mile or two inside the demarcation line. He headed for Marseille, intending to join his wife and daughter who were waiting for him there. He was aware of the danger. "Certain courtesans of the new regime . . . even went so far as to accuse Surrealism in the press of having had a hand in the military defeat. The immediate prospects were quite alarming. The vise was squeezing harder every day," he remarked in retrospect.[10]

Breton met up with his family and sought shelter in Salon-de-Provence, a small town northwest of Marseille, at the home of his friend Pierre Mabille. Together the families moved to an abandoned fishing cabin on the beach in Martigues near Marseille and plotted how to escape to America. It would not be easy. To get to the United States they would need an American visa, an American sponsor, and money for passage, which they didn't have since everything they owned had been left behind in Paris. They thought of their friend, the Swiss-born painter Kurt Seligmann, who had moved permanently to New York in 1939. Perhaps he could arrange some sort of sponsorship—a surrealist exhibition, an American lecture tour, anything to convince the Vichy officials to grant them the elusive exit permits.

The young Austrian literary agent Hertha Pauli and her friend the

German poet Walter Mehring had left Paris on foot just ahead of the
German army. They had been walking for two weeks, "crisscrossing
a dying country, passing through eerie villages whose names [they]
never knew. The houses along the road seemed like stage props."[11]
Doors shut in their faces when they knocked to ask for food. A bakery
might yield an occasional stick of bread. They drank water from farm-
yard wells and slept in ditches whenever they were turned away from
barns. Most of the time they didn't know where the Germans they
were running from were—ahead, behind, or all around them.

Her feet bloodied and her shoes in strips, Pauli collapsed one af-
ternoon and sprawled in a ditch, unable to move. "In Orléans there
will be coffee again," Mehring said, smiling, and tried to lift her.
When she refused he said: "Wait, I'm going to find you a bed." Pauli
thought he had abandoned her for good, but after a time he returned.
In a nearby farm he had indeed found her a bed belonging to a dead
soldier. Assuming they were Belgian refugees, the widow had taken
pity when Mehring said his "wife" was dying in a nearby ditch. This
was a Mehring Pauli hadn't seen before—with courage and optimism
enough to keep them both going.

When they finally made it to Bayonne, they joined a throng of
people trying to board the single British ship in port, but the mili-
tary police turned back the crowds. The ship was only taking on mili-
tary personnel. They attempted to buy poison in case they fell into
the hands of the Germans, but for poison one needed a prescription.
Hearing the coast was to be occupied, they decided to go inland, mov-
ing along side roads only in the mountain regions. They could not
afford to be caught without safe-conduct passes. By the middle of July
they were in Lourdes. There they met, by chance, Alma Mahler, the
widow of Gustav Mahler, and her husband, the novelist Franz Werfel,
whose books had been banned and burned in Germany in 1933. In
her trunk Alma was still carrying the scores of Mahler's symphonies
and Bruckner's Third Symphony.

Early in June Pauli, Walter Mehring, and two friends had sent
a telegram to Thomas Mann, who was living in the United States,

teaching at Princeton University. They'd asked for his help in getting out of France and signed it "in the name of us all."[12] All of those mired in France including Mann's own brother Heinrich Mann; his son Otto; Lion Feuchtwanger; Hitler's biographer Konrad Heiden; and many others. Walter Mehring continued to believe Mann's answer of salvation would somehow find them, but Pauli was despondent. She thought that even if an answer was sent, it would never find them.

They headed on foot to Toulouse, where, unexpectedly and with great rejoicing, they met up with Carli Frucht, still carrying Eric Sevareid's coat. He had been released from the concentration camp when he agreed to undertake unarmed military service as a *prestataire*, laboring on defense works, which turned out to be useless since no defense was mounted. But now he carried army discharge papers that made him semilegal.

The three reunited friends were able to buy train tickets for Marseille. The coaches were so crowded that, much to their relief, the conductor couldn't get through to ask for their papers. But without proper documentation, the question was, what would happen when they reached their destination? There would be police all over the station. As they drew close to the gare Saint-Charles, the train stopped at a signal switch. Carli opened the door and the three jumped out. They ran down the hill toward the sea until they reached a small fishing village called Pointe Rouge. At the Bar Mistral were other refugees. "Here in the bar, it's relatively safe," they said. The bar was outside the raiding range of the Marseille prefecture. "But you can't be too cautious."

Like many others in dark attics all over the Marseille region, they hid out in their small rooms above the Bar Mistral, the windows round and small, like targets. Late into the night under fog, listening to the sea's lonely roar, and with only one dingy bulb, they sat and talked of escape or turned to their manuscripts, writing or reading to each other their stories of witness.

Sometimes Pauli watched as Mehring and the other refugees fought over who was most endangered. "They've hated me a lot lon-

ger," Mehring would shout, unmindful of who might be listening in the café below. "I was personally expatriated—stripped of my German citizenship as an individual, on one of Goebbels's first lists."

The German novelist Leonhard Frank would retort: "I left of my own free will. As a so-called Aryan I would have needed only to change my tune . . . I have my convictions. Over there they hate that more than anything."

Pauli would end the discussions. "Now we're all in the same boat. . . . Let's go for a swim."[13]

But then, out of nowhere, a new rumor reached the Bar Mistral at Pointe Rouge. Somebody, someone who would help, was coming from America.

Her friend the novelist Hans Natonek warned Hertha Pauli: "Be careful. A fellow here claims to know the name of an American he says is looking for us. Wants only fifty francs. But when you've paid, he asks your name and address."[14]

The American might be a trap. The refugees, hiding in public in cafés, sticking together for safety, looked behind them nervously. Was this the final deception? People could not trust each other. If one had a bit of secret information, one kept it to oneself. "Sometimes you thought you had picked up a clue, had heard the American rescuer's name mentioned in some hushed conversation, for instance; when you asked about it the reply was a shrug."[15] Everybody wanted to be first in the lifeboat, but the lifeboat was a phantom. You had to be a *débrouillard*, a survival artist, knowing how to sift among the rumors for the tidbit that might save you.

By chance Hertha Pauli ran into an old colleague, a Viennese journalist, in Marseille's Vieux Port, and as they walked arm in arm among the fishwives shouting their wares, her friend whispered: "He's staying at the Splendide." "Who?" Pauli replied. "Why, the American, of course. I've been turned away already. I'm not on his list. But perhaps you are and he'll see you." "Well." Her friend beamed. "Am I a friend or not?" Pauli watched her disappear among the stalls, remembering too late that she had forgotten to get the American's name.[16]

Pauli walked into the lobby of the Hôtel Splendide. Except for two policemen, it was deserted. When she went to the desk, she mumbled something about wanting to see an American gentleman. The desk clerk assessed her at a glance, asked her name, and then shouted it over the hotel telephone. She cringed in fear, expecting to be arrested on the spot. Instead she was told to proceed to room 307, third floor, last room on the left. In the box elevator, which felt like a cage, the tension was terrifying—was she walking into a trap?

A young man in shirtsleeves sat at a small desk beside the bed. For minutes he continued to write, ignoring her and leaving her standing. He finally looked up: "Well, Miss Pauli," he said. "I've got you on my list."[17]

On that first encounter, she learned that his name was Varian Fry. And little else. Since she spoke little English, he quickly switched to a fluid French. He was poker-faced, matter-of-fact. He asked her a series of questions. She felt rather as if she were "applying for a job." It was extremely disconcerting. She examined what she thought of as his "Buster Keaton face." This was her would-be rescuer.

He told her she was lucky. The previous day the police had picked up all his clients and taken them off in one of their *panier à salade* (salad spinners, as the French called the police wagons). She was visibly shaken, both at the news of the arrests and the casual way he spoke of it. "Don't worry," he said, "the whole lot were quickly released. I have already established cordial relations with the Sûreté. Of course, I had to destroy all documents in this room. You never know. The Gestapo might see fit to take a hand in things. I'm down to a basic list of names again. Perhaps you can help me."

She looked at the list. There was her name. And also Ernst Weiss, Czech novelist; Hans Natonek, Czech humorist; Karl Einstein; Walter Hasenclever; Lion Feuchtwanger; Heinrich Mann. The A list of German, Austrian, and Czech writers. She knew most of them. There was Walter Mehring, but Carli wasn't on the list.

"I'm in touch with Natonek," Fry said. But what about Weiss?

"The Germans found him the day they marched into Paris. He

had taken poison and then, to be sure, slashed his wrists," Pauli explained.

Fry crossed Weiss off his list. "Now I have three vacancies," he noted.

Pauli was shocked. The dead had become vacancies.

Fry asked about Walter Mehring, and Pauli remarked that he was staying at the Bar Mistral. Bar Mistral, Fry wrote on his list. "Bring him with you tomorrow," he said. *"Au revoir."* The interview was over.

A shaken Pauli managed to make it back to their beach hideout in Point Rouge. She and her friends spent the night anxiously going over the facts. Their rescuer had materialized. A young, shirtsleeved, bespectacled American was searching for them all. Who was backing him? Was he to be trusted? Did he have any power? He seemed to have no idea what they'd been through. Would he help them or naïvely lead them into a trap?

MARSEILLE II

August 1940

If ever a friend was needed in a crisis, there was no one better than Miriam Davenport. She was a twenty-five-year-old romantic pragmatist, following her heart across Europe in wartime, but ready to help anyone she met en route. She had been in Ljubljana visiting her fiancé, Rudolph, when the news broke that the Germans had invaded Holland. She hurried back to Paris, certain that France would soon declare war. Now that France had surrendered and the armistice had been signed, she was determined to get back to Yugoslavia to save Rudolph. It would be only a matter of time before Yugoslavia fell to the Nazis. There was the huge problem of getting a permit to cross Fascist Italy, and then of finding a freighter to take the two of them to the United States, but she was not to be deterred. Her fiancé had nursed her through a serious illness the previous year and she was not about to abandon him.

On her arrival in Marseille, Miriam's first move was to visit the annex of the American consulate to renew her passport. She found herself deeply affected by the long queues of refugees, by their faces that revealed every nuance of mute panic, despair, polite fury, out-

raged pride. She watched the rude treatment they endured at the hands of the consulate's doorman. To her question of whether there were any American organizations in Marseille looking after the needs of these refugees, the reply was, "No, none."[1]

She soon learned that Americans with jobs in other countries had no passport problems at all. She demanded to see the consul general and told him she had a job teaching in Yugoslavia. It would be pointless to go back to the United States where she would only join the ranks of the unemployed. Magically, she found her passport renewed.

Next she contacted Mary Jayne Gold, who was back in Marseille. They met at the Pelikan, a café just across from the American consulate—a favorite spot of foreign refugees. The two got around to talking about the plight of anti-Fascist intellectuals like Konrad Heiden and Katia Landau, whom Miriam had met in Toulouse and now considered her friends. Mary Jayne was a committed anti-Fascist. She had even taught Dagobert to bark fiercely whenever he heard *Heil Hitler!*[2] Together they determined to do what they could to help.

They contacted the American Red Cross, only to be told their help wasn't needed. The organization was confining its assistance to helping the French deliver free milk through the French gas companies. They did spot a short notice in the newspaper announcing that a certain "Valerian [*sic*] Fry had arrived from the States with a boatload of canned milk." They dismissed him: "Another milkman."[3]

It was now the third week of August. Miriam walked the distance from the rue Madagascar, where she lived at the Hôtel Paradis Bel-Air (her "squalid barrack" as she called it). Her attic room cost fifty cents a month. She was heading to the Café Pelikan. As she sat down with Mary Jayne, she heard her name called softly. She looked up to see a diminutive figure skulking against the wall in a suit so disheveled and threadbare, he could easily have been mistaken for a pickpocket. Squinting into the shadows, she suddenly recognized the German poet Walter Mehring, whom she had recently met in Toulouse.

Furtively, Mehring asked to speak to her. He was distraught and yet excited. He explained that he had just come from the police station. He'd gone to meet the American Varian Fry at the Hôtel Splen-

dide, the one everyone was talking about—Fry had money and visas and a list of people he was going to save. He himself was on the list.

Mehring had secured an appointment to see Fry again the next day, but leaving the hotel he'd been picked up by the police and questioned for three hours. He dared not return to the Splendide. Miriam was an American. She wasn't in danger. Would she visit Fry on his behalf and explain to him what had happened and ask for a rendezvous in a safer place? Even though Mary Jayne offered to keep him company, Mehring was too frightened to stay in the café, so Miriam took him to the waiting room of the American consulate across the street. After advising him to help himself to the soap in the men's room, she set out on her errand.

She entered the spacious lobby of the Splendide and took the elevator to the third floor, joining the queue of refugees that snaked down the corridor. When her turn came, a young man listened patiently to her story and then took her over to another young man working at a table on the opposite side of the small room. He was in shirtsleeves, and she noted the tortoiseshell glasses that framed his face. She was introduced and he rose and shook hands with an inquiring smile, gesturing for her to take a seat.

When she told Fry that Mehring was afraid to return to the hotel, he immediately arranged an appointment with the poet for the next morning in a quiet café. Then she inquired whether he would like to contact Konrad Heiden, Katia Landau, and others, and she gave him the address of Charles Wolff in Toulouse.

Fry asked why she herself was in Marseille. She explained that she was waiting for visas to return to Yugoslavia, and he remarked: "That will be a slow process. Would you like a job?"

Miriam replied: "Oh, yes. You're doing exactly what I've been dreaming of doing for a long time now."[4]

Fry asked if she would be willing to be named "secretary general" of a committee he was setting up. "We could use a good American name like Davenport," he said.[5] "No work really. All you'd have to do is sign the annual report." He also needed an interviewer in the office he was hoping to open. He would pay her three thousand francs

(twenty-seven dollars) a month. He apologized for the small amount, but to her this seemed a wonderful sum.

Miriam joined Fry's staff on August 27, 1940. Unlike Hertha Pauli, she found Fry attractive — she would later say she had a "weakness for scholars and saints."[6] In her view, Fry was always warm, sensitive, witty, and relaxed with their clients. The difference between the perceptions of the two women may have been cultural. Miriam recognized the style of a fellow American. Fry's seeming arrogance and abruptness were simply good old American efficiency. However, the stakes were never as high for Miriam. Looking at this stranger, Pauli had known, even more than he did, that he held her life in his hands.

THE QUIET AMERICAN

Imagine the situation: the borders closed; you're caught in a trap, might be arrested again at any moment; life is as good as over—and suddenly a young American in shirt sleeves is stuffing your pocket full of money, putting his arm around your shoulders and whispering in a poor imitation of a conspirator's manner: "Oh, there are ways to get you out of here," while damn it, the tears were streaming down my face, actual tears . . . and that pleasant fellow . . . takes a silk handkerchief from his jacket and says: "Here, have this. Sorry it isn't cleaner."

HANS SAHL[1]

You must save us, Mr. Fry.

ALMA MAHLER WERFEL[2]

As Hertha Pauli and Walter Mehring dodged German planes and slept in ditches crossing France, they had no idea that the telegram they'd sent on the ninth of June to Thomas Mann in Princeton pleading for help had finally reached him in California, where he was then living.[3] The famous author was anxious to do whatever he could. Members of his family were trapped in Europe.

And there were others who wanted to help. Since 1934 Albert Einstein's International Relief Association (IRA) had been working quietly to aid refugees. But it was not easy to rouse the American pub-

lic. The vast majority were isolationist. Even sympathetic Americans of influence believed that, while "every aid should be given to the refugees from Nazism . . . the United States should on no account become directly involved."[4]

There were two men who believed otherwise and they were anxiously working behind the scenes. Karl Frank was an Austrian psychoanalyst and political activist who had fled Germany in 1933 and changed his name to Paul Hagen. He worked clandestinely, first in Prague, then Paris, and then London, organizing political opinion against Hitler. He traveled often to New York to raise funds and soon established the American Friends of German Freedom committee, chaired by the theologian Reinhold Niebuhr.

When he eventually moved to the United States in December 1939, he sought out a young man named Varian Fry whose 1935 article in the *New York Times* on Nazi riots in Berlin he had much admired. Both men understood the extent of Hitler's ambitions. The Fascists were after nothing short of world domination.

In New York City, Hagen's office on Fifth Avenue and East Forty-first Street was a scant city block from Fry's office on West Fortieth, where he worked as editor-in-chief of the Foreign Policy Association's Headline Books. They used to meet at Fry's favorite restaurant, Child's, to discuss the deplorable state of things in Europe.

When Hitler invaded Holland on May 10, 1940, Hagen summoned Fry to Child's for an emergency meeting. The Nazis have a list, he explained. "Every person designated as an enemy of the Reich—politicians, labor activists, artists, novelists, poets, scientists, musicians, journalists, intellectuals—every last dissenting voice would be routinely hunted down by the Gestapo." If France should fall, these people would be "either summarily executed or consigned to a slow death in a concentration camp."[5]

There was no time to be lost. The two men decided on the spot that it was imperative to establish a rescue committee. Fry's only concern was how they would even be able to locate those refugees who needed saving, but Hagen assured him there was a network referred

to as the "refugee telegraph." Someone always knew where even the most endangered refugees were hiding.

In Varian Fry, Hagen could not have found a better ally. They were both somewhat eccentric, both iconoclasts and political independents, and equally driven by moral outrage. Fry was the only child of a stockbroker who worked on Wall Street. Born in 1907, he grew up in Ridgewood, New Jersey. His education was impeccable. At the age of fifteen, he was sent to Hotchkiss School in Connecticut. Dismissing the fetish of money at his prep school, he devoted himself to the rigors of the mind, reading everything he could get his hands on, while reserving his deepest passion for Latin and Greek.

He passed the entrance exam for Harvard at the top 10 percent nationally. Awakening to the fact that it was 1930 and the Depression, he became a political activist in his senior year, leading the Harvard contingent in marches down Broadway demanding jobs for the unemployed.

On graduation he married Eileen Hughes, seven years his senior and an editor at the *Atlantic Monthly*, who shared his liberal politics. She found him very attractive. He was handsome, charismatic, and verbally inventive; yet beneath the "polished carapace" was a compelling seriousness.

Living in New York, the couple shared a passion for political causes. In 1935 Fry found a job as editor at the *Living Age*, and began to write articles about the dangers Hitler posed to world peace. Fry could be dogmatic and rigid in his principles, but often because he was right. He took the unpopular stand that America should discontinue its policy of isolationism. Hitler must be halted immediately.

In 1936, with Eileen, he joined the Spanish Aid Committee, a broad coalition of ideological groups working for the Republican cause in the Spanish Civil War. He was soon vaulted to an executive position on the committee, which suited him. He loved to organize. But within six months, he was expelled from the same committee for being too aggressively critical of the divisive tactics of the Communist faction.

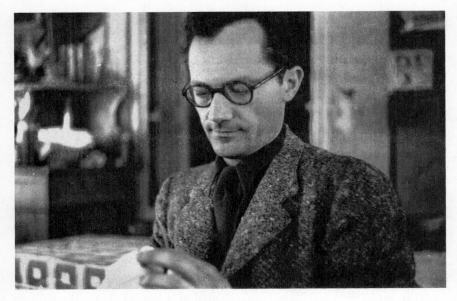

Varian Fry.

In 1937 he was offered a job with the Foreign Policy Association, which published a series of pamphlets and books on international issues. The job was perfect for him. Soon he was editor of the whole Headline series.

Determined to get their new project up and running, Fry and Hagen approached the professional fund-raiser and social militant Harold Oram, whom Fry knew well since they had worked together on the Spanish Aid Committee. Oram enthusiastically suggested an exclusive luncheon at the Commodore Hotel. The date was set for June 25. They had six weeks.

Fry and Hagen, with Oram's help, approached guests for the head table — university presidents, media personalities, and philanthropists. The list ran from Reinhold Niebuhr to Raymond Gram Swing, one of the most famous radio stars of the day. Dr. Frank Kingdon, a British-born Methodist minister, high-profile author, and president of Newark University, was invited to chair the evening. John Dos Passos and Upton Sinclair were asked to lend the prestige of their names, which they immediately did.

On June 15, ten days before the luncheon, the *New York Times* headline read: "Germans Occupy Paris . . . Reich Tanks Clank in the Champs-Elysées."[6] The news was extremely disheartening. It appeared they were too late.

On Monday, June 24, one day before the luncheon, Fry opened the *Times* and read: "Nazi Shadow Falls on Half of France."[7] He ran to the phone to summon Hagen to Child's. When they met, Fry exclaimed with uncontained excitement that the Germans had occupied only half of France. The rest of France was still free. "A backdoor to Europe had been left ajar, after all," he said.

But Hagen disabused him. The twenty-four clauses of the armistice had already been published, and he directed Fry's attention to article nineteen. "The French Government is obliged to surrender on demand all Germans named by the German Government in France as well as in French possessions, colonies, protectorate territories and mandates." He told Fry there would only be a short window of time when they could get people out. Then the Nazis "would let the French do their dirty work for them."[8]

The luncheon at the Commodore Hotel was a somber affair. The people who attended were the wealthy for whom Paris was a symbol of civilization. They were still reeling from the news that the city had been occupied and was now firmly in the hands of the Nazis. People eagerly filled out the blank checks placed at each table setting. Thirty-five hundred dollars, an astonishing amount for one luncheon, was raised with ease.[9]

When people had finished eating and the speeches from the head table were over, Erika Mann, Thomas Mann's daughter, took the floor. She suggested that the luncheon be the occasion to establish a permanent committee. "We mustn't forget," she said, "that money alone is not going to rescue people. Most of them are trapped without visas, without passports that they dare use. They can't just get on a boat and leave. Somebody has to be there to *get* them out."[10]

As soon as she said this, it was obvious, and the Emergency Rescue Committee was established on the spot.

That evening, with several of Hagen's friends who had recently

arrived from Europe, Hagen and Fry planned their strategy. The first thing on the agenda was to compile a comprehensive master list of people who needed to be rescued. Alfred Barr at the Museum of Modern Art and his wife, Margaret Scolari Barr, who were already in contact with artists in jeopardy, were asked to provide the names of painters and sculptors. Their long list included Max Ernst, Marc Chagall, and Jacques Lipchitz. Thomas Mann identified publishers, writers, art critics, and playwrights, including Lion Feuchtwanger, Hans Sahl, Anna Seghers, Walter Mehring, and Hertha Pauli, as well as his brother Heinrich Mann and his son Golo. Hagen himself noted his allies in the German Social Democratic Party. The émigré journalist Max Ascoli supplied names of anti-Fascist Italians; the exiled Czech leader Jan Masaryk did the same for fugitive Czechs; Alvarez del Vayo and Joseph Buttinger added Spanish and Austrian fugitives; and Dr. Alvin Johnson, head of the New School for Social Research, expanded the list with more names of intellectuals, scientists, and composers. The French theologian Jacques Maritain and the novelist Jules Romains completed the list.[11]

Inevitably disputes arose over the names on the lists. "Maritain accused Thomas Mann of favoritism to German writers. Max Ascoli told Maritain he was ignoring Italians and pushing too many French names. Paul Hagen accused Ascoli of ignoring radical socialist refugees. Jules Romains told Hagen he was forgetting about the Jews."[12] It was appalling, really, this haggling over the names of those to be saved. But everyone knew that one name on the list always meant that another name was not.

Next on the agenda was to persuade the U.S. State Department, which had recently assumed control of immigration, to issue visas for prominent foreigners. This was not going to be easy. It was an "open secret" that the officials and diplomats at the State Department and at various foreign embassies and consulates in Europe were less than keen to allow anyone in, let alone left-wing progressive intellectuals and Jews. Any refugee "on the run from a foreign government—Hitler's included—was almost de facto" suspicious.[13]

In July 1938, after the massive flight of Austrian refugees, Presi-

dent Roosevelt had convoked a thirty-two-nation conference at Evian, France, to discuss the international refugee crisis. But the conference was a failure in terms of its major objective, that of finding refugees a place to go. As the sessions proceeded, delegate after delegate excused his country from any increased acceptance of refugees. A Democratic senator from Colorado expressed the majority opinion in the United States when he insisted that the country should not be "a dumping ground for all these people." The Depression had caused massive unemployment. Two-thirds of respondents to a *Fortune* magazine poll said: "with conditions as they are, we should try to keep them out."[14]

By now it was understood that the Nazis were specifically targeting Jews. State terror had turned Jews into a convenient political scapegoat, and confiscating Jewish property had become a lucrative business. But in the United States, as elsewhere, anti-Semitism was on the ascent. As a result of the conference, Roosevelt took the position that to increase American "immigration quotas or appropriations of loans from public funds . . . [would] occasion public dispute."[15]

If, for political reasons, Roosevelt vacillated, it was known that his wife was sympathetic. On June 27 Hagen and Fry traveled to Washington to petition Eleanor Roosevelt for her help. After a twenty-minute phone conversation with the president, she reported to the two men who sat waiting that, although refugee quotas were already oversubscribed, a number of "emergency visitors' visas" would be made available for selected political refugees.[16]

Now the real question that preoccupied Hagen and Fry was who would be sent to France to get the refugees out?

The ideal person would have been a European exile who understood what was going on. But it was impossible to send a European back to France. He or she would be certain to be arrested. Even a Frenchman working for refugees would be typecast as anti-Vichy. A veneer of legality would at least protect an American, since the United States was still a neutral country.

Fry offered to go if no one else came forward, but Paul Hagen dismissed Fry's offer. He liked Fry as a friend and respected him. But what business did "a neurasthenic intellectual and expert on the an-

Varian Fry in Berlin, 1935.

cient Greeks" have in rescue work?[17] He felt Fry didn't have the tem-
peramental qualifications for clandestine operations.

Still, as the list of candidates shrank, Hagen began to see Fry oth-
erwise. Even the fact that he was not an obvious choice made him
start to appear ideal. He spoke German and French and could liaise
with the American consulates. The Vichy government and the Ger-
mans would dismiss him as a naïve Yankee. And at least he wouldn't
show up in the Gestapo's file.

However, Hagen was underestimating Fry. Fry had a very clear
idea what he would be up against. Back in July 1935, before taking
up the editorship of the *Living Age*, he had traveled to Berlin. He had
spent two months in Hitler's Germany. That trip had been so shock-
ing, it profoundly changed his life.

On the evening of July 15, 1935, Fry had descended to the lobby
of his hotel Pension Stern on the broad, tree-lined Kurfürstendamm.
His fellow guests were gathered at the windows peering out nervously.
"It's an anti-Jewish riot," someone explained. Fry slipped out onto the
boulevard and followed the crowd running toward what appeared to

be a knot of cheering people. When he broke through the crowd he reeled at the sight of the bloody orgy in front of him. An elderly Jewish man was being kicked to the ground; his head was bleeding and his hands were in shreds as he tried to protect his face. His frail wife, who had been attempting to fend off the gang of attackers, was punched in the face and also kicked to the ground as the crowd closed in.

When Fry looked up he saw other clusters of people raining boots and fists against helpless victims. The mob was also stopping cars. If their occupants couldn't prove they were Aryan, the cars were rocked from side to side and the inhabitants pulled out and beaten. On each side of the street, the mob advanced, smashing Jewish shops and restaurants while bypassing non-Jewish ones, easily identified since Berlin policemen stood guard out front.

To Fry's horror, there began a frenzied chanting. He knew enough German to understand the words of the popular song: "When Jewish blood spurts from the knife, Then things will go even better." The level of hatred rose like smog polluting the air. Some terrible nightmare was being unleashed. The crowd was euphoric with a kind of atavistic bloodlust hunting the Bolshevist-Jew enemy the Nazis had identified.

Fry took shelter in a café. What followed was the part of the story Mary Jayne Gold remembered he would retell only rarely and in a whisper.[18] Two storm troopers in jodhpurs and mud-colored shirts with Nazi armbands entered the café. Spotting a man, clearly Jewish, at a corner table trying to make himself invisible, they moved menacingly toward him. As the man reached for his beer, "a knife flashed in the air and pinned his shaking hand to the table. The storm troopers laughed."[19] That scene, scarred on the retina of his eyes and in his brain, would return to Fry every time he needed to be reminded of why he was in Fascist France.

The next day, "in a state of high indignation [at] the previous night's bestiality," Fry visited Goebbels's Ministry of Propaganda where he had been granted an interview with Ernst Hanfstaengl, chief of the Foreign Press Division. "Putzi," as his friends knew him, had been educated at Harvard. As one old Harvard man to another, Putzi was

unexpectedly candid. "In his cultured Harvard accent," he told Fry that it was probably storm troopers who had instigated the riots. He explained that within the Nazi Party, there was a division of opinion about how to "solve the Jewish problem." The moderates wanted to expel the Jews or put them on reservations, as the Americans had done with their native Indians. The radicals wanted to "exterminate" them. Fry did not believe Putzi. He couldn't imagine that a cultivated nation like Germany "could seriously entertain such a monstrous idea."[20]

Fry's report on the infamous Kurfürstendamm riot, sent via the Associated Press, appeared in the *New York Times* on July 17, 1935. A second report appeared on July 27. He quoted Putzi in identifying the Nazi Party as the instigators of the riot and in drawing a distinction between two anti-Semitic groups within the party: those who wanted "bloodshed" and those who "wished to segregate the Jews into specific areas." (Fry would later regret that he had sanitized the propaganda minister's words.) In an article subtitled "Hanfstaengl Says He Did Not Clear Jews of Blame in Riots," Putzi was quoted as saying that Varian Fry's report of his alleged remarks were "fiction and lies from start to finish."[21]

On his return to the United States, Fry continued to write about Nazi aggression. In one article titled "What Hitler Is After: The Historical Background of German Foreign Policy," published in *Scholastic* in March 1936, he exactly predicted Hitler's war plans as well as the breathtaking pace of German rearmament.[22] But no one was listening. For Fry, the practical consequence of his articles was that he could no longer safely visit Nazi Germany.

The opportunity to work on behalf of refugees in France was exactly what Fry had been waiting for. He discussed the matter with his wife, Eileen. They had been married nine years, and the separation would be hard on her. The mission might be dangerous, but he assured her the trip would be brief. She agreed it was his duty to go. She also had a secret agenda. She was now thirty-nine and childless, and she wanted her husband to bring back a refugee child. She didn't have the courage to tell him this except by letter, which she wrote the day before his departure, assuring it would reach him only after his ar-

rival in France. She wrote: "I did not speak to you about bringing back a French child, which probably seems an absurd suggestion to you at the moment, and of course I don't want you to go around looking for one. I just mean that you must be sure to bring one back if you feel that is what you want to do with any special one. I can manage the transportation and emigration problems. But I hope your sympathies will go out to someone."[23] It was a poignant request, and indicated both her own loneliness and the silence that threaded their marriage. Sadly, Fry did not respond to this plea and the subject was never seriously brought up again.

Fry's contract with the Emergency Rescue Committee was vague. It was merely a letter stating: "Your task for us in Europe is exploratory on the one hand and specific on the other." He was:

a) to find out and report to us the conditions under which refugees and rescue work must be carried on . . . with particular attention to transportation, money transmittal, personal surveillance, attitudes of American and foreign officials, etc.

b) to attempt to locate, and to aid with counsel and money as directed, certain individuals whom this Committee will specify, so that they may reach Lisbon or Casablanca and thereby be in a better position to be transported to this continent.

c) to investigate and recommend individuals in such centers as Lisbon, Toulouse, Marseille etc. whom we may in the future designate as agents to act for us in those centers.[24]

He was invited to use his own discretion in determining what degree of cooperation he should establish with the American consul in Marseille and how much information he should share with the consulate regarding the welfare of the refugees in his care.

Fry set about systematically preparing his trip. He went directly to the top. He wrote former ambassador to France William Bullitt, now

back in the States, and requested a briefing. To Fry's question: "How much refuge will consuls be able to give persons with visas whose lives may be in danger?" he was told: "None." Bullitt also warned him the situation was volatile, the blockade could be extended to include Spain, and Fry could find himself trapped in France with a "one-way ticket."[25]

Then Fry wrote to Eleanor Roosevelt. She replied briefly: "The President has seen your letter of June 27. He will try to get the co-operation of South American countries in giving asylum to political refugees."[26] Not exactly the reply he had been looking for, since it suggested that the hoped-for American "emergency visas" would be few in number, but it would have to do.

Fry set out to renew his passport. It was validated for six months of travel in Europe and was accompanied by a dire warning about the dangers of European travel. Finally, he bought a new suit. He needed to look the part of the intrepid, respectable American.

ENGLAND IS URSULA; FRANCE IS HEINRICH

Courage is like a bank account to be drawn on in time of need. The difference is that you never know what your balance is until you come to make a withdrawal.

LORD MORAN[1]

O n the afternoon of August 4, Fry boarded the Pan Am Clipper at LaGuardia Field in New York City. The clippers that crossed the Atlantic looked more like whales than flying machines. The ride was rocky, the plane bumping on patches of turbulence and vibrating to the rhythm of the propeller engines. The trip took thirty-six hours, with stops to refuel en route. During the day the passengers sat in reasonably comfortable chairs and walked uneasily through the clipper's three rooms, calming themselves with whisky. At night they slept in Pullman-style sleeping berths.

Fry was in a state of high anxiety. In his pocket he carried a notebook with the primitive code he and the Emergency Rescue Committee had agreed on in order not to arouse the suspicion of the censors. "Money" was "milk"; "transportation" was "clothing"; and "boat" was "warm clothing." Countries had names:

ENGLAND = URSULA

AFRICA = LELAND

SPAIN = ERNEST

GERMANY = ELOISE

FRANCE = HEINRICH[2]

It could hardly have been more amateurish. They were certainly not going to fool any sophisticated cryptographer with this child's play.

Fry took seriously the responsibility that chance and history had thrust upon him. In Lisbon he spent a week liaising with various foreign consulates, private aid organizations, and religious groups, many of which had set up headquarters in neutral Portugal. He needed to know who was working on behalf of the refugees. Then he headed by plane to Barcelona, from where he took the train to Marseille. As the train traveled along the Costa Brava, he saw the scars of the Spanish Civil War that had ended two year earlier. The Catalan border province had paid dearly for its stand against Franco. The land was still charred and the buildings were half in ruins, and at the frequent stops at small battered stations, Fry watched people, dull-eyed and emaciated, milling about on the platforms. He had entered the old world where bitter racial and ideological divisions had shattered the landscape.

It was a sobered Fry who walked out of the gare Saint-Charles in the early morning of August 14, retracing the steps of the refugees he had come to save.[3] As he stood at the top of the stone staircase leading from the station, he looked down at the magnificence of Marseille spread out beneath him. The way the city lay at his feet came as a shock, an effect created by the dizzying height. The staircase descended more than one hundred steps to the street. The thought occurred to him that only the victorious build such staircases. Statues of empire flanked it: on one side a naked Asia wearing a royal tiara and reclining languidly in the Mediterranean sun; opposite was a voluptuous Africa, more erotic, more expectant. Fry read the inscriptions: *"Colonies d'Asie; Colonies d'Afrique."* The staircase had been built in

3. MARSEILLE. — Notre-Dame de la Garde. — PB.

Vintage postcard—Marseille, Notre-Dame de la Garde.

1923 when France was a world power. In a brief seventeen years her soothing dream of empire had been shattered and she was reeling in defeat.

He descended the stairs carrying a suitcase filled with summer clothes, enough to last several weeks. He naïvely assumed he could get the job done in that time. His return flight to New York was booked for August 29. He carried a sleeping bag and air mattress. He expected to be backpacking in the remoter reaches of the South searching out refugees. He carried a list of about two hundred names of people the New York committee wanted him to save. Three thousand dollars was taped to his leg to keep it out of sight of thieves and French border officials. He also carried a letter of introduction from the State Department, obtained through the intercession of Mrs. Roosevelt, which gave him quasi-diplomatic status. Correctly attired in his "Brooks Brothers pinstriped suit, Finchley shirt with detachable collar, good cuff links, good shoes, his Patek-Philippe watch, and Homburg hat," he couldn't be more respectable. His cordial, impersonal smile suggested his business was "above reproach."[4]

In the overcrowded city, the only room he could find was at the

American consulate. 6, place Félix Baret, Marseille.

rather downscale Hôtel Suisse. Though he was exhausted from his long trip, he set out that first afternoon to visit the American consulate. At the reception desk on the second floor, an indifferent young woman told him that if he was interested in refugees he must visit the visa section of the consulate that was housed in a building in the eastern suburb of Montredon. He grabbed the trolley out of town, and as he sat through the half-hour ride drifting in and out of sleep, he watched the landscape turn into the dramatic gray limestone hills of the coast and wondered what he thought he was doing. He surveyed his fellow passengers. The crowded car was full of shabbily dressed men and women looking about furtively and speaking softly in a cacophony of languages. It didn't take him long to recognize that these were his future clients.

Almost the entire trolley emptied out at the imposing redbrick villa that housed the visa section of the consulate. While the others duly joined the long queue snaking around the building, with the assurance of an American, Fry walked confidently through the entrance and down the hall. A young guard accosted him and ordered him to

return to the queue, only to back down hurriedly when he heard Fry's impeccable American accent. Fry entered the inner office and presented his card. He was greeted by an official who told him the consul general, Hugh Fullerton, was otherwise occupied. He sat waiting for two hours, until finally, in a quiet rage, he got up and left. This, then, was the assistance he could expect from his compatriots. With the image of the abandoned refugees seared in his mind, on the trip back he thought over the job ahead of him. Fry was a stubborn man who hated arbitrary authority. He would find the resolution to counter this indifference to the tragic fate of others.

That night he met the first of the refugee clients on his list, Franz and Alma Werfel. He had sought out Werfel's sister in Lisbon, and she told him the couple were staying at the luxurious Hôtel du Louvre et de la Paix on the Canebière. Werfel's novel *The Forty Days of Musa Dagh*, about the heroic Armenian resistance to the Turkish invasion of 1915 that had resulted in genocide, had been read in Germany as an allegory against Nazism, and had been banned and burned. He was under a death sentence. His wife, Alma, the widow of Gustav Mahler, was imperious. Over dinner, she bombarded Fry with entreaties for help: "You must save us, Mr. Fry," she said. Rattled and not a little intimidated, Fry kept his nerve. He explained that he had just arrived. He needed to find out how things worked and just what he could do to help them. Later the Werfels reported to friends their impression of the American. She had found him laconic and gruff. "He did the job," she said, "but his expressionless face made him appear to be doing it grudgingly."[5]

By day two Fry met Frank Bohn, and things improved considerably. Bohn was a representative of the American Federation of Labor and the Jewish Labor Committee. He was booked into the Hôtel Splendide at 31 boulevard d'Athènes, just down from the gare Saint-Charles. He had arrived in Marseille just days earlier with his own list of names. His assignment was to facilitate the emigration of German, Austrian, and Italian labor leaders, union officials, and democratic politicians trapped in Marseille.

When Fry knocked on his door, Bohn grabbed him in a warm

embrace. "I'm so glad you've come. We need all the help we can get,"
he said. The two men conferred in Bohn's tiny room. Fry immediately
asked him how he was going to get his people out of France. "It's all
paper walls," Bohn replied, and went on to describe the baroque com-
plexity of the visa system currently operating in France.[6]

"All refugees needed five documents," Bohn explained. Thanks to
the Vichy government, they needed safe-conduct passes to travel from
city to city inside France. They also needed exit permits to get out of
France. Since no ships were sailing from the unoccupied zone, the
best way out was overland through neutral Spain and Portugal to Lis-
bon, but both those countries required separate transit visas. Finally
the refugees needed overseas travel visas to a country willing to accept
them. Of course, all visas had expiry dates, so you had to get all your
ducks lined up in a row.

When Fry said that this sounded rather daunting, the ebullient
Bohn replied: "For most people, old man, it's very simple. The disor-
der is working in our favor, you see."

So far, most ordinary refugees seemed to be able to travel without
the safe-conduct passes. "The police don't seem to be paying much
attention to them and the Gestapo don't seem to have gotten around
to them either," Bohn continued. "If they have overseas visas, they can
get Portuguese and Spanish transit visas and once they have these they
can go down to the frontier and cross on foot. Some of the *commissar-
ies* at the frontier have been known to take pity on refugees without
valid exit permits and let them through on the trains. It seems to be a
question of luck."

When Fry asked whether people ever got arrested, Bohn replied:
"So far nobody has." If it's that simple, Fry wanted to know, why hadn't
everybody left by now?

"For various reasons, old man," Bohn said. "In the first place,
many of them are still waiting for overseas visas. Many are still in con-
centration camps." And then of course there was the problem that the
most prominent among them were afraid to show their faces. They
were afraid that if they managed to get to Spain they would be recog-
nized, arrested, and deported back to Germany. Spain, though allied

with the Germans, had declared itself a nonbelligerent power. But under Franco it was still a police state.

Bohn explained that many of the refugees they were dealing with were *apatrides*, stateless people. Their passports, all their documents had been confiscated by the Nazis.

"Why can't they use false passports?" Fry asked.

"We can get false passports," Bohn assured him, "but people don't dare use them for fear of being recognized and exposed." He was working on a scheme to get the most vulnerable people out illegally by boat.

In the meantime, at least for the ordinary refugees, there was a window of time and bureaucratic loopholes that he and Fry could use to their advantage. But they had to work fast because things changed every day. And many of the people they were looking for were already hungry and starving. "They need money," Bohn said.

When Fry asked about the emergency visitors' visas that Eleanor Roosevelt had promised, Bohn was less enthusiastic. He himself had brought some of these emergency visas with him. The American Federation of Labor had managed to pressure the State Department into issuing them. But this involved a lot of paperwork. The persons who got them had to provide moral affidavits as to character and proof of financial support once they got to the United States. They needed sponsors. Fry could probably get some emergency visas, but only if his committee in New York had good contacts.

Fry then asked about cover operations. His friend Paul Hagen had advised him he'd need a cover for what he was up to. Fry had gotten a letter from Dr. Lowrie, the head of the YMCA, and was now passing himself off as a representative of the YMCA.

Bohn replied that Fry didn't need a cover, at least not yet. "Maybe in Germany, but not in France." Bohn himself had been seeing refugees in his hotel room at the Splendide and hadn't had any trouble with the police.

Fry was astonished: "You mean you operate openly?" he asked.

"Not quite openly, old man," Bohn replied. "Great secrecy is necessary." Just days before Fry arrived, on August 12 in fact, Vichy had

stopped handing out any exit visas to refugees. Bohn said their intention was probably to keep refugees in France so that, when they got around to it, the Gestapo would have an easier job of rounding people up.

Now there was no legal way out of France. Illegal escapes over the mountains could be arranged. But you had to be very secretive and play your cards close to the chest. Certainly with that and any dealings in false passports. Bohn explained his strategy: "If anyone asks us what we're doing we say we're helping refugees get their visas and giving them money to live on. All that is quite legal, the French can hardly object."

It appeared to Fry that things weren't quite as bad in France as they appeared from New York, but Bohn disabused him. Everybody expected things to get much worse once the Gestapo and Vichy got their lists in order and set about cracking down. Moving fast, that was the ticket.

Fry wasn't sure how to read Bohn. He seemed a bit of a bluffer, an aficionado of cloak and dagger operations. Fry was immediately suspicious about a clandestine boat operation. How much of this was bravado? Still, Fry suggested that they cooperate. They should divide their lists of endangered people so as not to overlap. Fry would focus on the artists and writers and the young political activists, while Bohn could take on the labor activists and politicians.

That night Bohn succeeded in getting Fry a room at the overbooked Hôtel Splendide. Fry moved fast. He wrote to every address on his list informing the refugees of his arrival and telling them he had messages for them from the United States. He asked them to come to Marseille if they could. As for those for whom he had no addresses, he hoped that what Paul Hagen had called the refugee telegraph would be functioning.

He need not have worried. The very next day, the refugees began knocking on his door at the Splendide. They were a desperate lot. Many told him stories of last-minute escapes from French internment camps in the chaos created by the German advance south. They had fled to Marseille, often walking hundreds of miles on foot, and then had hidden out in the backstreet hotels. In Marseille, they said,

the police were jumpy. Sometimes there were *râfles*, or mass arrests. You could be sitting in a café and suddenly the Vichy police had surrounded it, demanding papers. You always made sure before sitting down that there was a discreet back exit. If you weren't *en règle*, you would be sent back to the camps.

Some refugees who came had already acquired American visas. They just needed money to get to Lisbon, and they were perfectly prepared to cross the French frontier illegally, without an exit permit. One young man even presented Fry with a map of a secret route across the Pyrenees, marked with Xs to indicate the French border controls to be avoided. He was also up-to-date on the route through Spain. Once you got over into Spain, the Spanish police didn't seem to care whether you had an exit visa. If you could show you had money, they stamped *entrada* (entrance) on your passport and you could proceed. Of course you ran the risk of being picked up by the Gestapo, who were known to be operating in Spain, but it was worth it. All the Portuguese required was to see an international visa proving that you planned to leave the country. If you didn't already have an American visa, you could buy, from a Chinese bureau on the rue Saint Ferréol, a fraudulent Chinese visa costing one hundred francs. The rumor was that these "visas" really said: "This person shall not, under any circumstances, be allowed to enter China," but nobody could read Chinese.[7] In any case, no one intended to use the visas. The point was to get to Lisbon, where you could wait, in comparative safety, for your American visa to be authorized.

To those with the courage to set out on their own, Fry gave money and moral support. But he soon found that some of his clients, exhausted and in a state of nervous collapse, were too afraid to leave. They preferred waiting in hiding in Marseille. He later complained: "You could get them prepared with their passports and all their visas in order, and a month later they would still be sitting in the Marseille cafés, waiting for the police to come and get them."[8]

The work was intense and often overwhelming. Sometimes Fry would sit staring out of his hotel room window, wondering what he had gotten himself into. Below he could see the courtyard of a girls'

school and the children at play. Their innocent freedom reminded him of what was being lost. And he'd turn back to the grueling work.

Within the first week, word of the American with visas at the Splendide seemed to have spread all over unoccupied France. The line of refugees at Fry's hotel room door ran along the corridor and down the stairs. Of course it wasn't true that Fry could produce American visas out of thin air. The process of getting them was long and complicated and involved seemingly endless paperwork. Many of the people who came to Fry's door were not on his original list. He discovered that some on the list had already escaped; others could not be found. Some were even dead. Each night he had to cable the committee in New York requesting to add names to his list, a permission that wasn't always forthcoming.

By the second week, the crowds outside room 307 had grown so large that the hotel management complained and then the police arrived. They picked up the refugees in Black Marias and took them to headquarters for questioning. Fry was summoned downstairs to the lobby, where, under questioning, he insisted he was simply "making a study of refugees' needs and giving some of them relief."[9] That seemed enough. The refugees were released. But Fry now realized he had to square himself with the authorities. He must have an office, a staff, and the legal status of a committee if he was to carry on.

If there were people desperate for his help, Fry soon discovered that there was also a small cadre of people willing to help him. Near the end of the first week, a young man in his mid-twenties arrived at Fry's hotel room. He spoke in English with a Berlin accent but then switched to impeccable, unaccented French. Dark-haired and slender, with alert, intelligent eyes, the young man had an almost pouting expression until he smiled, which he did standing there at the door. His face broke into a wide beaming grin. Fry soon nicknamed him Beamish. He told Fry he had heard of his list and wanted to know what he could do to assist him. That night, recounting his story, Beamish gave Fry a detailed lesson in what it was it was like to be a European refugee on the run.

Albert O. Hirschman had been born in Berlin in 1915. When Hit-

ler rose to power he had had to get out of Germany fast. He was Jewish and had been actively working with a group of young Democratic Socialists opposed to the Nazis. He headed for France "with one change of clothes and a volume of Montaigne's *Essais*" under his arm.[10] After studying in Paris and then at the London School of Economics, he decided to go to Spain to join the fight on the Republican side in the Spanish Civil War. Bitter at the murderous intrigues among the Communists, he left for Italy where his sister was living. He got a job teaching at a university and soon joined the underground resistance to Mussolini. He became one of the most adept at smuggling documents across the French border. When the anti-Jewish laws of 1938 forced him to leave the country, he returned to Paris. In September 1939 he joined the French army prepared to fight Fascism.

After the humiliating defeat left the French army in disarray, he managed to convince a sympathetic officer to issue him false identity papers. Always resourceful and forward thinking, he selected Albert Hermant as his pseudonym and the American city of Philadelphia as his place of birth. Neither the Germans nor the French would be able to trace his birth registry in the United States. He then got himself legally discharged. He told Fry he was now a French-American citizen whose papers were perfectly *en règle*, and he had a legal safe-conduct pass. He could move about freely in unoccupied France.[11] Fry immediately understood that this young man could prove invaluable.

One morning a young woman named Lena Fischmann arrived at the Splendide. She said Dr. Donald Lowrie of the YMCA had sent her. She claimed to be Polish, safer than being Russian, which she actually was, and she spoke six languages. While Fry and Beamish watched, she tidied the disheveled hotel room as she told them how she'd escaped from Paris. She'd been working for the High Commission for Refugees that allocated funds collected by American Jewish charities. Just before the Germans arrived, she'd fled south and had actually made it across the Spanish border, but not having the right papers, she was sent back to France. Then her luck changed. She'd found an abandoned Packard by the roadside, useless without gas, but not to someone as resourceful as Lena. With the insignia of the Red

Cross clipped from a box and pasted to the windshield, she declared herself on official business and always got the extra gas rations she demanded at the small-town mayors' offices as she made her way to Marseille.[12] Fry immediately hired her as his secretary. He could see that she was unflappable.

Fry found a third, surprising ally. He had returned to the American visa office in Montredon, intending to vent his outrage against the treatment he had received and, more importantly, against the careless indifference with which the consular staff treated the refugees. He was ushered before the tall, imposing Vice-Consul Hiram Bingham. Bingham extended a warm hand and greeted him with apologies. He explained the U.S. consulate's cynical attitude toward the issuing of refugees' visas: "Issue all the visas you want, but not to those people who apply for them." In other words, the very people who needed visas weren't to get them. His boss, Hugh Fullerton, was "not an evil man but a nervous one, and keen to do nothing that might antagonize the Vichy authorities." Bingham was doing all he could to speed up the process of getting visas to the refugees, but it meant "disobeying direct orders," and he was "outgunned."[13] Fry was impressed with the man. He was soon to discover that Bingham was sequestering endangered refugees. Lion Feuchtwanger, who had recently escaped from Camp des Milles, and Thomas Mann's son Golo Mann were at that moment hiding out at his villa on boulevard Rivet.

Varian Fry was a quick study and he immediately got down to work. He wrote to his wife:

> *Life here is very different from what we imagined it would be before I left: there is no disorder, there are no children starving on the streets, and there are very few signs of war of any kind. The people of Marseille seem to have resigned themselves to defeat and even to take it rather lightly—as they take everything. The French refugees are rapidly being sent back to their homes, and soon only the non-French and those French whose homes are in the so-called zone interdit will remain . . .*

*It is the non-French refugees among whom one finds the
greatest misery today. Many of them—certainly a majority of
them—are Jewish, and the Jewish agencies have had to close
their doors for lack of funds. Formerly they received most of their
money from the J.D.C., but since Washington blocked transfers
to France, this source has been cut off, and the Jewish refugees
evidently condemned to slow starvation. . . . Incidentally I wish
everybody in America could be made to realize just who suffers
most from the policy of blocking funds. It is not, certainly, the
Germans, nor even the French, but the non-French refugees.
They are being crushed in one of the most gigantic vises in his-
tory. Unable to leave France, unable to work and so earn money
in France, unable to obtain funds from Paris or London or
(until Sept. 2, at least) from New York, they have literally been
condemned to death here—or at best, to confinement in deten-
tion camps, a fate little better than death: there is a typhoid
epidemic in one of these camps right now. . . .*

*The French people are no more ready for fascism than the
American people are: rather less so I should say, because they
are the most urbane and cosmopolitan people in the world, and
fascism is neither. Dozens of them have told me that the only
hope for France is the victory of Angleterre. You see Vive An-
gleterre chalked up on the walls. People ask you anxiously how
much longer before America enters the war and helps England
save France. . . .*

*[Relief work] is a crushing job. I have never worked so hard
in my life, or such long hours. Strangely, though there are a
dozen harrowing scenes every day, I love the work. The pleasure
of being able to help even a few people more than makes up for
the pain of having to turn others down.*

Much love, Varian[14]

By early September Fry opened an office for the Centre Améri-
cain de Secours (or CAS as he called his new organization) at 60 rue

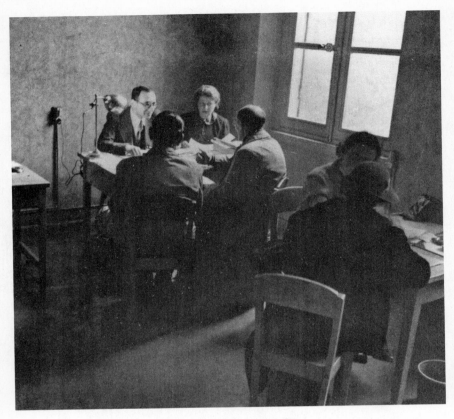

CAS office interviews, rue Grignan.

Grignan, a side street in the old port, two short blocks from the harbor. A Jewish leather-goods merchant had owned the office but had closed it down. One entered the building by a long, dark corridor. Halfway along the corridor, on the right, was a doorway and steps leading up to the first floor, where the hallway turned back toward the front of the building. The office consisted of three rooms. CAS used two rooms for interviews; the other was Fry's office. Very soon Fry had at least five people working for him, including Beamish and Miriam Davenport.

The day began at 8 A.M. Clients were interviewed until noon. After the ritual two-hour lunch, the committee met again to discuss the cases until 7 P.M. Dinner followed, and then they retired to Fry's room at the Hôtel Splendide to decide on those whom the committee could help. New names had to be cabled to New York for approval. The day

ended at midnight, by which time the committee knew whom it had rejected.

CAS took its directives from New York. Their purpose was to help those who were in imminent danger. Each interviewer saw about forty people a day and was keenly aware that the forcefulness of his or her advocacy would determine people's fates. Each refugee's claims were diligently verified. Fry had a rule. Only those who could be legitimized by a member of the committee would be taken in. He was suspicious that the Vichy police were watching him, which was, in fact, true. They'd begun their file on him as soon as he walked down the steps of the gare Saint-Charles. Fry was not naïve. He was afraid that Vichy spies might try to implicate CAS in illegal activities. Indeed he'd already found forged identity cards hidden amid the embers in the stove in his office. He suspected the police had planted them. At that point he'd hired a young American from Virginia called Charlie Fawcett to guard the office.

Fry may have appeared stiff and poker-faced, but it was clear he loved unorthodoxy. On his desk there were usually one or more bottles of *grand crus* Burgundy or a vintage Armagnac. When his staff met for late night conferences in his hotel room, he often became playful, even raucous, and was famous for stripping down to his Black Watch or Royal Stuart plaid boxer shorts to escape the heat.[15]

Fry chose the people who worked for him by instinct. They were all passionate individualists with a certain disdain for authority. They were risk-takers, young and high-spirited. Occupants of neighboring rooms at the Splendide occasionally called the front desk to protest about the loud parties on the third floor. And when the young committee members finally trooped out of the hotel, leaving their boss to catch a bit of restless sleep, they discussed their favorite subject: Fry. "Who was he and why was he here?"

Of course the question could have been asked of them all. Why do some people become rescuers?

Certainly Fry had learned the lesson of Fascism in a way he could never forget. He could always recover the image of a man's hand impaled on a table and the laughter of the perpetrators. But even from

the time he was an undergraduate at Harvard, he had always been impelled to act in situations in which he believed freedom of thought was suppressed and in which he felt injustice was obvious and stupidity intolerable. Fry was most himself when he was compelled by ferocious indignation. His biographer Andy Marino claimed: "Indignation was Fry's lifeblood . . . Fry was not truly happy unless he was in some way outraged."[16] And he was capable of sheer defiance. Even when the American State Department eventually ordered him to leave France, he simply refused to budge.

Like Fry himself, his committee had two faces. To the public, they were employees of a bland American aid organization giving advice to people who wanted to immigrate to the United States, and occasionally some financial assistance. This was perfectly legal. But behind the closed door of his office, Fry and a select inner circle of his committee had another purpose: to assist those people wanted by the Gestapo to get out of the country as quickly as possible.

Since the only way for certain refugees to leave France was to exit illegally, Fry started looking for passports. Through Dr. Donald Lowrie of the YMCA, he learned that Vladimir Vochoč, a Czech consul in the city, was smuggling Czech volunteers out of France to Britain to fight with the Allies. He'd been in Prague when the Nazis had marched in, and this was his revenge. The consul told Lowrie that he was willing to print Czech passports for any anti-Nazi refugee Fry recommended to him. Fry took to going to Lowrie's hotel Terminus with a brown envelope of photos and descriptions of his clients. Then he'd return later for the passports. But a sudden flood of Czech citizens in Marseille was bound to catch the attention of the Vichy authorities. Soon the ever-resourceful Beamish found him other sources: Polish passports from the Polish consul in Marseille and Lithuanian passports from the Lithuanian consul in Aix-en-Provence.

In addition to passports, CAS needed identity cards for its clients. Fry needed a forger. Beamish brought him a young Viennese cartoonist, Bill Freier, who'd been a popular cartoonist in France until, like other Austrians, he'd ended up in an internment camp, from where he'd escaped to Marseille.

His real name was Wilhelm Spira but he'd chosen Freier. *Frei* in German means free and he liked to joke that he was "more free than Fry."[17] He was a brilliant draftsman and was soon forging identity cards for CAS. He'd buy blank identity cards at the tobacco shops, fill them in, and then perfectly imitate the official stamp of the prefecture. When the cards were ready, Fry was always careful to use a middleman to collect them so that the forgeries could not be connected to CAS.

A German Jewish refugee named Heinz Ernst Oppenheimer (they soon called him Oppy) turned up at CAS. He was an engineer who had fled to Holland in the early days to escape Hitler and had set up a relief agency there. He knew a great deal about bookkeeping. He was gifted at disguising "illegal expenses in various ingenious ways and preparing beautiful statistical charts, all utterly legal and aboveboard," as Fry explained it.[18]

Before long, CAS was engaged in black market money exchanges (the penalty, if one was caught, was a lengthy prison term), in forging identity papers, and in herding their most endangered clientele over the Franco-Spanish border. It was dangerous work, and Fry carried a gun. His young American guard Charlie Fawcett remembered a moment when he and Fry had stopped in a café. He asked his boss if he ever felt afraid, and Fry replied: "All the time." Fawcett recalled: "He was the one who inspired us all. We would do anything for him and we were ashamed to let him down even though most of us were scared to death."[19]

To CAS's doors came every sort of European émigré: students, professionals, journalists, activists, artists, women with children whose husbands were in prison, most of them hopeless, penniless, and desperate to escape France. CAS was bound by the original list of names from New York, but Fry knew that the list had been drafted hastily and from memory by people who had little idea of what was actually going on. Even as he expanded the list, he still felt obliged to keep to the mandate of saving political activists, artists, and intellectuals. This elitism cost him much anguish. He wrote to his mother: "One of my major problems has been to find a clear-cut definition of an *intellec-*

tual."[20] Were scientists intellectuals? Which friends should he help and which not?

Fry was often filled with guilt because he had to turn away refugees who had not put themselves in danger as a consequence of their political or artistic activities, though their danger, as he was clearly aware, was no less palpable. Many of these people were Jewish. He referred them to the American Friends Services Committee or to HICEM.

But the bottom line was, Fry saved lives. On September 12 he had personally escorted seven people, including Heinrich and Golo Mann, and Franz and Alma Mahler Werfel, to the port town of Cerbère near the Spanish frontier for an illegal crossing. While they climbed over the mountain pass on foot, Fry crossed the border by train carrying the group's luggage. Other refugees fled across the Pyrenees helped by guides whom Fry hired. One guide was a courageous young woman named Dina Vierny who worked as a model in the atelier of the sculptor Aristide Maillol in the border town of Banyuls-sur-Mer.

The Austrian Hertha Pauli was one of the first refugees to cross clandestinely into Spain with Fry's assistance. She made it to Lisbon, from where she set sail for New York on the *Nea Hellas*.

As the ship moved slowly out of port on the stroke of midnight, September 3, Pauli waved to her friend Carli Frucht. He was standing on the dock below, spotlit by the red lights of the Lisbon World's Fair in the background. He'd made it this far but the Americans refused him an emergency visa to enter the United States. It would be spring before he was able to sail from Lisbon to Norfolk, Virginia, on a visa obtained through the intercession of his old friend, Eric Sevareid.[21] As she stood watching Lisbon fade into the distance, Pauli had a hallucinatory vision of Europe bathed in blood. Among all her closest friends, she alone was waking from the nightmare.

Walter Mehring had been afraid to cross the Pyrenees with Hertha Pauli and so was still trapped in France. Following Bohn's information that things were relatively safe, in early September Fry had sent him alone to the Spanish border, where he was supposed to meet up with a guide who would direct him across to Spain. But he'd been

picked up at a café in the train station at Perpignan. A small man in a scruffy suit and French beret with a furtive, anxious look, he'd attracted the attention of the police. They thought him a pickpocket, then quickly discovered he was a foreigner and *apatride*, traveling without a safe-conduct pass. At least he'd managed to flush the forged Czech passport he'd gotten from Fry down the station's toilet; a forged document would have put him in much more danger. He was transported to Camp Saint-Cyprien, a detention camp in the foothills of the Pyrenees.[22]

Fry immediately hired a lawyer to take up Mehring's case with the authorities. The lawyer telegraphed a colleague in Perpignan not far from Saint-Cyprien, and a few days later, the camp commandant called Mehring into his office. He handed Mehring an unsigned release order, and explained that he couldn't sign it without authority from Vichy. Mehring was sharp enough to take the hint. With the unsigned order, he walked out of the camp. He would never know why it worked. Perhaps the commandant had been bribed; maybe he was a closet anti-German. It didn't matter. Soon Mehring was back in Marseille and, much to Fry's consternation, insisted on hiding out in Fry's hotel room at the Splendide. He explained that he was afraid to leave Fry's side, and anyway he had nowhere else to go.

THE FITTKOS

September 1940

> *There is no document of civilization that is not at the
> same time a document of barbarism.*
> WALTER BENJAMIN[1]

After the fiasco involving Walter Mehring, Fry came to realize
that, for his more vulnerable clients, he would require reliable
escorts to accompany them to the border, and for those who
had to escape illegally, he must secure a fixed route over the Pyrenees
and trustworthy people to guide them across. It was Beamish who
found him the guides. He introduced Fry to a young German couple
named Lisa and Hans Fittko.

The Fittkos were both on the run. Lisa was Jewish. She had been a
bank clerk in Berlin, but she'd spent her free time participating in nu-
merous anti-Nazi demonstrations in the city. In those early days "Hit-
ler was always a sick joke . . . Goebbels was 'Joey the Crip' or 'Wotan's
Mickey Mouse.' "[2] But when Hitler assumed power in the spring of
1933, things had suddenly turned dangerous. Lisa found herself on a
list. Squads of storm troopers began to round up demonstrators who

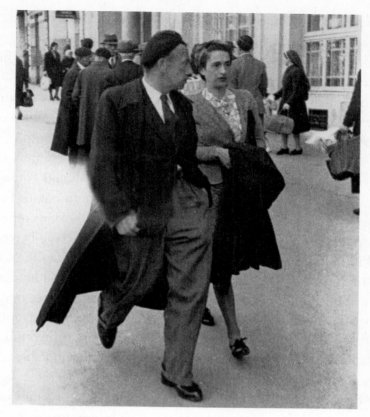

Hans and Lisa Fittko in Marseille, September 1940.

were then carted off to Nazi interrogation centers like the Storm 33 headquarters on Hedemann Strasse. Many were beaten and killed.

Lisa fled to Czechoslovakia, and there she met a fellow Berliner, Hans Fittko, who was also on a black list back home. As a journalist for *Die Aktion*, he had written an article critical of Hitler's storm troopers, and when a young Brownshirt was shot in the back (as it turned out by his own comrades), Hans was accused of being the "intellectual author" of the crime. He was sentenced to death.

When an informer betrayed the couple's hiding place in Prague, they fled to Basle, Switzerland, from where they continued to send anti-Nazi pamphlets and posters back to Germany. But borders meant

nothing to the Gestapo. If they knew where a "target" lived, they "slipped in with a fast car," and the subject disappeared. Eventually they drew a bead on Hans, and the couple had to flee again, first to Holland and then to France.[3]

The Fittkos were now in Marseille. Adept at the art of survival and escape, they had managed to pull together most of the documents necessary for getting out of France. Both had "interim" Czech passports issued to stateless émigrés and overseas visas courtesy of the Chinese bureau in Marseille. They also had Spanish and Portuguese transit visas. But they knew it would be impossible to obtain French exit permits. They were on Vichy's wanted list. While Hans remained in Marseille, Lisa set out to find an escape route across the Pyrenees.

Within less than a week, she had established herself in the seaport town of Port-Vendres, about nine miles from the Spanish border and well within the boundaries of unoccupied France. There, mingling among the dockworkers, she was advised to look up the mayor of the next fishing town, Banyuls-sur-Mer. Vincent Azéma turned out to be a Socialist and a compassionate man who was willing and able to help émigrés. He drew Lisa a map depicting a safe and secret smuggler's route that he called *la route Lister,* telling her that General Lister of the Republican army had used it to evacuate troops during the Spanish Civil War.

The refugee grapevine had already carried the news to Albert Hirschman (alias Beamish) that Lisa Fittko had guided Walter Benjamin across the Pyrenees. When Hans met Lisa at the train station in Marseille, he informed her that two Americans wanted to talk to them. "I assume they've heard you brought Benjamin across," he said. He told her he'd agreed to meet them that night at the Bistro Cintra in the Vieux Port. "They seem to be in a big hurry," he said.

The two Americans were Varian Fry and Frank Bohn. Albert Hirschman had set up the rendezvous and accompanied them.

Bohn, who didn't speak a word of French, was silent throughout the conversation. But Fry came immediately to the point. He said there were a number of CAS clients who needed to cross illegally into Spain. Would the Fittkos help these desperate people?

Lisa immediately offered to draw a map of the escape route she'd discovered.

"That won't be enough," Fry replied. Lisa remembered the moment vividly:

Fry cleared his throat like somebody about to make a speech. . . .
"The money is no problem; this all centers around finding the
right person with border experience, someone who is prepared
to do the job and on whom we can depend." He hawked again.
"We've been told that both of you brought people and anti-
Nazi literature across the German border. Would you, for a few
months—?"
"We?" Hans said. "No, that's impossible."[4]

Except for their Spanish transit visas, the Fittkos had their papers in order. To delay now would be reckless, if not outright insane. And both Hans and Lisa were suspicious of this man. He was so "conspicuously neat and nice," like an American innocent abroad. What could he possibly know about refugees? And his naïveté might even put them in needless danger.

Then Hans relented somewhat. "Maybe for a short time we could break someone in," he said.

If they stayed, Fry promised, he would guarantee to smuggle them out somehow once their work was finished. Of course, to Lisa and Hans, who knew the difficulties, this seemed an absurd promise, however honestly Fry meant it.

As the bistro emptied, the conversation switched to German. Albert Hirschman assured the two they could trust Fry and that, although he was not very experienced, he had resources.

At this moment Fry made a nearly fatal error. Misunderstanding Hirschman's German, he believed the conversation referring to resources was about money. He asked: "How much?" He meant how much did the Fittkos want. He assumed that, like everyone else, they had a price.

Hans was outraged. He turned on Fry: "Do you know that assist-

ing men of military age in illegal border-crossings now rates the death penalty? And you offer us money. We would have to be insane indeed. Do you actually know what an anti-Fascist is? Do you understand the word *Überzeugung*, convictions?"[5]

Fry immediately and abjectly apologized. That was not what he meant, he said. He'd really meant to say that money would be needed for living expenses for whoever assumed the role of guides. And there should be a reserve for emergencies. "When you have the new crossing route organized . . . let's call it the *F-Route*. We can and will come up with financial support," he continued.

Hans insisted that he and his wife must have time to think things over. But they could not and did not turn Fry down. Somebody had to take the risk, and given their temperaments, they would never say: "Let others do it."

There was one piece of information Lisa received this night that left her shocked and deeply saddened. It was only now that she learned of the tragic death of Walter Benjamin.

Lisa and Hans Fittko were guides for the Emergency Rescue Committee's new F-Route from October 1940 until early April 1941, sometimes making as many as three trips a week over the Pyrenees.

CONNECTIONS

Sometime in early July 1940, Dwight Macdonald, editor at *Partisan Review* in New York, received a tattered letter in the mail with the return address "Auberoche, Faulac, Dordogne, France." He knew no one at that address. He opened it with mild curiosity and saw that it was from Victor Serge. He had published an extract from Serge's novel *Ville Conquise* in his magazine the previous November and had sent a note along with a check for thirty-eight dollars: "In these tragic times I often think of you and wonder about your life in France. You can be sure you still have many friends (unknown to you) and admirers in this country. You promised to send me your new novel, but it never arrived. I suppose the war has interfered with its publication. . . . With warmest fraternal regards."[1]

Macdonald read Serge's letter with growing alarm.

By some luck I managed to flee Paris at the very last minute. We have been travelling in freight trains, spending nights in the fields. In a little village in the Loire country we were so tired

that we lay down behind some stones and slept through an en-
tire bombardment. Nowhere, in this completely chaotic world,
were we able to find any asylum. Finally the roads were barred
and we were stranded in the small village in the south from
which I am writing you. I do not think I will be able to remain
here since I know no one and have neither roof nor money nor
chance of earning anything.

Of all I once owned—clothes, books, writing—I was able
to save only what my friends and I could carry on our backs in
knapsacks. It is very little, but fortunately includes the manu-
scripts which I have already begun. This letter is a sort of S.O.S.
which I hope that you will also communicate to my known and
unknown friends in America. I have no money for stamps; I will
be able to send off perhaps one or two letters, but that is all. I
must ask you to immediately undertake some action of material
aid for me. I have scarcely a hundred francs left: we are eating
only one meal a day and it is a very poor one at that. I don't at
all know how we are going to hold out.[2]

Macdonald turned to his wife, Nancy. What could they do? She
was the magazine's business manager and the mother of a two-year-
old son. Her life was already chaotic. But it was not possible to turn
away from such an appeal. "We must contact the State Department to
get Serge an American visa and get him out of France," she replied.
She would take on this task herself.

She immediately wrote to Serge. He assured her that, however un-
tenable things became, "I must hold out and again I will make every
effort to hold out. . . . Your letter . . . has broken the terrible isolation
and lightened the sense of powerlessness I have felt."[3] He said he could
not leave France without his son Vlady, who was twenty, "a bad age
in Europe," and stateless. His six-year-old daughter, Jeannine, was safe
for the moment in a village in the Dordogne, but he was hoping she
too might join him. He claimed that she was, in truth, his only joy,
although he had been unable to see her for more than a year. There
was no chance of getting a visa for his wife, Liuba, who was now per-

manently confined in a Paris mental institution. No country would take her. She had had a final breakdown, from which she would never recover.

On July 20 Nancy Macdonald wrote to the American consul in Marseille:

Dear Sir:
I am extremely anxious to make it possible for my friend, Victor Serge, to leave France and to come to this country to live with my husband and myself. As the enclosed affidavit indicates, I am able and willing to take on myself full responsibility for his support and maintenance [sic] after he enters the United States.[4]

She had spent days getting documents together, getting notarized signatures, calling up friends and asking them to make pleas to the State Department for quick action. She enclosed a sworn affidavit of support, in effect an oath that she would ensure Victor Serge would not become a financial burden on the United States, and a moral affidavit, a sworn statement that he would comply with the standards of decency and morality set by the State Department. She also included a letter from her bank offering a full disclosure of all her and her husband's financial resources, from salary to bank balances to bonds and shares.

Meanwhile, in Marseille Victor Serge had heard, via the refugee telegraph, of the existence of the Emergency Rescue Committee. He made his way to rue Grignan and climbed the dark stairs to the committee's offices where a welcoming Miriam Davenport greeted him. He was allotted a small stipend, not enough to live on, but important because it safeguarded him from the charge of vagrancy that plagued so many of the foreign refugees.

On August 30 he wrote enthusiastically to Nancy Macdonald:

Urgency visas were asked for, for me and my children, yesterday—by telegram I was told—by M. Frey [sic] . . . the repre-

*sentative here of the Emergency Rescue Committee . . . This
gentleman seems to be a man of good will. I have found friendly
relations with this committee, they can make things easier for
me; but here there are so many people at the end of their ropes
and without resources, one is overwhelmed . . . I beg of you to do
quickly, what you can do. Fraternally yours, VS[5]*

Nancy Macdonald took the dossier she'd collected on Serge to
the Emergency Rescue Committee's head office on East Forty-second
Street, where she was assured his case would be followed up immedi-
ately.

On September 12 Mildred Adams, executive secretary of the
ERC, sent a letter to George Warren, chair of the President's Advi-
sory Committee on Political Refugees, a committee established under
Roosevelt to expedite quick visas for refugees at grave risk:

*Victor Kibalchich, whose pen name is Victor Serge . . . is an
outstanding anti-Nazi who has written and spoken of his op-
position to the Nazis and the Stalin government. He and his
family are in great danger if they are apprehended.*

*Mr Serge was in the Soviet Union from 1912 to 1936. He
was imprisoned in 1928 because of opposition to the Stalin re-
gime, and released in 1936 due to pressure brought on the So-
viet government. He went to Paris and made a career for himself
as a novelist and journalist.[6]*

Dwight Macdonald instructed his lawyer, John Finerty, also to
write to George Warren requesting a visitor's visa for Serge and his
family. Warren replied with a categorical no. He was certain, he said,
that the State Department would consider Mr. Serge a "potential
Fifth Columnist" and, in particular, a "potential Stalinist agent." He
refused to pass on the request to the State Department.[7]

Finerty resubmitted Serge's dossier to Francis Biddle, solicitor
general of the United States, with letters of support from John Dewey,
Eugene Lyons, Meyer Schapiro, Sidney Hook, Margaret Marshall,

Frederick Reustle, William Troy, Max Eastman, James T. Farrell, and Adolph Berle. He reiterated that Serge was "in almost equal danger of arrest by the Pétain government or of surrender to the German government. This danger is occasioned by the fact that Victor Serge has been one of the most outspoken anti-Nazi, anti-Fascist and anti-Communist writers in Europe."[8]

Finerty finally took the case directly to the attorney general. The reply from Henry Hart Jr., special assistant to the attorney general, was swift:

October 10th 1940
My dear Mr. Finerty:

The question concerning Mr. Serge at the moment is academic since the President's Advisory Committee on Political Refugees is not, and for some weeks has not been, sending in any names whatever. Due to criticism in various places the entire program has been in jeopardy and . . . temporarily in suspension.

In Serge's case, however, more is involved than an exercise of discretion. By virtue of Title II of the Alien Registration Act, 1940, an alien who "any any [sic] time" has been a member of one of the classes proscribed by the Act of October 16, 1918 is flatly inadmissible.[9]

Any individual who had ever been a member of the Communist Party was automatically proscribed from gaining entry into the United States. Though Serge had spent years as a prisoner of the Soviet Union for his antitotalitarian views and was no longer a member of any political party, the President's Committee would not be rescuing him.

Ironically, Victor Serge had once again become a *case*. For ten months, appeals and counter appeals determining his fate wound their way through the labyrinthine corridors of American bureaucracy. It was all subterfuge because the verdict was clear from the beginning. Serge would never be allowed to touch American soil.

But Nancy Macdonald would not give in. To keep up Serge's spir-

its, she wrote regularly. In an obvious effort to avoid attention from the censors, her letters became ever more elliptical. Friends lobbying the American government were spoken of as cousins or uncles; information was disguised as domestic news. She wrote in early November that her friend Max E. (Max Eastman) had "heard from his friend who wrote to the South and the South has written back that the matter will be attended to."[10] She was suggesting that it might be possible to get Serge a visa for Mexico. At least they could try. Since there were no direct sailings to Mexico, he would still need an American *transit* visa giving him permission to stop in New York, but the Macdonalds were confident that the State Department could not refuse Serge a simple transit visa.

There was another subject that preoccupied Nancy Macdonald and Victor Serge in their correspondence. It was the recent assassination of Leon Trotsky. On August 20, Ramón Mercader, an agent of the Soviet secret police, had assassinated Trotsky in his private home in Coyoacan, Mexico. It was a shockingly bold act and clearly demonstrated that Stalinist agents were operating freely in foreign countries. When Serge read the news, his first remark was that this "blackest hour" was an appropriate time for the "Old Man" to go, but he was devastated that a great mind could be so easily extinguished. He had had strong disagreements with Trotsky, accusing him of authoritarianism and of being "a prisoner of his own orthodoxy." Trotsky was defending his own doctrine rather than a renewed Socialism. But Serge had admired and even loved him. With Trotsky dead, he now felt that he was in a singularly perilous position. He was alone, "the last *free* witness — more or less — of a whole era of the Russian Revolution."[11]

He wrote to Nancy Macdonald, knowing she knew Trotsky's widow, and asked her to express "to Nathalie Ivanovna all the despairing affection that she inspires in a handful of dispersed, but nevertheless faithful friends — despite their different political views."[12] Now Serge began seriously to fear assassination. He told Nancy Macdonald that he tried never to be alone, especially when traveling.

Victor Serge had fought too long in the trenches to be seduced by the "lifeboat" mentality — he always tried to save others as well as him-

self. In his letters to the Macdonalds he included the names of other people he believed were also in need of rescue. Among these was André Breton. With his wife, Jacqueline, and daughter, Aube, Breton was still living with Pierre Mabille and his family in the abandoned fishing cabin on the beach in Martigues near Marseille.

Once he had located Breton's post office address in Martigues, Serge wrote to him. (Even if he was living in an abandoned cabin, Breton made sure he could receive mail. Mail was his lifeblood.) Serge told him that there was a man in Marseille called Varian Fry whose *secours* committee was dedicated to helping artists and intellectuals to survive and eventually escape France.

Breton wrote back on October 13:

My Dear Victor Serge,
If you see before I do the young woman [presumably Miriam Davenport] from the Secours, *can you try and find out if, as you were thinking, this aid is regularly renewable because, in spite of continuous efforts, we are going to be short of resources once more. I can't really see myself pleading my own case in front of them; however, our stay in the zone "libre" is more and more threatened.*[13]

Serge knew Breton was feeling cornered. Even with money, it was becoming difficult to find food and a place to stay, and no one had any money. Refugees, whether foreign or French, were considered intruders, even by relatives and friends, and daily life was unpleasant. Serge wrote to Nancy Macdonald of the sense of "moral decomposition" that made life wearying.[14]

When Serge suggested that Breton come to Marseille to meet with Fry himself, Breton wrote back with obvious relief: "Dear friend, Jacqueline and I will arrive the day after tomorrow at Marseille. We will wait for you at 11:45 at the *Café Riche*. Perhaps we can eat together. I will be famished. *À vous de tout coeur*, André Breton."[15]

KILLER

When Mary Jayne Gold checked in with the American consulate on her arrival in Marseille in early August, the officious young man at the passport desk told her it was her duty to go back to America. In these dangerous times, she would only be in the way.

Crossing Place Félix Baret with Dagobert in tow, she sat down under the blue awning of the Café Pelikan and pondered her choices. She didn't really want to return to the States. During the past year she felt she'd been participating in a momentous historical upheaval. "C'est finie, la grande aventure," she said disconsolately to Dagobert.[1] The adventure was over. For the next few weeks she would be trudging from one bureau to the next to get the French exit visa and the Spanish and Portuguese transit visas that even an American required.

But she hadn't counted on Miriam Davenport. That August in Marseille the two women had become close friends, seeing each other almost every day. Sometimes Miriam had Gussie in tow. He was the young fifteen-year-old Jewish boy whom she'd convinced to follow her to Marseille. He was completely alone in the world and she was keep-

ing an eye on him. She'd found him an attic room in her run-down hotel, Hôtel Paradis Bel-Air on rue Madagascar.

One day, in the midst of her usual gay patter, punctuated by giggles, Miriam confessed to Mary Jayne that she'd invited three Foreign Legionnaires to lunch. She'd slipped in the bit about lunch a little sheepishly because Mary Jayne would surely have to pick up the tab—but the men obviously needed a decent meal. Imagining three suntanned soldiers looking like Rudolph Valentino in white kepis, Mary Jayne was delighted.[2]

Two of the men turned out to be American journalists who had joined the Foreign Legion to fight Hitler. They had good American names: Robert Selmer, whom everyone called Beaver, and Sarge Newman. The third man was French. He was a slight, darkly compelling man in his twenties with black hair and a perpetual five o'clock shadow. He wore thick glasses, or sometimes large steel-rimmed sunglasses, and when he allowed his constrained smile to break into a wide grin, he had a seductive look. He answered to the name of Claude Aubry, though Mary Jayne noticed his friends stumbled suspiciously over the name whenever they addressed him. He'd been with the Foreign Legion in Algeria. He said he'd dug ditches in the Sahara all through the *drôle de guerre* so that it was a relief when real war broke out and he was finally shipped to England. In Norway he'd lost a lot of friends. He also claimed to have done a lot of killing. The Germans shot their prisoners, so the Legion did, too. There was, no doubt, a certain amount of bravado in his story, but it had the desired effect. Mary Jayne was shocked but fascinated. "How do you shoot a man with his hands up?" she'd wondered.[3]

"Claude's" company had landed in France days after the surrender. When the armistice was signed, their commanding officer was so disgusted that he told his men to desert. "Claude" had made his way south, sniping at the Germans and burying the weapons he'd found abandoned by French soldiers en route. He was sure he'd return to dig them up for the future fight.

By the end of the evening, Mary Jayne had learned that Claude's real name was Raymond Couraud.[4] And he was AWOL, having quit

the Foreign Legion by forging his own demobilization papers. He said that the Vichy government was planning to send the Legionnaires to Africa to fight the English, but he was having none of it. He intended to join de Gaulle's Free French Forces in London. If he were ever caught as a deserter with forged papers, however, things would not go lightly for him.

Mary Jayne was captivated. Raymond's narrative was heroic and dangerous, and his self-confidence seemed boundless. There was an erotic edge to his roughness: "Don't worry about me, bebby," he said.[5] He'd get to England on his own. His English was so full of expletives that he reminded Miriam and Mary Jayne of the actor Paul Muni in the popular 1932 film *Scarface*. They dubbed Couraud "Killer" because of the way he massacred the English language. He pretended to be amused, remarking that he hadn't learned his English at a girl's private school. But when Mary Jayne complimented his French as correct and proper, he smiled with the shy pleasure of a boy.

In crowded Marseille, Mary Jayne had finally found accommodations at the Continental, a mid-range hotel that was at least reasonably comfortable. Late into the evening the group of five friends would end up in her small hotel room where the nights had a clandestine charm. Mary Jayne kept a bottle of whisky in the armoire. Miriam was usually already a little tipsy on her preferred drink—the foot-high glass of beer called a *formidable*. She would become antic, stretching out across the bed, amusing the others, identifying the flowers on the dingy wallpaper as "hotel botanicals."[6]

At 1 A.M., in the half light cast by the single overhead bulb, Miriam, on her knees with her ear to the radio, would adjust the dial with delicate fingers, trying to focus the signal. In silence the friends listened for the BBC French news broadcast from London. Almost inaudible through the electronic jamming, came the words: *Ici la France! Trentième jour de l'Occupation allemande*.[7] The British Air Ministry's account of statistics in the Battle of Britain would follow.[8] The German air attacks on Britain had started on July 10. The English were holding out. There was still hope. The broadcast always ended with a rousing chorus of the "Marseillaise."

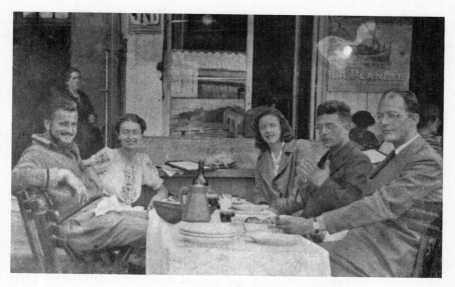

Beaver, Miriam, Mary Jayne, Killer, and Sarge,
at a restaurant in Vieux-Port.

Slowly Mary Jayne managed to piece together Raymond Cour-
aud's exotic career. He claimed to have joined the legion to escape a
crime boss whom he'd double-crossed. He'd been ordered to deliver a
group of prostitutes to Algiers, but, instead, he'd let them off at a port
near Oran so they could elude their pimps. Mary Jayne wasn't sure
she believed him; nevertheless, she was spellbound by his wildness
and unpredictability.

The five friends saw one another constantly. They met up at noon,
and spent their nights in the cafés of the Vieux Port, plotting how to
keep Raymond out of the hands of the Vichy police and how to get
the three men to England. They concluded the only way to escape
Marseille was to buy a boat and sail it to Spain. Mary Jayne immedi-
ately offered to extend the money for the boat.

She was deeply attracted to Killer, but before the two had a chance
to become lovers, the police arrested him for desertion. Somebody
had set him up. Plainclothes officers were waiting for him outside his
hotel. Beaver had been with him and informed the others that they'd
taken him to the local police station. Apparently Killer had told the

police that Mary Jayne was his fiancée. Presumptuous as that was, she agreed to play the role and accompanied Beaver and Sarge to the jail to see if she could help.

Killer knew that to be found with forged papers was a more dangerous offense than being a deserter, and so, audaciously, he used a passionate embrace to slip Mary Jayne his forged discharge papers, which she and the two Americans eventually managed to flush down the Turk (a primitive toilet that was just a hole in the ground). As he was being led away to his jail cell, Raymond turned and appealed to Mary Jayne:

"It's so easy to be forgotten," he said.

"I'm staying," she replied. "I'll see you through."[9]

Raymond Couraud was lucky in Mary Jayne. She was incapable of letting anybody down. And she was a "sucker for dangerous men and had a taste for derring-do."[10]

The lawyer she hired to represent Raymond said it would be months before his case would come to trial. But there was hope. His military record was excellent—he'd won the Croix de Guerre avec Palmes in Norway—and his extreme youth would be taken into account. This puzzled her since Raymond had told her that he was twenty-eight, but she let it pass.

Now that she had decided to stay on in Marseille, Mary Jayne was eager to help Miriam at the Centre Américain de Secours. Miriam had spoken of the increasing number of refugees turning up at the center; there wasn't going to be enough money to help them all. Mary Jayne immediately offered the committee five thousand dollars, almost double the initial amount Fry had arrived with. It was the money she'd set aside to buy the boat for Raymond and his friends' failed escape.

Mary Jayne waited to be introduced to Fry, and was a little puzzled when Miriam put her off. On her own Miriam had already approached him about bringing her friend on board. She had painted an enthusiastic portrait of Mary Jayne, with her private plane, Biarritz vacations, and fancy lifestyle. Fry dismissed her out of hand. He said he disliked her type. She was just a rich playgirl with a "passion for dukes" and "ultra-reactionary friends."[11]

When she told Mary Jayne of Fry's reaction, Miriam tried to be diplomatic: "Varian . . . says that people like you don't exist. He says people don't just barge in and offer a lot of money without a reason."

"Well. I'll be—!" was all Mary Jayne could say.[12] She wondered if Fry thought she was trying to infiltrate his group, perhaps for Vichy or for the American State Department.

A chance encounter with Fry and his young German assistant, Albert Hirschman, on the Canebière led to the four of them having an aperitif at Basso's in the Vieux Port. They talked in generalities about the war, how the former leaders of the French government like Édouard Daladier, Léon Blum, and Paul Reynaud were now "administratively interned" and were awaiting trial on charges of treason. When Fry asked her if she had joined the exodus of millions who fled Paris before the Germans invaded the city, she described her flight to Bordeaux, ending with a contemptuous portrait of Madame Leduc.

Mary Jayne was obviously on the right side. Fry told her to come round to the office. This was a lucky break for a large number of refugees. Her ongoing, generous financial assistance enabled the committee to draw up a second list of lesser-known refugees desperate to leave France. Miriam dubbed it "the Gold list." With the help of a black market money changer named Boris Kourillo, dollars drawn on her accounts in Great Britain and the United States were converted into a great deal of money.

She also joined the office as an interviewer. This was a daunting job. She was dealing with people who had reached dead end and were shattered, often holding on to their humanity only by threads. And of these desperately fearful people questions had to be asked about the numbers and types of documents they held; whether the documents were real or false; whether they had contacts overseas who might vouch for them financially; what kind of anti-Nazi activities they had engaged in to put themselves in danger. The political exiles told stories about the twilight labyrinth in which they lived, hounded from one hideout to another, from one country to another.

Soon Mary Jayne also worked as a courier. CAS had discovered that the police were tapping its phones and so messages had to be de-

livered in person. Some clients were in strict hiding. To reach them, Mary Jayne had to dodge through buildings and abruptly change streetcars to shake off any pursuers. There was always a chance of being followed by a member of the Kundt Commission, a commission that had been set up after the surrender of France to oversee article nineteen of the armistice. A branch of the Gestapo, they roamed freely in Marseille gathering information on anti-Nazi refugees.[13] Occasionally Mary Jayne's excursions took her to a *maison de passe*, one of the rooming houses rented by the hour where a madame might hide refugees for a reasonable price and where the police had already been bribed to look the other way.

Like the others, Mary Jayne often felt overwhelmed. She was holding the destiny of individuals in her hands. Inevitably, on her say-so, some people would be saved while others would be turned away.

STATUT DES JUIFS

October 3, 1940

I t was now the beginning of October. Though he was meant to return to the United States at the end of August, Fry had made the decision to stay on indefinitely. He sent a cable to Eileen on October 1.

> COULD NO MORE ABANDON MY PEOPLE HERE THAN COULD MY OWN CHILDREN STOP HUNDREDS HAVE COME TO DEPEND ON ME FOR MONEY ADVICE COMFORT STOP LEAVING NOW WOULD BE CRIMINALLY IRRESPONSIBLE STOP COUNTING ON YOU STOP EXPLAIN ARRANGE STOP LOVE FRY[1]

Eileen was not pleased with this curt message. She must have wanted to point out that they had no children. Still, she had resigned herself to waiting patiently. After all, the work her husband was doing saved lives.

But soon Fry had a more urgent reason to stay in France. Things had suddenly taken a diabolical turn. On October 3, four short

months after the defeat of France, the Vichy government announced a new *statut des juifs*. According to the *statut*, all Jews were to be barred from spheres of public influence, jobs in the military, the civil service, on university faculties, and in all educational institutions. Jews were to be dismissed from all positions in the press, radio, film, and theaters. It was clearly the beginning of the systematic segregation of even the French-born Jewish community. Obviously the point was to deny Jews access to any forum where they could influence public opinion. More sinister still was that the Vichy regime now defined what it was to be Jewish. The decree emulated a German ordinance enacted in the occupied zone that "assigned membership in the Jewish race to anyone with more than two Jewish grandparents." The truly Fascist nature of the Vichy regime became clear. They had tightened the Nazi criteria for being Jewish by declaring that "anyone with only two Jewish grandparents and a Jewish spouse [was] subject to the new law."[2]

Though he knew he shouldn't have been surprised, Fry was shaken. His mind flew back to Berlin in 1935 when he had witnessed the bloody orgy of the Kurfürstendamm riot. He recovered the image of the old man being beaten in the street and his frail wife assaulted by the crowds as she tried to help him, and of the young man's hand impaled on the table. He thought of Putzi's words about how the Nazis wanted to "solve the Jewish problem." But those were the Nazis. This was his beloved France.

He and Beamish endlessly discussed Vichy's motives. Beamish said the Vichy regime was eager to prove their good faith with the Nazis and were sacrificing the Jews for their own expedient purposes. They wanted to show the Nazis they were capable of controlling their own populations. Despite the fact that England was still fighting, they believed Germany had already won the war. Vichy was demonstrating that unoccupied France was a reliable and helpful partner and deserved a place in Hitler's New Europe.

On October 4, the next day, there was a second blow. The Vichy government authorized departmental prefects to "intern all foreign Jews in camps or to confine them to forced residences in remote vil-

lages, where they could remain under the watchful eyes of the local police."[3]

Beamish assured Fry that successful implementation of the new laws would take time. Vichy would need a new bureaucracy to execute their plans. There was still so much chaos from the war: jurisdictions overlapped, spheres of authority were confused. He knew his people. The refugees had already learned how to evade notice, scrounge for food, and find safe lodging and false papers. There was still time. In fact he was right. It was only the following year, in March 1941, that the Vichy regime began to take systematic and decisive action against native and foreign Jews.

But the reality was clear. Jewish refugees who had come to France for asylum, thinking they were getting as far away from the Nazis as possible, had ironically found themselves in one of the most dangerous places in Europe.

Fry's Jewish clients were now in desperate trouble. Fry knew there were only two other organizations willing to engage in legal and quasi-legal means of getting Jewish refugees out of France. Donald Lowrie of the YMCA was finding false passports any way he could. And the Jewish relief organization HICEM, much bigger than CAS with at least eighty employees in its Marseille bureau, was helping to provide vital papers and financial assistance to the Jews attempting to leave.[4] But everyone was running into the same problem—procuring international visas.

Fry was further shocked that on the streets of Marseille there were no public protests against the *statut des juifs*. Though there were always remarkable individuals willing to help, the majority of the French population seemed content to remain silent. People were otherwise preoccupied—with the food shortages, with the rationing, or with their own sons and husbands who remained prisoners of war in internment camps in Germany.

Fry thought of his Jewish clients, of the ones whom he had already gotten out of France. Lion Feuchtwanger and his wife were now safely in the United States. Franz Werfel and his wife, Alma Werfel, though she herself was not Jewish, were also safe in the United States, as was

Hannah Arendt, along with her husband and mother. And there were numerous others. But there were still so many left. He thought of Marc and Bella Chagall. They were naturalized French citizens, but Fry knew that wouldn't protect them for long. He felt guilty about the Fittkos. He had urged them to stay, and now they were facing a new risk. She was Jewish. His clients Rudolf Breitscheid, the former leader of the Social Democratic Party in the German Reichstag, and his right-hand man, Rudolf Hilferding, were problematic. They were still confidently waiting for Hitler's defeat and their return to the Weimar Republic. They believed neither Vichy nor the Nazis would dare touch them. But Hilferding was Jewish. Fry must now renew his efforts to persuade them to leave.

Fry still believed his priority was to help artists and intellectuals threatened, under article nineteen of the armistice, with extradition to Germany and certain death. They were on the Nazis' black list and in immediate danger. Some were Jewish, some were not. What he desperately needed now was to get his hands on that list. Beamish was working on it. Fry also needed more people. He urgently needed to expand his committee. And he needed to convince the American consulate in Marseille to issue more emergency rescue visas.

NEW STAFF AT CAS

On the twentieth of October 1940, Danny Bénédite climbed the stairwell of the Centre Américan de Secours at 60 rue Grignan, squeezing apologetically past the men, women, and children waiting nervously in line. In the room he could see five or six employees, one trying to keep order and the others at desks, engaged in interviews. The jarring sounds of multiple languages and the smell of shabbily clad people jammed together in an airless space daunted him as he thought of the possibility of working here.

Mr. Fry, president of CAS, had invited him for a job interview. It was Mary Jayne Gold's doing. *"Chère Naynee."* He did not know it yet, but this interview would begin the process of repairing the devastating sense of loss the war had brought, when he'd felt life itself was breaking apart.

After the armistice, Danny had remained with his unit in the town of Meyrueis, just east of Millau in the unoccupied zone, helping to distribute food to civilians. Communications were chaotic. He had had no news of his family for two months when Theo and Peterkin finally tracked him down and joined him. It was more than an emo-

tional reunion. Both were dumbfounded. It seemed impossible that all three of them had survived the disaster.

Demobilized on August 10, Danny was at a loss to know what to do next. When he discussed plans with Theo, one thing was certain. They would not be returning to Paris. He could easily have resumed his old position at the prefecture and, by keeping his head down, picked up the pieces of a promising professional career. But he would be working for the Nazis. To both of them, this was unthinkable.

Danny and Theo finally decided to move with Peterkin to the Languedoc region, well within the unoccupied zone, to take care of the farm of an uncle who, as a prisoner of war, had been transported to Germany. His mother, Eva, went to stay with friends in Juan-les-Pins on the Côte d'Azur.

They soon discovered they were barely able to survive. The only work was picking grapes and selling them in the local market. Danny sent desperate letters to all his friends asking if they knew of work inside the unoccupied zone, but he felt like he was tossing messages in bottles out to sea. Who could help? Everybody was preoccupied. They had their own troubles.

And then he received a long letter from Mary Jayne. She said she had put off her return to the United States and was working for a committee involved in helping anti-Fascist refugees. Why didn't he and Theo come to Marseille? She was sure she could get him a job. She had a certain influence with the committee since she was one of its "chief fundraisers."[1]

Fry had initially been skeptical about hiring an ex-functionary of the police, but Mary Jayne assured him that Danny wasn't one of those *rond-de-cuir* from Paris, bureaucrats who sat on their cushions and did nothing. He was relentless when confronted with a problem and had great moral integrity.

As soon as he met him, Fry realized that Danny had many virtues. Not only did he already know a number of the clients—many recognized him as the kind young official at the Service des Étrangers at the prefecture in Paris who had given them their *permis de séjour*—but he

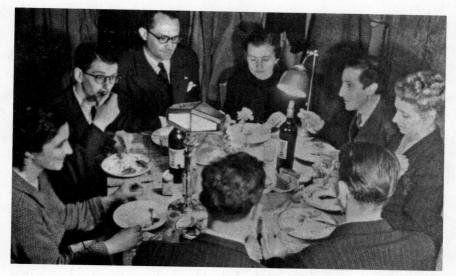

At a frugal dinner of CAS members *(clockwise from left):* Vala Schmierer, Danny Bénédite, Varian Fry, Theo Bénédite, Paul Schmierer, Annette Poupos, Maurice Verzeano, and Olivier de Neuville.

could also translate CAS's correspondence into the officialese that impressed ministers and their subordinates.

There was an instant rapport between Varian and Danny. Within a week, he considered Danny his *chef de cabinet*, whose job it was to run the office and to establish contact with refugees outside Marseille, particularly those interned in camps. When the boss was out of town, he was in charge.

The perfectly bilingual Theo became one of Fry's assistants. And Danny's friend Jean Gemähling, a Catholic who spoke perfect English and was a fellow veteran from the battle of Dunkerque, also joined the committee. Gemähling, though Alsatian, had been educated at an English boys' school and had begun a career as a chemist before the war broke out. Fry did not know it, but Jean was already a member of a nascent resistance group well before the French Resistance was organized.

Fry also took on staff a young Romanian, Marcel Verzeano. Marcel went by the name of Maurice. Although he was only a student

doctor, Fry asked him to join the committee as the doctor on staff. Some of CAS's refugee clients were in such distress that they badly needed medical attention, yet could not risk visiting a doctor's office. Miriam's young charge, Gussie, became the office boy. Fry also hired another secretary, Anna Gruss. She was a small, inconspicuous woman with an enormous capacity for work. Her boss thought of her as an innocent and a "queer little gnome," but she would turn out to be invaluable when CAS came under increasing police scrutiny.[2]

During the autumn of 1940, France settled into the psychosis of occupation. Ordinary life continued to follow banal and familiar routines, but fear of the unknown lay like quicksand at one's feet—which false step would lead to disaster? The signs of menace against intellectuals were growing. That September, the German ambassador to Paris, Otto Abetz, published the *Liste Otto*, a list of banned books that began with the preface: "These are books that, by their lying and biased nature, have systematically poisoned French public opinion; especially undesirable are books by political refugees or Jewish writers who, betraying the hospitality granted them by France, promoted war unscrupulously in the hope of furthering their selfish goals."[3] On the list were books by Freud, Thomas and Heinrich Mann, André Malraux, and Arthur Koestler; Victor Serge's translation of Trotsky; and many others.

The writer Pierre Drieu la Rochelle, an outright Fascist collaborator, took over the editorship of the most influential literary review in France, *La Nouvelle Revue Française* (NRF). In his diary at the time he wrote the remarkably vindictive note: "As for the N.R.F., it's going to crawl at my feet. That pack of Jews, pederasts, timorous Surrealists is going to be shaken up miserably."[4] Publishers were suddenly required to submit all books to a censorship board for an obligatory publication permit. Accordingly André Breton's publisher, Léon Pierre-Quint, submitted Breton's *Anthology of Black Humor* to the censorship board for clearance—it had been ready to go to press June 10, the day Paris fell. Months later, when the board's decision was finally handed down, the anthology was rejected on the grounds that Breton was "the negation of the spirit of [Pétain's] National Revolution."[5]

Among the millions who had fled the German advance were many of the country's best surrealist artists. The rush to escape had been so precipitous that most had arrived in the south with nothing but the summer clothes on their backs. Certainly few had been able to bring any money with them. There was no question of returning to Paris. Cut off from funds and their livelihood, they had to make a choice: to stay or to leave France. Held hostage by fear, most were living in nasty little *maisons de passe* in the backstreets of Marseille or in nearby towns.

Oscar Dominguez, a painter from the Canary Islands, had previously made a dramatic escape from Franco's Spain to what he had thought would be safety in France. Both he and Victor Brauner, a Romanian Jewish artist, were hiding in Marseille, as was Wilfredo Lam, a young, elegant Cuban of mixed Chinese and Cuban heritage. Picasso had arranged Lam's first exhibition in Paris in August 1939. A month later, after war was declared, Lam had watched as galleries closed and other artists fled the city. His promising new career, along with a splendid studio on rue Armand Moisant behind the Montparnasse railway station, was effectively over.

Others in hiding in the unoccupied zone included the painter Jacques Hérold, who came from the same Romanian town as Brauner, and Hans Bellmer, Max Ernst's former fellow inmate at Camp des Milles. Two years earlier he had been accepted by the surrealists after they discovered his obsession with sexual phantasms, particularly the disjointed and perversely erotic *poupées* (dolls) he created. Also in hiding was the Jewish actor and theater director Sylvain Itkine, who had been in a number of Jean Renoir's films, including *La Grande Illusion*, and who had mounted the works of Alfred Jarry at the Comédie des Champs-Élysées with sets by Max Ernst.[6]

The French surrealist painter André Masson was also in hiding. For the moment he was living with his wife and children in a hunting lodge on the 250-acre estate of the Comtesse Lily Pastré in Montredon, a suburb of Marseille. In response to the flood of refugees pouring into the south, the comtesse had opened her château to some forty refugees, including Darius Milhaud, Francis Poulenc, Pablo Casals,

and Josephine Baker. Dinners in her formal dining room were often followed by concerts given by an orchestra composed entirely of Jewish musicians no longer permitted to perform in public. Masson had been listening to the radio on the morning of October 3 when he heard the announcement of Vichy's *statut des juifs*. He immediately vomited. His wife, Rose, was Jewish. He knew they would have to leave France as soon as possible.[7]

Each of the artists had a story of escape, but particularly harrowing was that of Helena Holzer, Wilfredo's girlfriend. By March 1940, three months before the fall of Paris, it had been clear to the French government that the Germans were preparing to launch their formidable war machine. Indeed, Hitler made his first move a month later when he invaded Norway and Denmark. The French government, purportedly to stave off the threat of spies and fifth columnists, had ordered all German nationals to present themselves to the authorities for immediate internment: not only men between the ages of seventeen and fifty-six but women as well. Caught within this broadly flung net were German citizens long resident in France, ordinary refugees, German anti-Fascist dissidents, and German Nazi sympathizers who found themselves stranded in France. It was a murderous mix, with frequent and brutal attacks inside the camps themselves, usually by the Nazis against the anti-Fascists.

In Paris, along with all other female *ressortissants allemands* (citizens of Germany), Helena was ordered to report to the ice-skating stadium, the Vélodrome d'Hiver. She dutifully took the bus to the stadium. There she was placed amid a group of women destined for the internment camp of Gurs in the lower Pyrenees. Gurs had at this point been designated a camp for women and children and would eventually hold ten thousand prisoners.

The women and their children spent days waiting in the stadium with little food and no shelter, followed by an all-night trip to the camp in a cramped railway car with blackened windows. The worst part, though, was arriving in the railway station only to be greeted by a hostile crowd shaking angry fists and screaming *Boche* and *assassin*. Helena later recalled: "The smell of lynching was in the air."[8]

From April to mid-June 1940, Wilfredo raced around Paris contacting every friend to find some way to secure Helena's freedom, but in fact there was nothing he could do. Then, suddenly, he discovered that Helena had been released. As the German army advanced relentlessly through France, most prisoners in internment camps all over the country were set free to fend for themselves. Certainly most women at Gurs were let go. Helena hitchhiked to Marseille. On at least one occasion she took a ride with a friendly truck driver who hid her under blankets in the back of his truck as they passed the many control stations. Wilfredo then found out that Helena was waiting for him in Marseille. By October they were together again, living in a seedy hotel in the rue de la Rotonde.

"Precariously lodged" with his family in Marseille, André Breton caught up with the other surrealists at the café Au Brûleur de Loup in the Vieux Port. It was the name "to roast the wolves" that drew them. Afternoons they sat looking out with hypnotic intensity at the blue expanse of the Mediterranean, watching the fishing boats bob in the harbor. For millennia, ever since first settled by the Phoenicians, the port of Marseille had been free. But now, without the right pieces of bureaucratic paper—exit visas, transit visas, affidavits of support, testimonials of character, and the ever-elusive American emergency rescue visas—the boats they looked at longingly were of absolutely no use to them. Over wine that, despite the rationing, was still plentiful, the political discussions were heated. When the drunken artists started raging against the cretinous Vichy government, Breton had to shut them up. They would all get arrested.

Nearby was the office of the literary periodical *Les Cahiers du Sud*, where refugee artists could find shelter for the night. Sometimes as many as twenty people slept on the floor. The editor, Jean Ballard, was publishing Breton's poem *"Pleine marge,"* which he had recently completed in the abandoned fishing cabin on the beach in Martigues.[9]

In this tense and worrisome time, Marseille was a dangerous place. The police continually raided the cafés to check identity papers: particularly vulnerable were the foreign-born refugees whose papers were rarely *en règle* and who always sat at the back close to the exit for quick

escape. With the newspapers censored, news traveled only by rumor. Living without information added to the chaos. Everything was sold for a price: food, visas, and especially contacts.

Homeless, penniless, and distraught, André Breton found little ground for optimism. He had had to leave everything in Paris. In 1923 he had moved into his two-room studio at 42 rue Fontaine in the ninth arrondisement between the nightclubs and brothels of Places Blanche and Pigalle, and the working-class district of rue Notre-Dame-de-Lorette. At the top of his street he could see the Moulin Rouge and around the corner follow the endlessly entertaining goings-on at Place de Clichy. He had delighted in the fact that his studio sat above a cabaret called Le Ciel et L'Enfer (Heaven and Hell). This apartment, "always rented, never owned," was "his crystal, his universe," his daughter Aube would later explain.[10] There, over the years, the ever-changing cadre of surrealists gathered for their nightly conversations, and there Breton kept his vast collections of paintings, African art, and esoteric books. Now all that was lost to him.

He was still depressed from the assassination that August of Leon Trotsky. He'd met Trotsky in Mexico in 1938, and his murder had hit him hard. "It was early morning," Jacqueline later recalled. "The newspaper had just arrived. On the first page, of course, was TROTSKY ASSASSINATED. We couldn't believe it. It was unthinkable. And yet, there was the newspaper. It was absurd of us not to accept the obvious, but we simply couldn't. André was sobbing. He kept repeating: 'The bastards, they finally got him!' "[11]

Now Breton was anxious to get out of France. "We hope to go to New York," he wrote his friend the poet Benjamin Péret on an interzone card, "but not certain."[12] To the young Maud Bonneaud he wrote: "America has become necessary . . . only in the most negative sense. I don't like exile and I have doubts about exiles . . . [we are] rather unpleasantly suspended between New York and Paris . . . and to tell you the truth, without much hope."[13]

THE VILLA AIR-BEL

Until they arrived in Marseille, Danny and Theo could not have imagined how glutted with refugees the city was. The first week they moved from hotel to hotel, never managing more than two days in the same one before they were told other clients had previously reserved the room. Expecting to continue moving through pensions like musical chairs, they took Peterkin to stay with Danny's mother, Eva, in nearby Juan-les-Pins.

One Sunday at the end of October, Mary Jayne and Theo decided to go house hunting in the suburbs east of Marseille. They were looking for a small house with a garden for Peterkin. Wanting to escape the city, Miriam Davenport and Jean Gemähling tagged along. The four took the tram at the gare de Noailles on the Canebière. About a half hour into the countryside, as the tram passed the district of La Pomme, they noticed a small café where inquiries about rentals might be made. They jumped off the tram and began to walk along a road bordered by a high embankment and the main Marseille-Toulon train line. On the other side of the railway underpass, at 63 avenue Jean Lombard, they came upon two large gateposts carved with the name

Air-Bel. Miriam shouted happily that this was the name of her fleabag hotel spelled backward, clearly an omen. She insisted they inquire despite the sign saying: *"Propriété Privée/Défense d'entrer."*

As they walked up the drive, they saw an immense three-story, nineteenth-century manse. It was somewhat battered but still elegant, and it immediately conjured up the haute bourgeois worlds of Balzac and Flaubert. Around part of the house ran a stone terrace on which grew three ancient plane trees. There was even a greenhouse to one side. The terrace overlooked a formal garden, with a fountain and pool as centerpiece, leading to a small forested area with a dazzling view of the distant mountains. The house had clearly stood vacant for a number of years, for the gardens were overrun and the hedges untrimmed.

"It's way too big for our purposes," Mary Jayne said definitively. "Much too big," added Theo. But as a poor student at Smith College, Miriam had lived in cooperative housing and she wasn't ready to dismiss the idea so easily. "Look," she said, "It would be cheap. We could share the rent and the food. We could even afford to hire a cook. It's so large we could invite other members of the committee who could pay, and maybe even some of our clients could join us. Think of the company."[1]

On the other side of the gateway, they spotted a small man on his knees digging in the earth. Jean approached to say that they were looking for a house to rent.

"Nothing to rent around here," the old man replied abruptly. "This is private property."

"We're Americans," Miriam piped in.[2]

When the old man heard this, he was suddenly interested. Americans had money. He introduced himself as Dr. Thumin and, warning that the house would be expensive, he offered to show it to them anyway. He advised them to wait while he collected the keys.

When he returned, Dr. Thumin rushed inside to open the iron shutters that covered the large windows on the ground floor and invited them in. The villa had eighteen rooms, and it was fully furnished.

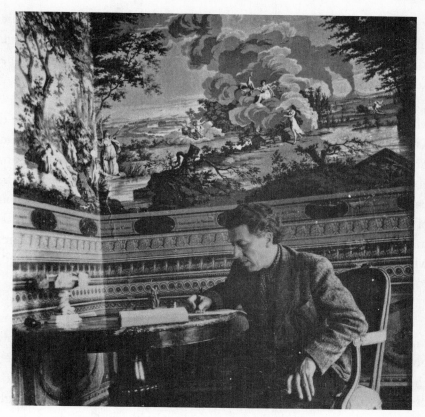

André Breton in the Villa Air-Bel library.

On the main floor were three reception rooms and a dining room as well as a kitchen, breakfast room, pantry, wood storage room, and a bathroom. A spacious entrance hall tiled in black and white marble led to the parlor at the center of which was a large stone fireplace ornamented with brass fittings. Above the marble mantel was a huge gilt mirror spotted from age; the hands of the gilt clock that sat on the mantel had stopped permanently at a quarter to twelve. The chairs and tables were mostly Louis Quinze and there was also an upright piano with elaborate brass candlesticks.

In the dining room the walls were covered with a heavy wallpaper embossed to simulate Cordova leather, and the chairs and dining table had a pseudo-Spanish bulk and severity. Beyond was a breakfast

room containing a charming marble hand-washing fountain. In the kitchen there was a twenty-foot-long wood-burning stove and a large soapstone sink. Beyond this room was the only bathroom containing a tub. It was zinc, with ornamental swan's-neck faucets.

The story above contained three large bedrooms, each with a white marble fireplace, double bed, large armoire, and washstand with a crockery jug and chamber pot discreetly hidden behind a door. All these rooms opened onto a large central library. The walls were covered with black and white wallpaper depicting classical scenes; in particular the flight of Aeneas, the first refugee, escaping the sacking of Troy carrying his aged father on his back. Shelves were lined with many original editions, including leather-bound sets of Lamartine, Musset, and Victor Hugo. On the top story there were six more bedrooms.[3]

It was the furnishings, mostly Second Empire, that gave the house the feel of a stage set: its collection of lacquered paintings, somber tapestries, leather-bound books, and cushions. All were in remarkably good condition for a house that had not been occupied for quite some time. The electricity functioned—clearly a later renovation since electric wires snaked across the surfaces of all the walls. Although there was no gas or telephone or central heating, there were stoves and chimneys sufficient for the temperate Midi.

They asked Dr. Thumin how much the rent would be. He gave them a crafty look: "I cannot ask you less than 1,300 francs a month." This was about thirteen dollars. The group was shocked. The smallest hotel room in Marseille cost fifteen francs a night. Clearly Dr. Thumin was living in another age. Readily agreeing to his terms, they made arrangements to return with Danny to sign the lease.

When Danny was introduced, the old man got right down to business. "You want to rent my house," he said. "I've never rented this house before. If I rent it, the people must be decent and proper, not vandals."

"Yes, Doctor," Danny replied. "My friends who will share the house are respectable. Writers from Paris, and Americans."[4] Danny played the part of the gullible Parisian well.

Feeling somewhat guilty at his shrewd swindle, the doctor offered to include the brushwood behind the house for burning in the fireplaces and free run of the villa's grounds. Danny asked that this be written into the contract. He signed a six-month renewable lease and deposited the first month's rent.

Danny returned to Marseille and immediately went to see Victor Serge to tell him that he and his family could quit their musty hotel and join them at the villa the next day. Serge accepted the invitation with relief. When Danny told him how large the villa was, Serge suggested that André Breton and his family were also precariously housed. "He's thought to be a difficult man," Serge said, "but I can guarantee that he is charming and enriching company."[5] Danny replied that he had no objection but must consult the others. Breton was accepted unanimously.

Initially Mary Jayne, who was actually advancing the rent for the group, did not want Fry as a permanent member of the household. She felt that, at least toward her, he remained diffident and unforthcoming. But Fry was invited to visit the first Sunday, and once Mary Jayne saw him running around from room to room, opening closets and drawers like a delighted child, and realized that the villa would provide a needed escape for him, she softened.[6]

Jean Gemähling was invited to stay at the villa since he had been among those who found it in the first place and, anyway, having been through so much together, he and Danny had become loyal friends. When the group then invited Beamish to join them, he said he was not interested. In fact, he considered even the idea of renting the villa a little reprehensible. It was half an hour out of town and had no telephone, which would mean that their clients couldn't reach them in emergencies. Fry's insistence that they could spell each other on weekends so that someone would always be available did not convince him. His room was therefore given to Maurice (Marcel Verzeano), the young Romanian doctor.

That Sunday evening at the end of October in the pseudo-Spanish dining room, the new residents of Villa Air-Bel sat down to their meager dinner and celebrated their good fortune. The twelve of them had

all been through so much that this moment felt like a miracle, how-
ever momentary it might prove to be. André Breton was in a playful
mood. He had found a pair of praying mantises in the greenhouse,
like themselves, unexpectedly alive. The insects' dramatic copulation
provided the table's bizarre centerpiece. Victor Serge was scoffing but
indulgent. Fry briefly forgot the weight of the frantic refugees whose
lives he held in his hands. That evening they didn't trade stories of
the various traumas they'd been through—the bloody evacuation of
Dunkerque, the *pagaille* as they'd fled along with millions of oth-
ers through the back roads of France under the German bombings,
the painful separations, and the terror that sat like a "hunch-backed
dwarf"[7] on their shoulders. Instead they drank the plentiful wine; they
laughed and sang haunting French folk ballads and bawdy barrack-
room songs. There was a moment, though, when the fun stopped and
the twelve people around the table looked at one another in amaze-
ment, shocked to numbness at the horror that life in France had be-
come. A few months back they could not have imagined it.

It was the pragmatic Danny who looked at the faces around the
table and pondered what kind of danger each of them was in. He was
very clear that, for the moment at least, the greatest threat to the people
in the room did not come from the Nazis. Not yet. Of course he didn't
really know who was on the Nazis' black list, but he suspected that the
Kundt Commission, operating freely in the camps and secretly in the
streets of Marseille, was looking specifically for people whose names
were on file back in Berlin. There were always rumors, of course, that
the Germans were about to occupy the whole of France, and then they
would all be in trouble. But Danny didn't consider this likely. For now
Vichy was doing too good a job of keeping the Germans happy. He
saw little difference between Nazi and Vichy ideology, though Vichy
was not yet killing people. Yes, it was Vichy and its Fascist henchmen
from whom they had most to fear. Vichy propagandists had identified
the enemies: Jews, Communists, Socialists, and all foreigners.

In Danny's estimation, Victor Serge was most at risk. He was a
known "Communist agitator" and a foreigner. Any day he could be
picked up in one of the roundups. And Danny did not consider it

paranoia on Serge's part that Serge feared Stalin's agents. He himself knew stories of their assassinations in Spain. Katia Landau's husband, head of the Spanish Worker's Party, the POUM, had been murdered, and she herself, now hiding out in Marseille, had just managed to escape from prison in Barcelona. It wouldn't surprise him to learn that the Stalinists were after Serge in Marseille.

Breton was a different case. Danny looked at the man and admired his charisma. It was he who sustained the antic mood at the table and brought relief from the general gloom. Probably Breton's most serious worry was starvation. Except for the pittance that CAS could give him, he had no money. His books were being censored, and even though he was clearly willing to work at something, there was no work to be found. When the collective work duties at the villa had been parceled out, Breton had shown himself as willing as anyone to pitch in. The real danger for him would come once Vichy got more organized and consolidated its power. Then it would look for scapegoats, and none would serve better than the degenerate intellectuals who had "authored" the fall of France. Then Breton might find himself in a detention camp.

Fry was at the other end of the table. He looked relaxed for the first time in months. Danny was certain that, even if his illegal activities were exposed, Fry would be expelled from France rather than sent to prison. The American embassy would protect him. The Vichy regime was opportunistic. They wouldn't want to annoy the Americans, who might, after all, enter the war and might even win it for the English.

As to Naynee and Miriam, they were also safe because they were Americans. And even Theo, though she was British and the enemy, was comparatively safe for the moment. All the committee's illegal activities had been carefully screened from the women. Transactions involving black market money, forged passports, helping British soldiers escape France—all took place in Fry's inner office behind closed doors with only himself and Beamish, and sometimes Jean, present.

In fact, though he would never have said it openly, Danny knew it was he and the other two Frenchmen who were taking the greatest risks. Authoritarian regimes like Vichy maintained a pretense of legal-

ity, but there were always two systems of law—one public, the other secret. As long as they kept under the radar of visibility, the Vichy forces could do anything they wanted. Vichy would have no qualms about throwing French nationals into prison indefinitely.

But for now, Danny was as grateful as any of them for this brief respite. He was among like-minded people. The conversation was stimulating, and the Pétain jokes were lively and a relief. He too ate his meager meal and downed his wine with relish. Everything could change in a second. The present moment was all that existed.

SUNDAY AFTERNOONS: REBELLION

It's a striking thing that dictators don't play golf.

JOSEPH ROTH[1]

André Breton had just descended into the living room of the Villa Air-Bel. It was noon. Around the large table in the middle of the room he placed every available chair. In the center of the table he set a big samovar filled with tea. Around this he strategically placed a number of oblong pads of paper, numerous colored pencils, pastel chalk, a pot of paste, old magazines, and several pairs of scissors. Breton had invited his surrealist friends to the villa. As he gazed at his work with satisfaction, he remarked to Mary Jayne, who had just entered the room, that they were going to play surrealist games. Mary Jayne was amused. "That's fine," she said. "We'll watch." "Oh no," said Breton, "this is for everybody."[2]

Breton was serious about his games. He'd evolved them over several decades as part of his attack on reason and on bourgeois respectability. Now, as he prepared the scene to play the game of *cadavre exquis* (exquisite corpse), his purpose was to affront the totalitarian mentality that had taken over the whole of France, including the unoccupied South, the so-called *free* zone.

Breton was a complex man who had invented himself out of the most unlikely circumstances. Born in Normandy, he was the only child of a policeman and a seamstress, and was named, he claimed, after a great uncle who had disappeared on his wedding day. "I believe I was very well brought up," he once remarked, "may it be said with rancour and hatred."[3] His mother drove the family. He described her as "authoritarian, petty, spiteful, and preoccupied with social . . . success." She would make him stand before her "so she could slap me, cold-bloodedly." From his late teens, he had dedicated himself to art as a code of conduct that dictated how one behaved in the world, and had mounted his attack on the bourgeoisie.

World War I left him severely scarred, as it did his whole generation. His preference would have been to go to prison rather than serve in the current war, even if only as a doctor. But it would have meant deserting his family, and though he had once been embittered about parentage, he was devoted to his daughter.

But he railed against war. It was the savage distortions caused by repression of the human spirit that drove society to sanction war and armed butchery. A "revolution of the mind," an entire remaking of the human was called for. "There had to be a great No that would start everything at Zero."[4] He was uncompromising: "When society is dissolving, the best one can do is help it crumble," he said. He was in favor of anything that would outrage!

In the decades since the First War, Breton never wavered from his self-designated role to *changer la vie*. He was intimidatingly self-assured, certain of his own opinions, and, in terms of his work at least, devastatingly ruthless with those who disagreed with him, as he had shown each time he expelled a wayward member of the surrealist movement. He had made himself the "pope of surrealism" and collected acolytes over the years. Even though many had fallen by the wayside, those who remained close to him found his sense of clarity and purpose exhilarating. He had, as one friend remarked, a "strange integrity" that "gave ideas, as it were, a solid existence."[5]

Breton felt that the future lay in what he called the "new attitudes that were laying bare the irrational mind beneath the skin of culture."[6]

Seeking mappable routes to the unconscious, he tried automatic writing, séances, and dreams.

Now in the midst of a new world war, what had all his ideas amounted to? He, of all people, who had once bravely said: "Perhaps the imagination is on the verge of recovering its rights," was living in a Fascist hell, and he understood, more than most, just how extreme, terrifying, and crackpot the Fascist agenda was. But whatever his private doubts, Breton kept up a brave front.

The weather in the fall of 1940 continued to be temperate well into December; it was what the French call a Saint Martin's summer. Every Sunday Breton hosted an open house at Villa Air-Bel for his surrealist friends. These Sundays became a regular ritual and a highlight of the refugees' week.

André organized the games and Jacqueline presided as the dominant muse. She had a dramatic beauty, enhanced by the way she dressed. She wore long flowing skirts, clinking bracelets on her arms, and had the habit of placing flowers or pieces of colored glass in her hair that sent off shards of light when the sun hit them. She owned a necklace of tiger claws, and it was said that she had a "stiletto tongue" to match.[7]

Those Sundays, when the surrealists sat down to their games, they played with a vengeance and much hilarious laughter. To hell with totalitarian regimes that cannot tolerate laughter and impiety. They played *cadavre exquis*, a game they'd invented in the old days in Paris. Sitting around a table, each player was instructed to write down a definite or indefinite article and a noun. Then the paper was folded so as to conceal the words, and passed to his or her neighbor. Next each wrote down an adjective, and the process was repeated with a verb, another definite or indefinite article and a final noun. The first sentence to emerge had been "Le cadavre / exquise / boira / le vin / nouveau" (the exquisite corpse shall drink the new wine).[8] Breton eventually evolved a question and answer form of the game, which once produced an amusingly apt definition: "What is André Breton? An amalgam of humour and a sense of disaster; something like a top hat."[9]

At a party at Villa Air-Bel *(clockwise from left):* Varian Fry, Sylvain Itkine,
Jacqueline Lamba, Benjamin Péret, André Breton, Jacques Hérold, and
(seated) Frédéric Delanglade and Laurette Séjourné.

The technique was soon extended to include drawings, and Breton
called the fantastical hybrid creatures that surfaced from the collective
effort *les petits personnages.* At Villa Air-Bel the group made a collec-
tive drawing of a head, which they captioned: "The last Romantic has
been buggered by Marshal Pétain."[10] Such a trifle, if discovered by the
Vichy police, could have landed them all in prison.

"Breton," Helena Holzer said, was "a natural leader. [He] tried
everything to preserve certain spiritual and poetic values in the face of
destruction and the breakdown of human dignity."[11] Breton explained
his games more modestly—he was simply "hoping to outwit the an-
guish of the hour."[12]

ESPERVISA

Fall 1940

It is so simple to be killed in this world. To kill is far more complicated.
VICTOR SERGE[1]

It was Victor Serge who renamed Villa Air-Bel Villa Espervisa—
Hoping for a Visa.[2] Serge, Breton, and their families were wait-
ing through the long, tedious process of getting their international
visas to the United States. It was disheartening. Vichy had already de-
clared a moratorium on all exit visas out of France. Occasional ones
were granted, but only in special circumstances and after very careful
vetting. After all, if Vichy were to keep to the terms of article nineteen
of the armistice—to surrender on demand all German nationals and
any others the Nazis requested—they had to have a pool of people to
be surrendered. The Germans were still organizing the bureaucracy
of occupation in the north, and the Nazis' Kundt Commission had
only begun to search the internment camps and to comb the cities for
enemy aliens in hiding. Victor Serge wrote Nancy Macdonald that,
for now, the villa was under surveillance. In this, as in many things to
do with the police, he proved to be right.

Still, life at the villa provided a respite from harsher realities. By

pooling their resources, the villa's occupants were able to hire help to run the large house. Madame Nouguet, a local Marseillaise, took over as cook and general housekeeper. Before heading out to the shops, she would collect everyone's ration books. These were booklets made of cheap paper in which the number of grams of foodstuffs allotted to each person was marked in little squares ready to be clipped by storekeepers or restaurateurs. After spending long hours in lengthy food lines, Madame Nouguet did manage to create tolerable, if bland, meals. The ersatz[3] coffee was made from crushed acorns or barley, but neighbors in the area brought over fresh vegetables and fruits and there was even a clandestine milking cow, eventually seized by the Vichy police who sent out "food spies" to comb the farms and confiscate any produce the farmers had withheld. A local woman named Rose was hired as a cleaning lady and Maria, a fifteen-year-old Spanish refugee, looked after Peterkin while Theo worked at CAS.

When Varian, Danny, and Theo returned, exhausted by the brutal pressures of rescue work, evenings at the villa were a welcome relief. To Danny they served as a kind of "detoxification."[4]

With the wine plentiful, they would end up in the dining room after dinner. They discussed the reports printed in the censored newspapers, competing in reading between the lines. When they could locate the American broadcast on their illegal shortwave radio, they danced to the "forbidden," decadent jazz from Boston.

Some evenings Breton read them witty letters he'd received from Marcel Duchamp and Benjamin Péret. And of course he orchestrated their games: *verité* (truth), which usually included titillating sexual interrogations; a form of charades in which a person took on the identity of an object; and murder, whereby the assassin was allowed to select his victim (Hitler and Stalin were at the top of the list). It was the ensuing cross-examination of the murderer that made for the amusement; Breton, with his legal rhetoric, was easily the most accomplished at the game.

Sometimes they would sit in the library around the porcelain stove while Victor Serge told them stories of his arrest in Moscow

and his forced exile in Orenburg on the edge of the Arctic Circle. Fry later recalled that "listening to him was like reading a Russian novel."[5]

Serge's twenty-year-old son, Vlady, was an excellent draftsman and artist who, when he wasn't sketching, spent his time reading Marxist texts. Breton thought he had a great deal of talent. He was hugely amused when Vlady went around the house tagging the various mediocre nineteenth-century paintings on the walls of the villa with the names of the famous: Nicolas Poussin; attributed to Claude Lorrain; School of Ingres. He was even more amused when visitors were taken in by the ruse. Vlady took Mary Jayne's political education upon himself. She remembered him delivering his lectures on the Russian Revolution in the upstairs library as the two of them curled up by the porcelain stove. As he explained to her enthusiastically the complexities of dialectical materialism, she could see on the wallpaper behind his head a depiction of the Rape of Persephone. In future she would always associate the Russian Revolution with Persephone's inevitable return in the spring.[6]

Fear lay just beyond the grounds, but within the villa, camaraderie and benevolence reigned. All the residents understood how privileged they were to have found this place.

One night the housekeeper, Rose, got so drunk that she fell down the staircase and lay in a heap at the bottom covered in red wine and vomit. The normally fastidious Breton picked her up gently and carried her upstairs. A half hour later he descended, commenting that poor Rose hadn't broken anything. When the others expressed astonishment at his diagnosis, he remarked: "But I'm a trained doctor." They hadn't known.[7]

It was probably Fry who benefited most from the refuge of Air-Bel. At CAS he had a reputation for being stiff-necked. To the refugees he often appeared remote, even though he always listened attentively, but this formality was mostly a front he kept up to inspire confidence. At the villa something of the surrealists' anarchy rubbed off on him. Mary Jayne grew to appreciate him as a great joker, always looking for relief from the bleakness around them. He even bought himself a

poodle, which he called Clovis. At night in the villa he could dance as
hard as anyone.

Fry kept work at the office and life at the villa scrupulously sepa-
rate. He was careful never to speak of any of the committee's clan-
destine activities—whether it was helping the soldiers of the British
Expeditionary Force trapped in Marseille to escape, or smuggling
out lists of the names of those too famous to be openly mentioned in
telegrams to New York. The lists were carefully hidden in toothpaste
tubes in the luggage of refugees leaving and willing to take them out.
These people were instructed to take the tubes to designated individu-
als in Spain or Portugal who could then send the names on to the
Emergency Rescue Committee for processing.

Of course, Fry's secrecy was a bit of a ruse, since it was pretty clear
to most of his staff what he was up to. One night Mary Jayne returned
late to Air-Bel and noticed light coming from under the dining room
door. Fry came out and asked if there was any chance of finding a bit
of food in the pantry. He said he had guests and they were hungry.
She was about to retort that everyone was starving when she heard
muffled English voices from behind the door. She stumbled to the
kitchen where she found some wine, stale bread, and a bit of sausage.
When she knocked at the dining room door, Fry accepted the tray of
food but did not invite her to enter. The next morning she asked if the
men had been British officers. Swearing her to secrecy, he admitted
they were and told her the sausage had been good. "It was horse," she
said. "Never mention it," she joked.[8]

Fry wrote to his mother that he had found "peace and quiet at last,
after three months of the most gruelling work I have ever done in my
life. Almost drowned in a flood of anguished human beings in search
of advice and help."[9] He also wrote to his father:

> It's too bad there's a war, because we could all live here in
> Marseille in surroundings which are not far from perfect. . . .
> [We have] one of those magnificent views which only the Medi-
> terranean can boast, a view of pine trees and olive trees, dark

green and light, of soft red tiled roofs, of mist and the fascina-
tion of distance, and back of it all the rugged grey limestone
mountains which surround the Marseille area like a great
amphitheatre. The whole view is framed by a neat box hedge
at the bottom, by the trunks of the cedars right and left, and by
the graceful, feathery branches above . . . The only trouble is
the war.[10]

Fry had long been a member of the Audubon Society, and on Sundays, if he had a moment to relax, could often be found tramping around the villa's grounds with Danny or Victor Serge, bird watching and taking inventory of the flora and fauna.

He became close friends with Stéphane Hessel, the twenty-three-year-old son of a refugee family whom he had met in October. The father, Franz Hessel, had co-translated Proust into German with Walter Benjamin. Years later, Stéphane told Fry's biographer Sheila Isenberg that he had "nursed" Fry through periods of depression—there was so much work, never enough money, and never enough visas. "When he was tired and despondent because life was not easy for him, then I would come and cheer him up."

The two men took Sunday excursions into the countryside to hunt down Romanesque churches. They talked about marriage—both were married. Hessel remarked that Fry "had the bearing of a husband who was not entirely satisfied." Theirs was, he said, "a very close companionship between two young men, not particularly homosexual, although there was physical nearness, closeness, hugging of each other." "It isn't something where we were physically close to the extent that we wanted to sleep together. But we were close enough to feel that we were not only soul mates, but we were also buddies."[11]

Under the pressure of wartime many people found both soul mates and bed partners. Marcel Verzeano recalled that "Varian liked good looking women and occasionally had an affair of very short duration. That was true of all of us."[12] Mary Jayne Gold was waiting patiently for Raymond Couraud to be released from prison. Miriam

Davenport, who had stayed less than a week at the villa before leaving
for Yugoslavia, was now crossing Fascist Italy to reach her lover. And
Jean Gemähling periodically took himself to bed for a week to nurse
his latest broken heart.

André Breton watched all the dramas with tolerance. He had
his muse in Jacqueline and his business was writing. During the
day he installed himself in the greenhouse where it was warmest
and worked on his new poem, *Fata Morgana*. It was a love poem
named for the Arthurian enchantress Morgan le Fay, whose great
skill was the art of shape shifting. He later told the American poet
Charles Henri Ford: "This poem states my resistance, which is more
intransigent than ever, to the masochistic enterprises in France that
tended to restrict poetic freedom or to immolate it on the same altar
as other freedoms."[13]

It had fallen to Breton to deal with the landlord, Dr. Thumin, who
could usually be found skulking around his vast holdings, checking
to be sure his tenants had not stolen his sticks of firewood. Thumin
often insisted that Breton accompany him to his house to view his vast
collection of fifteen thousand butterflies. Breton went and not just to
placate the landlord. He was fascinated.

As he bounded from one display case to another, describing to
Breton his prizes, their Latin names, the nervous system of one, the
wing sheath of another, the brittle and ill-tempered old man's voice
changed. Suddenly, through Thumin's words came visions of the blue
skies, the prairies and savannas where his specimens had been cap-
tured and from where they had been transported to this dark room.
When the tour was over, he immediately resumed his landlord per-
sona, leaving the poetry of birds and butterflies behind him.[14] It was
stupéfiant, Breton told his fellow residents at Villa Air-Bel. In the per-
son of the old landlord, it was as if the living imagination had been
locked inside a sterile bourgeois propriety in a manner so unstable
that something would have to explode. For Breton, Thumin was an
allegory of the fate of France; he loathed the bourgeois propriety that
locked the imagination in a dark sealed room.

Like Breton, Victor Serge never stopped writing. In his squalid quarters in old Marseille where he hadn't even had a table, he continuously wrote. The villa was an unexpected luxury. He worked in the library with its nineteenth-century wallpaper depicting classical scenes that spread like frescoes on the walls: the flight of Aeneas, Athena and the Muses, the Rape of Persephone.

Serge was certainly a kind of Aeneas. This was his fourth exile, his seventh flight in twenty years. All his close relatives in Russia had been arrested, including brothers-in-law and sisters-in-law. They had not been heard from again. His eldest sister and his mother-in-law had been deported and he never knew to where. Serge believed that secret agents of the OGPU, Stalin's state police, were still shadowing him.

It says a lot about Victor Serge's integrity that he asked no special favors from Fry. When he needed to discuss his visa problems, he got on the tram for Marseille and waited in line on the stairs of the CAS office on rue Grignan, like everyone else.

In Marseille he had almost as much to fear from the Vichy police as from Stalin's secret agents. During the last few months he had twice been caught in street roundups, but in the general chaos, so far he had always been released. When he was with Mary Jayne or Danny, they often remarked that he never walked without looking over his shoulder and that he sat only in the corners of cafés, with his back to the wall. People couldn't help but notice how he was always asking his companion to forgive him. He explained: "It's an old Bolshevik habit, a habit one does not lose easily."[15]

As the days passed brutally slowly, Victor Serge worked on his novel, *The Case of Comrade Tulayev*. Fueled by anger and bearing witness, he was re-creating the days in Moscow when Stalin's show trials and the purges that followed had destroyed the best minds of his generation. He was a calm, benevolent man, with "courtly old-school manners" to match those of André Breton. He had been nicknamed "the Wall" for his tendency to slink by without being noticed.[16] But Serge believed books had to be "thunderbolts, full of merciless indict-

ments."[17] In *The Case of Comrade Tulayev* he raged not only against the past but also against the present:

> *Tell them that I'll yell at the top of my lungs, that I'll yell for all those who didn't dare yell, that I'll yell by myself, that I'll yell underground, that I don't give a shit for a bullet in my head, that I don't give a shit for you or for myself, because someone has got to yell at last.*[18]

MARSEILLE III

October 1940

T he city of Marseille was becoming more and more unfamiliar. With gas rationed, there were almost no automobiles in the streets and the quiet was unsettling. As if time had turned back on itself, wagons and horse-drawn carriages filed down the empty boulevards. The cafés on the Canebière were crowded, ringing like any port with a dozen different languages, but laughter was rarely heard. People seemed groggy, paralyzed.

The newsstands were piled high with newspapers and magazines, but they carried only propaganda, and anyway half of them were in German. The shop windows were full, but there were no customers because everything was rationed and few could legally get enough coupons, even for necessities.

By the end of October, almost overnight, certain shopkeepers had blatantly begun to display the sign *"Entreprise Française"* along with large photos of Marshal Pétain in their windows. It was the same anti-Semitism as in the occupied zone. There Jews were obliged to post signs identifying "Jewish" enterprises, but this was more hypocritical. The storeowners attempted to justify themselves by explaining it was

20. Marseille — Rue de la République

Vintage postcard—Marseille, rue de la République.

simply that, after all, Jews weren't quite French. The Légion des Anciens Combattants had begun marching in the streets shouting slogans of *Vive la France* and *La France aux Français*.

Marseille was becoming more dangerous every day for foreign refugees. One needed the right papers to move about freely. Any foreigner caught without a *permis de séjour* (residence permit) and a *sauf-conduit* (travel pass) could be picked up and immediately sent to a forced labor camp. It was safest to stay put, hoping to evade the police who continually staged random *rafles*, or roundups.

Four hotels in the city, the Hôtel Bompard, the Hôtel du Levant, the Hôtel Atlantique, and the Hôtel Terminus des Ports, had been turned into internment centers for women and children, mostly Jewish and Spanish.[1] Many of the women had husbands in internment camps such as Camp des Milles, waiting for international visas, usually for the United States or Mexico, with which they hoped to get special exit visas for leaving France.

Some hotels held as many as 250 people. They were crowded, vermin-infested, and unhygienic. And the saddest thing was to see the children. Relief organizations intervened as much as possible, provid-

ing classes and teachers for them. But there was little time for school-
ing. Since the guards permitted only children to leave the premises,
their mothers were constantly sending them out to hunt for food or
with letters for their fathers interned elsewhere in Marseille or as far
away as Aix-en-Provence.

Because refugees could be squeezed for money, corruption was
rampant. The Hôtel Bompard was especially notorious. As soon as the
first refugees began to arrive in Marseille, a number of the women
were arrested, with no effort to justify such an action. They were con-
fined to the Hôtel Bompard, where they stayed until their relatives
were able to scrape together enough money to ransom them.[2]

By the end of August of 1940, the Kundt Commission, in the in-
terest of tracking down anti-Nazi refugees, had identified ninety-three
internment camps in unoccupied France.[3] According to Vichy's own
statistics, which were grossly deflated, there were 41,500 interned
aliens in France and its African colonies, 29,000 of these in France
proper: 15,000 Spanish Loyalists, 9,000 German refugees, and 5,000
nationals from forty-two different countries, the majority of whom
were Czechs and Poles.[4] A more accurate statistic would suggest that
there were 50,000 prisoners in internment camps in France itself.[5]

When he arrived in France, Varian Fry had been stupefied to learn
of the existence of the internment camps and even more shocked to
receive numerous letters from individuals on his "first" list who were
being held behind barbed wire. He had sent endless cables to Wash-
ington to protest the unspeakable conditions in the camps, but had
had no response.

In November he asked Danny Bénédite to undertake an inquiry
into conditions in the camps. Danny's mission was to track down
CAS's clients and to find out how to obtain their freedom. He would
also write a detailed report, including testimonials from the internees,
to be sent, as a form of protest, to the Vichy and American govern-
ments.

In this, as in everything, Danny was thorough. He first identi-
fied the numerous kinds of camps. There were about fifteen *camps de
prestataires*—forced labor camps that held between twenty-five

thousand and thirty-five thousand male refugees of fighting age who were organized into work details.[6] There were various *camps d'hébergement*—like Gurs, Bram, Rieucros, and Noé, which held individual refugees and refugees' families, often arbitrarily designated as being without resources or permanent domiciles. There were the *camps de rassemblement*—Saint-Cyprien and Argelès, where, two years after their escape into France, Spanish refugees, both soldiers and civilians, were still being held. There were *camps d'internement*, like Le Vernet, for undesirables, Communists, extremists, and anyone designated to be a threat to public peace or "injurious" to national defense. Conditions in Le Vernet were the worst. And finally there were the *camps de transit* like Camp des Milles, reserved for those refugees who had finally found a country willing to take them and were only awaiting French exit visas.[7]

Danny's tour included Camp d'Argelès near Perpignan. He was surprised that a simple certificate from CAS was sufficient accreditation to gain him entry. To his horror, he discovered that the camp still held thousands of Spanish refugees—those same people whose exodus out of Spain he had worked so hard to facilitate in 1939. In his memoir he recorded what he saw: "A medium wind, blowing in gusts, lifted waves of sand that insinuated themselves through the floorboards, penetrating the clothes, the hair, the eyes, the nostrils. It must have driven people crazy when the tramontane blew! A miserable humanity, ragged, filthy, wretched, peopled these great empty spaces where no vegetation grew. The food was notoriously insufficient, at base the skimpy remains of vegetables; hygiene was non-existent; the water . . . tepid and brackish."[8] As he walked through the camp in his warm fall coat, Danny felt sickened to see thousands of men, women, and children squatting listlessly in the sand, their thin bodies wrapped in canvas lacerated by the wind.

He also went to Langlade, a forced labor camp where conditions were somewhat better. The barracks didn't seem to be that different from those of ordinary French soldiers. The men said the food was adequate and the guards not particularly ill-disposed. The worst thing was the enforced idleness.

Le Vernet was closed to all visitors, but before returning to Marseille, Danny decided to visit Bram near Castelnaudary, where another five thousand prisoners were interned. He had been so appalled by Argelès that Bram seemed almost acceptable. While the internees were clearly undernourished and lacking in medical facilities—there was endemic dysentery and several cases of typhoid—they reported to Danny that at least the guards weren't sadistic. "Here we have to be content with small mercies." In the vicinity of Carcassonne, Montpellier, and Toulouse there were seven camps holding a total of twenty thousand internees.

After his tour, Danny returned to Air-Bel shocking the residents with his account of conditions: people were starving, were living in fifth and disease, and were often treated with sadistic cruelty.[9] And people were dying. The women's camp, Gurs, where Helena Holzer had been imprisoned, held ten thousand women and children, five thousand of whom were Jewish, and an average of three hundred prisoners died each month. There were no drugs or medicines, and in their weakened state, people succumbed to heart disease, diabetes, pneumonia, malnutrition, enteritis, and whatever other brutalities the camp could inflict.[10]

The only thing to do was to go to Vichy to shame the government into improving conditions and allowing the sick and the women and children to go free. On November 13, Fry and a colleague left for Vichy, Danny's detailed report in hand.

Vichy is a small city on the river Allier known since Roman times for its healing springs. In the nineteenth century, the fashionable upper class went there for extended cures of rheumatism, arthritis, and digestive complaints. Fry felt as if he had stepped into a buffoon show; it was both depressing and ridiculous. In the grand hotels, hastily converted into government ministries, he spotted the sign "*Chef de Cabinet*" between two doors, one marked "*Hommes-Dames*" and the other "*Bains*" (baths). Black heating pipes snaked out of the windows of the ancient pavilions, drowning them in thick fog. Generals, admirals, and colonels, their decorations plastered on their uniforms like patchwork, strutted through the avenues.

After two weeks of incessant lobbying of members of the cabinet and other officials at the highest levels, Fry's attempts were futile. The Vichy government felt no embarrassment whatsoever at conditions in the camps. And a visit to the American embassy made it clear to him as well that his own government had no intention of intervening. Internment camps in France were a French internal matter. He'd expected his embassy to at least take the moral high ground and help him covertly. Instead they'd been openly hostile.

If Fry was outraged, he was not surprised that his own embassy seemed anxious to wash its hands of him. As early as the end of September, the U.S. consul in Marseille, Hugh Fullerton, had called him into his office to inform him that Vichy was "uncomfortable" with his and Frank Bohn's "refugee work." Although Vichy had filed no formal charges, Fullerton had taken the initiative to cable the complaints to Washington. He had shown Fry the State Department's reply:

> This government cannot countenance the activities as reported of Dr. Bohn and Mr. Fry and other persons in their efforts in evading the laws of countries with which the United States maintains friendly relations.[11]

What had worried Fry most was the subtext of the cable. What unlawful activities had Fullerton attributed to his committee and who were the "other persons" he had identified? Fullerton refused to answer Fry's questions and dismissed him from his office, but not before informing him that he thought the Nazis would win the war anyway.[12]

Fry left the town of Vichy deeply depressed. His country wanted to maintain friendly relations with Vichy, even as Vichy seemed bent on turning the unoccupied zone into a vast and heartless prison.

THE COMMANDANT

On Monday, November 4, a few short days after the Villa Air-Bel was rented, Miriam Davenport left for Yugoslavia and, though she hoped to return to France with her fiancé, they were repeatedly denied visitors' visas. Without Miriam, Mary Jayne felt lost and anchorless. CAS was giving her less and less to do.

She was still providing them with a great deal of money. When she first joined, she had donated five hundred thousand francs (five thousand dollars), and by December she'd increased that amount by another two hundred thousand francs.[1] As well, she and the committee had devised what she called a "confidence game in the good sense of the word." There were always wealthy people who managed to get themselves to Lisbon, often by bribing Vichy officials for the necessary exit and transit visas. Able to prove that they were financially independent and rarely compromised by past political activities, they didn't need CAS's help in getting the affidavits and other documents required to get U.S. visitors' visas. These people wanted to get as much of their money out of France as they could. Mary Jayne would inform her broker to deposit a certain amount of money in a New York or

Chicago bank in the name of one of these individuals. Once word reached Lisbon that the money had indeed been deposited, the individual would arrange to hand over the equivalent amount to CAS. "I didn't need money for myself," Mary Jayne explained casually. "I was living very simply."[2]

Though she always remained truly generous in her donations to the committee, she had a feeling of being excluded from their more important activities. Looking back, she remarked a bit nostalgically: "You know, a woman wasn't very important unless she'd had a career. Miriam was doing graduate work and she was . . . well I'd never done anything, you know, so I wasn't given much to do. If it had happened in another generation I mean I would have taken it for granted that I would be given a little more to do."[3]

But before Miriam left, one questionable assignment did come Mary Jayne's way. Varian Fry's old friend in New York, Paul Hagen, coorganizer of the luncheon that had led to the establishment of the Emergency Rescue Committee just five months previously, wrote to say that he had arranged American emergency visas for four friends. They were members of a German Social Democratic group called Neu Beginnen, which he had helped to found. The problem was, the men were interned in Le Vernet concentration camp. Could Fry get them out?

Because the American embassy demanded that all individuals pick up their own papers in person, concentration camp prisoners with American visas were often issued travel passes (*sauf-conduit*) to visit the consulate in Marseille, under armed escort. Both the consul and Fry had written to the camp requesting temporary release of the four prisoners but they had received no reply. It was clear that, even though the prisoners had American visas, Vichy, either assuming or knowing that the Kundt Commission had designs on them, was not about to release them. With Miriam and Beamish, Fry came up with a more desperate plan.

Miriam and Beamish invited Mary Jayne to Basso's on the quai des Belges, and, over Cognac, they presented her with a proposition. Beamish spoke of the terrible conditions in Le Vernet. This was the

camp for the most undesirable prisoners. It was hedged with barbed wire, and anyone caught escaping was shot on sight. Would she, they pleaded, visit the camp and appeal directly to the commandant to release the prisoners? When she asked why her, Beamish said that the commandant wouldn't be able to resist her beauty and innocent looks.

What they expected her to do was never openly stated. But she was worried. "I'm a lousy liar," she told them. Beamish persisted. "You're our best bet. *Ils jouent leurs têtes*," he said. Their lives were on the line.[4]

Mary Jayne was not fooled about what the others were asking. She had no idea what it would cost her to sleep with the commandant. Or if she did go to bed with him, what assurance would she have that the prisoners would be let out. Still, she agreed to try.

Traveling illegally without a safe-conduct pass, she set off by train for Le Vernet. She studied the map and rehearsed her story: she had cousins in the area of the camp. She was a friend of the prisoners' wives. Getting off at Le Vernet station, she stopped at the Café du Commerce across the road and, after fortifying herself with a Cognac and several cigarettes, she made her way up the hill to the camp. As she approached, she could see that its twin towers were fitted with searchlights and patrolled by soldiers carrying machine guns.

She was invited into the commandant's office. Before her stood a handsome, middle-aged man with slightly graying hair, clearly a career officer who had probably found himself at Le Vernet due to his administrative abilities. Nervous and yet intrigued, Mary Jayne babbled on until she thought to ask the commandant for a cigarette. Drawing on her cigarette and blowing out the match in his extended fingers, she was somehow able to convince herself she was playing the role of a heroine in a film. Her panic subsided and she explained her case with confidence. Assuring her he would examine the dossiers of the four prisoners, the commandant suggested dinner at a local inn and Mary Jayne accepted.

She was allowed to visit the four prisoners. Their emaciated condition came as a shock, but the men greeted her with grins. They talked

of the war. These were seasoned politicals, who had rigged up a short-wave radio in the camp and so were much better informed about the war's progress than she was. When she asked about their living conditions, they replied that at least the guards weren't sadistic, though one of them broke in: "You must admit, Dachau was much cleaner."[5]

What the commandant's intentions were Mary Jayne never discovered, for he missed their rendezvous. As she sat waiting for him to appear she wondered what she had done wrong. Perhaps he hadn't found her seductive at all. She was certain she had failed, and because she had drawn attention to them, the four prisoners were probably at that moment being deported to Germany. With a remarkable courage, she decided she needed to go back to the camp and try again.

When she was ushered into the commandant's office the next morning, he immediately apologized. Gestapo officers of the Kundt Commission had unexpectedly visited the camp the previous night. They were there, no doubt, to check the list of prisoners whom they intended to deport under the "surrender on demand" clause of the armistice. The officers had invited the commandant to dinner, an invitation he had been unable to refuse. He expressed his regret and gave his word as a French officer that the four men would be allowed to travel to Marseille. The commandant kept his word. Mary Jayne later met up with the four sitting casually with their guards in a café on the quai de Rive Neuve.

One evening a few days later, the men and their guards visited a cheap brothel on rue Dumarest. While their guards were otherwise occupied, the four joined Varian and Beamish in another room to plot their escape by boat from Marseille. Beamish had found a sea captain with an old boat who, for a bribe, would make the illegal crossing to North Africa. It proved easy to elude the guards, but unfortunately, the second night after sailing, *La Bouline*, the boat on which they were traveling, was spotted by the coast guard and the four were rearrested. Though this first attempt poved a failure, all four men eventually made their escape. Each expressed his eternal gratitude to the courageous Miss Gold.[6]

In early November Mary Jayne received word that Raymond Couraud's case was coming up for trial. His lawyer, Maître Bottai, assured her that the verdict would probably go in his favor. He added casually that a young man named Mathieu would soon be contacting her. He was someone Killer had met in prison.

Mathieu turned out to be a young Corsican. He was small and dark with cold blue eyes and a manner that was both aggressive and furtive. When he met Mary Jayne, he was obviously taken aback that Killer's story of his tony girlfriend turned out to be true. Over drinks in a bistro, where he seemed to be a well-known character, he got down to business immediately. Wartime desertion was a serious matter. Things would go hard for Raymond, especially as he had made his pro-Gaullist sympathies clear. She had best bribe the judge. She was told not to speak to Raymond's lawyer, who wouldn't want to be involved in a bribe. She was to hand the money over to Mathieu's contact, a retired general with connections and sympathies toward de Gaulle's government in exile.[7]

In the midst of war, where did the line between legal and illegal lie? Mary Jayne reminded herself that even Varian Fry had "a gift for illegality."[8] For a substantial sum of money, Mary Jayne bought the court. Or had she just bought Mathieu? Or had Killer and Mathieu always planned to divide the money between them?

Under the power of Maître Bottai's eloquent defense, Sergeant Couraud was given a six-month suspended sentence. Mary Jayne would never know whether the judge had received her bribe or whether it had ended up in the pockets of her lover and his friend. Within the week Killer was walking the streets of Marseille.

WE PROTEST AND RESERVE
ALL RIGHTS

Around midday on Monday, December 2, hearing the unusual sound of automobiles, Theo Bénédite looked out the window and saw a police car and two paddy wagons pull up to the wrought-iron gate of the Villa Air-Bel. Four plainclothes policemen dismounted. Distraught, she shouted up to the house's inhabitants: "Police!"

In a state of panic, they all made a hurried search of their rooms for compromising documents. Working at home that day, Fry was upstairs dictating a letter to his secretary, Lena Fischmann, when he heard Theo's shrill cry. He looked lamentably at Lena and hastily threw his address book with all the private addresses he'd accumulated into the fireplace and then, as an afterthought, added his secret account sheets. The two descended to the living room, where they found the rest of the household hastily assembled. The policemen marched into the house, and the inspector in charge of the raid herded everyone into the dining room. Confronting Fry, he thrust a piece of paper in his face.

Fry read it in anger. "This is a carbon copy of an order from the Prefect to the Chief of Police authorizing a search of all locations suspected of being involved in Communist activities," he said to the others. "It is not even signed." In a cold rage he turned to the inspector: "What nonsense is this?"[1]

"That's enough," replied the inspector gruffly. He turned to his men: "Search the house."

The search had barely begun when there was a sudden noise on the terrace. Danny and Jean Gemähling had just returned for lunch. As they approached the house, they were harpooned, as Danny put it, by two of the "flics" and roughly pushed into the dining room.

The inspector turned in their direction, first addressing Danny by his father's name: "Ah, Monsieur Ungemach, the anarchist," he said. When Danny made to reply, he added: "Be quiet. I forbid you to speak." And turning to Victor Serge, he remarked: "Monsieur Serge, or should I say Monsieur Kibalchich?" The inspector was making it clear that he knew Danny's father's name—presumably it was still on his file at the Paris prefecture—and also Serge's real name, though Serge had long abandoned it for his nom de plume. Clearly the inspector had dossiers on both men and probably on everyone else in the house, confirming that the villa had been under surveillance for some time.[2]

Danny looked about the room. Fry was obviously distraught and kept repeating like a madman in precise and controlled French: "We protest and reserve all rights." André Breton was pacing across the floor with an air of supreme agitation, saying over and over, "invraisemblable, grotesque, extravagant." Victor Serge was sitting in an armchair leafing through a book, as if suggesting to the others that they calm down. This was nothing new to him. Laurette sat stiffly beside him, attempting unsuccessfully to imitate his composure, while his son, Vlady, looked worried. Lena reported that they'd already checked her papers when they'd raided her hotel that same dawn and, for hours, kept everybody standing in the lobby in their nightshirts. Theo and Jaqueline tried to control the children, who had caught the spirit of

high tension in the room. The housekeeper, Madame Nouguet, sat immobilized in a corner, while Rose repeated hysterically that she hadn't stolen anything, and the Spanish nursemaid, Maria, looked petrified, concluding the police had finally come to take her off to a concentration camp for Spanish refugees.

The villa's inhabitants were told they would each be interrogated separately and were escorted upstairs to attend to the search of their rooms. "Unbelievable," shouted Breton as he and his wife were led up first.

When they returned, the police deposited their booty on the dining room table. The first item was a revolver. "What was this revolver doing in your drawer?" the inspector demanded of Breton. "I was a medical officer, authorized to carry it," he replied. The inspector shot back: "Carrying a weapon without a permit is a serious offense."

The police had also confiscated a small drawing, a collage of a face made from magazine clippings with the title: *"Ce sacré crétin de Pétain."* Breton told the inspector he was misreading it. It said *putain*—whore. "This damned idiot of a whore," he said directly into the policeman's face. "Tell it to the judge," the inspector replied.

In Serge's room, the police picked up the tiny revolver with the mother-of-pearl handle that he always carried when he left the villa in case he encountered the Soviet secret police. They also seized his typewriter and his manuscript of *The Case of Comrade Tulayev.*

They confiscated Danny's war journal, claiming it was full of ignoble attacks on French officers. "And you worked at the Paris Préfecture. You're a dangerous anarchist. We're going to hold you to account," the inspector said with evident malice.[3]

Finally they seized all of Fry's official papers, including his and Danny's reports and notes on the internment camps in France. They also confiscated his personal correspondence with Eileen and his mother and father, and his letters of recommendation. For Fry, this was an unforgivable assault on his privacy.

The inspector then asked to see the suitcase that had been delivered to the villa by a porter the previous night. Everyone looked puzzled until Jacqueline said: "Yes, my sister is coming for a visit and

has sent her suitcase ahead." The suitcase was produced. From the careful way they handled it, the police must have been expecting a bomb. They seemed disappointed to discover it contained only children's clothing.

Into this confusion burst Raymond Couraud. "Chérie," he said as he ran to embrace Mary Jayne. He was on leave and had come to take her to Marseille. He was wearing his uniform and service revolver, and carrying a suitcase. For once his papers were in order, but the blanched look on his face suggested he had other troubles. He managed to take Mary Jayne aside long enough to tell her that he had forty thousand francs' worth of stolen money orders in his suitcase.[4]

Terrified, Mary Jayne turned to Victor for help. He was the only one who tolerated her boyfriend. The others had already made it clear that they thought of Couraud as a shady character. Victor told her sternly that Killer must dispose of them. Mary Jayne begged Jaqueline to distract the police for a moment. While she did so, Killer managed to remove the money orders from his briefcase and hide them behind a Chagall painting. Just in time, in fact, as he and his suitcase were thoroughly searched and his revolver confiscated. For this he demanded a receipt: "A Legionnaire is responsible for his arms," he bluffed.[5] His bravado was outrageous. He, and by association Mary Jayne, had just put the whole house in a disastrous position. Nothing would have satisfied the inspector more than to have arrested them all for trafficking in stolen money orders.

Jacqueline, Theo, and the servants, who were left behind to care for the children, watched in disbelief as the rest of the villa's residents were piled into the waiting police van. To calm Fry, the inspector said: "There is absolutely nothing against you. No suspicion of any sort. But you would oblige me by accompanying the others, merely as a witness. You will be able to return to your work within an hour. I give you my word of honor that I will not detain you longer."[6]

Only Serge managed to maintain his composure. He climbed into the van with a small valise, which he placed carefully on his knees. It contained toiletries, a few old books, and a change of linen. To Fry, who was sitting beside him, he explained that he never went to prison

unprepared. He warned Fry that when an inspector says a few hours, it usually means a few days, a few weeks. "At least you're an optimist," Fry replied glumly.[7]

The group was driven across the city and into a courtyard where the van finally came to an abrupt stop. They could hear the clank of iron gates shutting behind them. When they got out, they discovered they had been taken to the Evêché in the Vieille Ville, now serving as police headquarters. They were herded under armed guard into a large attic room for processing. After their names were recorded, they were led into a much larger room where Fry was chagrined to find many of CAS's clients, also under detention. His first thought was that it would be hard on their morale to see their protectors in the same predicament as themselves. "I am an American citizen," Fry raged. "I demand to be allowed to communicate with my Consul." His demands were peremptorily ignored. He confessed shamefacedly to Danny that he was feeling "the high indignation which Americans sometimes feel when they are not treated as superior beings in foreign lands."[8]

It soon became clear that the police were most interested in the French nationals. André Breton was pulled aside and subjected to the severest interrogation. He had a police record. In his youthful days as a surrealist in Paris, he had been arrested twenty-five times for "disturbances of the public peace."[9]

Danny was also the object of particular attention. His war journal was read for proof of treasonable pro-British sentiments. He was told the journal would be held as evidence against him. He never saw it again.

By eleven o'clock that night, orders came to evacuate the Evêché. In the pitch dark, the hundreds of men and women in the room were herded into a dozen trucks that stood idling in the courtyard, their engines rumbling. Though the occupants could see nothing in the blackness surrounding them, it seemed that the trucks were heading toward the nearby quays. Did this mean deportation? To camps in the east? To forced labor gangs in North Africa? The terror in the whispered queries was palpable.

The trucks finally stopped beside a dilapidated steamship called the S.S. *Sinaïa*, docked in the port. Flanked by armed guards, the women were directed up the gangplank to the third-class cabins while the men were taken to the hold. A headcount revealed that there were 577 internees on board the *Sinaïa*.[10]

As he climbed the plank, Fry was astonished to note that this was the very ship on which he had crossed the Atlantic more than a decade before when he had been a Harvard undergraduate visiting Greece.

The most frightening aspect of the ordeal was that no one had any idea why they had all been arrested. That night those who could slept in their clothes on burlap sacks filled with straw. As the hatch remained uncovered, they could at least see the stars. In the morning the group managed to reunite and Breton collected their food—black bread and a tin pail half full of a brown liquid meant to be coffee. That night dinner was a foul-smelling lentil soup. When Mary Jayne balked at the prospect of eating it, Serge took charge. He convinced her that the white things floating in the disgusting brew were not worms but most probably sprouted chickpeas. "One must eat everything one can get down," he told her. "And hold it down."[11] One never knew if there would be a next meal.

On the afternoon of the second day, orders were suddenly given to herd all prisoners under deck. Then the hatches were locked. The prisoners stood in terror, crammed like bait in the dark hold. Above their heads the bizarre sound of whistles pierced the air and the weight of footsteps battered the decks. Rumors spread quickly that they were definitely being transported to forced labor in the colonies.

Among the frightened prisoners were many Jews who had heard of deportations to German concentration camps. They expected to be singled out. They were going from one person to another, anxiously asking if they were Jewish. Mary Jayne remembered the courtesy of Serge's response, "It happens that I am not."[12] Finally, that evening, without explanation, the hatches were opened again.

The first day on board the *Sinaïa* when they had been free to walk the decks, Fry had tried to get word of their detention to the American consulate by dropping a message wrapped in a banknote over the side

of the boat. A small boy had picked it up. Clearly the boy had indeed delivered the message since, on the third day of their detention, Vice-Consul Hiram Bingham arrived carrying ham sandwiches for the residents of Villa Air-Bel. He assured them that he was doing everything he could for them. He had called the prefecture numerous times, but he was unable to find out either the charges against them or how long they would be held. Bingham vowed he would continue to do his best and left.

On the morning of the fourth day, they still had no idea what their fate might be. Then about ten o'clock, a group of detectives boarded the ship with sinister-looking dossiers under their arms, and, installing themselves in the first-class lounge, began summoning individuals by name. The group from Villa Air-Bel was called at noon. They had been held, they were told, because they had been identified as being a threat to public order. And were summarily dismissed.

As they descended the gangplank, they suddenly realized Danny was not with them. He had been kept on board. Deeply anxious, they made their way to the nearest tram station through armies of street cleaners sweeping up confetti and paper ribbons. Fry thought to send word to Captain Dubois, his friendly contact at the Préfecture de Police.

Taking Fry's secretary, Lena Fischmann, with him, Dubois went immediately to the *Sinaïa* and used his authority to secure Danny's release. The three then drove to the office on rue Grignan, which, much to Lena's and Danny's relief, had not been searched. "Why didn't you call me sooner?" Dubois asked him. "I would have got you all out."

Captain Dubois explained that there was no mystery to the group's detention. In the last few days, Marshal Pétain had been making an official visit to Marseille. As a precaution, the police decided to pick up all civilians whom they considered suspicious, especially foreigners. The day before the marshal arrived, they swept the city and suburbs and arrested thousands of people. Four boats as well as soldiers' barracks and the largest cinemas in the city had been requisitioned to serve as jails. The sweep had been indiscriminate.

When the prisoners aboard the *Sinaïa* had been forced below deck, it was probably because the marshal's cortege had visited a naval hospital on a neighboring quay.[13] The sight of a prison ship would have marred the parade.

Still, Dubois speculated, it was also possible that a neighbor had denounced the villa's residents. Most of the house's inhabitants were foreigners and hardly inconspicuous. And the villa was well placed for anyone contemplating sabotage. The Marseille rail line passed through a tunnel just beside Air-Bel, and the marshal had been due to arrive by train. Eight years earlier, a bomb targeting a visiting dignitary had exploded in that same tunnel. The conspirators had never been found.

Perhaps the worst part of the whole ordeal was the impact the incident had in New York. On December 4, two days after her husband's arrest, Eileen Fry received a letter from William T. Stone of the Washington Bureau of the Foreign Policy Association:

> Dear Mrs. Fry,
> The State Department has just informed me that Mr. Varian Fry was arrested by the French authorities yesterday and is being held incommunicado on a prison ship in the harbor of Marseilles. The American Consul at Marseilles is making every effort to reach him, but so far without success. The Department assures me that it will continue to do everything possible to effect Mr. Fry's release and to secure the necessary permission for his immediate departure for the United States. . . .
> Sincerely yours,
> William T. Stone[14]

The words were shocking: *incommunicado, prison ship.* Eileen Fry reeled at the news. Was Varian alone? Was he with others? What had he done? It was days before she learned what had really happened.

Most damaging was the reaction of the American consul general Hugh Fullerton. Instead of protesting the violation of the rights of American citizens, he sent a cable to the State Department in Wash-

ington, who passed it on to the Emergency Rescue Committee in New York:

FRY AND MISS GOLD WERE TAKEN INTO CUSTODY PRIMARILY BE-
CAUSE THEY WERE ARRESTED IN SUSPICIOUS CIRCUMSTANCES
AND IN SUSPECT SURROUNDINGS STOP THEY ARE IN COMPANY OF
A SUSPECT PERSON (ADEREK LEYYU) AND CERTAIN OTHER INDI-
VIDUALS WANTED BY THE POLICE STOP[15]

This was a patent lie. Who was Aderek Leyyu? No one had ever heard of him. The incident was the clearest indication yet of the hostility of the Marseille consulate toward Fry and his work.

Though he had written to his mother describing the arrest as a "drole experience—harmless but intensely annoying,"[16] it had in fact been a terrible shock. He wrote to Eileen:

To me accustomed to the principles of Anglo-Saxon and Roman law, this was one of the most surprising and shocking experiences of my life. To be searched without a search-warrant, arrested without a warrant for arrest, held incommunicado, and then released without ever having a charge brought against you—surely this is enough to make you wonder where you are. I understand that that sort of thing is common in Russia, but this is the first time I have heard of it in France.[17]

Immediately upon his release, Fry telephoned to report details of the arrest to the American Press Association at Vichy. He was demanding a formal diplomatic protest, an investigation, and an apology from the French government. Of course he got none of these.

"It is now utterly impossible to consider leaving [France] until the apology has been made," he wrote Eileen, somewhat disingenuously."[18] He knew that she wanted him home, but the truth was he wasn't yet ready to leave France and was using the arrest as what he hoped was an acceptable excuse. In the end he didn't regret the

whole experience aboard the *Sinaïa*. He wrote to his mother that it had given him an "appreciation of what the thousands and thousands of refugees in French concentration camps go through."[19]

Now that the ordeal was over, Danny and Theo had time to be absolutely furious with Mary Jayne. Just before the group was taken away in the police van, Mary Jayne had managed to speak to Theo and told her about the stolen money orders hidden behind the Chagall. Theo was enraged. Afraid the police might return for a second search, Theo had buried the money orders outside the house under a mound of leaves. The next morning, she just managed to stop Dr. Thumin from setting fire to the whole lot.

It didn't seem to register with Mary Jayne that, had the stolen money orders been discovered, it would have jeopardized not just the villa's residents, but also the entire committee and the refugees who depended on them. Or that by tolerating Killer's illegal activities, she was compromising everyone. Danny and Theo knew that they should ask her to move out of the villa immediately. The fact that they didn't do so spoke of just how desperate CAS was for her financial support. Or perhaps because there was such a long history of friendship between Danny and Theo and Mary Jayne, they convinced themselves this was a one-time lapse. In the future she would have to be much more careful.

When Mary Jayne reported to Killer how Theo had just managed to save the money orders from Thumin's bonfire, he laughed and said they were lucky: "If we'd lost them, Mathieu would have blown us all up."[20]

THE HONEYMOON

The afternoon of Mary Jayne's release from the S.S. *Sinaïa*, Raymond Couraud arrived at the villa to take her to Marseille for their long-anticipated "honeymoon." That's how she thought of it. She was clearly in love, but whether with him or the dangerous adventure he represented, she didn't yet know. Together they climbed the narrow streets of the Vieille Ville to the seedy Place des Moulins, full of prostitutes and underworld characters, just to get the whiff of danger.

Mary Jayne expected Raymond would soon return to active duty with the Foreign Legion in North Africa and always assumed their time together would be romantically short. But the next thing she knew she was being sent out to buy him civilian clothes. He was deserting again. He said he was going to team up with Mathieu, who was part of a Marseille gang called the Guérini, with whom, in fact, Fry's team sometimes laundered money. To counter any scruples she might have about him associating with criminals, he assured her that the Guérini gang was pro de Gaulle and secretly helping the Allies.[1]

She and Killer took a room in a *maison de passe* where rooms were normally rented by the hour. They called it the "nest" and soon the proprietress, taking Mary Jayne for an Englishwoman and possibly an English agent, was reporting news she heard from the BBC on her clandestine radio. Mary Jayne domesticated the room with a bamboo stand and books, and the madam brought tea. After he returned from his secretive missions, the two lovers would sit on the floor and drink their tea. At night she often had to nurse him through nightmares of the war.

To Mary Jayne, it was a scandalous and romantic time, but she was being gradually seduced into Killer's shady world. She and Killer were invited to the apartment of Mathieu and his girlfriend, Odette, where Mary Jayne was introduced to the local pimps. Much of her energy went into pretending she wasn't shocked, but there were shocking encounters.

One evening the foursome went to an elegant apartment overlooking the sea where she was told the guests were *"des gens biens"*—the upper class.[2] One young man worked for the Minister of the Interior. As Mary Jayne watched, he rolled up his sleeve, exposing an arm filled with needle marks. This was the first indication she had that Mathieu dealt in drugs. Seeing her in conversation with another man, Killer exploded in a fit of jealousy—these people he thought of as being in Mary Jayne's class threatened him. Later he apologized: "I'm so afraid of losing you. I've never had a girl like you." She found him endearing.[3]

In this company, Mary Jayne's version of herself was that she was plucky and full of bonhomie. In fact she was astonishingly docile and acquiescent. She made no moral judgments and never censured Mathieu's activities. As for Killer, she seemed to forgive him everything. He had "crazy, unprincipled ways" but these showed his "panache" or were simply his "endearing frailties."[4]

In fact, the relationship was about power. Killer always refused to say what he was doing. He might simply have been going to the pharmacy to buy medicine for his malaria attacks, but she was not

supposed to question him. He was training her and she was a willing student.

Killer intuited that the mention of money made Mary Jayne feel guilty, and he exploited this. Early in their relationship, she had set out to buy an extra bed for him, which she intended to install in her room at the Villa Air-Bel, but all she could find was a cot with a straw mattress. Since she assumed that Killer would shortly be called back to the Foreign Legion, she'd bought it without a second thought.

He was furious and accused her of buying him second-rate stuff while giving all her money to "those no-good intellectual refugees, who were mostly dirty *Boches* anyway." Instead of being angry, Mary Jayne burst into tears, feeling half guilty that she hadn't bought him something better and yet feeling the refugees deserved all she could give them. Astonishingly, she apologized.[5]

Killer hated the residents of the Villa Air-Bel, especially André Breton, in whose presence he was clearly outclassed. It triggered in him a reaction of cockiness, and he would contemptuously dismiss Mary Jayne's intellectual buddies.

His hostility was juvenile and dangerous. On one occasion he and Mathieu came to the villa and absconded with Fry's dog, Clovis. Mary Jayne tried to convince the others that this was just a prank, though secretly she was worried that the two men might have been plotting to hold the dog for ransom. They returned it the next day.[6]

Several weeks later, the two broke into the villa at lunchtime. Like movie gangsters, they brandished revolvers supposedly concealed under their coats and hurled menacing insults at the group. What they were up to was a mystery since they didn't demand money or anything else. Mary Jayne "yelled at them to get the hell out" and the two men left. She told herself that Mathieu was putting Killer up to these pranks and she told Killer that he'd better "lay off the committee if he expected to continue with" her.[7]

Only Victor Serge seemed to accept Killer. He told Mary Jayne that Killer reminded him of himself when he was young.

Serge was referring to the fact that when he was twenty-one and living in Paris, he had become involved with a group of Belgian and

French anarchists called the Bonnot gang. They lived in a commune, and Serge was their street orator and propagandist, encouraging others to make their "own revolution by being free men and living in comradeship."[8] The gang engaged in what they called "illegalist" activity, which involved robbing banks, much like their later descendants the Black Panthers or the Baader-Meinhof gang. Like them, they had the public's sympathy as romantic revolutionaries until a bank manager was killed in a raid, and other atrocities followed. Serge disengaged himself from their criminality, describing their descent into violence as "a kind of madness" and a form of "collective suicide." But when the gang was arrested, he was sentenced to five years in solitary confinement as the "intellectual author" of the group. He was released in 1917 and expelled from France. But there was, of course, not the remotest similarity between Serge and Killer. Serge had been caught up in their youthful, if terribly misguided, ideological enthusiasm to change society. Killer's only concern was himself.

Nevertheless, in Raymond Couraud, Serge saw a young man who was a product of his class and the victim of the fratricidal patriotism of the war. Couraud had fought bravely and had been decorated, and yet, like all the common soldiers, he discovered that, for the elite officer class at least, he was expendable cannon fodder. Couraud had a right to his cynicism.

To most others who encountered him, however, Killer was simply a foul-mouthed petty criminal. He had lied to Mary Jayne about his age. He was in fact only twenty, not twenty-eight, as he claimed to be. He had been on his own since the age of twelve, a street urchin abandoned by father and mother. Yet beneath his cynicism and bravado, there was a kind of sincerity and a foolhardy courage. For Serge and certainly for Mary Jayne, a brutal childhood, class hypocrisy, loneliness, and war accounted for Raymond Couraud's temperament. Both were ready to forgive him.

Mary Jayne seemed trapped in terrible confusion. She could not make a distinction between Killer's world and that of the committee. On the one hand, she loved working for the committee, which was involved in the dangerous and idealistic work of saving people. On the

other hand she was in love with Killer, and, in spite of herself, she was also attracted to his outrageous gangster activities.

Forty years later, when she tried to explain herself to herself, she looked for a psychological explanation. She recalled her authoritarian father who demanded perfection; her bullying and yet loyal brother; a code of honor inculcated early—that of hating the snitch or the stool pigeon. She tried on many confusing and futile explanations for why she was drawn to Killer. There was a special connection between them and something in herself that she could identify in him. Perhaps his loneliness and his rebelliousness. She would stay with him. She was stronger than he was. She could save him.

POLICE REPORT

On December 24, 1940, a letter arrived on the Marseille desk of the prefect of the Bouches-du-Rhône. The stationery was boldly embossed: *État Français*: the Cabinet—the highest level of government. The letter was from Monsieur le Ministre, Secretary of State for the Interior and Director of Police in Charge of the National Territory and All Foreigners, Chief of Bureau Seven. It was curt:

> *I would be obliged if you would send me all information in your possession, or which you can obtain, on the "Centre Américain de Secours" located at 60 rue Grignan, Marseille.*
>
> *I would also request an inquiry on the file of Monsieur Varian Fry, director of the said association.*
>
> *I expect your reply by the next courier.* [1]

On December 30 the prefect returned his report. He made it clear that Fry had been the object of police surveillance from the moment he descended the steps of the gare Saint Charles.

The prefect itemized his report:

I. ACTIVITIES OF THE CENTRE AMÉRICAIN DE SECOURS: This organization had as its original mandate the saving of elite intellectuals forced out of their countries, has favoured their liberation from the camps, their exit from France, and their entrance into America, meanwhile offering them financial assistance. In reality, the committee has rapidly enlarged its actions in a manner that calls into question its intentions. It is certain that they do not always follow legal procedures in obtaining their aims. . . . The Centre also supports foreigners of nationalities not interested in emigration. They give particular help to international extremists who would be viewed with the same suspicion by the United States as by France and the Reich.

II. RELATIONS BETWEEN THE CENTRE AND THE AMERICAN AUTHORITIES: It's certainly for this reason that the American government has concluded that the actions of the committee will nullify the good relations they wish to maintain with France and have demanded that M. Fry . . . return to the United States. The order to leave was given 25 September 1940. . . . M. Fry is still in Marseille.

III. ACTIVITIES OF M. FRY. HIS RELATIONS WITH THE FRENCH AUTHORITIES: The haste with which M. Fry has acted, the aggressively persuasive tone of the letters in which he does not hesitate to put forth the American opinion at the price of French interests . . . the threats if we do not accede to his demands . . . have put this bureau on its guard.

RELATIONS BETWEEN M. FRY AND THE POLICE: From the moment of his arrival in Marseille, he was classed "under

surveillance" by the Special Branch of Police . . . On 22 October 1940 an order was executed to investigate the centre for forging passports and trafficking in visas. . . . On the occasion of the President's visit to Marseille, the domicile of M. Fry was visited where were found M. Fry's habitual collaborators:

KIBALTCHICHE [*sic*], VICTOR, exiled, authorized to reside in France until 22 February 1941. Identified in the archives of the Security Services as an anarchist, capable [susceptible] of committing a terrorist act on the occasion of the visit to France of the King of Belgium 12 October 1938.

BRETON, ANDRÉ ROBERT, author of many works of an anarchist tendency.

The presence of these individuals near the old railway line at the La Parette Bridge where a terrorist attack was committed against the *train bleu* in 1932, was judged suspect. M. Fry and his collaborators [*hôtes*] were interned aboard the SINAIA. In addition, in the bedroom of M. Fry and those of his fellow boarders were seized a number of reports and typed documents in which the authors were critical of the regime in the camps, in a fashion dishonourable to the French government and also critical of the reasons and consequences of our defeat.

IV. RELATIONS BETWEEN M. FRY AND THE AMERICAN AUTHORITIES IN FRANCE: M. Fullerton, Consul General of the United States has visited me many times to discuss the case of M. Fry. . . . He has informed me that the US Embassy has ordered the Associated Press of America not to give in to M. Fry's demands and asked me to do whatever was necessary to rid him of the said M. Fry. He assured me that M. Fry would not hesitate to exploit his incarceration [aboard the *Sinaïa*] for propaganda purposes hostile to France.

v. CONCLUSION: Resumé: 1) M. Fry directs a work which, under the pretext of emigration, protects foreigners of doubtful morality and political tendencies unfavourable to the government of France.

2) Without acting in concert, the Police Spéciale, the Sûreté, and the Surveillance du Territoire have all been interested in M. Fry.

3) He frequents and receives Anarchists at his home.

4) Not only would the American government countenance action against M. Fry, but they would be happy to see his activities stopped.

In consequence, I propose that we expel M. Fry.[2]

This was a very dangerous document. Fry was not being accused simply of forging passports and trafficking in the sale of visas. His refugee organization was a pretext. He was really engaged in fomenting anti-state activities. His *hôtes* (fellows) at the Villa Air-Bel were suspected of terrorist acts and anarchistic tendencies. The document was a masterpiece of half truths and lies. The slander against the two writers was certainly absurd, which only made it more deadly.

At the Villa Air-Bel, the residents lived as most people do who are under investigation, that is, ignorant of the documents circulating above their heads. Over their communal dinners, they spent many evenings analyzing what they now called the *Sinaïa* episode. Had it been chance that brought the police to the villa on December 2? Other houses in the area had also been investigated, though, as far as they knew, no one else had been arrested. The teacher at Aube's school called to see the Bretons. "There are collaborators about," she said conspiratorially. "Not all the parents at the school are on our side." Apparently, that September, Aube had told her schoolmates that her father was sad at the death of the old man. When the children asked if she meant her grandfather, Aube replied: "No, it's Trotsky." "Someone could have reported you as Communists," the teacher said. The residents dismissed her anecdote.

But in truth, Breton was furious at his own and his friends' treatment at the hands of the Sûreté. "I refuse to stay in such a country!" he raged, and asked Fry to get him a visa to "anywhere at all."[3]

Serge had no idea that he was now on record as "an anarchist, capable of committing a terrorist act," but long training led him to be cautious. Assuming his mail was censored, he wrote elliptically to Nancy and Dwight Macdonald that he'd been *"immobilized"* for four days, from December 2 to 5. "It's quite obvious that I'd better leave as soon as possible. It has become impossible for me to work, I cannot be of any use to anyone, and my situation can become unbearable now, quite against my will. From a personal point of view, the atmosphere reminds me of what I lived in 1932."[4] Clearly he was speaking of his fear of arbitrary arrest and detention of the sort he'd experienced in the Soviet Union. "Annoyance after annoyance and absurd complications. In all this stupid fuss, I have lost (for the time being?) my typewriter . . . I hope to have it returned but there are neither rules nor simple common sense any more."[5] "This is a shipwreck with too many castaways," he said.[6]

Since their detention on board the *Sinaïa*, things had gotten very much worse for the villa's residents. Fry reported that his friend Captain Dubois warned him he was now under surveillance. He'd counted about eight different plainclothes policemen following him in shifts.

Even Mary Jayne was questioned, in particular about the sources of her money. "On what did she live?" the police wanted to know. Fry told her that in her file at the prefecture she was described as the "tall blonde with little black dog."[7] The police were sure her money came from high-class prostitution.

Then, appropriately on Friday the thirteenth, two plainclothes officers arrived at the CAS office looking for a certain Hermant. "Probably a dirty De Gaullist," one of them said. Luckily Beamish was out of town.[8] Fry told them that the man they were looking for had resigned weeks ago. On his return to Marseille, Beamish decided it was expedient to leave France. Friends in Berkeley, California, had already managed to obtain an American emergency rescue visa for him. He

immediately took a train for Toulouse, where, always brilliant at deal-
ing with officials, he convinced Spanish and Portuguese consuls to
give him transit visas. He then set off for Banyuls. Expertly guided by
Hans Fittko, he crossed the mountains into Spain in less than three
hours, making it easily to Lisbon, where he managed to "spirit" him-
self aboard a ship to New York.[9] The committee missed him terribly.

Charlie Fawcett, the young Virginian who had served as CAS's
doorman, also left Marseille. Before he crossed the border into Spain,
the police questioned him at length. Among his interrogators, he rec-
ognized a young man who had twice applied for a job at CAS. In
a coded message Fawcett sent a warning to Fry that CAS was being
infiltrated.

It was Captain Dubois who told Fry that the Villa Air-Bel was
compromised. The police considered Breton a dangerous anarchist
and Serge an international extremist.

Late in December, Fry decided that he would have to leave the
villa to protect CAS. His connection to Breton and Serge left him
open to the accusation of associating with "Communists," which was
very dangerous for his clients. At the end of December he moved into
a room at the Hôtel Beauvau. This was an enormous sacrifice. For
Fry, Villa Air-Bel had been his one respite in the horror of the times.

DEEP FREEZE

Where could I have applied? Who to? How? I was standing outside the world. The Germans were marching in. The twilight of time had come.

ANNA SEGHERS[1]

With Fry gone and Mary Jayne staying only infrequently, life at the Villa Air-Bel was changing. Danny, Theo, Jean, and Maurice still left each morning for work at CAS. When they weren't writing, Breton and Serge frequently took the tram downtown to check on the status of their international visa applications. Sometimes Laurette and Jacqueline accompanied them. There was no point in hiding. If Vichy was interested in them, the police could as easily arrest them at the villa as pick them up in a café or on a city street.

Marseille was also changing. The Vichy regime's ruthless rationing was starving the city. Bread was scarce, as were meat, cooking oils, dairy products, chocolate, and even wine. Victor Serge observed a clutch of people on the rue Saint Ferréol gazing through the window at the *rôtisserie* where a single chicken was being roasted.[2] The only good thing was that the degrading poverty in a country once prosperous was now opening eyes.

A rumor spread that empty sacks, stamped "Imported from Germany," were being filled with potatoes on the Marseille docks and sent to Paris to make Parisians believe they were getting food from Germany.[3] The Vichy government claimed that a breakdown in transportation caused by war-damaged roads was responsible for the shortages, but it was well known that much of the food supply was going to feed the occupying German forces or was being sent back to the fatherland.

To Breton's immense satisfaction, silent protests began to appear in the city streets. People spit behind the backs of German soldiers as they marched arrogantly along the sidewalks. Large V's—Winston Churchill's symbol of victory—were painted on walls and shop windows. As quickly as the French police could efface them, they reappeared. Young men could be seen walking about with two fishing rods slung crossways over their backs in the middle of January. The symbol translated as *deux gaules*.[4] People were wearing safety pins on their lapels. The French word for safety pin was *épingle anglaise*.[5] Breton remarked that the police could hardly prosecute visual puns.

Now the prolonged Indian summer was over and temperatures in the South of France began to drop dramatically. Snow fell on New Year's Day and blanketed the park of the Villa Air-Bel in white, and did not melt for a month. By January 3 the temperature reached −8°C (18°F). It was clear why Dr. Thumin hadn't rented the villa in a long time: the roof and skylights leaked. The icy wind crept in through the windows and under the doorframes. With coal rationed, there was nothing except damp wood with which to heat the small stoves in the bedrooms, and the residents were reduced to gathering scrap firewood from the park to burn in the dining room fireplace. Everyone wore coats indoors, even to dinner, and tried to keep moving.

Each day Madame Nouguet came back from the market more desperate. Dinner might consist of Jerusalem artichokes, stewed carrots, turnips, or rutabaga, with a small ration of stale bread. Someone put a copy of the book *Le Boeuf Clandestin* in the pantry in lieu of meat. Even heating the food became a problem. One pot simmered

Artists at Villa Air-Bel *(from left, in front)*: André Breton and Aube, Helena
Holzer, Oscar Dominguez, Jacques Hérold, and *(standing at back)* Sylvain
Itkine and Wilfredo Lam.

in the Bretons' chimney, one on the stove, and another in the back
pantry *fumoir*.

Victor Serge's son, Vlady, would bring them *croques-fruits*. He
spent his days working for a cooperative organized by the actor Sylvain
Itkine and a few others. They collected wild dates and rolled them in
almond paste, producing a delectable sweet.

But the bitter cold and the lack of food had become so extreme
that Peterkin fell dangerously ill and, by January, it was thought best to
send him to Juan-les-Pins to stay with his grandmother Eva. The food
situation there was at least better than in Marseille.

Breton made the only protest he could. In a spirit of solidarity,
he continued his Sunday gatherings, though with the brutal winter
weather, fewer and fewer artists came. However, Wilfredo Lam and
Helena Holzer often showed up. Breton had asked Wilfredo to illus-
trate his poem *Fata Morgana*. Since the Cuban artist spoke virtually
no French, a handicap that, added to his being black, did not make
his life any easier in Marseille, Helena offered to translate the poem.

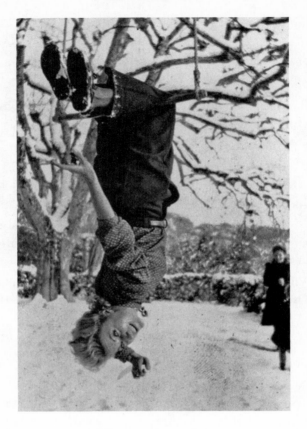

Jacqueline Lamba in the snow.

Drawn on parchment paper with black China ink that he had carefully hoarded, Wilfredo's illustrations thrilled Breton. They were exquisitely simple line drawings of magic creatures adorned with mysterious symbols from his native Cuba.

In the freezing cold of Air-Bel, the exotic tropical flora and fauna multiplied mysteriously until Lam had completed forty-five drawings. To Breton they represented the rebellion of a free spirit in a world of war and destruction. As the massive snow clouds hung over the villa, the artists continued their subversive play as well as they could. One photograph taken at the time by a friend shows Wilfredo Lam and the painter Jacques Hérold looking with amused fortitude at the camera. Each has an arm through the sleeve of a single coat inside which they

huddle to keep warm. No one underestimated the danger they were all in as the once luminous Marseille became more and more restrictive. Finding solace in friendship, they waited stoically for the international visas necessary to leave France, wondering who would make it out. Not all of them did.

Occasionally, hoping to escape the collective doom and depression of the city, Fry would show up for a weekend visit to the villa. Things were not going well for him at CAS. Ironically, most of his problems came from the United States.

Since his detention on the *Sinaïa*, the Emergency Rescue Committee in New York had not been happy with his leadership. Fry received a cable from the director, Frank Kingdon, telling him that he was being recalled to the United States. Given his relations with Consul General Hugh Fullerton in Marseille and the American embassy at Vichy, Fry suspected that the State Department was putting pressure on Kingdon to force him to leave.

He was livid when he received a second cable complaining that his expenditures were "overlarge considering emigration results."[6] In fact by now, even after the brutal months of November and December when the French border had been completely sealed, CAS's work since that summer had resulted in the emigration of 350 individuals.[7] Some had managed to leave perfectly legally with all the proper documents, but many others had had to make clandestine escapes across the Pyrenees guided by Hans and Lisa Fittko.

On December 26 Fry went to his office only to learn that one of his clients, a young photographer named George Reisner, had committed suicide in Nice while visiting Henri Matisse. Fry turned his fury against the Emergency Rescue Committee in New York, reporting that Reisner "had been waiting for his American visa since July and the strain had proved too much for him. A few days after the funeral, we got a note from the Consulate that the visa had been authorized at last."[8]

Fry felt the New York committee was inept and inefficient, and sometimes even morally reprehensible in its slowness, and he made sure everyone knew his opinion. A flurry of correspondence followed.

He complained they had no idea of the work he was doing, or any idea of the personal price he was paying. (Of course, in safe, neutral New York, how could they?)

Harold Oram, who still worked as a fund-raiser for the committee, took Fry to task. The truth was the committee was doing its best. He reminded Fry that between July 25, when the committee had been formed, and December, they had raised one hundred thousand dollars, even in the atmosphere of isolationism and opposition to refugee immigration that prevailed in the United States. Fry begged Oram to make the committee understand the level of human tragedy he had to deal with. Fund-raising was all very well, but efficiency in getting visas was a matter of life and death.

In the end, Fry offered to return to New York as long as a competent successor could be found to replace him. He thought that if he could get back to explain things to the committee, he could make them understand the appalling conditions under which he was trying to work. Of course, he had every intention of returning to France. His major worry was that if he left, even briefly, his European staff would quickly land in Vichy prisons.

An unlikely potential candidate came his way. The art collector Peggy Guggenheim had received a letter from the painter Kay Sage, asking her to help rescue and to pay the passage to America of certain distinguished European intellectuals. When Peggy cabled to inquire who they might be, she received the answer: André Breton; his wife, Jacqueline Breton; his daughter, Aube; and Max Ernst. Peggy had also received a plea for help from her old friend Victor Brauner, who had written asking her to save his life. She was by then living in Grenoble where she had managed to convince the local museum to store her recently acquired art collection, and decided to go to Marseille specifically to visit Varian Fry and his committee.

Peggy Guggenheim had spent most of 1940 in Paris buying paintings for her future museum of modern art, though she was still not clear where it would be located. With the war on, no one was buying art. When word got out that she was paying cash, she was "pursued mercilessly" by artists desperate to sell. Her policy was to buy at the

rate of "a picture a day." She boasted that "the day Hitler walked into Norway, I walked into Léger's studio and bought a wonderful 1919 painting from him for one thousand dollars. He never got over the fact that I should be buying paintings on such a day."[9]

Though she was criticized for opportunism, in her own mind she was helping starving artists, and most artists did sell her their work. Except Picasso. When she arrived at his studio, he told her contemptuously: "Lingerie is on the next floor."[10] But that was Picasso's style. He would spend the entire war in Paris working in his studio on rue des Grands-Augustins, continuing to frequent the Café Flor, and eating the rationed food at his favorite Catalan restaurant. He lived as an "internal exile" imperially indifferent to the German occupation.

On June 8, 1940, as the German Panzers were within forty miles of Paris, Peggy Guggenheim was sitting at the Dôme sipping champagne with a friend. Looking back, she remarked: "It is really incomprehensible now to think of our idiotic life, when there was so much misery surrounding us. Trains kept pouring into Paris with refugees in the direst misery, and with bodies that had been machine-gunned en route. I can't imagine why I didn't go to the aid of all these unfortunate people. But I just didn't; instead I drank champagne — with Bill."[11] It was only on June 11, three days before the Germans marched down the Champs-Élysées, that, having forged the date on her expired travel permit, she piled into her tiny Talbot automobile with her friend Nellie van Doesburg and two Persian cats and headed south along clogged highways through the clouds of black smoke that blanketed the fleeing pedestrians.

When she arrived in Marseille from Grenoble, Victor Brauner brought her to Fry's office to meet him. Impulsively Fry asked her if she would take his place as head of the committee while he returned briefly to the United States. She was after all an American, could maintain the committee's camouflage as a legal organization, and would be safe for the time being. But she was so frightened by the story of the committee members' recent detention aboard the *Sinaïa* and by the seedy, black market atmosphere of Marseille where everyone seemed to be engaged in illegal deals to get visas, passports, or money for food,

that she went to the American consulate for advice. She was warned
that under no circumstances was she to become involved with Fry.
She was not told why. She had no idea how risky his work was becom-
ing. "Thinking only about art I was completely unconscious of the
underground and had no idea what all this was about," she said.[12]

Peggy rejected Fry's offer, leaving some money for the committee,
and promising to pay Ernst's and the Breton family's passage to Amer-
ica. It was probably lucky for the committee that she scuttled his plan
for her to replace him. Though she was a shrewd woman, she hardly
had the temperament for refugee work. It's also certain that, had Fry
left, he would never have been allowed to reenter France.

Just before Christmas Fry received a peremptory note summoning
him to the bar at the Splendide. It was unsigned. He went immedi-
ately. Seated at the bar was the American journalist Jay Allen swilling
back Scotch, which he'd obviously brought with him since Scotch
had disappeared in Marseille months ago. Fry had met him before and
had always considered him a bombastic egomaniac. Allen informed
Fry that he'd been sent by the Emergency Rescue Committee in New
York to be his replacement. Fry's first thought was that the committee
had been unable to find anybody more competent to accept the job.

Jay Allen had become famous as a journalist in the new macho,
tough-talking style of Hemingway, who had given the role of foreign
correspondent star billing. Allen told Fry that he didn't actually intend
to visit the committee's office. He had important investigative journal-
ism to undertake. He then introduced Fry to Miss Margaret Palmer,
the middle-aged woman seated beside him. She would serve as Allen's
woman on the spot relaying his orders to the committee.

Fry was stunned by Allen's audacity. He immediately refused to
give over the reins of power. His coworkers at CAS wrote to the New
York office urging them to reconsider, explaining that Fry's leaving
would be a disaster for the refugees.

At the beginning of January Fry decided to move CAS from their
shabby office on rue Grignan. The *Sinaïa* incident had made him
aware that his committee needed a higher profile with more respect-
able premises. But he was also asserting his authority over Jay Allen,

who was not consulted about the move. By chance Danny had come across a huge apartment at 18 boulevard Garibaldi, two blocks from the Canebière and three blocks from the gare de Noailles, the tramway terminus for La Pomme. It had been the premises of an elegant hairdresser, and when the committee moved in, the hairdresser's mirrors were still on the walls.

Allen was furious. Things between the two men had come to a stalemate when Fry reported to Eileen that Allen made his first visit to CAS in mid-February. He had raged through the office screaming and slamming doors.

> *He said he would like to break my neck. I have no idea why. He promised to do his utmost against me as soon as he got back to New York: I hope you will warn what friends I have. . . . He said he had never hated anyone so much in his life, that I was slippery and dishonest, that I was a "careerist" (what is a careerist?), that I was "washed up," that he would "show me". . . . It was really a regular tornado he let loose in my office. . . . The most curious thing of all was his idea that I was here to make myself famous. I can't tell you how much that idea hurts me, for if I have ever been devoted to a task, it is now. I don't give a hoot for publicity. . . . If I could do my work anonymously I'd be perfectly happy to.*[13]

The war between the two men continued until mid-March, when Fry learned that Allen had been arrested by the Gestapo for illegally crossing the demarcation line between the occupied and unoccupied zones in quest of some scoop.[14] Allen was being kept in prison in the occupied zone and it was clear he would be there for months. Fry couldn't help but gloat a bit; after all it was what Allen deserved for his careless bravado. But he was also anxious. Allen's imprisonment indicated that Americans could end up in jail or in an internment camp just as easily as everybody else.

Meanwhile, officials at the American consulate in Marseille continued to make it clear that they had no use for Fry or for those he was

helping. A friend from a Quaker relief organization repeated a conver-
sation she'd had with one of the consular staff officers:

> *"I hope you're not helping Jews to get to the United States," the*
> *staff member said.*
> *"What would you do with them?" she asked*
> *He hunched his shoulders in the position of a man holding*
> *a submachine gun.*
> *"Ptt ptt ptt ptt ptt," he said.*[15]

By now Fry was incapable of being shocked, but he was morally
repelled.

Captain Dubois had confirmed to Fry that both Consul General
Fullerton and the prefect of the Bouches-du-Rhône wanted him out
of France. But the police had not yet caught him out in any illegali-
ties. To expel a director of a legitimate refugee organization would
have repercussions in the U.S. media. Hugh Fullerton was a cautious
man. It would certainly be easier on him if Fry left on his own initia-
tive, and so for now, he determined to continue to make things as diffi-
cult for him as possible. But he obviously didn't know Fry. Fry thought
back to his old days at Harvard when he'd been forced to repeat his
senior year for planting a "For Sale" sign on the dean's lawn. Any exer-
tion of arbitrary authority got his back up. He was stubborn. He wasn't
going anywhere.

Fullerton made his first move at the end of January. When Fry's
passport expired, the consulate refused to renew it unless he agreed
to return immediately to the United States. It also denied him a let-
ter of recommendation to the Swiss government. This was unheard
of. If the Germans invaded the unoccupied zone, which everyone ex-
pected at some point, the American embassy's contingency plan was
to evacuate Americans to safety in Switzerland. To get the necessary
entry visa that Switzerland required, every American had a letter of
recommendation to the Swiss government. To deny such a letter to
Fry was personal. Without such a letter, he would be trapped in Nazi-
occupied France.

This was a hard time for Fry. Exhausted, he decided to take a two-day rest in the town of Toulon, a naval training center east of Marseille. He found it strange to be there. There were a few destroyers tied to the piers and a battleship in the middle of the harbor, but nothing moved. "The atmosphere is the atmosphere of death—of a wake, of those solemn hours between the passing of the soul and the disappearance of the body underground," he wrote lugubriously to his wife. The cold and hunger and loneliness were getting to him.[16]

On January 30 Fry received a rather cryptic cable from Frank Kingdon's assistant in New York, Ingrid Warburg:

CABLES SIGNED KINGDON UNAUTHORIZED HAVE FULL CONFIDENCE IN YOU WILL DO EVERYTHING POSSIBLE TO REACH AMICABLE SOLUTION HAVE PATIENCE KEEP THIS CONFIDENTIAL[17]

Clearly Warburg was on Fry's side, but things had gotten vicious at the Emergency Rescue Committee. She seemed to be suggesting some kind of conspiracy and felt it was imperative to keep her support confidential.

The pincers were closing around Fry, and his personal safety was increasingly at risk. He was now a man in wartime France with no papers, ironically in the same illegal position as his long-suffering and endangered clients.

VISA DIVISION:
DEPARTMENT OF STATE

The madmen outside have shut up the sane people.
WILLIAM BLAKE[1]

In early January, Varian Fry found himself in the terrible position of having to ask Victor Serge and his family to vacate Villa Air-Bel. He felt he had no choice. Even though he himself was no longer living at the villa, Serge's presence there could still be used against the committee. Fry was miserable about his cruel request—he and Serge had become friends and he frankly admired him. But the committee always came first.

It was shortly after Jay Allen's arrival in Marseille, and the gossip about Fry was flying. This was made clear to him by the Emergency Rescue Committee in New York, who informed him of a cable Jay Allen had sent to his wife demanding that she:

INFORM KINGDON CONFIDENTIALLY VARIAN FINE BOY DEEPLY INVOLVED WORK BUT TIED UP ALL SORTS OF SPLINTER GROUPS STOP LIVING WITH VICTOR SERGE BACKING SPANISH POUM TROTSKYITES[2]

For the committee's sake and for the sake of the refugees Fry was trying to save, Victor Serge must be sacrificed.

Serge was devastated at having to vacate the villa. He wrote to the Macdonalds in New York:

5 January 1941
Dear friends,
 . . . On a personal level, everything has become very an-noyingly complicated for me. Some good friends—including André—and I rented an uninhabited villa on the outskirts of the city; friends who happen to be collaborators of Mr. Fry live with us, but people have set up a whole scheme to force us to separate, on the pretext that the collaborators of the Em. Res-cue Com. could be compromised by their close relationship with me! The most outrageous of it all is that, despite the clarity of everything and the deep esteem that unites us all, the scheme has succeeded, on account of the atmosphere. I am thus faced once again with the problem of lodging, which is linked to many others. . . .
 Right now we are short of fuel, we live with our coats on, in rooms that are often freezing. The rare potatoes that we can find are reserved for the children. We have not seen any butter for months. Etc. One privation I will be especially sensitive to is the lack of tea, because it is the only thing that is difficult for me to do without. I have 20 grams left. On snowy nights see-ing women gathered in front of the empty grocery stores, I have found memories from elsewhere. I am giving you these details so that you will have a somewhat concrete idea of our living condi-tions, but please do not get alarmed. Somehow we have always managed to eat sufficiently, we are all very healthy . . . and we are in good spirits.
 In friendship. A firm handshake. VS[3]

With the American authorities remaining so uncooperative, the Macdonalds had decided to try for Mexican visas for Victor Serge and his son. They were thrilled when these arrived, through the intercession of Max Eastman, and forwarded them to Serge. He wrote back that the visas had arrived, but were invalid. They were issued under his pseudonym of Serge, and listed him as a Spanish citizen; they would have to be changed for his real name Kibalchich. Again he begged for an additional visa for Laurette Séjourné and recommended they get in touch with Jean Renoir in Hollywood for a moral affidavit or even financial support. Renoir would know her since she had acted in one of his films. Time was running out.

In mid-January Serge wrote that the consul general of Mexico had assured him a simple cable to Mexico was all that was required to secure the name change to Kibalchich. He added that a rough cold spell had hit the country. He was now living in a downtown hotel:

> It is freezing everywhere. The seagulls of the port, who probably used to feed on food waste they found there in plentiful supply, don't find anything anymore, and we can see them flying around the city in front of the windows, from which we throw them a few crumbs. We are quickly reaching a level of deprivation similar to that of Russian cities in the bad years.[4]

Now Serge had a valid international visa for Mexico for himself and his son, though he hadn't been able to get visas for Laurette or for his daughter. However, they were in less danger than he and Vlady, and could follow later. But Serge's problems were not yet over. To get to Mexico, Serge would still need an American transit visa since all Mexican-bound ocean liners stopped in New York en route.

The plan was that, once he had the transit visas in hand, Serge and Vlady would take the usual route through Spain to Portugal and sail from Lisbon. But he explained to the Macdonalds that they still faced innumerable bureaucratic hurdles. The paper walls seemed as impenetrable as stone:

Today we will get the necessary Mexican documents; tomorrow we go to see Mr B. [Bingham] for the American transit visa, which is essential, since the Portuguese Consulate refuses to send a request for a visa to Lisbon unless you have an American visa and you can only ask for the Spanish visa after you have the Portuguese visa. In the meantime, I will request a French exit visa and a safe conduct pass because the French authorities don't give the exit visa without a safe-conduct pass and because the Spanish won't recognize the Mexican documents—for the moment all depends on the American visa . . . It's all very annoying and fatiguing, but we are glad to have entered this active phase.[5]

By early February, Serge was reporting that he couldn't get an American transit visa, or at least a firm answer about whether he could expect to get one. "My notoriety as a militant" is apparently "a heavy weight for the American functionaries," he wrote:

The consulates have agreed with each other to multiply the hurdles. Moreover people are about as welcome there as beggars in good Christian households. Judging from how you struggle yourselves, on our behalf, in a country where you have rights, you can have an idea of how we struggle without having any rights at all.[6]

He concluded it would be mid-March before he could escape from France.

By now Nancy Macdonald had accumulated a stack of at least fifty letters regarding her friend Victor Serge. She wasn't about to give up. If her own government wasn't going to allow Serge in as a refugee, then at least she could get him the simple American transit visa he would

need to get to Mexico. On February 11 she wrote to Serge that they had paid his passage from France to New York to the American Export Line. The price had been four hundred dollars, which included embarkation taxes and the price of the trip from Marseille to Lisbon. They had done the same for Vlady. To the penniless Serge this must have seemed a staggering sum of money. Then she informed him they had also bought the tickets from New York to Mexico.

At last things seemed straightforward. Then, appallingly, given Serge's desperate circumstances, there was yet another delay. Nancy was informed that the State Department, in accordance with the Macdonalds' instructions, had asked the consul in Marseille for another report on Serge. She immediately wrote to Serge and vigorously reassured him that neither she nor her husband had made any such request. "I can imagine that you must be thinking all sorts of thoughts about us. But I assure you we are battling against—we know not what."[7]

On February 19 Dwight Macdonald wrote to A. W. Warren, Chief, Visa Division at the Department of State, arguing that Serge "has been internationally famous since 1928 as an *opponent* of the Soviet regime (spending the years 1928 through 1935 in various Soviet prisons and only able to leave the Soviet Union, in 1936, through the intercession with Soviet authorities of a group of prominent writers and liberals)."[8] He added that Solicitor General Francis Biddle had assured them that if the Serge family could obtain visas to another country, it would be possible to arrange American transit visas.

On February 24 Serge wrote the Macdonalds that he had news. He was no longer going to need a transit visa through the United States. Varian Fry had informed him that, almost miraculously, on January 24, the Vichy government had declared that commercial shipping to Martinique could resume. If they could get an exit permit, refugees could now leave the country legally. Fry was baffled at this development. He was used to the schizophrenic behavior of the authorities, but this sudden change was harder to interpret than most. Perhaps Vichy had concluded that those refugees whom the Nazis would eventually want to extradite were already safely behind barbed wire in

internment camps. Whatever was up, Fry wasn't asking questions. He told Serge he was going to try to get him an exit permit out of France and a visa and tickets for Martinique so that he could get to Mexico.

Still, this was not the end of Serge's difficulties. Refugees traveling to Mexico via Martinique needed a transit visa for Haiti or Santo Domingo, where the ships stopped en route. Could the Macdonalds try to get him such a visa in advance? He told them there was a committee in New York called the Dominican Settlement Association that provided visas. If they could get him a transit visa for either country—and how could this be refused?—he could leave in three weeks. He himself was also trying for a Moroccan visa in the hope he might travel through Casablanca. He also had thought of the Brazil-Mexico route, but many people who attempted that route were refused entry and forcibly returned to France. He added:

> *The hardships of winter are over, the others have just started. A lot of people are leaving, but only for the United States. Most of those who are leaving or waiting to leave are tired, discouraged castaways whose only wish is to rest in peace, and who can hardly be relied on for the least favour. One feels, in the midst of these pitiful emigrations, an impression of moral defeat that is infinitely more distressing that the impression of the defeat itself. It seems to me that on the other side of the ocean, you must have a strange complementary vision of all this.*[9]

On March 6 Serge wrote that he was still waiting for the transit visa through Santo Domingo and afraid that the route might close any day—"everything changes so quickly." This was his last hope. Morocco had denied him a transit visa.

On March 14 the Macdonalds received a letter from A. W. Warren on State Department letterhead about the case of Victor Kibalchich:

> *The full dossier in the case was considered by the Interdepartmental Committee on Political Refugees at its meeting on*

March 11th. . . . Your sympathy and admiration for Mr. Kibal-
chich are fully understood. . . . In view of Mr. Kibalchich's ad-
mitted past membership in the Communist Party, it is believed
that he falls within the excluding provisions of Section 23 (a) of
the act of June 28, 1940, commonly known as the Smith Act. In
the light of the provisions of the Act referred to, Mr. Kibalchich
would be inadmissible into the United States even in transit in
the absence of specific authorization by the Attorney General
for his temporary admission, under the Ninth Proviso of Section
3 of the Act of 1917, which empowers the Attorney General to
prescribe conditions for the temporary admission of an inadmis-
sible alien. Under the circumstances you may wish to consider
whether there are other routes by which Mr. Kibalchich would
be able to proceed to Mexico.[10]

On the fifteenth, the Macdonalds received a second letter, this
time from Edward Prichard Jr., Special Assistant to the Attorney Gen-
eral. He had received a copy of Warren's letter, and he told them he
dissented from the actions of the majority of the committee. He sug-
gested that the Board of Immigrations Appeals "would consider fa-
vorably an application for the exercise of discretion under the Ninth
Proviso of Section 3 of the Immigration Act of 1917." He advised them
to file an application, with the addendum: "You must understand that
this communication is purely in my personal capacity, and is in no
sense to be taken as a commitment on behalf of the Department. . . . I
must ask you to keep this letter confidential."[11]

On March 19 Dwight Macdonald wrote Ralph T. Seward of the
Board of Immigration Appeals to again request American transit visas
for Victor Serge and his son. If it seemed desirable to the board, after
their arrival the Kibalchich family could remain on Ellis Island until
the first boat left for Mexico. He and his wife were willing to put up
cash bonds to guarantee their departure.

The Macdonalds could be forgiven for thinking they had entered
the labyrinth of Kafka's *Trial*. What was Serge's unnameable crime?
Nonetheless, Nancy wrote to Serge on the eighteenth of March tell-

ing him that they themselves were still trying to get him an American transit visa. After all, the tickets via New York had been bought and paid for. Nancy was going down to Washington to see about it.

In the eyes of the United States, Victor Serge, having once been a Communist, was apparently never to be trusted. By now Serge himself had wisely given up on ever getting an American transit visa. He wrote the Macdonalds that he felt as if he were reassembling a jigsaw puzzle that constantly crumbled in his hands. He now pinned all his hopes on getting to Mexico via the Martinique route and waited impatiently for a Martinique visa. Varian Fry was working on it and he trusted Varian Fry.

WAITING AT THE VILLA

Spring 1941

Because you hold
In my being the place of a diamond set in a pane of glass
That details minutely the pulleys of the stars
Two hands that reach for each other it is enough for the roof of tomorrow
Two transparent hands . . .

ANDRÉ BRETON[1]

Spring came early to Provence. By the beginning of March, the peach and cherry trees were already in bloom, spreading a pink and white blanket over the park of Air-Bel, and the winds carried the scents of lilac and magnolia. The farmers had begun to plow and sow the fields. From the terrace of the villa, the colors were dazzling: the deep green of the cypresses bled into the light gray of the limestone mountains and the blue of the sea. André Breton watched a flock of magpies flying in frenzied pirouettes. The small miracles of daily life made the tension bearable.

He could see Dr. Thumin's stooped ancient figure in the distance pacing his huge park. He wore the usual battered and moldy bowler hat and black suit with pants flared accordion style over his enormous

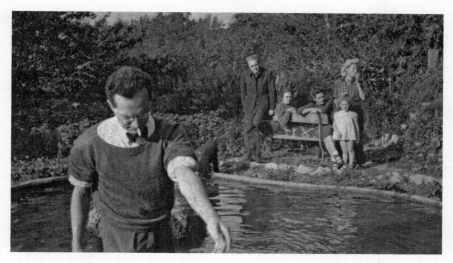

At the pond at Villa Air-Bel: Varian Fry and *(in the background, from left)* Victor Serge, Laurette Séjourné, unknown woman, Jacqueline Lamba, Aube Breton.

shoes. The old miser had kept vigil all winter in the bitterest cold for fear a dead bough would be taken away, but now that the spring had come, no one was stealing his wood. The "crystalline green concerts"[2] of the season's first frogs had sounded all night. The frogs were so numerous one had to be careful not to step on them.

Breton stood on the edge of the pond watching the female frogs swimming laboriously across the water, trailing gelatinous strings of black eggs. The next morning, the dead females would be found floating in the green slime, white bellies upward. He loved to watch this melancholy ceremony of copulation. He remarked to Danny who shared one of his vigils: "Life feeds on death. We are witnessing one of the great lessons."[3]

Varian was visiting Villa Air-Bel that afternoon. As he and Danny fished the last carp and goldfish from the pond for the residents' dinner, they talked about food. "Garden snails have become an obsession here," Danny said. "We've taken to plucking snails from the garden walls." Varian had lost twenty pounds and said he now knew what it felt like to be both gaunt and cold.

Danny was enthusiastically pacing out the garden he intended to plant with Dr. Thumin's permission. He showed Varian where the tomatoes and beans would go in. There would also be a flower garden under the villa's windows.

But Varian had come about more serious matters. He wanted to talk about Marc Chagall. Along with the American vice-consul Hiram Bingham, he had just spent the weekend of March 8 and 9 with the Chagalls in their home in Gordes in the Vaucluse. Much of the town was abandoned, many inhabitants having left when the shoe manufacturing industry had closed down. With the shortages, people were recycling old shoes by putting wooden soles on them. A year ago the Chagalls had bought a large house, formerly a Catholic girls' school, and now it was the only occupied dwelling in the immediate area. Fry found it "an enchanted place."

But he was frustrated. He believed Chagall was not taking the danger he was in seriously enough. He'd gone to Gordes with Bingham to convince him to leave France. "He kept asking me anxiously whether there are cows in America," he told Danny. Fry was puzzled. He had mistaken Chagall's words to imply that he was reluctant to go to the United States. He had missed the joke. Chagall had once told a friend he wanted to use the image of the cow, that stupid animal (*beheyme* in Yiddish) on his personal calling card. He was asking Fry: "Would America accept a *beheyme* (an idiot) like me?"[4]

Chagall's case was particularly difficult. There had been a lot of miscommunication. Both the Museum of Modern Art in New York and CAS had applied for international visas for the couple. The visas had finally come through in January, and Fry believed that Chagall had still not yet left because he was afraid of the journey through Spain. But Fry seemed not to have thought of the anguished family councils that must have been taking place around the table in the Chagall household. If they left now, the Chagalls would be leaving behind their beloved daughter Ida and her French husband. The young couple had so far been denied American visas.

In fact, Chagall had no illusions about the danger they were all in. He had written a friend in April 1940: "Art remains with us, which is

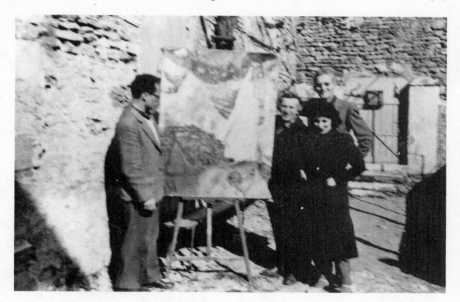

Varian Fry with Marc Chagall, Bella Chagall, and Hiram Bingham.

today the most important thing, along with love. But my God, how far we Jews are from all that. It's terrifying. Forgive me."[5] In 1939 he had painted *The White Crucifixion*, with Jesus on the cross wearing a Jewish prayer shawl. It was a gesture of protest and disgust at European anti-Semitism.

The previous September 1940, Chagall had contacted two acquaintances, both of whom were associated with the Fund for Jewish Refugee Writers in New York, to ask for help in getting out of France. He'd had Bella write the letters in English to avoid the Vichy censors: "I would be so happy to talk personally," he said in code.[6] The fund immediately contacted Alfred Barr at MoMA and got Chagall an invitation to exhibit his work in New York, but that was only the first small step in a very long process. Bringing the Chagalls to America required affidavits of support. The fund was informed that a bond of three thousand dollars had to be posted as security to ensure "the individual would not be a burden to the government." They were already besieged by thousands of requests for aid, but they began a fund-raising effort for the Chagalls.

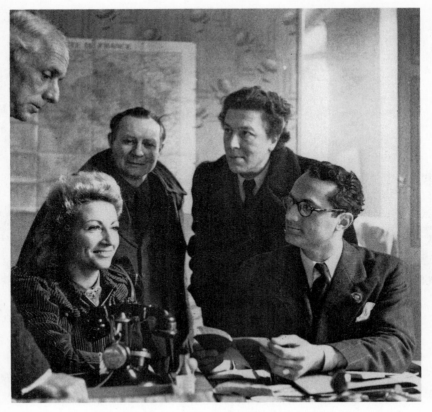

Max Ernst, Jacqueline Lamba, André Masson, André Breton,
and Varian Fry.

When the fund wrote the Guggenheim Foundation in November 1940, the reply was unhelpful. The foundation said that they had already purchased a number of Chagall's paintings and that he should be able to take care of himself "over there."[7] At fifty-five, Chagall was almost as famous as Picasso and Matisse, but he did not have capital. It seemed that he had unwisely sunk much of his money into the purchase of the house in Gordes.

Still searching for money, on February 1 the fund wrote to Solomon Guggenheim personally, asking for help with the seven hundred dollars needed for the Chagalls' ocean passage. Again the reply was abrupt: "While I should like to be in a position to assist all the people who appeal to me, my list is already so extremely heavy that I do not feel I should care to take on anything more."[8]

The fund sent out letters to individuals, appealing for fifty dollars at a time, adding: "this money can be repaid at some future date, either in cash or in the form of one of his works, as soon as Chagall has arrived in this country and is able to work again."[9] In the end, Solomon Guggenheim relented and offered his support. Now, six months after Chagall's initial appeal, only the bureaucracy involved in getting exit and transit visas remained to be confronted. Leaving their new home in Gordes behind, the Chagalls moved to the Hôtel Moderne in Marseille. And waited.

The Chagalls and their daughter Ida were among the many artists who visited Villa Air-Bel that March. In fact, the villa had so many visitors that the painter Victor Brauner remarked: "[One day] there will be marble plaques at the entrance or on the wall! All the celebrities who have come through!"[10]

Almost all the artists who visited the villa were enduring the long wait for international visas. Tragically, in retrospect they could be divided into those who succeeded in getting out of France and those who didn't. Varian Fry and his committee managed to get Wilfredo Lam and his girlfriend Helena Holzer passage on a ship to Martinique on March 25. André Masson, whose wife was Jewish, would leave by the same route in early April. Max Ernst crossed the Spanish border by train on May 1. CAS would get Jacques Lipchitz out on May 16. Jean Arp would leave for Switzerland a year later in the spring of 1942. Marcel Duchamp would be among the last of the artists CAS succeeded in helping escape France. On May 14, 1942, he sailed from Marseille to Casablanca, where he waited almost a month for a second ship to take him to New York.

The German artist Hans Bellmer, whose father was probably a member of the Nazi Party, was trapped in France, but survived the war. Neither Victor Brauner nor Jacques Hérold, both Romanian Jews, could find the supporters they needed for the requisite affidavits. Both survived by hiding in the remote regions of Provence and were never found by the Nazis. In August 1944 the actor Sylvain Itkine was arrested by the French police for Resistance activities and turned over to the Gestapo. He was tortured, and reputedly murdered by Klaus Barbie, the Butcher of Lyon.[11]

The writers who came to the villa included the French poet René Char. He would become an officer in the French Resistance. Though he tried to get out, the Dadaist Tristan Tzara did not succeed and eventually also joined the Resistance. The novelist and philosopher Jean Malaquais, with CAS's help, managed to leave France for Venezuela in 1942. André Breton's closest friend, Benjamin Péret, would also escape. CAS got him, along with his lover, the painter Remedios Varo, on a ship to Mexico at the end of November 1941. One of the villa's most colorful visitors, the lively and skittish Consuelo de Saint-Exupéry, left Air-Bel to join an artists' colony in the remote village of Oppède and finally joined her husband in New York in 1942. Using his influence, he was able to obtain her papers.

Most of the artists who came for Sunday afternoons at the villa were destitute. Day-to-day survival was a matter of sheer desperation. Someone came up with the idea of holding art auctions at Air-Bel to raise a little money for artists who had gotten all their papers *en règle* and were about to leave the country. The artist hung his or her paintings in the giant plane trees that shaded the villa's terrace, and Sylvain Itkine stepped up as auctioneer, setting the initial price. The bidding process was a reflection of their ingenuity. The visitors raised the bids on the works under auction by only the pittance they could afford. The accumulated small bids of a few francs were collected and given to the artist whose paintings were up for sale. The paintings themselves went to the final bidders.

For the first auction, the garden table on the terrace was loaded with salvaged bottles of wine and the party got under way. In a photograph taken at the time, Sylvain Itkine can be seen standing on the table leading the bid for a painting by Wilfredo Lam. In another photograph, Varian Fry and Consuelo de Saint-Exupéry perch in the branches of a plane tree, mooring themselves as they wait for someone below to hand them up a painting. An early spring sun lights their smiling faces. No one could know then that while some were about to leave, others would never escape.

Over the winter André Breton had become even fiercer in his insistence that Fascism could only be opposed by defiance. Perhaps the

arrival from Paris of his friend Benjamin Péret had helped to lift his spirits.

Péret told Breton that he had been living clandestinely in Paris and surviving on fifty centimes a day. Paris was "far too sinister," he said. "Hardly anything to eat, no coal, and a temperature of −10 degrees for almost two months." In the face of the "dull German propaganda and its vile French servants, it was impossible to say anything or do anything publicly."[12] He had finally managed to escape to the unoccupied zone by hitching rides with sympathetic farmers who had hidden him beneath the straw in their horse-drawn wagons.

Breton was convinced that all the surrealists must defy the spirit of Fascism "by singing, playing, and laughing with the greatest joy."[13] He had a new plan to distract his friends from the bleakness that lay lodged in the heart like broken glass. At Air-Bel they were to undertake a collective work of art. They would invent a new deck of cards. They would need new suits to replace the diamonds, hearts, spades, and clubs of the old deck and new figures to replace the heraldic military figures of king, queen, and jack. André immediately went to the public library on the Place Carli in Marseille to research the origins and history of the game. To his deep satisfaction, he discovered that modifications to the game over the centuries had always taken place in times of great military reversals or defeats.[14]

The surrealists wanted a game relevant to their universe, and a deck reflecting their fascination with magic, alchemy, and psychic phenomenon. They settled on four suits: Love (a flame), Dream (a black star), Revolution (a bloody wheel), and Knowledge (a door lock). The genius, the siren, and the magus replaced the royal cards. The most daunting task was to pick the figures that would become the new face cards. These they drew from the surrealist pantheon: the genius, siren and magus of Love were Baudelaire, La Religieuse Portugaise (author of the *Portuguese Letters*), and the poet Novalis. The figures of Dream were: Lautréamont, Alice in Wonderland, and Freud. The genius of Revolution was the Marquis de Sade, with Lamiel, a character in a novel by Stendhal, as the siren, and Pancho Villa as the magus, while the hierarchy of Knowledge was represented by Hegel, the Swiss

medium Hélène Smith, and the medieval alchemist, Paracelsus. The joker was the ultimate surrealist trickster, Alfred Jarry's *Ubu Roi*.[15]

André Breton, Jacqueline Lamba, Victor Brauner, Oscar Dominguez, Max Ernst, Jacques Hérold, Wilfredo Lam, and André Masson executed the exquisite drawings. To determine who would do the drawings on which cards, the names of the cards were dropped into a hat and each participant extracted two. In the end, the *Jeu de Marseille* became a legendary work of art, always associated with the Villa Air-Bel. The drawings were preserved and eventually came to André Breton's daughter, Aube. She donated them to the Musée Cantini in Marseille as part of their permanent collection, where they remain to this day.[16]

SLIPPING THE NOOSE

March 1941

A ndré Breton had written months earlier to his friend, the Swiss-born artist Kurt Seligmann, asking for help in getting himself and his family to America. The Seligmanns had sailed to New York in September 1939 to launch an exhibition of Seligmann's work at the gallery of Karl Nierendorf. When they left their house in Paris, they locked the door behind them and left everything ready for their return. Once in the United States, however, friends warned them that it was too dangerous to go back to Europe, and by that November they had joined the ranks of permanent refugees. Seligmann's work expressed what he was not able to admit to himself. The last work he painted in Europe was called *Sabbath Phantoms*. It depicts a group of wildly gesticulating skeletal figures, a *danse macabre*, escaping through a black foreboding landscape.

Seligmann was by now associated with the New School for Social Research. Pierre Mabille had earlier told Breton that the school had money at its disposal to bring over intellectuals and employ them.[1] Breton suggested to Seligmann that he could give a series of lectures on subjects of Seligmann's choosing. Could Seligmann secure him

an invitation from some important arts organization? Breton would need this to get an exit visa from Vichy. He would also need to be advanced a sum of money since he was flat broke. Seligmann approached Alfred Barr at the Museum of Modern Art, who had always championed the surrealists. Barr's office at MoMA was by now a clearinghouse for information and aid. He and his wife, Marga, were sending moral affidavits and raising guarantees of financial support for numerous artists.[2]

By October 1940 Seligmann wrote to Breton that Barr had agreed to set up lectures for him and that there remained very few obstacles to his coming to New York. The artist Kay Sage wrote on November 9 that the art dealer Pierre Matisse had signed an affidavit of support for André and his family and that her cousin, artist David Hare, was willing to sponsor them.[3]

More than five months later, Breton was still in France. But his patient waiting was paying off. In early March he received word that American visas had come through. Fry assured him that now that Vichy had relaxed its moratorium on visas, the French exit visa wasn't going to be a problem. As Danny put it, the government was determined to empty France of all "*les bouches inutiles* (useless mouths) and other debris."[4]

Whatever was behind the change, for the moment at least, those whose exit visas had been deferred for months were suddenly being allowed to leave France legally. Fry told Breton he was looking for passage for them on board a ship. Martinique was the best hope. Even though it was a colonial department of France and the laws of Vichy still applied there, refugees would be safer from Gestapo interference.

In early February, Fry had begun to buy up passages for a number of his clients. Walter Mehring and CAS's own bookkeeper, Heinz Oppenheimer (Oppy) were among them. The loss of his trusted associate Oppy was hard. But Fry was not sorry to see Mehring go. Ever since he had invaded Fry's room at the Hôtel Splendide in the early days, he had become one of CAS's most obstreperous clients. Had Fry known, however, what Mehring was to go through in his final exit from France, he would have been more sympathetic.

The scruffy poet had dutifully presented himself at the dock in Marseille only to find an officer of the Sûreté Nationale du Port scrupulously scrutinizing passengers' papers. When he reached the head of the queue, the officer pulled out the file for M. There was the name Walter Mehring and beside it the instruction: "Forbidden to leave France. Decision of the Kundt Commission." As Mehring tried lamely to disguise his terror, the officer disappeared into a back room to call the prefecture. Incredibly, when he returned, he handed the poet his stamped papers. "Perhaps it's another Walter Mehring," he said. "Depart." Luck or a sympathetic officer willing to look the other way? Mehring would never know.[5]

With the chance of escape through Martinique, André Breton was at last feeling optimistic. The endlessly awaited French exit visas for himself, Victor Serge, Wilfredo Lam, and their families finally arrived and all the dates were valid. Wilfredo's girlfriend Helena Holzer remembered the terror of sitting in front of two French police officers on whom she knew her whole future depended, and the unspeakable relief when, after what seemed an eternity, she suddenly found she was holding her exit visa in her hand.[6]

Peggy Guggenheim had already guaranteed Breton money for the passage and it was now only a matter of waiting for a ship. The Portuguese freighter *Capitaine Paul-Lemerle* was due to leave Marseille on March 25. To their astonishment, Fry told them he had booked all their tickets (though he warned Serge his visas weren't yet in order). Only once it was a reality did Breton realize how little he had believed escape from France would ever be possible.

As Breton and his family prepared to leave—he was seen in Marseille entering a bookstore to buy his own books, which he had had to abandon in Paris—Victor Serge also awaited his fate. Though he now had the requisite exit visa, he still needed a transit visa to get to Mexico. Nevertheless, always generous, he took the time to write Nancy Macdonald on March 6:

> *Breton, his wife, and daughter intend to go to New York soon via the West Indies. You will probably meet them. André is a*

*man with great charm, perfect dignity, and singularly stylized
convictions and intelligence. He is brave, in addition.*[7]

But in fact Serge was desperate. All month he continued to ex-
change letters with the Macdonalds as they tried to decipher the U.S.
State Department's contradictory information about his chances of
getting the transit visas to the United States for him and Vlady. The
French authorities had already refused Serge permission to journey by
way of Morocco and the French West Indies. He tried to hide his an-
guish, but his true feelings were made clear when he wrote to Nancy:
"The atmosphere here is getting stifling . . . Our very existence is
hanging from slender threads which may break at any moment."[8]

Then suddenly, just two hours before the *Capitaine Paul-Lemerle*
was due to sail, Serge and his son learned that Vichy officials had fi-
nally granted them a Martinique transit visa en route to Mexico. Fry
gave them the money for their passage. Miraculously, after so many
tortuous months, they too were free to leave.

Before the departure Serge inspected the *Paul-Lemerle* docked in
the harbor. "It looks like a sardine can in which someone has extin-
guished his cigarette," he told Danny.[9] The shipping companies had
discovered they could make a profit by transporting refugees in the
old pack boats that had been transformed into troop carriers.

Danny, Theo, Varian, and Mary Jayne went to the quai Mirabeau
to say good-bye to the Bretons, Wilfredo and Helena, and Serge and
his son (Laurette and Serge's daughter Jeannine could not leave yet
because their visas still weren't *en règle*). Danny remembered the mo-
ment of departure as extremely sad. Through the five months they had
spent together they had shared pleasures, trials, hopes, and deceptions
and had become dear friends. On the quay they embraced hurriedly.

Among the 350 passengers milling about on the dock waiting to
leave were the novelist Anna Seghers and the anthropologist Claude
Lévi-Strauss. Lévi-Strauss later described the scene: "Helmeted
gardes-mobiles, with automatic pistols at the ready, severed all con-
tact between passengers and the relatives or friends who had come
to see them off. Good-byes were cut short by a blow or a curse. . . . it

was . . . like the departure of a convict-ship." Still, being Jewish, he saw himself as "marked down for a concentration camp," and was extremely relieved to be leaving France any way he could.[10]

The *Capitaine Paul-Lemerle* had only two cabins; one reserved for three women, and the second for four men, who included Lévi-Strauss, a mysterious Tunisian who carried a painting by Degas in his luggage, and a young man cut off by the war from his native Martinique. All the other passengers had to crowd together in the dark, airless hold. Beds had been constructed of scaffolding, one on top of the other, with straw pallets for bedding. The women were placed on the starboard side, the men on the port. On deck, the crew had erected two pairs of wooden cubicles at each end of the ship. One contained two or three showers that functioned only in the early morning, and the other a wooden trench that served as a toilet and emptied directly into the ocean.

Thus the first of the refugees of Villa Air-Bel embarked on what they thought would be their voyage to freedom. It would take thirty miserable days to reach Martinique. What they did not know was that as soon as they touched dry land, they would immediately be sent to an internment camp.

Six days after the ship lifted anchor, the special assistant to the attorney general informed Dwight Macdonald in New York that Victor Kibalchich would "be permitted to tranship to Mexico, under safeguards, in accordance with the discretion contained in the 9th Proviso to Section 3, Act of February 5, 1917."[11] Serge had finally been granted a transit visa through the port of New York, but of course it had come too late. He was already on his way to Martinique.

ART LOVER

We are still alive. We are still the same. Nothing has changed. Life goes on around us.
The sun rises and sets. We can still walk, talk, think. Yet we must listen to these things
they are saying: France has lost the war; the Germans are in Paris; your husband is a
prisoner; there is no more coal or wood to keep you warm this winter; perhaps there
are no more schools for your children.

CONSUELO DE SAINT-EXUPÉRY[1]

It did not take long for the Villa Air-Bel to fill up again. Having found the solitude of his hotel in Marseille almost insupportable, Varian Fry returned to his old room. Now that Victor Serge and André Breton were gone, the house had become "less compromising" in the eyes of the police. Max Ernst, who had been living in Saint-Martin d'Ardèche on the charity of friends, took over Serge's room, and the Comtesse Consuelo de Saint-Exupéry, presently estranged from her husband who was in New York, installed herself in the Bretons' room. But the place was not quite the same. Along with Breton had gone much of the magic.

The cook, Madame Nouguet, was ill and tired. When she gave notice that she would be leaving, Theo asked her if she would not miss them all. She replied: "Yes, I am very fond of everyone, but, you know, since Monsieur André's departure, it's not like it was."[2]

Still, Consuelo was engaging. She climbed the plane trees on the villa's terrace with the agility of a monkey and made her salon there.

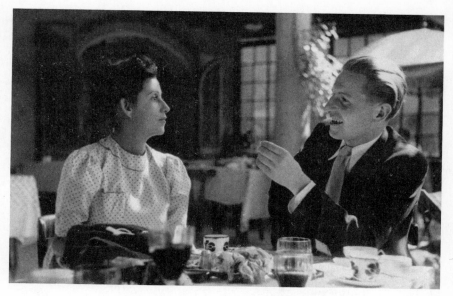

Consuelo de Saint-Exupéry and Jean Gemähling.

She would say: "If you wish to visit me, you will find me on the second branch of the plane tree on the left."[3] She was a good raconteur and loved to tell stories of her youth in El Salvador and her tempestuous relationship with her husband, "Tonio." It was Tonio who had gotten her safely away from La Feuilleraie, their country house outside Paris, when the Germans marched on the city the previous June. While he set out to join his squadron to fight the war, he had insisted she go to Pau. He assured her that French gold was being evacuated by truck to Pau and, if she stuck close to the trucks, she would be safe. The Germans knew about the cargo and would never bomb it since they intended to confiscate it after their victory. From Pau she had made her way to Marseille. "What will become of us?" she would ask. "We are all like dice spilled out on a table."[4]

Fry's young protégé Jean Gemähling fell immediately and desperately in love with Consuelo, a malady that caused him a sort of nervous collapse. It sent him to bed for several weeks when she finally left the villa to join a group of artists in the remote village of Oppède.

Max Ernst brought a different kind of drama. Because of him, Peggy Guggenheim made her second visit to the Villa Air-Bel.

Peggy Guggenheim and Max Ernst being interviewed by reporters
in New York.

Marseille was going through a new transmutation. The *statut des juifs* had been passed the previous October 1940. As yet, though, by March there was no organized effort to see to its execution. Chaotic local politics and the dramatic refugee problem, which placed overwhelming demands on municipal bureaucracies, accounted for the lack of any coherent policy. Certainly anti-Semitism was prevalent— anti-Jewish signs appeared increasingly in shop windows and "certain" people had been fired from their jobs. But it was haphazard. Jewish people were afraid, but many nervously hoped that this was as far as things would go.

Now, everything was about to change. On March 29, 1941, under German pressure, a bureau called the General Commissariat for Jewish Affairs (the CGQJ) was created and a zealous anti-Semite, Xavier Vallat, was put in charge.[5] The systematic persecution of French and foreign Jews was about to begin. *Rafles* to pick up Jews and random

hotel searches for those in hiding were to become routine. Soon the CGQJ organized the Office of Economic Ayranization, specifically to expropriate Jewish property.

Peggy Guggenheim sensed the growing anti-Semitism. She also knew that her immunity as an American could not last long. If America entered the war, she, like the other refugees, would become an enemy alien in France, and as a Jew, she could be immediately packed off to a detention camp. But she would not leave without her art collection. Finally her friend René Lefebvre-Foinet, who worked in shipping, informed her that she could send her paintings home to America as "household goods." She'd spent the months of January and February jamming the masterpieces into cases between linens and blankets.

At the end of March, after having consented to pay Max Ernst's passage to America, she wrote to him and asked him to give her a painting. He agreed to meet her in Marseille. She knew Ernst's reputation as a womanizer. A friend asked her what she would do if he ran away with her daughter. She replied: "I would rather run away with him myself."[6]

On March 31 Victor Brauner met her at the gare Saint-Charles in a state of high anxiety. He had recently been Peggy's lover and was counting on her to save him. He had been desperately hoping to get to the United States but, as a Romanian Jew, again and again he had been refused an American visa. He was being told by the American consulate that the small quota of visas for Romanians was filled for the next two years. That night he accompanied Peggy to the café Au Brûleur de Loup, where Max Ernst was waiting for her. Ernst had changed a great deal since they had last met in his Paris studio. His internment in the concentration camps had aged him, though he still looked romantic wrapped in his black cape. He and Peggy arranged to meet the next day at the Villa Air-Bel so that he could show her the paintings he had tacked up on the dining room walls. Over a bottle of wine that he had managed to salvage from his vineyard at Saint-Martin d'Ardèche, they made a deal. Guggenheim would give him two thousand dollars for his early work, minus the money he owed her for his passage. His dealer of many years, Julien Levy, remarked,

"Max resented terrifically her buying all his paintings."[7] But he had no choice. His paintings were not selling. He was broke. And she was helping him get to America.

He invited her to celebrate his fiftieth birthday the next day, April 2, in the Vieux Port. Varian Fry, Victor Brauner, and René Lefebvre-Foinet joined them and they had a splendid meal at one of the small black-market restaurants flourishing in the city's back alleys. Marseille was a port city. Contraband food was nothing new. The police could always be bribed to turn a blind eye.

Peggy was outrageously flirtatious and Max was not one to pass up such an overture. At the end of dinner he whispered to her: "When, where, and why shall I meet you?" She replied: "Tomorrow at four in the Café de la Paix and you know why."[8]

Peggy Guggenheim fell in love with Max. He was a great painter, and, along with Marcel Duchamp, probably the most talented among the surrealists. And he was also a wonderful raconteur and self-mythologizer. He was born in Brühl, near Cologne. His authoritarian Catholic father had run a school for the deaf, and Max described himself as stamped with silence. He told her the story of how his father, a Sunday painter, painted the family garden, but was such a literalist that, once, having forgotten to include a tree in his painting, he'd gone out and chopped down the tree.

Max said he was committed to rebellion from the age of five when he ran away from home, only to be returned soon after by a band of religious pilgrims who'd mistaken him for the infant Jesus. The enchanted forests and birds of his childhood filled his canvases. When his favorite cockatoo had died on the eve of his sister's birth, he said, "A dangerous confusion between birds and humans became encrusted in [my] mind."[9] This was why he called himself Loplop, the Bird Superior. "To be really immortal," he once commented, "a work of art must go beyond human limits. Good sense and logic will have no part in it." Good sense and logic had no part in his life either, which made him, of course, irresistible to women.

The torrid romance between Peggy and Max lasted ten days. Walking the streets of Marseille as new lovers they would regularly bump

Max Ernst and Jacqueline Lamba on the terrace of Villa Air-Bel.

into Max's old friends from the concentration camps. She remarked:
"They seemed more like ghosts than anything else, but to him they
must have been real and brought back many memories. To me they
represented a new, strange society. He always mentioned the name of
the camp where he had met them, as casually as if he were referring
to St. Moritz."[10]

Peggy Guggenheim departed briefly for the town of Mégève to
join her ex-husband and children, but was soon back in Marseille and
living with Max at the Villa Air-Bel. The villa had changed. The surre-
alist court had disappeared and dinners were now a rather cold affair.
Mary Jayne remembered Ernst looking remarkable in his sheepskin
jacket with his chiseled profile and ice-blue eyes. She found Peggy
sympathetic and funny. Once Peggy complained: "Oh! This new
insult—bourgeoise. Why doesn't he call me a whore like all the other
men in my life?"

On another occasion Peggy described how one night she had
heard a scratching noise at her bedroom door. Thinking it was Max,
she opened it, only to find Dagobert and Fry's dog, Clovis. The dogs
knocked her over and jumped onto her bed. So she slept with them
instead.[11] Soon Villa Air-Bel proved too crowded for Peggy and she
moved to the Grand Hôtel du Louvre et de la Paix on the Canebière.
Of course Max was a frequent visitor.

Despite her privileged life style, she too was learning how un-
safe it was to be Jewish in Marseille. One morning after Max left and
the breakfast cups were still on the table, a plainclothes policeman
knocked on her hotel room door and demanded to see her papers.
When he noted that the date on her travel permit had been altered,
she insisted it was the officials in Grenoble who had changed it. She
was asked if her name was not Jewish and she replied that her grandfa-
ther was a Swiss from St. Gallen. He searched her room. She told him
to feel free to look in the cupboard; "he would find no Jews in there."
In the end the officer said: "Come with me to the police. Your papers
are not in order." It suddenly hit home to her that she might just dis-
appear. She was also terrified they would discover Max had slept at
the hotel—he had no permit to stay in Marseille—or that they would
find the large sum of black market money she was carrying.

She insisted the officer wait in the hall while she dressed privately. She was hoping to hide the money and leave Max a note, but she was given so little time, she managed to do neither. As she emerged from her room, she found the policeman in a heated discussion with his chief in the hallway. The United States had just delivered a ship-load of food to the country and Americans were currently popular in France. There would be no arrest. The chief apologized and asked her politely to register with the police in Marseille at her earliest convenience. When Peggy later mentioned to the hotel management how distraught she had been by the intrusive visit she was told: "Oh, that is nothing, Madame. They are just rounding up the Jews."[12]

Ernst's position was becoming increasingly precarious. He was in daily fear of being caught in a police roundup. His papers were not in order and he was certain that he was on Hitler's black list. He had seen the photograph of Hitler at the Degenerate Art Exhibition of 1937, standing in front of his painting *The Beautiful Gardener*, glaringly labeled "A Slur on German Womanhood." He would end up in another detention camp and this time he'd be deported back to Germany. When Alfred Barr at MoMA had written an affidavit of support for Ernst, he stated the situation correctly:

> *Ernst is in danger because he is a German citizen who refused to return to Germany after the Nazi regime came to power. His active dislike of all totalitarian forms of government is well known and he has made no secret of it; no fascist or communist government would tolerate him. The unrealistic nature of his work is the kind most actively persecuted by such governments. His wife is Jewish. [This was a reference to his first wife Lou Straus-Ernst though they had long been divorced.] His son is steadily employed in the Museum of Modern Art.*[13]

Through the intercession of both Alfred Barr and the Emergency Rescue Committee, Ernst had already been granted an emergency visitor's visa to the United States, but while he waited for a French exit permit, the American visa had expired. Now he had to go back to the U.S. consulate to reapply. This involved frequent and increasingly

risky trips to the visa office in Montredon. Peggy usually accompanied him and, because she held an American passport, they were able to bypass the long queue of exhausted refugees waiting their turn to enter.

When the new American visa was finally granted, Max decided to wait no longer for a French exit permit. He would try to get by on an old one he'd received courtesy of the subprefect in Saint-Martin d'Ardèche, even though it had long expired. This was risky, of course, but he felt it was even riskier to stay. On May 1 Max packed his suitcase and headed alone for the Spanish frontier with plans to meet up with Peggy and her family in Lisbon.

When he arrived at the border town of Campfranc, the French border official pointed out that his old exit visa was useless and immediately confiscated Max's passport.

Max felt he'd lost the throw of the dice and had nothing further to risk. Stiffening his back, he ignored the French official and proceeded brazenly to the Spanish customs room. By chance, he had placed a package containing his carefully rolled-up canvases at the top of his luggage. When ordered to open the bag, he unfurled work after work. The improvised show garnered exclamations of *Bonito!* from the attending customs officers. Watching from the sidelines, the French official requested Max to come into his office. "Monsieur," he remarked, "I respect talent. Monsieur you have great talent. I admire that." He returned Max's passport and led him out to the train platform where two trains stood waiting. "The first," he said, "is going to Spain, and the other to Pau, to the next prefecture. . . . Be careful not to take the wrong train."[14]

Max couldn't believe his luck. Not only were there still French officials willing to subvert the rules but he'd found the one art lover among them! It was almost laughable. He immediately took the man's hint and boarded the train heading for Spain. Within ten minutes he was over the border and, from there, made his way to Lisbon.

Peggy remained in Marseille. On the fifth of May, probably just after Max had crossed into Portugal, the last surrealist *grande fête* took place at Villa Air-Bel. Under the Vichy regime, no gallery in the city

had been willing to risk mounting an Ernst show. In defiance, the Villa Air-Bel held its own exhibition of his work.

Artists living in and around Marseille showed up at Air-Bel to admire the paintings and engravings propped against trees in the woods and hung from the branches of the plane trees. Peggy presided over the event and even lent the show some of the canvases she had already purchased. In a photograph taken that day, Danny Bénédite can be seen in the crook of one of the plane trees, hanging Max Ernst's remarkable painting *The Robing of the Bride* as well as two paintings by Leonora Carrington, which Max must have salvaged from his house in Saint-Martin d'Ardèche.[15]

Peggy spent the rest of her time trying to arrange with the Banque de France for withdrawal of the $550 per person that departing foreigners were permitted to take out of the country. There would be thirteen passengers with her on the clipper bound for New York. She was taking Max Ernst; her former husband, Laurence Vail; her son, Sindbad; her daughter, Pegeen; Vail's estranged wife, Kay Boyle; and the numerous children they'd collected between them. Impatient at the delay, she sent the others on ahead to Lisbon and finally, after three weeks, when the money was released, she left. At the border, as were many refugees, she found herself being strip-searched and was very shaken by the experience. The guards had suspected her of smuggling currency. Afterward, when she was finally crossing the frontier, months of tension fell away like dust. It was amazing to be free and to be able to celebrate life once again.

But Peggy was due for an unpleasant shock when she arrived in Lisbon. The first thing Max said as he greeted her at the train station was that he had "something awful" to tell her: "I have found Leonora. She is in Lisbon." The way he said it made it clear to Peggy that he was still very much in love with Leonora. She simply replied: "I am very happy for you."[16]

Leonora's escape the previous June had been harrowing. The German army had just invaded France and were marching relentlessly south. At that time, most of the foreign prisoners held in internment camps had been released. Max had been released from Camp des

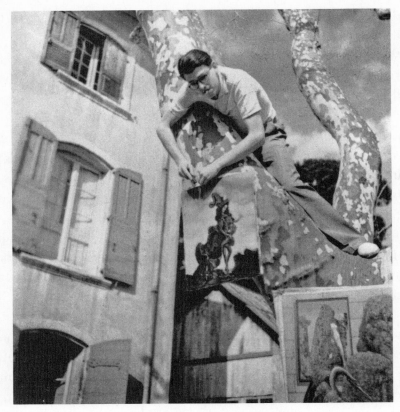

Danny Bénédite hanging paintings by Max Ernst
on a tree at Villa Air-Bel.

Milles, but Leonora had no idea where he was or what had happened to him. Friends said the situation was urgent. She had to save herself. She had to get out. There was nothing she could do for Max. She had to trust that he'd eventually find her.

She finally agreed to accompany her friends as they fled by car across the Pyrenees to Madrid. But the emotional pressure on her was leading to disaster. In Spain Leonora began to spiral out of control. It was the fear, the not knowing what had happened to Max that undid her. When she was found standing outside the British embassy threatening to assassinate Hitler, the embassy interceded. She was committed to an asylum in the Spanish town of Santander. There her

experiences of shock and drug therapy were so horrendous she called them "death practices."[17]

Eventually her wealthy parents sent someone (Leonora always claimed it was her old nanny) from England to secure her release. Convinced their intention was to ship her to a mental hospital in South Africa or somewhere in the colonies, she persuaded the woman to take her shopping in Lisbon. After all, a lady could not travel without gloves and hat. Leonora had a plan. When they stopped at a café, she slipped out the back door and fled at once to the Mexican embassy. She had an acquaintance there, the poet-diplomat Renato Leduc, whom she'd first met in Picasso's studio in Paris. Leduc was more than ready to change his life forever for this remarkable woman. He immediately offered to marry her and take her out of Europe. As a diplomat he would have no trouble booking passage to Mexico for himself and his wife.

For Peggy it was a pain-wracked month. As she was trying to secure plane flights out, she was also waiting for her personal anguish to be resolved. It was not at all clear if the situation between Max and Leonora would hold. In the end Leonora decided her love affair with Max was too costly, too intense for her in her fragile state. One day she brought Max to Peggy's hotel room, and Peggy thought she "seemed in some strange way to be giving him back."[18] Though Peggy was certainly feeling unsure of herself, when it came time for her and Max to leave on July 13, she magnanimously offered to pay Leonora's plane fare to New York as well. Leonora refused. She and her new husband, Renato Leduc, boarded a ship bound for New York. But she was touched by the offer. She would always say that Peggy was a noble, generous woman.

There was still one person left behind. For more than a year, Jimmy Ernst, working in the mailroom at the Museum of Modern Art in New York, had been desperately trying to get both his parents to the United

States. Back in November 1939, a few days after he had received the postcard from his father telling him he was incarcerated in Camp des Milles in Aix-en-Provence, he'd also received a letter from his mother, Lou Straus-Ernst, informing him that she too had been interned, in Gurs, the concentration camp for women, but that she was released after only a few weeks. In the spring of 1941 she was also in Marseille, trying to escape. At this time she and Max had been separated for more than eighteen years.

Jimmy's boss, Alfred Barr, had helped Max Ernst to obtain his emergency rescue visa. It was made out in the name of Max and his wife, but the wife in question referred to his estranged second wife, Marie-Berthe Aurenche, who was a French citizen and had no intention of leaving France. Jimmy was grasping at straws. He went to Alfred Barr with a new plan. Since his parents' divorce papers had been executed in Germany and likely never translated, in the eyes of the French government, they were probably still married. Wouldn't it be possible for Lou Straus-Ernst to travel with Max as his wife?

Alfred Barr was sympathetic and said he thought it might work. "I'll try it with the committee," he said. When Barr explained the situation to the Emergency Rescue Committee, the committee consulted none other than its leading patron, Eleanor Roosevelt. She immediately scuttled the idea of smuggling Lou Ernst into the United States as Max Ernst's legal wife. In France, Fry was informed of the committee's decision and sent a telegram: ELEANOR RIGHT ABOUT LOU ERNST UNABLE POSE AS STILL MAX'S WIFE.[19] Jimmy Ernst would never receive an explanation for this decision. Eleanor Roosevelt probably decided that the Emergency Rescue Committee could not be seen to bend the rules or commit any illegality. And Fry had to publicly go along with the pretense. The president's wife seemed to have no idea that Fry was bending the rules every day. It was the only way he could operate in France.

Before Max left for Lisbon, Fry and Vice-Consul Hiram Bingham called Max and Lou to the consulate for an interview. Bingham reluctantly informed them Lou could not travel as Max's wife. On the spot Max offered to marry Lou again. In words that had probably been re-

ported to him by Max, Jimmy Ernst described his mother's response: "But Max, you know that this is nonsense. We have led separate lives for a long time now and neither one of us has ever resorted to sham. I am sure that Jimmy will get me out. After all, he got us both this far, I don't like charades. A life for a marriage license? And who knows, maybe none of this will be necessary after all. I'm an optimist."[20] Later, in Fry's office, in the presence of both Fry and Danny Bénédite, an exasperated Max begged her to reconsider. She refused.

Lou Straus-Ernst went into hiding in the village of Manosque in the Alpes Maritime and waited. From there she wrote to her son that she was under the protection of the French poet Jean Giono and that "if the Germans ever came to Vichy, the peasants here revere this poet . . . so much that they would hide me from them."[21] Lou's letter arrived a few days after December 7, the day the Japanese attack on Pearl Harbor brought the Americans into the war.

Though he feared his mother was trapped, Jimmy Ernst continued his desperate efforts to get the affidavits of support she needed for a visa. On July 3, 1941, a visa was finally recommended by the State Department, but then, just as suddenly, it was suspended on the grounds that regulations had changed. There was no further explanation.[22] Jimmy approached Peggy Guggenheim, who was by then in New York. She informed her bankers to forward whatever money was necessary and she tried to intercede with the State Department. Max was desolate and worried to his son that he hadn't insisted forcefully enough that Lou remarry him.

Finally, a year later in October 1942, a memo recorded by a Miss Lewinski of the New York Emergency Rescue Committee indicated that "advisory approval for the issuance of an immigration visa to Mrs. Luise [*sic*] Ernst (former wife of Max Ernst)" had been sent to France.[23]

Then a final terrible blow fell. In November 1942 the German army, in response to the American invasion of North Africa, moved in to occupy the whole of Vichy France. Jimmy knew at once that he had failed to save his mother. He anguished about whether, had he made a phone call a few hours earlier, or had one of his letters

reached some bureaucrat's desk more opportunely, it would have made the difference. It didn't make it any easier that his mother "belonged to the millions of expendable pawns on a board of inhuman size," one of the "inconsequential victims, spider webs disposed of by the flick of a finger."[24]

In May 1944 Lou Straus-Ernst was taken to the Drancy concentration camp near Paris and then put on Transport 76 for shipment to Auschwitz with more than a thousand others. One of her sister-inmates, an Auschwitz survivor, described to Lou's son the final tragic image of his mother, "a woman totally exhausted, half lying down, half leaning against a wall, warming herself in the last rays of a dying sun."[25]

BOULEVARD GARIBALDI

I owe Varian Fry my life. I did not want to go away from France. It was his severe and clairvoyant letters which helped me finally do so.

JACQUES LIPCHITZ[1]

B y mid-spring of 1941, Fry was employing about twenty people in the office on boulevard Garibaldi, including French nationals and highly qualified refugees. Charles Wolff, the Alsatian journalist from Paris whom Miriam Davenport had befriended the previous summer in Toulouse, joined the staff, as did his fellow Alsatian Jacques Weisslitz, who assumed responsibility for the many intellectuals who fled Strasbourg after the German invasion. Fry's secretary, Lena Fischmann, had left for Lisbon in early February, and a feisty young woman called Lucie Heymann replaced her.

The hiring of Paul Schmierer was particularly dramatic. An Austrian-born Jew and a physician practicing in Paris before the war, Paul was a friend of Danny's from his days at the prefecture. Paul, his wife, Vala, and their children were living with friends in Marseille. Vala had a part-time job at CAS, but, after the passage of the *statut des juifs*, Paul had been denied the right to practice medicine. They were so destitute that Paul decided to risk returning to the occupied zone to look for work. Vala was frankly terrified. Her husband was doubly

threatened. He was Jewish and had been a vocal Socialist before the war, and she was certain he would be recognized and denounced.

Even if Paul did get work in Paris, how was he going to get money back to his family in the unoccupied zone? But he was distraught and not thinking clearly. Knowing there was nothing she could do to dissuade him, Vala accompanied him to the gare Saint-Charles and then returned to the office. When Danny saw her crying, he inquired what was wrong. She told him of Paul's desperate decision to return to Paris. Danny grabbed her by the hand and ran to the gare Saint-Charles. The train hadn't yet left the station. He pulled Paul from the car and, berating him for not telling him of his dire situation, immediately offered him a job at CAS. "It was a marvellous thing," Vala remembered.[2]

Fry needed all the staff he could find. Now that Vichy was suddenly liberal with its exit permits and visas to Martinique, CAS was inundated. On February 18 Fry put about fifteen of his clients on the first scheduled sailing. After the *Capitaine Paul-Lemerle* left with Breton, Serge, and the others, he managed to find passage for twelve more clients, including André Masson and his wife, on the *Carimare*, and on other ships like the *Winnipeg*, which left with ninety clients. The *Mont-Viso* carried thirty-six and the *Wyoming* another seventy.[3]

However, there were still clients who were being refused exit visas. Fry tried to fathom Vichy's regulations but as usual they were shrouded in mystery. Rumor had it that there existed a Vichy list of people who were to be denied. It took a couple of weeks before a young Socialist, Bedrich Heine, brought the list to CAS. He had obtained it by bribing a clerk at the prefecture in Pau who'd copied it down for him. A number of Fry's clients were on the list, including some who had already escaped. Fry contacted Lisa and Hans Fittko and told them their illegal escape route over the Pyrenees, the F-Route, had to be stepped up. Between February and May, the committee helped another hundred refugees cross clandestinely from Banyuls-sur-Mer to Spain. From there, often using forged transit visas, they all managed to reach Lisbon.[4]

In the first two weeks of May, Fry estimated that a thousand people passed through CAS's hands. The staff was working twenty-hour

days as they scrambled to solve last-minute crises. Fights broke out as desperate refugees invaded their office. They needed to be consoled, reassured, and even fed. Still, with all this, a sense of exhilaration permeated the staff. They forgot their fatigue. Secretaries worked from morning to night typing the required cables, documents, certificates of guarantee, and invoices for the shipping offices. Speculators were buying up dozens of tickets from the shipping lines that they then sold at outrageous profits. To avoid the scalpers, CAS had to secure blocks of tickets in advance from companies like American Lloyd even when they had no idea how many people they were going to be able to place on the boats. For security reasons, the steamship companies announced departure dates only four or five days in advance of sailing. This only made matters more complicated for CAS. Money to pay for passages was always an issue. Though Mary Jayne was still helping out, and Peggy Guggenheim had left funds for CAS before she left, there was never enough. Danny, who was now their official treasurer, struggled desperately to augment CAS's resources by exchanging U.S. dollars on the black market. It was risky work.

There was reason for panic among the refugees. The story of the fates of two of CAS's clients had traveled like lightning through the refugee telegraph. Rudolf Breitscheid, the former leader of the Social Democratic Party in the Reichstag, and his right-hand man, Rudolf Hilferding, were near the top of both Fry's and the Gestapo's lists. Fry had tried many times to persuade them to leave, but they were illusional about the security their former exalted political status gave them.

Fry finally suggested the Martinique route. At the beginning of February, he booked them passages on the *Winnipeg*. However, they refused to depart when they discovered they would have to travel steerage. Breitscheid and his wife felt too ill to travel for thirty days sleeping in bunks in the hold. They decided to wait for a later sailing. Fry urged them again to leave, but they demurred. Days later, the French police arrested the two men in their hotel and handed them over to the Gestapo for immediate deportation to Germany. Hilferding was reported to have committed suicide the next day by hanging himself in his prison cell, though murder was equally plausible. Breitscheid

was sent to Buchenwald concentration camp, where he died in August 1944. On May 6 the wives of both men sailed for Martinique on the steamship *Winnipeg*.[5]

So far Fry had been fortunate. He had not lost many clients. Although the capture of the two politicians was tragic, he did not feel they weighed heavily on his own conscience. They themselves had thwarted his best efforts to help them.

In a summary report Fry calculated that, in less than eight months, more than fifteen thousand people had either visited or written CAS. Eighteen hundred cases had fallen within the scope of the committee's activities, representing about four thousand individuals, to whom a weekly living allowance of 560 francs was paid. By the end of May, CAS had helped more than one thousand of them to escape.[6]

Despite all the successes, however, Fry had no illusions. April had been a very cruel month.

On April 9 the first huge *rafle* or roundup of French and foreign Jews resident in Marseille hotels took place. That day Fry received a hysterical call. The wife of Marc Chagall was on the phone, in tears. She explained that her husband had just been arrested at the Hotel Moderne and taken to police headquarters at the Evêché.

Fry knew the terrors of being interrogated at the Evêché and immediately put in an enraged phone call to the station. "Did they know whom they had arrested? Did they not know that Chagall was the most famous painter in the world? Did they have any idea how, when the news leaked out, the international press would turn this into a sensational story and France would be humiliated?"

Danny later recalled that Fry banged down the phone and Danny, standing beside him, grabbed his arm. "That's the way to talk to them, boss," he said. Varian acknowledged the compliment with a grin. Then, the smile fell from his face. He took off his horn-rimmed glasses and wiped them, muttering to himself. "No, we should be able to save them all. Why just the world's greatest painter?" He turned to Danny and asked for another refugee file.[7]

Half an hour later, Madame Chagall phoned to say that her husband had just returned to the hotel. It still took another month before

Bella and Marc Chagall finally had all their papers in order and were able to leave France. On May 7 they crossed the French border by train into Spain, eventually making their way to Lisbon, where they boarded the Portuguese ship the S.S. *Pinto Basto*, bound for New York. They had had to leave their family behind.

Chagall's daughter Ida and her husband waited anxiously in Gordes until June. Then, when gendarmes came to the house to demand the return of all their documents, they had a small piece of luck. One of the gendarmes proved sympathetic and offered them twelve hours to *find* the documents. They took the hint and fled to Marseille. After many trips to Vichy to secure their papers, they made it to Lisbon with a crate of Chagall's work and from there eventually got a ship to New York. They had had to travel via Havana and Bermuda. The trip to Havana alone took forty days because the ship had to zigzag to avoid German submarines patrolling the Atlantic.[8]

By early May, things in Marseille had gone from bad to worse. After an interview with the German authorities in Paris, Admiral Darlan, Pétain's vice-premier, embarked on a reorganization of the French police. He had been ordered to apply the same methods of control as the German occupiers, particularly with regard to using refugees as foreign laborers. From then on all foreigners were required to work to help rebuild the country, and it was in the district of Marseille and the Bouches-du-Rhône region that these new measures were first applied.

On the morning of May 7, the same morning the Chagalls departed, police with huge trucks swept through the city, searching for refugees in hotels and restaurants, in the streets around the Centres d'Assistance, and even in front of the American consulate. Approximately fifteen hundred foreigners were rounded up and held in groups on the Canebière, on the adjacent avenue Cours Belsunce, and at the gare Saint-Charles.

Men of working age were wrenched from their families, who were assured that the *rafle* was simply a measure of control and that their loved ones would be returned within a few hours. But the trucks headed for the port where a ship, *The Massilia*, awaited them. A

cordon of one hundred guards escorted the refugees aboard, taunting them with xenophobic and anti-Semitic slurs. After three grueling days of interrogations, only three hundred men, including some Americans, were released. The rest found themselves requisitioned into forced labor, either there in France or in North Africa.[9]

Fry watched helplessly, heartsick at what had become of his beloved France and its ideals of refuge for the persecuted. But he had yet more troubles. He lost two of his most important supporters. His friendly contact Captain Dubois at the Surveillance du Territoire was demoted for his sympathy toward the refugees and sent to Rabat in French Morocco, and the only official at the American consulate to support Fry's work, Vice-Consul Hiram Bingham, was recalled to Washington.[10]

Furthermore, Fry's tenure as director of CAS was still being contested from New York. The situation had gotten so tense that Eileen Fry wrote to Eleanor Roosevelt asking her to intervene on behalf of her husband. Mrs. Roosevelt replied:

May 13, 1941
Dear Mrs. Fry:

Miss Thompson gave me your message and I am sorry to say that there is nothing I can do for your husband.

I think he will have to come home because he has done things which the government does not feel it can stand behind. I am sure they will issue him a passport to come home even though it means someone else will have to be sent to take over the work he is doing.

Very sincerely yours,
Eleanor Roosevelt[11]

Fry was also running the very real risk of personal physical danger. Young French Fascists from the group Jeunesse de France one night tried to vandalize the office. Fry had been working late and was just descending the stairs when the thugs, wearing the recognizable Jeunesse uniform of baggy green pants and blue berets, entered the build-

ing. While he hid in the lobby, they tried to break down CAS's door on the second floor, but luckily the locks had just been reinforced. Fry made a pro forma complaint to the police the next day, all the while suspecting they were behind the raid.

At the end of May, he reported in a letter to Eileen:

I have been subjected to all kinds of special tactics from the first: intimidation, agents provocateurs, attempts to "plant" documents and propaganda in the office—everything which the imaginations of policemen can conjure up. . . . It is very amusing but it takes strong nerves! . . . They are even trying to "frame" me on a morals charge, sending both girls and boys. . . . Needless to say I don't touch the people sent any more than I touch the "important documents" which people tell me someone told them I could get to the British authorities for them.[12]

Then, much to Fry's horror, Danny Bénédite was arrested.

ARRESTED

On May 20 Danny was arrested for trying to trade gold bullion on the black market. This was a very serious charge and Fry was distraught. It could mean at least a prison sentence for Danny and possibly the end of CAS itself.

Since early on, the committee had worked with certain Marseille gangsters. Charles Vinciléoni, the owner of the restaurant La Dorade, was the head of one of Marseille's principal gangs.[1] To those not in the know, he seemed like an unloquacious, dyspeptic, grandfatherly type. He was a specialist in contraband. For a good price, he helped to find a safe route out for British soldiers in hiding and still trapped in France after the Dunkerque debacle. Since he had the whole port in his pocket, he knew which of the boats that were destined for Beirut, Algeria, or Casablanca could safely hide "human cargo." Some of CAS's more robust and youthful clients followed this route. Charles was the only gangster in Marseille who never double-crossed the committee.

Occasionally the committee used *maisons de passe* provided by the gangsters to temporarily lodge endangered clients. They were

even given access on at least one occasion to a room hidden behind contraband in one of the underground cellars of the Vieux Port.

These activities eventually brought the committee into contact with Raymond Couraud's friend Mathieu. Claiming he had connections with the Spanish embassy at Vichy, Mathieu offered to transport five of CAS's clients across the Spanish border in a diplomatic car. Papers would not be checked since all five would be traveling under diplomatic immunity. The price was one hundred thousand francs, fifty thousand francs up front. As it turned out, the "diplomatic car" never materialized. Fry berated himself for his gullibility, but this wasn't to be the last time the committee was duped.[2]

Since the Martinique route had opened up, CAS's funds in dollars and francs had shrunk, and it became necessary to use a stock of gold coins that Danny kept buried in the pinewoods at the Villa Air-Bel. Most of the gold had been given to them by fleeing refugees who were to be reimbursed with U.S. funds in New York. The gold had to be changed on the black market and, from the beginning, Danny knew he was on shifty ground. Only their old contact Boris Kourillo, a former clerk in the American Express Company, would continue to deal in something as dangerous as gold. Gold was a national resource. If one was caught, the penalty was just too high.

On the twenty-first of May, Kourillo told Danny he had found a buyer for the gold. Danny was to carry two thousand dollars in coins to Kourillo's hotel on rue Thubaneau. When Danny arrived Kourillo suggested that, if he could bring even more gold, a second transaction could be completed at the same time. Danny returned that afternoon with an additional two thousand dollars' worth of coins in his briefcase. As he approached the hotel, though, he sensed something was wrong. A black car was parked in the street and two men were loitering with "studied detachment." Danny tried to walk on past the hotel without turning his head, but Kourillo came running out of the doorway. He grabbed Danny with a fishlike hand and whispered: "Something's wrong. Come back at eight this evening." Immediately two policemen descended on Danny, seized him by the arms, took hold of the briefcase he was carrying, and thrust him into the waiting car.

In the short ten minutes it took to get to the police station, Danny invented an alibi to protect the committee. This was his deepest anxiety. Thinking quickly, he told the police that Max Ernst had given him the gold to thank the committee for having secured his safe passage to Spain. Ernst was thought to be rich and by now he would be safely in Portugal. Danny's story was that Fry had refused the gold, but he had taken it upon himself to accept it, aware that the committee needed money to help the struggling refugees. He said that of course the committee knew nothing of this, that Ernst himself had told Danny he could get a fair exchange for the gold if he went to a man called "Robert." He was about to meet this anonymous Robert in a nearby café when the police arrested him. Danny knew his story wasn't very convincing, but at least it kept the committee out of it. He spoke of his "regrettable initiative" and hoped they would believe him. When concocting his alibi, what Danny hadn't yet realized was that it was Kourillo who had betrayed him.[3]

Danny was taken to the Douane (customs) where he was assured that his dilemma was understandable and was told to return with thirty thousand francs the next day. A bribe of course. That would be enough to avoid a judicial process.

That evening he returned to the Villa Air-Bel. Everyone was deeply concerned at his late arrival. When he heard Danny's story, Fry continuously removed his glasses, which was his habit when nervous, saying: "My poor Danny."

Theo was beside herself. Although she was made of strong stuff, she knew a little bit about getting arrested. She herself had been the cause of both their arrests.

The previous month, on April 5, a spontaneous demonstration had erupted on the Canebière in support of the Yugoslavian government's decision to rescind the country's alliance with Hitler. It began with people throwing flowers on the Canebière. When the police closed the flower shops, the demonstrators bought artificial flowers. Finally the police cordoned off the avenue, but then people boarded the trams and threw flowers from the windows. Danny and Theo happened to be on the spot. Theo was so moved by the protest and so enraged by

the action of the police that she crossed the barrier and ran to deposit her bouquet of flowers in the middle of the empty street. She was immediately arrested and put into the police van, where Danny joined her "in solidarity," as he put it.

As they were led off to the Evêché, Theo whispered to her husband that she was carrying a number of compromising memos written by Varian. "What am I going to do if they search me?" Danny told her she would have to discreetly eat the papers, which is what she did. When Fry came to the police station to collect Theo and Danny, he couldn't decide whether to be angry at Theo's lack of caution or impressed by her courage. But he offered to compensate her for her unsavory appetizer by inviting the two of them to dinner at La Dorade.[4]

But this was different. Danny was in serious trouble. Getting caught dealing in gold was a criminal offense. With his usual stoical calm, Danny kept up a good front, but he was terrified. He spent a sleepless night wondering if his bribe would work. What would become of his family if he were imprisoned? Even if he was freed, could he continue to work for CAS? Wouldn't he be a risk? The police would be watching him.

Danny returned to customs the next day with the thirty thousand francs the captain had demanded. Clearly something had transpired. The captain refused the "fine" and told Danny that he was to be transferred to prison. The charges were "illegal possession of gold, the intention of illegally exchanging gold, and illegally profiting from gold for his own personal use." He was taken to the Evêché and spent the night in a cell. The next day he was photographed and fingerprinted and taken to the Palais de Justice, where he waited several grueling hours before being led, handcuffed, in front of a judge. Reading the charges against him, the judge ominously asked if he had a lawyer. Then Danny was taken to Chauve prison. He was permitted only two minutes for an interview with Gaston Defferre, the lawyer Fry had sent to defend him. He took the occasion to give Defferre the evidently useless thirty thousand francs he still had on his person.

In a cell meant for one, with an Italian robber, an Armenian jewel thief, and an Algerian who had killed his wife, Danny spent nine days

reflecting on his imprudence in walking into Kourillo's trap. The food was insufficient. Only a small piece of blue sky could be seen through his cell window. In the distance he heard the clank of the tramline heading to Air-Bel.[5]

Then suddenly, unexpectedly, he was granted a provisional release until his trial. The whole staff of CAS was at Defferre's office to greet him. He looked thin, unshaven, and dirty. Theo threw herself into his arms and then Varian, with tears in his eyes, pulled him to his chest and embraced him. As it turned out Defferre had had great difficulty dissuading Fry from presenting himself at the customs and taking on responsibility for the trafficking. He wanted to offer himself as a prisoner in Danny's place. Defferre assured him this would only lead to the closing of CAS.

Instead Fry had gone to the consulate and demanded that the consul general intercede in Danny's favor. To Fry's amazement, Hugh Fullerton personally went to see the director of customs demanding an explanation for why an employee of a benevolent American aid organization had not been granted provisional liberty before trial.[6] Fullerton's intervention was a public performance. He certainly didn't believe Danny was innocent. The careful diplomat was demonstrating his outrage that any American organization could be perceived to be involved in illegal activities.

MY BLACK HEART

One day in the middle of May, Fry asked Mary Jayne to leave the Villa Air-Bel. Her connections to Killer and his friends were putting CAS at risk. He thought it would be a good idea for her to return to the United States. This she was not ready to do but she immediately agreed to leave the villa. Still, she worried about why Varian had waited until now to ask her. Killer had previously told her an outrageous story. He and Mathieu had assassinated a stool pigeon and they had buried the body on the villa's grounds. Her sense of reality was astonishingly askew. Not only had she believed Killer's cock-and-bull story—she had walked the grounds of the park furtively looking for freshly turned earth—but she convinced herself not to question the morality of "offing" a stool pigeon who, supposedly, had set up Mathieu, landing him in jail for a month. She believed Mathieu and not Killer had pulled the trigger. Her deepest concern seemed to be that Fry had learned of the story, which was why he was asking her to leave.

But after Mathieu had stolen that fifty thousand francs of CAS's hard-earned money with his phony scheme of the diplomatic car, Fry

had reason enough to be fed up with Mary Jayne's continued association with her criminal friends. Danny's subsequent arrest at the end of May only confirmed that the committee had to be much more careful in their dealings with the Marseille gangs.

With her dog, Dagobert, Mary Jayne moved into a small hotel just north of the Canèbiere, though she kept her room at the villa. She was mostly on her own, seeing Killer only now and then and members of the committee only occasionally. She spent a good deal of time with Victor Serge's companion, Laurette Séjourné. When she dropped by Air-Bel only her old friend Theo seemed happy to see her. Varian pointedly left the house whenever Mary Jayne arrived.

Mary Jayne and Killer had become estranged. He claimed she refused to tell him she loved him, and that she held out on him. And even though her so-called friends had abandoned her, she was still giving her money to the damned committee. One day she was in a beauty salon—living in a city strangled by rationing was no reason to neglect one's coiffure—and Killer showed up. Mary Jayne immediately noted his aggressive and hostile look. He publicly accused her of considering him a "no-good punk," and left in a huff, saying: "I can be a real devil. You'll see."[1] She thought he was merely on one of his tirades, but in fact he was setting her up for what he was about to do.

That evening there was a knock on her door. It was Marcel Verzeano from CAS. He had come to tell her that Killer had broken into her room at Air-Bel, terrifying the young Spanish maid, Maria. He had turned the room upside down. Mary Jayne immediately took the tram to La Pomme.

Her room was a shambles. The contents of the drawers and armoire had been emptied. As soon as she picked among the pile of her possessions, she realized that Killer had stolen her jewelry and many precious heirlooms. She could hardly believe it. She was traumatized. She never considered that he could do this to her. As if to erase the deed, she tidied the room, putting everything back in its place.

Theo arrived back from the office and ran to console her. She threw her arms around the sobbing Mary Jayne and told her she'd better spend the night at the villa where she'd be safe.

But Mary Jayne wasn't yet done with Killer. Now she decided she couldn't leave him to navigate alone in Mathieu's world. She would save him yet. Besides, she wanted her jewelry back.

To say that, for a woman in her thirties, Mary Jayne was immature and self-involved would be a gross understatement. She was caught in a personal melodrama, in some kind of neurotic headlock.

Inconceivably, Mathieu showed up at the villa with an atrocious story. He claimed the robbery had been Killer's idea and offered to get the jewelry back. Of course Mary Jayne didn't believe a word of this, but Mathieu could lead her to Killer and she needed to see Killer. Mathieu said he would accompany her by train to Cannes, where he would demand Killer join them.

Theo was frightened for her when she learned of Mary Jayne's plan to leave with Mathieu, but Mary Jayne told her not to worry. "I'll stay at the Carlton," she said. "They can't shoot me at the Carlton."[2]

During the trip to Cannes, Mathieu made protestations of love and offered to shoot Killer. What he was up to Mary Jayne could scarcely fathom. Perhaps he wanted the rich girlfriend for himself. She put him off with hysterical giggles, which wasn't hard since she was actually feeling quite hysterical.

In Cannes the melodrama worked itself out at the Hôtel Carlton just as one might have predicted. Mary Jayne insisted on seeing Killer privately. With a great deal of finesse, he wormed his way back into her good graces. He said he must have been crazy. He'd been a fool. Mathieu had probably already fenced the jewelry, but he would get it back. The thing that really seemed to shock him was Mathieu's offer to kill him. Killer had always been a loyal lieutenant in Mathieu's gang.

Mary Jayne finally got to play the starring role in her own gangster film. Or at least that's how she remembered it. Later, when she and Killer met up with Mathieu in a local café, she took over. She told Mathieu: "You can make a deserter from the Foreign Legion disappear, and no questions asked. . . . But you can't make me disappear. Headlines in the New York *Times*. . . . So hands off. And hands off [Raymond], or I'll go to the police." As they walked out, Killer kept

repeating: *"Tu es formidable."* Looking back with a certain degree of self-irony, she would say: "I was so elated by my big scene that I had no time to be frightened."[3]

Mary Jayne, thirty-two, and Killer, just twenty, were playing dangerous games while the real tragedies of war swirled around them. It is difficult to understand her. She seemed to believe that he was a soul mate and that in saving him, she was saving some orphaned part of herself. Now that she had protected him from Mathieu, she had no illusions about the longevity of their relationship.

Both knew that Killer was in a precarious position. It was clear that he had defected from the gang and that Mathieu would not stop looking for him. It was imperative for him to get out of Marseille. With an audaciousness that must have been offensive, Mary Jayne approached Varian Fry. He politely declined to lend the committee's help. She wasn't surprised he'd said no, but was rather hurt that he had done so without a moment's hesitation. She approached all the other members of the committee and was peremptorily refused. How could they disclose their invaluable clandestine route to a guy like Killer? Finally Mary Jayne found an ally in Charles Wolff from CAS. Without Fry's knowledge, he located a Spanish guide who was willing, for a stiff price, to take Killer across the Pyrenees. Killer said all he needed to do was reach the British consulate in Barcelona. He was going to join the British army and become a British officer. He would explain his French accent by claiming he was a Canadian from Quebec and therefore a citizen of the British Empire. He wanted Mary Jayne to join him in England. Surely there was war work she could do. She demurred.

Killer slipped away with his Spanish guide one morning at dawn. He left Mary Jayne a note: "I love you with all my black heart. Think sweetly of me — Killer."[4] In Spain he managed to get to Barcelona and the consulate, where, with no trouble, he was given the certificate he needed stating he was a British subject. But he was picked up as he was making his way to Gibraltar and, like many British soldiers caught in Spain without transit visas, he was put in the concentration camp Miranda-del-Ebro, British section.

Soon after, Mary Jayne and even Theo at CAS began receiving demands for money from Killer. He claimed to have lent the money Mary Jayne had given him to some of the committee's clients at the internment camp, and was demanding more. The committee was thrown into a panic. Such wires were all the confirmation the police needed to prove that CAS had been illegally helping refugees and British officers escape France. Mary Jayne wrote a frantic telegram telling Killer to shut up. But she sent him more money through the Unitarian Service Committee.

Before long, Killer was transferred to Gibraltar. On October 1941 he made it to England. In no time, he received a commission as lieutenant in the British army. He wrote to Mary Jayne: "All my dreams are realized. . . . I beg you not to say anything to your English friends, who have been so kind to me, about how awful I was to you in Marseille. . . . If you could only see the new Raymond in all the splendor of his new uniform!"[5] Eventually Killer became a paratrooper. He and other members of the elite commandos became the darlings of English upper-class society. Using Mary Jayne's friendships and contacts, he was soon referring to weekends at country estates at which "Lord Dickie" [Mountbatten] was the featured guest. His English had improved dramatically. Much to Mary Jayne's surprise, Killer, it turned out, was a snob.

In the end, Mary Jayne was vindicated in her judgment of Raymond Couraud. He became a hero. His temperament of bravado and derring-do was brilliantly suited to war. He was seriously wounded at the infamous battle of St. Nazaire, where a force of 611 British seaborne commandos launched a raid against the German-controlled shipyards. Even after he recovered he was parachuted many times behind enemy lines. He claimed to be one of the first British officers to march with his squadron down the Champs-Élysées after Paris was liberated. He wrote Mary Jayne that, on that very afternoon, he made a pilgrimage alone to her old apartment near the Bois de Boulogne, where he sat in her dining room and once more berated himself for his betrayals. The Boche who had occupied her apartment had left it in pristine condition and had even added a grand piano. It was ready and waiting for her return.[6]

By the time the war was over, Raymond Couraud had achieved the rank of major in the Second Regiment of the Special Airborne Services and had earned the Military Cross for bravery in battle. He was twenty-four years old.

By the middle of June, Mary Jayne concluded it was finally time to leave France. With Killer gone, the villa's residents had gradually become friendlier. They never mentioned Raymond Couraud. By the end of June, she had secured all the necessary papers and prepared her good-byes. She was pleased when the committee showed enough confidence in her to give her a final assignment. Carrying condoms inserted inside tubes of toothpaste and face cream, she left with secret messages for British intelligence in Lisbon. She encountered no difficulties getting these through.

In her memoir *Crossroads Marseilles*, when she examined her Marseille experience years later, she expressed regret at having missed the opportunity to know André Breton better. Breton had made life feel like a voyage of inner discovery. She regretted, through her own fault, never having been fully accepted by the committee and not having been as useful as she could have been. But she never regretted "succouring" (as she put it) that "delinquent boy."[7] They remained in contact over the years. Raymond would write of his love for her and tell her about his current love affairs. The war years had been his glorious years and he was always grateful to her for giving him this gift.

TRISTE TROPIQUE

Europe, with its bullet–ridden Russias, its crushed and trampled Germanies, its in–vaded nations, its gutted France—how one clings to it! We are parting only to return.
<div align="right">VICTOR SERGE[1]</div>

ndré Breton stood on the bridge of the converted freighter *Capitaine Paul-Lemerle*. He could see in the near distance the lighthouse of the Fort-de-France, the capital of Martinique. It had been thirty grueling days at sea. The ship had seemed to be carrying some secret cargo; it had put in at innumerable tiny ports along the Mediterranean and the West Coast of Africa, no doubt evading inspection by the Royal Navy. As the voyage lengthened, hunger, exhaustion, and the unbearable stench from the latrines had left the 350 passengers completely depleted. The food had been execrable. Breton was thinking of the children below playing their games in among the slabs of rotting beef and mutton hanging in the open air. This morning he had come upon the strangest view. He had seen, perfectly aligned, the suspended, bloodied, and skinned carcass of a cow, behind which loomed the upper cabin of the ship, and behind that the rising sun. Right now he looked out at the blue expanse of sea, the lush tropical forests, and black sands of Martinique, and he watched the flying fish arch over the water. He inhaled the fresh breeze on the bay.[2]

He could feel a new elation among the passengers. Some of them were taking out the tiny shards of mirrors they had kept throughout the voyage, as they tried to tidy themselves. Their thoughts were only of freedom and clean water.

What the passengers had forgotten was that Martinique was a territory of France and they were still subject to Vichy law. Without warning, a dozen port authorities in khaki uniforms boarded the ship armed with revolvers and headed for the captain's stateroom. A sub-officer of infantry demanded complete silence from the passengers assembled on deck. "This is nothing," he told them derisively, "compared to what awaits you on the island." The passengers were called one by one into the officers' quarters. They could hear, from within the cabin, one officer shouting: "No. You are not French, you are a Jew and French Jews are worse for us than foreign Jews."[3]

When Breton was led before the officers, he was addressed with contempt: "A writer! You think you can come here to give conferences." The officer demanded nine thousand francs as a bond for landing and another fifteen hundred to defray the cost of Breton and his family's internment.

That night all the passengers were taken in boats across the bay to Pointe-Rouge. They were imprisoned at the Lazaret, a former leper colony.

In this pro-Vichy colonial outpost, they were enemies once again—Jews and dirty anarchists who were responsible for the defeat of glorious France. Only three passengers had been allowed off the boat to enter the city: the young Creole from Martinique, the mysterious Tunisian with his Degas, and Claude Lévi-Strauss. Because of Lévi-Strauss's frequent trips to Brazil on this same shipping line, the captain had insisted he be allowed to disembark. In fact, his trip had not been entirely unpleasant. As a cabin passenger, he was segregated from the refugees. He remembered looking down on André Breton "ambling up and down the rare empty spaces on the deck, looking like a blue bear in his velvety jacket."[4] He once sent him a note and they had managed the occasional meeting on deck. Apart from that, they carried on a correspondence by letter and had become friends.

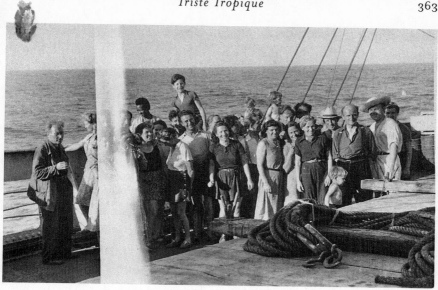

Refugees aboard the *Capitaine Paul-Lemerle*. Victor Serge is seen at the far left.

The former leper colony consisted of deserted brick buildings, the doorways and windows only holes opening to the sky. Men were once again segregated from the women and children. Food was limited to tins of sardines sold at execrable prices. At least the prisoners had the comfort of the sea. They were allowed to bathe at a small beach within the compound, but just one step beyond its boundaries brought an armed guard. Roll call was held morning and night.

Only French citizens were allowed to leave the compound, and then only until five o'clock in the evening. When Breton presented his passport requesting permission to enter the city, the lieutenant in charge said: "Breton. Non." "The security council opposes what they know you intend to get up to in Fort-de-France."[5]

Finally, after five days, Breton was granted a pass to leave the camp to visit the Dominican consulate, where he needed to apply for his transit visa. Unexpectedly, his demand for an interview with the island's governor was also approved.

Breton found himself seated before a small, gray-haired man with a pleasant, even self-effacing manner. He presented his case. How could he, who had served his country as chief medical officer for a

pilots' training school, be arrested on French territory? The governor stumbled to explain. Naval authorities had taken control of the island. Besides, a report had either preceded Breton or come with him (the governor wasn't sure which), making it clear that he was a "dangerous agitator." The governor said that he personally found Breton sympathetic, but that Breton was, after all, a writer, a journalist, which in itself was alarming. Breton replied that he had never been a journalist. He wrote poetry.

That very night the camp commandant released Breton and his family. They installed themselves in a small hotel and the next day reported to the police station as they had been instructed. Sitting under a large portrait of Pétain, the officer in charge responded with contempt: "OK, give me the address of your hotel, but be careful. Surrealist poet, hyper realist, we don't have any need of that in Martinique." To Breton's disgust, the commandant warned him not to mix with "the coloured elements," who were "big children" and not to be trusted.[6] That same morning André and Jacqueline encountered the two officers of the secret police who would shadow them throughout their forced stay in Martinique.

Eventually all the prisoners at the Lazaret were freed. They owed this to a dispute between the maritime authorities and the chamber of commerce. The business community saw the refugees as an unexpected economic boom for the island and so, while police kept them under surveillance, the refugees walked the streets of Fort-de-France, spending their few francs on the outrageously priced food and besieging the Dominican consulate with requests for visas.

One morning, walking into a store to buy a ribbon for his daughter, Breton came across a magazine. On a shelf among the haberdashery was the first issue of a modestly produced periodical called *Tropiques*. Breton read it with growing astonishment. The poetry and essays in its pages contained a ruthless examination of the war and the colonial exploitation of the island. "We are those who say No to this darkness," the editor wrote.[7] This was better than anything he had read in the periodicals in France.

Breton immediately tracked down the editor, Aimé Césaire, a twenty-eight-year-old teacher at a local lycée. Césaire, who was to become Martinique's greatest poet, would later say that his meeting with Breton was "utterly crucial and decisive. If I am who I am today, I believe that much of it is due to my meeting with André Breton. [It was like] a great shortcut towards finding myself."[8]

Soon the literary refugees were able to collect in the café Place Savane, with the secret police brazenly sitting at the tables next to them. Helena Holzer and Wilfredo Lam joined the Bretons in exploring the city's markets. André Masson, his wife, and two sons had left Marseille on the *Carimare* a week after the *Capitaine Paul-Lemerle*, and had suffered the same internment at the Lazaret. But they too were now free. Césaire and his wife, Suzanne, took the whole group on an excursion to the volcano Saint-Pierre and the Abyss of Absalom, where the Carib Indians were said to have gone to commit suicide when the indignities of slavery became unbearable. Césaire introduced them to the marvels of the jungle, to the infinite varieties of palms, ferns, and wild orchids. Breton and Masson collected material for what would become *Martinique, charmeuse de serpents*, a collaboration published in 1947, which was titled after a painting by Henri Rousseau.

On May 16 the Bretons, Massons, and Holzer and Lam embarked on the cargo ship *Rafael Trujillo* for Ciudad Trujillo, as the capital of the Dominican Republic was then called. The country was under the dictatorship of General Trujillo. Posters everywhere displayed his motto: *Law and Order*. Trujillo was seeking to keep refugees on the island so as to add professional doctors and teachers to the national resources. Even so, on June 12, after almost a month, the Breton and Masson families left for New York. Wilfredo Lam, who had not seen his family in eighteen years, departed with Helena for his native Cuba.[9]

The authorities in Ciudad Trujillo had impounded all Breton's correspondence and with it, all his correspondents' addresses. But he remembered Kurt Seligmann's address. A telegram to Seligmann announced the Breton family's imminent arrival in the United States. Breton said he was determined to make up for "those two lost years in

France." "There will be no backward glances," he remarked curtly.[10]
Jacqueline Breton wrote to Fry at the end of June: "The trip was like
that of Columbus'. It was as long. It took two months and it was pretty
disgusting and beautiful. . . . I don't know yet if I like New York. Ev-
erything seems so very new. What is certain now is that America is
the Christmas tree of the world. . . . When I eat everything I want and
whatever I want, I think of the big table at the chateau and of the
weird look it had on Sundays."[11]

If Breton's transit through the tropics had its extremely unpleasant
side, that of Victor Serge was a horror. The sea voyage to Martinique
had been particularly hard on him, and his health was frail. He was
preoccupied with the fate of Laurette and his six-year-old daughter
Jeannine, and concerned that neither he nor Vlady had yet received
the transit visas that could get them to Mexico. His nerves were on
edge. One day on board ship he came across Vlady reading Bukha-
rin's *ABC of Communism*. Serge grabbed the book and threw it into
the sea. "This is not the time," he said. "You should be studying a
Spanish primer."[12]

Vlady remembered officials boarding the boat in Fort-de-France.
When they made the rounds, demanding to be told which passengers
were Jewish, Serge replied: "I do not have that honour."[13] His detain-
ment at the Lazaret was longer than that of the others, and he found
the incarceration grueling: scorching heat, no running water, and
twenty-five francs a day for the "indescribably nasty food."

When he was finally released into the city, Serge spent his time
not with the surrealists in cafés but in isolation, trying to recuperate.
He was so tired he couldn't even get to the post office to collect his
mail. This could only be done in person, and it was imperative for
him to receive it. He had to start work again on procuring visas for
himself and his son. The Martinique transit visa that Fry assured him
had been secured seemed to have evaporated into thin air. His volu-
minous correspondence with the Macdonalds resumed.

Serge was once again trapped in limbo. He did not have permis-
sion to stay in Martinique. The only way to get to Mexico was via the
United States or Cuba, and the Macdonalds had informed him that

the U.S. transit visa, which had been sent to him six days after his departure from Marseille, had since been revoked.

Decades later, Serge's biographer Susan Weissman was able to explain why. The visa application process had brought Serge to the attention of American intelligence and Serge was being investigated.

> *His FBI file indicated that the US Army, Navy, FBI, State Department, Justice Department, and Military Intelligence had all been spying on Serge. The correspondence between Serge, the Macdonalds and official agencies in France was photographed by the FBI and all the names mentioned were investigated, no matter if the correspondence was sent through the mail, by clipper, telephone, or American Express. . . . Ironically, once the Macdonalds succeeded in getting Serge a temporary visa his bags were marked USA. The belongings got in, but not their owner! The Immigration Department confiscated Serge's two suitcases . . . and the FBI assigned special agents to photograph the contents and translators to translate the documents [which] were then summarized for the attention of J. Edgar Hoover.[14]*

In this manner J. Edgar Hoover inadvertently became an authority on the work of Victor Serge, since the only things the suitcase contained were manuscripts and some correspondence.

Serge wrote to the Macdonalds on May 10: "It is understandable that you should be drowning in refugee cases. Since August [1940] we have been living through this wreck and this constant struggle, and if I tell about it one day, it will make a farcical and terrible book."[15]

The Martinique authorities were anxious to be rid of refugees and finally allowed Serge and his son to depart for Ciudad Trujillo on May 23. By now their Mexican visas needed to be renewed, but luckily the Mexican government of former president Lázaro Cárdenas, who was now secretary of defense, was still sympathetic to the plight of exiles. Serge's Mexican residence visa was renewed two weeks later on June 5.[16]

Although he expected to be in Ciudad Trujillo for only a few days, Serge and his son found themselves trapped there for four months.

During their stay, the U.S. naval attaché John A. Butler, captain of the U.S. Marine Corps, visited them. In his confidential report to Washington, Butler remarked that Serge was a "brilliant, well-trained observer, whose first thoughts are against Stalin, although he is for democracies."[17] Butler indicated that Serge was waiting in the Dominican Republic for a transit visa through Cuba en route to Mexico.

In June Dwight Macdonald wrote to say that Serge could now get a U.S. transit visa only if he agreed to testify before the Dies Committee, a body of the U.S. Congress that for two years had been investigating subversive activities. He would be asked about the activities of Stalin's secret agents. While Macdonald admitted it was a "reactionary committee," he explained that Serge should be able to formulate his testimony "in such a way that its effect would be on the whole progressive, helpful to the real interests of labor."[18] But Serge's dogged sense of integrity prevailed and he demurred.

That June 22, 1941, he learned that 190 divisions of Hitler's Wehrmacht had invaded the Soviet Union. The news was bad. Taking literally hundreds of thousands of prisoners, the Germans had succeeded in driving the Russians back and were heading relentlessly toward Stalingrad, Moscow, and Kiev. Serge was desolate. He might have hated Stalin but he loved Russia. He was haunted by mental images of the fighting "over there." At that moment the last of his comrades were probably in Russian jails being shot under Stalin's orders for failure to defeat the enemy. It was always that way in Stalin's Russia. Still, he believed the Russian people would somehow find the inner resolve to defeat the Germans. Perhaps the whole world's fate hung on their courageous resistance. He predicted Stalingrad would be defended ferociously and that Russia's unconquerable winter would sabotage Hitler's vainglorious ambition for world domination.

By working from dawn to lunch, Serge and Vlady adapted themselves to the tropical heat. In four weeks he finished his book *Hitler contra Stalin: La fase decisiva de la guerra mundial* (*Hitler Against Stalin: The Decisive Phase of the World War*) which he dedicated to the workers of the Mexican revolution. According to Susan Weissman, Serge's biographer, the tiny Mexican publishing house that issued it,

Ediciones Quetzal, "was ruined after publishing such an uncompromising anti-Stalin and anti-capitalist analysis of World War II."[19]

Giving up on any hope for an American transit visa, Serge and Vlady departed for Haiti. This was risky since they had no Haitian visas, but they couldn't stay any longer in Ciudad Trujillo. At the Port au Prince airport the police took them into custody and deported them back to the Dominican Republic. Next they tried Cuba, where they were immediately interned in the Tescornia concentration camp. The Macdonalds' appeals to Cuban immigration were fruitless. In corrupt Cuba, all that worked was bribery. In the end, a Salvadoran political activist living in Havana, who had read Serge's poems in French, paid Serge's and Vlady's "bail."[20] Father and son were allowed to proceed on their journey.

More than six harrowing months after they had left Marseille, on September 4, 1941, Serge and Vlady finally set foot on free Mexican soil. Serge was no longer an outlaw, no longer hunted, reviled, begging for a chink in a doorway somewhere that would open to allow him in. He hoped this would be his last exile. And so it was.

WINDING DOWN

Summer 1941

On the boulevard Garibaldi in Marseille, Fry sat alone at his desk. He was deeply depressed. He had written to his wife, Eileen, in January: "The truth is that I like this job better than any I have ever had in my life. . . . [I am] using all my capacities . . . for the first time in my life."[1] But now, in late June, he was feeling emptied. He felt close to the people he worked with. They were family, and each time he watched someone go, even though to safety, he felt a terrible loss.

He had lost Miriam Davenport. She had written recently to say that she and Rudolph had gotten out of Yugoslavia just before the Germans and Italians invaded in April, but now they were stuck in Switzerland. She was having endless trouble getting Rudolph a visa for the United States. In February, Fry had lost his loyal secretary Lena Fischmann. He was very disturbed when she wrote to tell him that she had been strip-searched crossing the border into Spain. The most distressing loss of all was Beamish, who by now had arrived safely in the United States. Though Danny Bénédite had so ably replaced him, Fry still felt devastated over Beamish's departure. Despondent and lonely,

he occasionally wrote to Eileen about the possibility of her coming to join him in France, though the invitation was hardly realistic and he knew it.

With the departure of Breton, life at the Villa Air-Bel had lost much of its charm. Fry had now moved into Breton's room on the top floor. He found little bits and pieces of André's colored paper cutouts on one of the window recesses and on the back of a door and some of his shells and butterflies on the mantel. Fry felt the echo of his laughter in the house and missed him. Breton's friend Benjamin Péret still came to visit with his beautiful companion, the painter Remedios Varo, but most of the other surrealists had drifted away.

The work of the committee was at a standstill. At the end of May the Martinique route was permanently closed. The British Royal Navy had seized the *Winnipeg* on her way to Martinique and rerouted the ship to Trinidad, detaining most of the passengers, including some of Fry's clients. To prevent other seizures, Vichy immediately ordered the French ships *Wyoming* and *Mont Viso* to put in at Casablanca. CAS refugees had been on board those ships as well. After feverish telegrams and much work, CAS was able to get them out of detention camps and arranged for them to resume their journeys. But no more refugees would be using the Martinique route.[2]

In April Fry's crucial F-Route was permanently shut down as well. Lisa and Hans Fittko had been operating the escape route over the Pyrenees for more than six months. On March 25 the Pétain government decreed that all border areas were to be cleared of foreigners within ten days. Banyuls was within the border zone. The town's gendarmes arrived one morning to tell the Fittkos they were to be evacuated.

The Fittkos immediately found themselves plunged into the miasma of French bureaucracy. Realizing they had no alternative but to leave, Hans Fittko asked for *sauf-conduits* to get to the town of Cassis near Marseille, where Lisa's brother lived. But a dispute arose over the legality of Lisa's *pièce d'identité*. Her identity papers carried the official stamp: *refus de séjour* (rejection of residence). She explained that this applied only to Paris. The Banyuls gendarmes, who thought of the Fittkos almost as natives, were stymied. They could not issue

a safe-conduct pass without recording the number of the individual's *pièce d'identité*, and Lisa had no such number.

"Couldn't they just leave the number blank?" Lisa asked. "Out of the question. The line must be filled in!" she was told. Then the adjutant to the sergeant came up with a suggestion. Instead of writing a number beside the phrase *pièce d'identité*, why didn't they simply repeat the words *pièce d'identité*. The sergeant beamed at his adjutant. His solution was ingenious. On Lisa's safe-conduct pass, beside the line *pièce d'identité* he duly wrote *pièce d'identité*. Any examining official would think the repetition simply a clerical error while, ever the conscientious official, the sergeant could satisfy his conscience that he had stuck, more or less, to the truth. After shaking hands all round, Lisa and Hans headed to the train station. If things hadn't been so serious, the Fittkos might have laughed at the absurdity of French bureaucracy.[3]

Worse still, things were suddenly getting tough in Spain. As long as refugees had transit visas and international visas making it clear that they were just passing through the country, most had had no problems getting through Spain. But at the beginning of May the governments of Vichy and Spain signed a new accord that included an agreement to reinforce controls at the frontier. The Spanish police now thoroughly checked people on the trains and at border posts. Anyone without the necessary collection of visas was arrested. These now included not only entrance and exit visas, but also Banque de France and customs seals of authorizations.

Passage through Spain had itself become more dangerous. Perhaps because of the German military successes that spring in Yugoslavia, Greece, and Libya, Franco had decided to cooperate more overtly with Hitler, and the Gestapo was now touring Spain in search of anti-Nazis. It was no longer enough to get people to the Spanish border. They now needed to be guided safely through to Portugal.

In March of that year Maurice had encountered a Spanish anti-Fascist named Silvio Trentin, a bookstore owner in Toulouse, who'd introduced him to a man called Garcia. For some time Garcia had been operating an underground route out of the seaport town of Port Ven-

dres, mostly for Spanish Republican soldiers and politicians. He called it the Carlos Route because Carlos was one of the best of his guides.

Garcia was proud of his route and explained it to Maurice. French guides led the escapees through a brutal walk over the Pyrenees, and then entrusted them to Spanish guides, mostly militant anti-Franco railway workers, who knew all the police inspectors on the trains. The price for the clandestine route was high since many palms had to be greased and higher still when forged documents had to be procured. On the Spanish side of the border, there were good resting places in old churches and abandoned barns. When the refugees reached Barcelona, they were hidden in the house of a local waiter. His wife even washed their clothes. The guide from Barcelona to Madrid had somehow procured a visiting card belonging to Ramon Serano Suñer, General Franco's foreign minister, which said: "Please show every courtesy to the bearer." When he pulled it out, it worked every time. In Madrid the travelers were put up in out-of-the-way hotels that demanded no identification papers. From there they were led over the Portuguese border and directed to take the train to Lisbon.[4]

By May only the Carlos Route was still functioning. But many refugees following that route were landing in jail at Miranda-del-Ebro. As it turned out, the transit visas Garcia was carelessly giving them were forgeries and crude forgeries at that. Words were misspelled on the documents, and even the signature of the Spanish consul was traced with a pencil and then inked in. Police could spot them easily.

Even the committee's assistance to stranded soldiers of the British Expeditionary Force and to British fliers who had bailed out and gotten trapped in France had come to an end. The Germans had announced that anyone discovered to be assisting British soldiers would be immediately shot. Fry sadly explained to his British contact he had no choice. His mandate and responsibility was to save the refugees.

With the escape routes frozen, Fry staunchly set about doing whatever he could in order to continue. Over the past months, to give the committee a higher profile, he had been collecting the names of influential Frenchmen to add to the CAS masthead as a *comité de patronage*. These names included André Gide, Henri Matisse, Pablo

Casals, Georges Duhamel, and Aristide Maillol. Most of them were at least indirectly aware that Fry had been spiriting people out of France illegally.

Fry began to make excursions outside Marseille, particularly to the mountains of the Luberon. His new endeavor was to establish safe houses for those refugees who might never succeed in escaping. He also explored CAS's plans for refugee resettlement. In the hills of the Var he rented two old farms at a ridiculously low price. Then, through some contacts of Danny's, he began setting up a small industry for the manufacture of charcoal at La Garde-Freinet.[5] The idea was that the refugees could live inconspicuously in the local communities. Having work to support themselves would help protect them from denunciation and inevitable internment.

Danny and Theo were now talking seriously about trying to get out of France themselves. After the grueling year of work, imprisonment, and police harassment, Danny longed for normal life. He knew things would only get worse in France. Of course Fry wanted them to be safe, but he was saddened at the thought of losing Danny. Danny was his favorite colleague by far, even though he often criticized Fry's methods. For one thing, Danny always felt that, with Fry's approval, Maurice and Jean Gemähling chose collaborators carelessly and were too fond of playing at conspiracies. Maurice had found Garcia. When it became clear that Garcia was giving the refugees patently forged documents, Danny had been furious, and, in a hot-tempered moment, he had called Jean and Maurice adventurers gambling with the fates of refugees. Indignant, Maurice had threatened to resign. Both he and Jean were risking their lives, he said, and used illegal contacts only as last resorts to help the most endangered clients.[6] Everyone was exhausted from the enormous pressure. Rancorous disputes were mounting.

Mulling over the decision to depart left Danny intensely divided. Without his knowledge, his mother had been working since January to secure American visas not only for Peterkin and herself but also for Theo and Danny. The Bénédite branch of the family in the United States had university connections, and Harvard and Wesleyan had of-

fered Danny assistant professorships in French literature and philoso-
phy.[7] His degree from the University of Paris was in philosophy and
the idea of teaching was very seductive. Theo was desperate to leave.

For Danny, though, to leave would mean deserting the battle
against European Fascism. He would be abandoning CAS in its dark-
est days and leaving Fry alone to confront the detestable Vichy regime.
Still, what help could he be? His arrest had made him the subject
of constant surveillance and now he was facing the possibility of five
years in prison. As a matter of fact, he wondered if his arrest wasn't the
cause of the increased harassment at CAS.

June 15 three police inspectors raided the office on boulevard
Garibaldi, looking for forged passports and identity cards and a print-
ing machine. They harangued Fry: "Of course you're not stupid
enough to keep your materials here, but one day we'll catch you,"
they said viciously.[8]

Two days later the police from the Surveillance du Territoire
raided the Villa Air-Bel at dawn. After marching the residents down-
stairs at gunpoint, they searched the house from top to bottom looking
for a clandestine shortwave radio. Alerted by the raid at CAS, the resi-
dents had wisely disposed of the one they had.

Within the week the police raided CAS yet again, looking for the
six thousand dollars Fry had just received from a departing client.
They turned the office upside down and then went out to search the
villa. But Danny had already buried the money on the grounds in the
pinewoods.

The question was, who had alerted the police? They knew who had
given Fry the money and exactly how much. It seemed to be the work
of Boris Kourillo, the same crook who'd betrayed Danny. The depart-
ing client had first attempted to exchange the money with Kourillo.

On July 10 the U.S. consulate informed the Bénédites that their
American visas had come through. Theo was pressing to leave and
then Varian agreed. CAS's days were numbered, he said, unless the
New York Emergency Rescue Committee could interest the Ameri-
can government in the plight of the refugees. In New York, Danny
could plead their case. He would be more useful in New York.

There remained one huge hurdle. While Eva and Peterkin had obtained exit visas relatively easily, it was not to be expected that Vichy would ever permit Danny and Theo to leave France. His trial was pending. Theo was English. The police had files on both of them. They had also accused Danny of being a supporter of General Charles de Gaulle and the Free French movement he was conducting from England. Of course they would be heading to England to join de Gaulle's forces. There was no chance, no point in even applying for exit visas. Danny and Theo's only option was to flee by the Carlos Route, the very route Danny had accused Maurice and Jean of having set up in such a slipshod manner.

In the third week of July, after Danny returned from a trip to Clermont-Ferrand in the Massif Central, Theo told him all arrangements were made and they were leaving the next day for Toulouse, where Charles Wolff from CAS was waiting for them. Garcia's gang was ready to guide them to Lisbon.

The Bénédites packed a few clothes in small duffel bags they could carry on their backs. Everything else had to be left behind. They must appear to be casual tourists on the train to Toulouse. They hid the Spanish money they would need in toothpaste tubes.

But when they met up with Charles at the station in Toulouse, he informed them that the guide Carlos was nowhere to be found and the man who was to take them over the Pyrenees into Spain had been arrested the previous day. They were trapped. They were both despondent and weary. Danny wanted to give up and return to Marseille. Theo said they had gone too far to turn back. Finally Charles intervened, assuring them that he knew of a safe house in Toulouse where they could hide out while he looked for another guide.

It was a long, anxious week, but Danny managed to distract them both by hunting down an old professor of psychology who had taught him at the Sorbonne. They passed their evenings in pleasant conversations. They spent their days at the bookstore of Maurice's friend Silvio Trentin.

On August 9 Charles returned to fetch them. He said he had made contact with a new group calling itself La Bande à Sancho through

whom he had found them a new guide. He also brought them newly forged exit permits. Danny noted that at least these were good forgeries.

Charles offered to accompany them on the train to the port of Cerbère, just south of Banyuls, at the Spanish border. There he would personally introduce them to the guide. "You are in good hands," he assured them.[9]

At Cerbère, Charles embraced them in a warm farewell and then handed them over to their guide. Immediately Danny was suspicious. He didn't like the look of the man. He remarked to Theo that he had eyes like "the buckles on ankle boots." On the brief train ride from Cerbère to Banyuls, the man was taciturn. They spoke little. As the three descended onto the small Banyuls platform, Danny surveyed the territory carefully. On one side of the station was a high cliff. He imagined the police chasing them. There would be no place to run.

As they cautiously threaded their way through the police check, some of the guards who were scrutinizing their papers advised them not to proceed further. What did this mean? Was the advice simply formulaic or was it a real warning? But Danny and Theo were stuck in one gear. They had no choice but to proceed.

They sat out the afternoon and evening in a café, anxiously waiting through long hours. Then, when the moon rose, they followed their guide down the dark train tracks, carrying their duffel bags. They watched the man's back in the distance with a deep apprehension. Was he trustworthy? They were putting their lives in his hands.

Suddenly the very guards who had examined their papers earlier at the train station jumped from behind a pile of wood and seized them roughly in a headlock. Predictably, the guards made no effort to apprehend the guide, who ran off down the tracks. Theo and Danny had been betrayed.

Danny had the presence of mind to tell the guards that they were just going camping. He said they had met a helpful peasant who had told them about a good camping site. The guards only laughed in contempt.

The couple were taken to the basement of a nearby industrial building that served as a temporary jail. They passed the night on two

straw mattresses that had been thrown hastily across planks. Danny managed to hide their forged exit permits under debris. He was confident that their bags contained nothing compromising and could only hope that the guards would not discover the Spanish money hidden in the toothpaste tubes.

The next day they were led before an adjutant. *"Mes petits agneaux"* ("my little lambs"), he called them. "Yes, of course, you are innocent tourists," he said sarcastically. They would see what the commissioner of police at Toulouse would say. He had been telephoned. There was no hurry. Nobody seemed to care. Danny and Theo were kept at police headquarters for three nights. Graffiti on their cell walls told local stories of stool pigeons and threats of paybacks.

When they were brought before the commissioner from Toulouse, the man said: "I don't know you, but I think I can trust you. Consider me like a friend."[10] He told Danny that his story obviously didn't hold up. Although he and Theo had clearly intended to cross the border, still, they hadn't actually done it. French law dictated that an intention of illegal action was not the same as an enactment. He would ensure they got back to Marseille. As a favor to them, he would tell the adjutant that he himself was conducting them both back to prison in Toulouse. They would board the Banyuls train together. The commissioner would get off at Narbonne and go on to Toulouse. Danny and Theo could proceed on to Marseille. All records of this incident would be expunged, he added, warning them that they must never return. Next time he would not be so lenient. Danny and Theo had just been saved. They felt like embracing the man.

On the train home, Theo berated herself for having insisted they continue on. She had been feeling desperate. Danny consoled her. "All considered," he assured her, "the outcome hadn't been terrible." To himself he pondered: was he a dupe or a "lucky devil"? He had been betrayed twice, first by the slimy moneychanger Boris Kourillo, and now by this stool pigeon into whose "safe hands" Charles had delivered them. Yet, so far, he was not in jail. He had twice slipped the noose.

END GAME

Evil is unspectacular and always human,
And shares our bed and eats at our own table.

W. H. AUDEN[1]

At six o'clock in the evening on July 10 a motorcycle dispatch driver arrived at boulevard Garibaldi. He carried a summons for Fry to appear at the prefecture before Maurice Anne Marie de Rodellec du Porzic, a vicious anti-Semite whom Vichy had appointed that spring as the intendant of police for Marseille and the entire region of Bouches-du-Rhône. Failure to comply with the summons would result in immediate arrest.

The next morning, Fry dutifully arrived at the prefecture. He passed through its ornately carved wooden doors into its intimidating interior and glanced up at the ceilings with their elaborately painted themes of optimism and progress so dear to the nineteenth century. But he was not feeling optimistic. He waited nervously for forty-five minutes before being conducted into Rodellec du Porzic's office. The intendant sat at his desk with the sun behind him so that Fry could not see his face. He produced a huge dossier, and the rough interrogation began. Fry recorded it in his notes afterward:

"You have caused my good friend the Consul-General of the United States much annoyance," he said.

"I guess the Consul can take care of his own problems," I said.

"My friend the Consul-General tells me your government and the American committee you represent have both asked you to return to the United States without delay," he continued.

"There's some mistake," I said. "My instructions are to stay."

"This affair of your secretary," Rodellec du Porzic went on, obviously referring to Danny, "will have serious consequences for you."

"I can't see how. . . . One of my employees has committed an indiscretion. But he acted entirely on his own responsibility. There is no proof that I was involved in any way."

"In the new France, we do not need proof," de Rodellec du Porzic said. "In the days of the Republic, it used to be believed that it was better to let a hundred criminals escape than to arrest one innocent man. We have done away with all that. We believe that it is better to arrest a hundred innocent men than to let one criminal escape."

"I see," I said, "that we are very far apart in our ideas of the rights of man."

"Yes," de Rodellec du Porzic said, "I know that in the United States you still adhere to the old idea of human rights. But you will come to our view in the end. It is merely a question of time. We have realized that society is more important than the individual. You will come to see that, too."[2]

The intendant paused to close the dossier. "When are you leaving France?" he asked. Fry said he had no definite plans. "Unless you leave France of your own free will," he said ominously, "I shall be obliged to arrest you and place you in a *résidence forcée* in some small town far from Marseille, where you can do no harm."

Fry said he needed time. If he were to leave, he had to make sure that his relief organization could continue on. Someone would have

to be sent from America to take over CAS. This person would need a passport, a visa, a transatlantic ticket. All time-consuming. With remarkable sangfroid, Fry said that he would be prepared to leave in one month, by August 15. The intendant replied that that would be satisfactory.

The next day Consul General Fullerton called Fry to the American consulate. Fry suddenly found himself in possession of his passport, validated for Western travel only, with the French exit permit and the Spanish and Portuguese transit visas already stamped in it. The consul general and Rodellec du Porzic were in collusion.

Against the advice of Fullerton, who insisted he would surely be arrested, Fry instantly went to Vichy to protest. But there he found all doors closed to him. The French Ministry of the Interior refused an audience. The American ambassador William Leahy declined to see him. "You should have returned to the U.S. a long time ago," the embassy staff told him dismissively. To his utter shock, he was even denied a permit to stay in the town overnight "because of suspected Communism."[3]

Thinking he might get some inside information at the Press Bureau in Vichy, he went there. A journalist from *Progrès de Lyon* told him that the German representative at Vichy was putting strong pressure on the French to get rid of him. His friend Archambault of the *New York Times* had one piece of advice: "Stay away from Marseille. Keep a low profile. Keep out of sight."[4]

Possibly Archambault had heard rumors of a telegram Consul Fullerton had sent via the American embassy to the State Department. Fullerton had reported that Fry's position was becoming "increasingly dangerous." The only reason for Fry's immunity so far was "the reluctance of the French authorities to lay themselves open to further criticism of France in the American press [for] measures against American citizens."[5]

Fry had strong nerves and wasn't going to give in to pressure. His committee and the lives of refugees were at stake. He would insist that the Emergency Rescue Committee in New York send a replacement. He would wait until whoever it was arrived.

But it was time to disappear from Marseille. After a brief and disturbing visit to the Villa Air-Bel where he found Danny waiting for him (the Bénédites had returned from Banyuls and it was then that he learned of their harrowing ordeal), he set out along the Côte d'Azur.

Fry stayed at the Pension Beauséjour in Sanary-sur-Mer for three days and then went on to St. Tropez. He was there on August 15 when Rodellec de Porzic's deadline expired. Expecting to be arrested at any moment, he moved on through Saint-Raphaël to Cannes. As he traveled, he made sure that CAS knew his whereabouts. At each town, a senior CAS staff member would come to discuss the restructuring of the committee after he was gone. He nominated Jean Gemähling to take over as director should his American replacement never appear. Danny would have been preferable, but, with his trial still pending, it was imperative that he remain in the background. The inner circle was still intact. Maurice, Paul Schmierer, and Lucie Heymann knew all of CAS's secrets.

As his period of grace lengthened without incident, however, Fry began to think that perhaps Rodellec du Porzic had been bluffing. He booked into the Hôtel Majestic at Cannes. The stress was getting to him and he spent a lot of time drinking in the bar. He wrote to Eileen that he felt "utterly alone" and he feared he was becoming an alcoholic. "I have become an *apatride* myself by association," he said.[6]

At his urging, Danny joined him in Cannes on August 23. Both men felt demoralized. Fry could not bear the thought of leaving the committee, while Danny wondered what he himself would do if Fry were actually expelled. Danny was a marked man. He had a family to support. What other work could he find? And Theo was depressed. Her mother-in-law had left for the United States and taken Peterkin with her. Perhaps they shouldn't have let the child go. Perhaps she and Danny should make another attempt to escape.

As the two men started back to Marseille, Fry insisted that they turn this into a real vacation. They deserved one. Dreading what awaited him, he wanted to put off their return as long as possible. The August weather was exquisite. They walked along the Croisette and

dined in the small restaurants in Cassis. Then they went to Antibes, took an excursion to Cagnes, and went as far as the town of Vance.

At Nice they visited Henri Matisse, who had invited them to tea in his famous atelier de Cimiez filled with tropical plants and exotic caged birds. Almost since his arrival in France, Fry had been trying to convince Matisse to leave. They argued once again over his safety. Fry insisted Matisse was in danger, at the very least from starvation, and probably worse. But Matisse demurred. "If all the talented people left France," he had told one journalist, "the country would be much poorer. . . . I will lock myself up in Nice with my 200 birds and paint."[7]

Matisse was old and ill with cardiovascular and abdominal disorders, and he was not about to leave his country. Throughout the war he remained disengaged, shielding his art from all politics, though he proved, at least passively, to be supportive of the growing Resistance. His son Jean became involved in sabotage operations. His daughter Marguerite was arrested and tortured by the Gestapo. In the chaotic waning days of the war, she managed to escape from a cattle car that was stalled on a siding on its way to a prison camp.[8]

As Danny and Fry continued their travels through the Côte d'Azur, Fry took pictures of broken windows of Jewish shops and of signs at the local legions that read *"Entrée interdite aux juifs non-combattants"*—entrance forbidden to non-fighting Jews. He was collecting evidence to take back to America. In the small town of Beausoleil, he photographed a Vichy propaganda poster and he and Danny were immediately arrested as spies. Taken before the *commissaire*, Fry brazenly protested with indignation: "Here, you arrest admirers of the Marshal? Not only am I an American citizen, but I am an admirer of your National Revolution. It's a regime that I wish for my country!" With profuse apologies, the *commissaire* released them.[9]

When Fry finally returned to his office in Marseille on August 27, he was feeling much more relaxed. The grace period accorded him by Rodellec du Porzic had long since passed and the visas in his passport had expired. Strolling about the city freely, he experienced

no police harassment and began to half believe Danny's assurances that Vichy would never dare arrest him for fear of antagonizing the U.S. government.

But on Friday, August 29, at 1 P.M., two police inspectors arrived at boulevard Garibaldi. They found Fry in the back office and handed him an arrest order, signed by Rodellec du Porzic. As his distraught colleagues watched, Fry was taken off to the dreaded Evêché. His secretary, Lucie Heymann, was allowed to accompany him. Jean Gemähling recalled that Fry "was quite composed. He had no reason to be frightened. He knew they were after him, though he didn't expect it that morning."[10]

Fry's staff scrambled to figure out what to do. Danny immediately left for Vichy to see if he could get the arrest order rescinded. When Lucie Heymann returned to CAS that afternoon, she called Roger Homo, secretary general of Provence. Homo said he could do nothing for Fry. He said Fry was "either insane, a saint, or an anti-Nazi 'Bolshevik' agent." Lucie replied: "possibly a saint, probably insane, but definitely not a 'Bolshevik agent.' "[11]

The likely explanation for Fry's arrest was more sinister. There had been a shooting the previous day at Versailles and the high-profile targets were no other than the government minister Pierre Laval himself, along with a pro-Nazi, Marcel Déat. The shooter was a man named Paul Colette, part of a newly emerging circle of *résistants*. Laval was seriously wounded and now Vichy was feeling directly threatened. It was time to get rid of a potentially dangerous irritant such as Fry.

Fry was held in isolation that evening and refused access to a telephone. He spent a restless night stretched out on a table in the room of the *brigade des rafles*. He had kept up a brave front, as was his wont, but on his mind was Rodellec du Porzic's threat of a *résidence forcée* in some small town far from Marseille. The next morning he was led into the office of the *commissaire* and shown an *ordre de refoulement* (expulsion) signed by the intendant. It stated that he was an undesirable alien and was immediately to be conducted to the Spanish frontier and forcibly expelled from the country.

It was almost a relief. A sympathetic inspector named Garandel was brought into the room. He was to escort Fry to the border. The inspector's manner was respectful and almost apologetic.

Fry was taken by police van to his office at CAS. It was late and, except for one of the secretaries, Anna Gruss, and the night watchman, Alfonso, the office was deserted. He emptied the contents of his desk into his briefcase, and Alfonso, almost in tears, embraced him as he left.

Fry was then driven to the Villa Air-Bel. Here too only the gardener, the cook, and the housemaid were home. He had one hour to collect all his things. He shook hands with the weeping house staff and with a puzzled Dr. Thumin, who had come up to the villa to see what all the fuss was about. Fry insisted he would not leave his dog behind. Garandel did not object. Leading Clovis on his leash, Fry turned his back on the villa that had served him so well as a shelter in the darkest of times.

The two men and the dog proceeded to the gare Saint-Charles. Fry took his last melancholy look at the city he had come to love:

> *I went to the top of the monumental staircase and looked down the boulevards d'Athènes and Dugommier to the Canebière and the boulevard Garibaldi. The city was golden in the late afternoon sun, and people were hurrying home from work. But it was hushed and silent. . . . Everywhere people were wandering down the middle of the streets, as unconcernedly as though they were on sidewalks, and almost the only sounds you could hear were the distant moans of the trolley cars' horns and the occasional patter of wooden-soled shoes on the pavement. Even the port was dead.*[12]

They made their way to the station restaurant and Fry was overjoyed to see almost the entire CAS office staff waiting for him. Word had spread quickly. Among the group were Theo, Maurice, Jean, Paul, Lucie, and Jacques Weisslitz, the Alsatian who'd been hired ear-

The final lunch at Cerbère Station, September 6, 1941. *From left:* Varian
Fry, Jacques Weisslitz, Theo and Danny Bénédite, Lucie Heymann,
Louis Coppermann, Marcel Verzeano, Jean Gemähling.

lier in the spring. Danny hadn't yet returned from Vichy. Dinner was
a hurried and doleful affair after which Fry was hustled aboard the
train in a car marked *"Réservé pour la Sûreté Nationale."* Then, quite
unexpectedly, Garandel allowed Fry's friends into the compartment
to accompany him to Cerbère. As they passed through Nîmes, the city
was completely dark under the wartime blackout, but they saw fire
burning atop the Tour Magne. This was the eve of the first anniversary
of Pétain's Légion: Résurrection Française. To celebrate, Vichy had
organized a relay of runners carrying torches from the Tomb of the
Unknown Soldier in Paris to every corner of France.

The group arrived in Cerbère, only to discover that Fry did not have
valid exit and transit visas. Inspector Garandel phoned the prefecture
in Marseille and was ordered to take Fry to the nearby town of Perpi-
gnan and there hand him over to the local police. He was to be kept in
jail while the documents were prepared. Inspector Garandel told Fry
not to worry. He would see to it that Fry was allowed to stay at a hotel.

After his fruitless efforts at Vichy, Danny caught up with them.
The group booked rooms at the Hôtel de la Loge just around the cor-

CAS workers say farewell to Varian Fry at Cerbère Station.

ner from the ubiquitous Préfecture de Police where they stayed the whole five days it took for Fry's permits to arrive. Inspector Garandel left Fry and his friends alone to enjoy the city and their last few moments together. But as dusk fell, he was always at Fry's side. Fry asked him why he was so lax all day and yet vigilant at night—Fry could easily have escaped had he wanted to. Garandel replied that the city was full of Boches. "You can never tell what they might do to you on one of these dark streets if you should go out alone at night." Garandel was protecting him and Fry was grateful.[13]

On the morning of the final day the group set out again for the port of Cerbère. They had a last sad lunch together. Fry remembered that it "was a depressed and awkward ceremony, in which there were many silences."[14] Tearful embraces were exchanged at the train station. Fry clasped Garandel's hand and wished him good luck. Without friendly officials like Garandel, he knew CAS could never have carried on its work.

Danny was disconsolate: "You can't leave us, *mon vieux*," he whispered in Fry's ear as he embraced him. "You've become almost more

French than American." He slipped him a copy of Antoine de Saint-Exupéry's *Terre des Hommes*. On the flyleaf he'd written a dedication: "this which we must reread from time to time to keep up our optimism. We will have need of it more and more often."[15]

When the conductor blew his whistle and cried, *"En voiture,"* Fry boarded the train with Clovis and stood on the bottom step of the coach waving his handkerchief. His staff waved back. They were still standing stiffly on the platform as the train entered the international tunnel.

DECOMPRESSION CHAMBER

Fry sat on the train leafing through Saint-Exupéry's account of his crack-up in the desert, but he could not focus on the book. Images flooded back to him—of the streets of Marseille and the magnificent view from the gare Saint-Charles, of the Villa Air-Bel and its gardens and the Sunday gatherings of surrealists, of his office and staff and the close friends he'd made, of the traumatic days aboard the *Sinaïa*, of the grateful faces of the people he'd saved and the despairing faces of those he was leaving behind. It all flooded together. He felt he was leaving a lifetime behind.

With the inspector at his side, the Spanish guards at Portbou barely examined Fry's trunks, and he thought of the missed opportunity to have smuggled out crucial files. When Garandel left Fry to continue through Spain on his own, he remarked:

"I hope you will not think ill of France."

Fry replied: "Of France, never. Of certain Frenchmen, yes. You understand?"

"I understand," the inspector said.[1]

* * *

The long ride to Barcelona was melancholy. With Clovis at his feet, Fry watched the rain beating against the window. The trees and fields looked as desolate as he felt. He wrote a long letter to his wife. It had been almost thirteen months since they had seen each other:

September 7, 1941.

Forgive me, then, if I am sad today. It is not merely the sadness of parting from friends and familiar sights and sounds. . . . It is also, and perhaps especially, the terrible let-down that was sooner or later inevitable after such a strenuous and turbulent year. For I have just reached the end of the most intense twelve months I have ever lived through. When I left New York on August fourth, 1940, I had no idea at all of what lay ahead of me. (Such ideas as I had proved to be fantastic.) Even during the first days and weeks in Marseille, I was far from realizing the true nature of the situation I faced. Today I think I understand as well as anyone else what is happening to France. And yet I still don't quite know what happened to me. . . .

What I do know is that I have lived far more intensely in this last year . . . than I ever have before, and that the experience has changed me profoundly. . . . I do not think that I shall ever be quite the same person I was when I kissed you goodbye at the airport and went down the gangplank to the waiting Clipper. For the experiences of ten, fifteen, and even twenty years have been pressed into one. Sometimes I feel as if I have lived a whole life (and one to which I have no right) since I first walked down the monumental stairway of the Gare St. Charles at Marseille and timidly took a small back room at the Hôtel Splendide.

Since that day I have had adventures—there is no other but this good Victorian word—of which I never dreamed. I have learned to live with people and to work with them. I have developed, or discovered within me, powers of resourcefulness, of imagination and of courage which I never before knew I possessed. And I have fought a fight, against enormous odds,

of which, in spite of the final defeat, I think I can always be proud. . . .

When I look back upon this year, the thing which impresses me most is the growth *I have undergone. . . . The roots of a plant in a pot too small will eventually burst the pot. Transplant it to a larger pot and it will soon fill it. But if you transplant it to [a] pot altogether too large, it will "go to root" as gardeners say and may even die from the shock. I was transplanted, 13 months ago, to a pot which I more than once had occasion to fear was too large; but I didn't die; in the end I think I very nearly filled it—not entirely, but nearly. At least I didn't die from the shock or the excuse of my own inadequacy.*

The knowledge of that fact has given me a new quality which I think I needed: self-confidence. . . . I don't know whether you will like the change or not. I rather suspect you won't. But it is there, and it is there to stay. It is the indelible work that a year spent in fighting my own little war has left on me.[2]

By the time he arrived in Lisbon, Fry was thinking more about the mistakes he had made. Why had he not been able to save more people? Perhaps he might have established better relations with the American consulate or he could have been more diplomatic with the committee in New York and cultivated the State Department more assiduously. Should he have been more open with the clients of CAS? He was too shy, too self-conscious in company, too much of a bureaucrat. He dreaded what was to come. How could he ever find his way back into normal life in New York?

He booked into the Hotel Metropole and went directly to the Pan American Airways offices to place his name on the waiting list for a flight out of Lisbon. There he learned that his return ticket had expired. It was disheartening. He had to cable to the New York Emergency Rescue Committee to ask for the $525 for a new ticket home.

He wrote a long letter to Theo Bénédite. After the blackout in France, he said the neon lights of Lisbon were dazzling. He'd eaten a "scandalously" large meal at his hotel with multiple courses, and

butter and white bread, the first he had seen in twelve months, all the while having the uncomfortable feeling he was about to "be arrested for flagrant violation of the food laws and failure to give tickets for my consumption." After dinner he took a hot bath. Then he and Clovis walked through the streets of Lisbon looking at the shops. He told Theo he felt:

> *like a child taken for the first time to the circus, goggle-eyed at the elephants and the popcorn and the giraffes. . . . Camera shops filled with cameras . . . Typewriters for sale at perfectly ordinary prices. Tailor shops displaying English cloth in their windows. The latest books from England and the United States. Yesterday's Times, Daily Mail, and Daily Telegraph for 8/10 scudo (4 cents) . . . all for sale as if it were perfectly natural to be so. . . .*
>
> *It makes one realize, of course, how very much life has changed in France. The changes have come about little by little, so that one has got used to the privations. It ought to be obligatory to come back to the normal standards of 20th century civilization as gradually and as imperceptibly as one has gone away from them—as a diver goes into a decompression chamber to be gradually accustomed to the normal pressure of air at sea level: too sudden change produces the "bends." Clovis and I are afraid we have come up for air too quickly, and that tomorrow we too may have the bends.*
>
> *It makes one realize, too, how terribly important it is to do something about it, both by continuing to favor emigration and by somehow managing to send food in to those who cannot come out.*[3]

Fry took advantage of the long delay in his flight to visit the offices of the other relief organizations. The truth was he was not yet ready to abandon Europe or to abandon his work. He met with Dr. Charles Joy, head of the Unitarian mission, to discuss dormant refugee cases. Joy warned him to look after himself. He seemed far from well. He was

forgetting names. "Something is happening to my mind," Fry said. "I have never been so frightened in my life." A year of malnutrition had depleted his body and the chronic lack of vitamins was affecting his memory.[4]

One afternoon, Fry and Mary Jayne Gold met up and were as enthusiastic over their reunion as were Clovis and Dagobert. She was also waiting for a flight to the United States. They talked nostalgically of their days at Villa Air-Bel. She told him the story of the hell that she had been through with Killer during her last few months in France. He listened sympathetically. He was looking back now, and, after all, she had been so generous to the committee. They shared their anxiety about returning home to what Fry called "the hard geometry of New York."[5]

Fry wrote to Danny on October 31. He was probably a little drunk from the wine he was consuming in increasing quantities:

> *I left my heart in France, I guess. Somewhere between Les Baux and the Villa Air-Bel, in the moonlight and on a crisp winter night. . . . Someday, though, I shall be back in France. . . . Then we shall go arm in arm over the hills and into the valleys, singing the songs and drinking the wines, of your beautiful, your incomparable, country. Until then Danny, good-bye. I love France, and I love you.[6]*

The next day, Fry boarded the clipper bound for New York.

EMPTY VILLA

September 1941

People in Washington sit in great offices dealing with papers. It may be boring . . . but it doesn't tear their hearts out. It doesn't take their souls and twist them like towels until they can hear the fibers crack.

VARIAN FRY[1]

By September, after Fry had gone, the Villa Air-Bel was emptied of most of its permanent occupants. Even Maurice and Jean had moved out. Maurice was soon to escape to the United States via the Carlos Route under the alias Maurice Rivière, born in Paris. Jean moved into a room in Marseille and was now actively involved in the nascent Resistance group Combat. Theo and Danny were the sole survivors of the original group of twelve residents.[2]

Soon Charles Wolff joined them, though this was not an entirely comfortable mix. It was hard for the Bénédites to forget that Charles had been the one to pass them into the "good hands" of the guide who had betrayed them at Banyuls. To deflect police attention from the villa, Charles suggested that they turn the house into a center for Alsatians who had been expelled from Alsace-Lorraine when the Germans

invaded. Alsatians were French after all and mostly ordinary people without politically suspect pasts. And CAS could cover the rent.

One Sunday evening in early October, a huge rainstorm flooded the Villa Air-Bel. Danny and Theo scrambled with buckets to catch the water pouring through the doors and skylights. Torrents turned the stairs and garden paths into a waterfall. The next day the poet Benjamin Péret and the painter Remedios Varo knocked on the front door. Their apartment building had been inundated. Water had risen almost to the top of the first floor. Wading through their flooded rooms with the water up to their chests, they had just had time to collect their few possessions. Theo and Danny invited the bedraggled couple to stay with them at the villa.

Theo liked Remedios Varo. In the days when the surrealists had gathered in the garden on Sundays, Remedios, with her exquisitely carved Catalan features and huge dark eyes, had always seemed the most elegant, even though she was certainly as shabbily dressed as everyone else. Though shy, she was fun. Theo remembered her laughter when the group made a collage called "The Last Romantic has been buggered by Marshal Pétain."[3] It was the kind of drawing that had gotten Breton into so much trouble when the villa was raided the previous November, but Remedios was attached to it. She still carried it with her. Theo knew there was a dark period in Remedios's past when she'd been jailed in Paris for several months for her associations with Spanish Republicans. This had left her traumatized, and terrified of imprisonment and deportation. Theo longed to help her.

Péret was an unlikely companion. He was an unattractive little man, with balding features, and often the butt of jokes. André Breton, his closest friend, would dismissively respond to Péret's boasts of having fought in the Spanish Civil War by saying that he had sat out the war "in a Barcelona doorway, holding a rifle with one hand and petting a cat on his knees with the other."[4] But Péret was a fine poet, and the surrealists loved his anticlerical scatological humor.

Péret and Varo now felt completely abandoned. They were almost the last of the surrealist artists still around. They had been waiting in Marseille for ten long months, and their prospects of escape looked

entirely hopeless. Rumor had it that if you hadn't gotten out by now, you weren't going to get out.

Péret was a particularly difficult case. The forty-two-year-old poet had always been one of the most politically active among the surrealists. He was on record as having fought, however ineptly, with the International Brigades in Spain, and when called to French military service in February 1940, he had refused to serve. The result was that he had been incarcerated in a military prison in Rennes, and only the Germans' mistaken notion that he'd been imprisoned as a German sympathizer led to his release.

Péret had already been denied entry into the United States because of his political record as a Communist sympathizer, but there was always Mexico. Holding to the commitment made in June 1940, Mexico was still offering its protection to all Spanish refugees, as well as to anyone who had fought in the International Brigades.

The Emergency Rescue Committee had been working on the couple's case doggedly for six long months. André Breton was anxiously sending telegrams from New York to France: SEPT 16TH 1941: ASK B PÉRET DATE AND PLACE OF BIRTH OF REMEDIOS VARO stop ASK MARITAL SITUATION stop AFFIDAVITS TRANSIT OBTAINABLE.[5] Forty-eight pages of correspondence on their case had accumulated in New York when at last their Mexican visas were issued.

Quite suddenly, in the middle of November, there were new grounds for hope—the French authorities reopened the Martinique route. The irony was that, at the very moment when it had become possible to get Varo and Péret to Mexico, the Emergency Rescue Committee was strapped for money. All that was needed was $350 for each passenger, but donations had dried up. A flurry of correspondence took place between Danny and Fry, who was now back working with the committee in New York City, still dedicating himself to the emigration of refugees.

CAS had sent a telegram to New York on September 30: HAVE YOU CONTACTED PEGGY GUGGENHEIM, BRETON FOR PASSAGES PÉRET AND REMEDIOS NO TIME MUST BE LOST.[6]

By the middle of November, passage was finally booked for the couple on the Portuguese ocean liner *Serpa Pinto*. The ship was scheduled to sail in late November from Lisbon to Mexico, with a stop in Casablanca. But Péret and Varo certainly couldn't reenter Spain to reach Portugal. Now the problem was how to get them to Casablanca.

Hounded and worried for himself and Remedios, Péret lost all patience with the constant setbacks. He began his own search for a fishing boat captain to take them across to Morocco. He eventually found someone. Never a good judge of character, Péret gave the money for their passage to a questionable young man on the dock who said he was the intermediary and would give it to the captain. Of course, he ran off with the money. This, as it turned out, was a blessing. Péret and Varo learned that the captain was a black market operator and a murderer. He never took any passengers across. He took their money, slaughtered them, and buried their bodies in his backyard. Twelve corpses were eventually dug up.[7]

At last Danny found the couple passages to Casablanca. How he managed this remains unclear, but on occasion CAS disguised refugees as demobilized French soldiers or merchant seamen and sent them across on French cargo vessels bound for North African ports.[8] With her Catalan looks, Varo could easily pass for a boy. On November 20, well over a year after their arrival in Marseille, the couple set sail from Casablanca on the *Serpa Pinto* bound for Mexico.

In October the painter Victor Brauner became the last surrealist artist ever to occupy the Villa Air-Bel. He took over the room still haunted by the spirit of Breton, and there he painted his canvases of one-eyed cats and women in exotic vegetation, some of it inspired by Dr. Thumin's magnolias. He wrote to André Breton in New York:

> *It's raining at Air-Bel. We regret your departure. No more boeuf-clandestin, nor roses in our shoes, and, as winter is approaching, a great boredom is invading the area.*
>
> *There's few of us in the house—Theo, Danny, Wolff, and a lot of guests just passing through.*

There will be marble plaques at the entrance or on the wall!
All the celebrities who have come through!

I will never forget your magnificent attitude and your calm
until the last moment. Will we ever see each other again? We
must soon.[9]

Victor Brauner never made it out of France. Even though Peggy Guggenheim offered financial support, he was unable to secure the requisite American emergency visa. When the Germans occupied the whole of the country Brauner abandoned Marseille. He survived the war as a shepherd in the mountains of Haute-Provence near Gap and was never found by the Nazis.

If the Villa Air-Bel had changed completely, CAS was also undergoing transformations. Fry had left behind a tightly organized and loyal staff who were not about to abandon their posts. Jean Gemähling was the new director and the group continued to work hard on refugee cases. Yet Jean seemed distracted by other activities. Then suddenly, on November 25, he left the office at lunchtime and disappeared. His girlfriend said he had not come home that night. All inquiries proved fruitless. Everyone at CAS assumed that Jean had been arrested, and yet no police arrived to raid the office or to arrest or even question them. This was very puzzling. It occurred to Danny that perhaps Jean had fallen into the murderous hands of Mathieu and the Marseille gangs.

Two weeks later Danny uncovered what had really happened. It was a shock. He had no idea that Jean was the secret head of a local Resistance cell. An agent provocateur from Vichy had set Jean up. The man had arranged to meet him at a café, claiming to have secret documents for him and a machine gun for Combat. Now Jean was being accused of treason and held prisoner at the fort Saint-Nicolas. No doubt he was being tortured. Everyone was devastated but there was nothing to be done. Except wait. Four months later, Jean was somehow able to convince a judge that he had been the subject of gross provocation and he was released on bail. Unable to believe his luck, he immediately disappeared into the underground.[10]

Despite the fact that he himself was under provisional release and was awaiting his trial for trafficking in gold, Danny assumed the public role of director at CAS.

Back in America Varian Fry's life was falling apart. When he first arrived at LaGuardia on November 2 and stepped out of the Dixie Clipper with Clovis, Eileen was on the tarmac to meet him. They walked arm-in-arm into the airport, pausing long enough for Fry to give a brief interview to the waiting reporters. He told them bluntly that he thought the State Department was acting "stupidly" with regard to refugee cases. The couple returned to their apartment at 56 Irving Place, but they were like two strangers. Their letters in the last few months had been strained. The long separation had magnified the inadequacies in their relationship. After the intensity of so many of his friendships in France, Fry knew he was not going to be able to slip back into the old mold of comfort without intimacy that characterized his marriage with Eileen. He found Eileen's need for reassurance intolerable. She had wanted a child. He had brought her a dog. She longed for their normal life to resume, but he was changed and could not make the transition back. He had only one passion now, and it was CAS and saving refugees. She felt his new style of assurance was imperious. In safe New York, he could not make her understand what he had been through and she called him obsessive. For him there were no subtleties now; everything was black and white. People were dying and only action mattered.

Within days of his return to New York, he walked into the offices of the Emergency Rescue Committee on Forty-second Street. He knew that his relations with the director, Frank Kingdon, and with other staff members had become strained, though he expected his old friend Harold Oram to be pleased to see him. He was not. The entire executive was angry about the interview he'd given at LaGuardia. His remarks had been "undiplomatic."

Through November and December, Fry's relations with the committee continued to deteriorate. He could not hide the fact that he thought they were slack. Their refugee files were in a mess, the disorder was beyond belief. Fry personally knew the people whose lives

were at stake. To Theo Bénédite, he wrote: "Everybody here finds it extremely difficult to understand how I can have been so popular in Marseille as here I am my usual stiff and self-conscious self."[11] In New York his peremptory manner did not sit well with the committee. But Fry was no diplomat. He could not help himself.

Soon there was a new reason for Fry's sense of urgency. On December 7 the Japanese attacked Pearl Harbor. Four days later Germany and Italy declared war on the United States. Now America itself was no longer safe from the Nazi menace.

In mid-December he walked into the office only to find Miriam Davenport seated behind a desk. She jumped up and greeted him with hugs and kisses. Despite some close calls, she and Rudolph had finally made it to Lisbon and had sailed to New York on the Friday after Pearl Harbor. Miriam was now working at the Forty-second Street office. When she told stories of Fry's brilliant work in Marseille and of the reverence and loyalty he inspired in his CAS staff, she was scarcely believed.

Fry had begun to write articles for the *Nation*, and these particularly irritated Frank Kingdon. Kingdon made it clear that it was unstrategic for Fry to criticize the American government or the State Department on refugee issues.

In February Kingdon formalized his complaints with a brutal finality. He wrote to Fry: "Unfortunately your attitudes since your return to this country have made it unadvisable for us to continue your connection with the Committee. Therefore I must ask you once again not to speak in the name of the committee, to accept any commission in behalf of the Committee, or to make any commitments for the Committee. Please believe that it is a matter of personal sorrow with me that I have to make this as explicit as I do."[12] Fry was fired.

It was a spring of sheer misery. Fry was devastated about Jean Gemähling's imprisonment and felt guilty that he had encouraged him in his Resistance activities. Fry carried in his mind the image of his young friend trapped and tortured in a dark prison cell.

He and Eileen tried to keep up appearances, but it was clear they were heading for divorce. They visited Fry's old friends like Consuelo

de Saint-Exupéry, who had managed to get to New York to join her husband. André Breton was now living in an apartment in Greenwich Village and he'd covered the walls with paintings and collages by the surrealists in exile. At the Bretons' they played murder and truth, but André now seemed "like a fish out of water" and Fry no longer enjoyed the games as he had once done at Villa Air-Bel.[13]

That spring he hunted for jobs. He tried to join the army. He was thinking of the intelligence branch, but it was hardly likely that he would be accepted, given his file at the State Department. When his application to the Office of Coordinator of Information was vetted, the treasurer of the Emergency Rescue Committee, David Seiferheld, described Fry as "intelligent, but highly unstable . . . uncontrollable."[14]

In his voluminous correspondence with Danny, Fry laid bare his profound frustration. He told him to take his name off the letterhead of CAS. Having his name openly associated with a refugee only guaranteed the person would be ignored. "It will be a red flag to the bull to certain persons, and why stir up hostility unnecessarily? . . . Bury me decently and quietly. I shall live on, I trust, in your hearts and you in mine."[15] He was disconsolate and he had earned his despair. He began to prepare a book about his experiences in Marseille.

His terrible alienation in New York only made his nostalgia for his life in France more pronounced. He wrote to Theo that her chatty letters about life at the villa took him "back to the house with a wallop":

> [I] *think again of the house and all its inhabitants, past and*
> *present; of that fearful kitchen, and that funny bathroom, of the*
> *dark stairs and of the rain that comes pouring down from the*
> *skylight, of the pictures in the front rooms and the labels that*
> *Danny put on them [in fact it was Vlady who did this] and how*
> *Mehring was taken in by them, of the dining room and Domin-*
> *guez's frightful picture, of the beautiful library and the pleasant*
> *teas we used to have in it on Sunday afternoons and of my old*
> *room next to Mary Jayne's, the one I always liked best . . . of the*
> *terrace and the plane trees and the fish pond and Ernest's pecu-*
> *liar garden, of the geraniums and the zinnias and the marigolds*

and those hours and hours Danny and I used to spend hunting
snails on the garden wall. Somehow, I confess, I feel lonely here
when I think of it all and wish I were back there even if there is
no coal and very little to eat.

Write me again and tell me how the house is now. Is it full
of Alsatians?[16]

If things were in disarray in New York, CAS was hard at work.
By January 1942, possibly because the United States was now actively
involved in the war, CAS was again booming with business. The
American consulate was suddenly granting visas to refugees whose
emigration had been blocked for months. Mexican and Cuban visas
became almost plentiful. Many refugees stalled in Lisbon found ship-
ping companies accepting passengers. Even though the difficulties
remained innumerable, over the next several months CAS was able
to send another two hundred beleaguered refugees out of France.
Among those who left were pianist Heinz Jolles, harpsichordist Wanda
Landowska, artists Marcel Duchamp and Jean Arp, and novelist Jean
Malaquais.

But Danny and Theo's private life was becoming increasingly
stressful. Theo wrote to Varian that February was a very difficult
month. "For the first time we knew what hunger was. . . . There were
several manifestations (all women) before the Préfecture with empty
market baskets. These manifestations not only took place in Marseille,
but also in the other large towns of the free zone."[17] The fuel situ-
ation was equally disastrous. There had been a terrible explosion at
the Marseille gas factory. The delivery of wood to every district in the
Bouches-du-Rhône was blocked. At the villa they were living in one
room where they had to cook, wash, and sleep all together.

And now Theo was pregnant. This was the unexpected result of
her and Danny's detention at Banyuls and the euphoria they had felt
when they were released. She wrote Varian: "I now seem to live in
a little world of my own into which Danny occasionally enters and
which chiefly concerns woollen goods, nappies, talcum powder etc.
All quite hopeless to find."[18] The Bénédites' daughter, Caroline, was

born April 19. Danny wrote Varian that Peterkin had a new sister. He never ceased asking, longingly, for news of his son, who was now living with his grandmother and aunt in Hanover, New Hampshire. He wanted Varian to make sure Peterkin had swimming lessons at least before he reached the age of four.

Danny and Theo continued to receive frequent guests at the Villa Air-Bel. The historian and essayist Julian Benda, who was ill, stayed for a bit. The philosopher Simone Weil arrived gruesomely thin and wrapped in her brown cape with her hair tightly packed under her beret. She was soon to leave for the United States. But the scheme to house Alsatians was proving a disastrous headache. There were fights between the Bénédites and Charles Wolff as to who would manage the villa and who would do the work. Danny was completely exasperated. He wrote to Fry that the Alsatians "behave as though they were in a conquered country, and have nothing more pressing to do than to try to put us out and to conduct themselves in general like thieves and blackguards, at the very moment when we are having our most serious difficulties. . . . The experiment seems likely to end in complete failure."[19]

By June Danny was clearly fed up and wrote an uncharacteristically bitter letter to his old friend:

> . . . As a matter of fact, these last months at the Committee have made me very weary. We have had to face incomprehension, sometimes on the part of our best friends, and cowardice on the part of others; persecutions and calamities. My devotion to the Centre . . . has almost become a habit — a habit I should like to rid myself of. But there is still something which prevents me from abandoning everything, from resigning and withdrawing into my tent. When, nearly a month ago now, our most serious difficulties occurred, I can almost say that it was only to quiet our own consciences that we left no stone unturned to bring us out of it once more; that we undertook all those exhausting démarches, withstood the war of nerves, maintained our optimism. We didn't want anyone to be able to reproach us with having

abandoned our task, or even with having neglected some slight chance or other; — but for some of us, and for me particularly, it would have been, I swear, a real relief to receive a letter from the Préfecture notifying us of the official closing of the Committee.

When I say relief, I mean, of course, subjectively. For objectively not a few poor devils would be left in the lurch. But I have often had the question flash across my mind: "When will the blessed moment of the forced closing come?" For I often ask myself whether it is really worth while to expose ourselves to this extent and stand what we have had to stand physically and morally. You, Varian, were often divided between "Fry, the apostle" and "Fry, the tourist." (I remember our last days at Nice!) As for me, I am fed up with being an apostle — and how![20]

Something had occurred in May that caused Danny to lose heart. The month had begun well. On May 1 Danny met with his lawyer, Gaston Defferre, who informed him that judicial proceedings against him had been stopped. The court had simply decided to confiscate the two thousand dollars' worth of gold coins it had seized when he was arrested the previous year and to demand fifty-five francs for the speedy closure of his case. To his enormous relief, he was permanently "discharged" of the crime.[21]

But any euphoria he might have felt did not last long. The war that had been declared in September 1939 was reaching the end of its third year. Repression in France suddenly took a terrifyingly brutal turn. The execution of Resistance fighters and of hostages was more and more frequent in the German occupied north. Under German pressure, Pierre Laval was put in charge of key portfolios: the Ministry of the Interior (which controlled the centralized police system), the Ministry of Information, and the Ministry of Foreign Affairs. Even though Pétain continued to hold the title in Vichy, Laval had effectively become chief of state, working in direct collusion with the Nazis.[22]

This was terrible news for Jews. In May, Xavier Vallat, head of the General Commissariat for Jewish Affairs, was replaced by a Nazi pro-

tégé, Louis Darquier de Pellepoix. Vallat had annoyed the Germans by proving to be too "tame" an anti-Semite. Although he had been entirely effective in depriving Jews of civil rights and in confiscating their property, he had broken with the Nazis over the issue of forcing Jews in the unoccupied zone to wear the yellow Star of David. Now, with quotas dictated by Berlin, Jewish refugees were to be rounded up, transported to Drancy north of Paris, and, from there, deported to "unknown destinations" in Germany. According to the historian Donna F. Ryan: "Those who cared to wonder might have assumed that deportations to 'unknown destinations' meant to labor camps, where slow death from overwork, hunger, and disease could be expected." As yet, "it was impossible for the average French observer to know that the Nazis had erected killing fields in the east."[23]

On May 13 Danny traveled to Camp des Milles outside Aix-en-Provence, the closest camp to Marseille, to find out about the deportations. He wanted to witness firsthand what was happening in order to send a report back to the committee in New York. Refused permission to enter the camp, he stood outside the gates and saw armed guards herding together a group of about one hundred men, women, and children. Overwhelmed and shaken, he watched as these people were dragged, sobbing and exhausted under the blistering sun, toward cattle cars lined up on the railroad tracks.

He watched the guards pushing pregnant women with emaciated infants in their arms toward the cars, forcing them to run and prodding them as they fell on their knees. He thought of his new baby, Caroline. That this could be done! Who could do this to innocent children? He felt a depth of despair beyond weeping.

Years of fighting xenophobia and anti-Semitism, of visiting internment camps, had left him exhausted, but this was a new horror. He looked at the cattle cars. On the side of one he read: "Capacity: 40 men; 8 horses." Once these rail cars had carried military personnel. Now helpless Jews were being herded aboard. There were so many people being shoved into each car, he knew some would surely die of asphyxiation before they reached Drancy. He looked through the fence at the sprawling brickworks factory. This had once been an

internment camp for CAS's clients waiting for visas that could lead them to freedom. That was bad enough. Now he was witnessing this unspeakably brutal roundup, and French policemen and French military guards in soldiers' uniforms were carrying it out. He felt nauseated and ashamed.

He immediately went to a phone box in a nearby café and called the American consulate in Marseille, hoping at least to provoke a response. He demanded to speak to the consul general but was handed off to a secretary who said: "It's most unfortunate, Sir, but we can't do anything about it."[24] He insisted that the American ambassador and the press corps at Vichy be alerted. Terribly, this was all he could do. He was powerless and he could hardly bear it.

RESISTANCE

1942–44

We are digging a grave in the air. There's room for us all.

PAUL CELAN[1]

Inhumanity is typical of fascism, not characteristic of a nation, I try to explain. Only the structures change. One would so like to believe that the character of the German people was responsible. For then one could also believe that it could never happen here. Those who so believe have not learned anything.

LISA FITTKO[2]

It was two days after Danny returned from Les Milles, and he was still profoundly shaken. What was happening to *his* France? It had been Frenchmen herding those people into the railway cars. When a friend and fellow refugee worker from Geneva, René Bertholet, entered the office on boulevard Garibaldi, he found Danny in a terrible state. "There is still work to do," Bertholet told his friend. "We must continue." And he opened the sack he was holding. Inside was five thousand francs. "This is just a float," he said, "just the beginning. From now on we will be transferring money from Switzerland. I will

get you more cash. It will always be in French francs. You won't have to use the black-market money-changers anymore."

He added that he knew the risks Danny had been taking getting refugees across Spain and the acrobatics he was performing to get visas. "We're setting up a new escape route on the Swiss frontier near Saint-Gingolph," he continued. Switzerland had not been considered as an escape route before this. It was landlocked with no way out, and the Swiss were not welcoming. Afraid of antagonizing the Nazis and incurring an invasion, Switzerland had closed its borders early on to the floods of refugees.[3] "Undoubtedly illegal immigrants will be detained in Swiss camps," Bertholet told Danny, "but they will be better treated than in the Spanish ones. And some of our friends will make it to Zurich and Lausanne where they can wait while we finish off this damn war."[4]

On May 28 Danny sent a report to Fry. It had been nine months since Fry's expulsion, yet the committee continued to function. Since then, four hundred people had been sent legally to *le nouveau monde*, as Danny called it. CAS had evacuated twenty-two illegal refugees whose names were on the Nazis' black list. They had sent twenty-seven British soldiers back to England where they could rejoin their units and continue the fight. They had also provided work in the Var and elsewhere for 150 men and women. The results weren't sensational, Danny said, but the work continued. Fry could be proud of what they were doing.[5]

On the morning of June 2, as he always did, Danny went early to the CAS office on boulevard Garibaldi. He'd developed the habit of glancing about for any signs of unusual activity. There were only a few customers at the two cafés adjacent to the office and they looked nondescript. There were no undercover cops standing around looking conspicuously indifferent, no parked cars with chauffeurs at the wheel. It seemed a day like any other. But as he opened the door to CAS's office, he saw Alfonso, the night watchman, in the grip of two policemen. The police immediately grabbed Danny by the arms and led him before their inspector, who was sitting at one of the desks leafing through a pile of CAS dossiers. The inspector frisked Danny

for weapons and seemed surprised to find none. He demanded to see Danny's identity papers. Danny retorted that he needed to see the inspector's search warrant. Showing Danny the usual "form" without letterhead or signature, the inspector stated that he was authorized to search all "subversive" organizations. "How could CAS be subversive since we are an officially recognized relief center?" Danny asked. The inspector smiled derisively. This had become a familiar dance.

Danny was relieved of the seventy thousand francs he was carrying in his briefcase and directed to label the seven typewriters, and a number of documents that were being confiscated. As employees and the occasional client arrived, they were also frisked and then locked in an adjacent room. Danny wasn't too worried. All CAS's "hot" dossiers had been hidden and most of its financial reserves were buried in the pinewoods at Villa Air-Bel.

But suddenly the inspector triumphantly flashed a document of several pages in front of him. During the five-hour search, it had been found at the back of a desk drawer. "This, Monsieur, will get you into deep trouble," the inspector said.[6] It was a handwritten, unsigned revolutionary tract calling for the reorganization of all the splinter groups of the extreme Left. Danny was livid. Someone had been so negligent as to leave such a document in the office for the police to find. He couldn't imagine Jean Gemähling being so careless. It must have been one of the refugees. Along with eleven others, Danny found himself once again in a *panier à salade*. This was his fourth trip to the Evêché.

After a night in prison Danny was submitted to a seven-hour interrogation. He and his committee were accused of being anarchists and of helping leftist revolutionaries, Communist dissidents, and Trotskyites. Now added to the list were partisans of the nascent Resistance. He was released the next day, but was told there would be an inquest before the military court, which was competent to judge whether he was a "threat to domestic security."

Lamentably, this final raid proved to be the end of CAS. Without their confiscated files, dossiers, and typewriters, the committee had been decapitated and there was nothing to do about it. Appeals to the

American consulate fell on deaf ears. Danny told the staff their jobs were over.

But there were still five people who had belonged to CAS's inner circle: Danny, Charles Wolff, Paul Schmierer, the diminutive Anna Gruss, and Wolff's friend Jacques Weisslitz.[7] All had been working on CAS's "hot" files. And there was the money buried in the pinewoods. They would go underground. The Swiss route was operational.

Danny and Theo immediately moved out of the Villa Air-Bel. They found a small house in the same area. It was more private, and they still had a view of the Saint-Cyr mountain chain across the valley of the L'Huveaune. Danny was delighted by the garden where he could plant the tomato seeds he had carefully collected and where he could hide confidential papers and secret dossiers. The days of Air-Bel had come to an end.

Then, one afternoon, a certain Robert Dexter, ostensibly working for the Unitarian Service Committee to aid refugees, called Danny to his office. This small, innocuous, and congenially plump man made Danny a proposition. Would he organize a group to pass information to the Americans?

Danny responded that he was uncomfortable with the idea of spying. Yes, America was a foreign country, Dexter replied, but they were on the same side of the barricades in the fight against Fascism. Yes, the State Department had treated Varian deplorably. And of course he and many others found the embassy's tolerance of the reactionary Vichy government reprehensible. But now there was a war to win.

Would Danny use his contacts with militant Socialists to gather information? Could he find out how much pressure the Germans were exerting on the French economy? What was the attitude of the working class? What were the aspirations of the underground groups? It was clear to Danny that the Americans were planning covert operations and, eventually, strategic bombings of German facilities in both occupied and unoccupied France.

Danny might be forgiven for noting with cynicism that the "militants," the so-called anarchists and Communists, had suddenly become valuable to the Americans.

After discussing the idea with Theo and Schmierer, Danny agreed to help. Soon they had organized a group able to move clandestinely through the Bouches-du-Rhône, gathering information about train schedules, factory production, ship arrivals, anything that would help the Allies. A contact at the Central Post Office was discreetly checking official mail. The bureau chief at the gare Saint-Charles collected information on military convoys, the number of train wagons, and what they were carrying. At the CNT (Confédération Nationale du Travail) another contact was providing reports on industrial production under Vichy. Men who had escaped from forced labor camps in Germany were reporting on German factories devoted to military production, on their locations and all adjacent rivers and canals. The foreman at the aeronautics factory at Marignane outside Marseille was passing on documents and plans for prototype aircraft. At the Bureau of Navigation, a secretary reported on the movement of ships near Cap Croisette. Danny was actually astonished how quickly everything came together. Ordinary Frenchmen were obviously ready to boot out the Boches. Theo served as the courier to take this information to the American consulate.[8] It was dangerous work.

The couple worked from their small house near the Villa Air-Bel. Then, on the thirtieth of September, a trial took place that made it imperative for Danny to get out of Marseille. Ten people were accused of being "a threat to domestic security," the same charge that had been laid against him. Three were condemned to "forced labor in perpetuity." CAS was implicated in the trial as a *"centre de liaison"* of extremist groups and it was announced that the committee members would be prosecuted.[9] Danny's lawyer told him he was on the list for a life sentence. It was now time for him to disappear.

He and Theo and five-month-old Caroline left for Cap d'Antibes, where Theo's relatives owned a small cottage. From there they kept up their contacts with Dexter. Anna Gruss, the former secretary and now a member of the secret CAS, was able to make furtive visits to report on the continued functioning of the Swiss refugee route. Jean Gemähling also sneaked into town for the occasional visit. He was using the code name Henriot.

One day in early November, Danny and Theo slipped into Marseille to meet with the American consul general Benton who had replaced Fullerton. It was terrifying to be in Marseille under the eye of Vichy again and especially while carrying compromising secret documents. Benton greeted them warmly. "I was profoundly shocked by the hostility the Department manifested toward your boss, Varian Fry," he said. "I'm so glad you're working with the O.S.S. [Office of Strategic Services]."[10] And he offered to supply Danny with whatever funds he needed to carry on. Danny accepted the money. He only wished Varian had been there to hear the consul general's apology himself.

By November 1942 it looked like the Germans might lose the war after all. They were bogged down fighting the Russians in the Caucasian Mountains, the winter snows were falling, and, just as Victor Serge had predicted, Stalingrad was holding out. In North Africa the British had definitively beaten General Rommel at El Alamein west of Cairo. By November 2 the Germans' Afrika Korps was in retreat.

On November 9 German troops poured over the demarcation line into unoccupied France. Virtually overnight, the German army was in Marseille.

Marseille fell under a complete news blackout. No information was getting out. In New York, Fry was in a state of anguish: "Silence, silence. . . . I have tried again and again to reach my friends in France, to have even one direct word from any one of them. I have tried again and again, but I have always failed. Whether I whisper or whether I shout, there is not even an echo to reply; only silence, silence so complete that I can hear my blood singing in my ears."[11]

Fry did not know it, but Danny's providential luck had held. When the Germans entered Marseille, Danny and Theo were back in Antibes, which was at that time occupied by the Italians. And the Italians were never as efficient as their German allies.[12]

Toward the middle of November, Danny slipped away to the port of Toulon to meet a contact, Roger Taillefer, alias Max Gauthier. As soon as he knocked on the door, Taillefer pulled him inside: "*Mon vieux*, you have to get out of here quickly," he said. "There's an order for your arrest." He'd already taken the precaution of obtaining false

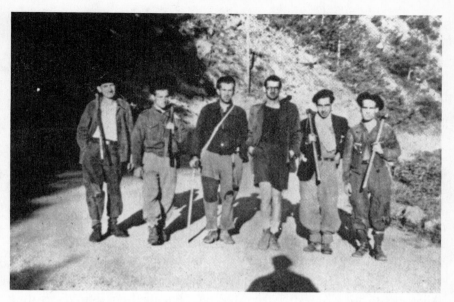

Danny Bénédite and the resistance crew. Danny is fourth from the left.

identity papers for Danny. Danny glanced at his papers. He was now Marcel Corblet.[13]

Danny immediately headed for the Haute Var region, where Theo and the baby joined him. Hiding out, he worked in Châteaudouble in the small woodcutting and charcoal industry Fry had helped set up. He still managed to keep the clandestine CAS open for business. Incredibly, in the following three months, they got another twenty-seven refugees, in groups of five or six, across the Swiss border with the help of anti-Fascist mountaineers willing to guide them. Among those who escaped were Vera and Giuseppe Modigliani, brother of the painter and former leader of the Italian Socialist Party. Once in Switzerland, the refugees were most often arrested and put into detainment camps, but at least they were safe from deportation to Germany.[14]

In June 1943 Danny and Theo moved to Régusse, where Danny directed a lumber camp in the Pélenq forest. The local Resistance soon contacted him, and gradually the camp became a *maquis* (guerrilla) camp. Until recently the Resistance movement had been poorly organized. The general population had considered these "outlaws"

more dangerous than the Germans. But after the Germans occupied the whole of France, the fiction of a "free zone" was exploded. Premier Laval soon instituted a "voluntary work program," sending thousands of young Frenchmen to labor camps in Germany. To avoid deportation, many young men escaped to the hills to join the *maquis*.[15]

On May 10 of the following year, using the convenient cover of the forest, the British parachuted a consignment of arms into the camp. A week later, alerted by an informant, an attachment of the feared Wehrmacht surrounded and raided the camp. By that time all the weapons had been carefully buried, but four workers, including Danny, were arrested. Theo took over leadership of the Pélenq Resistance group. The men were taken to Gestapo headquarters in Brignoles and eventually to jail in Marseille. Danny was condemned to death.

The Allied forces landed along the coast of Provence in mid-August. On the sixteenth, the Germans began their retreat. As they pulled out of Marseille, they liberated all prisoners, except those with death sentences. But the guards were lax, probably deliberately so, and Danny escaped once again. Elated by his unexpected good fortune, he headed back to Régusse on foot to join his fellow *résistants* in the *maquis* camp. The journey was exceedingly dangerous. He had to stealthily maneuver his way through enemy lines in the Var where the Germans were still mounting a fierce defense. He made it through.

In the end, Danny and his brave colleagues had always remained faithful to the ideals of Varian Fry. Had it not been for the Centre Américain de Secours, it is estimated that two thousand people would never have escaped from France. In the opinion of Lisa Fittko, many refugees believed they were fleeing simply to escape the "Nazi period." Only in retrospect did they understand what their true fate would have been, to perish in the Holocaust in Nazi extermination camps.[16]

On January 1, 1945, the Emergency Rescue Committee, renamed the International Rescue and Relief Committee, delivered its summary report on 1944:

France—We recently received a cable informing us that two of our most valuable collaborators in France, Daniel Bénédite

and Dr. Paul Schmierer, who directed our work after the total German occupation, have come safely through two years of silence . . . The courage and integrity of these two men and of those who worked with them during more than four years in Nazi-dominated or Nazi-occupied Marseilles, deserve record among the heroic deeds of this war.[17]

Varian Fry was not even mentioned.

AFTERWORD

RESIDENTS OF THE VILLA AIR-BEL

Varian Fry

Even after refugees saved by CAS arrived in the United States, Varian Fry continued to help by giving them contacts and trying to find them work. With money from his own small income, he also privately supported a handful of people still stranded in Europe. In the early 1940s, unable to reestablish his life, he moved from job to job. In 1942 Hertha Pauli met him at a party in his honor. "A part of him had remained in Marseille . . . We got out of the trap like foxes that nevertheless leave a piece of leg behind," she remarked.[1] Fry and his wife were divorced in the summer of 1942. When Eileen was diagnosed with cancer a few years later, Fry nursed her through a long illness. She died on May 12, 1948. Fry's book *Surrender on Demand* was published in 1945. Congratulations poured in from former refugees and the reviews were good, though the book did not sell well. Americans wanted to look forward, not back. In the winter of 1948, Fry, at the age of forty-one, met the twenty-five-year-old Annette Riley.

"He was fun and he adored me," she said.[2] They married in November 1950 and had three children. He lived by freelance writing and teaching. His last job was teaching Latin and Greek at Joel Barlow High School in Easton, Connecticut. In the last two years of his life, Fry suffered depression and the couple were divorced, though they remained in contact. On April 12, 1967, Fry was made a Chevalier de la Légion d'Honneur for his rescue work in France. Six months later, on September 12, 1967, Fry died alone in Easton from a cerebral hemorrhage. He was one month short of his sixtieth birthday. In 1996 Yad Vashem, Israel's Holocaust Memorial, posthumously named him "Righteous Among the Nations." At the ceremony, then U.S. Secretary of State Warren Christopher apologized to Fry: "We come to pay tribute to . . . Varian Fry, a remarkable man and a remarkable American. Regretfully, during his lifetime, his heroic actions never received the support they deserved from the United States government, including, I also regret to say, the State Department."[3] At his funeral, the artist Jacques Lipchitz remarked: "He was like a racehorse hitched to a wagon load of stones."[4]

Danny Bénédite, Theo Bénédite, and Peterkin

During the 1944 liberation of France, Danny Bénédite served as liaison officer between the High Command of the Allied Forces and the prefects of Var and the Basses-Alpes. After the war, he became executive director of the newspaper *Franc-Tireur*, and finally director of the publishing house Éditions Rombaldi. In 1947 Danny and Theo were divorced. "I no longer live in Danny's shadow and sink my personality in his," Theo wrote Varian Fry.[5] Both soon remarried. Theo worked for UNESCO in 1947 in the Cultural Activities Department, eventually setting up their rights and permissions section. Pierre Ungemach (Peterkin) returned to France in 1945 to complete his schooling. He undertook graduate studies in geophysics in Strasbourg and Paris. He worked in Africa, Australia, Latin America, and the Middle East on the development of water supplies in arid areas, and finally for the Common Market in Brussels. In 1984, Danny published *La Filière marseillaise*, his memoirs of the Marseille years. He died in 1990 after a stroke.

Mary Jayne Gold

When Mary Jayne Gold returned to the United States, she worked briefly for the International Rescue and Relief Committee and then undertook a degree in psychology with the intention of specializing in criminal psychology. She soon returned to France to live in Gassin, near St. Tropez, where she named her villa Air-Bel. She met Raymond Couraud twice again. The first time was in New York in 1947 when they toured Quebec and the Gaspé. The second reunion was in the 1960s at Air-Bel in Gassin. Couraud's life after the war was nomadic and full of mystery. He worked as a mercenary: as chief of the army of the Nizam of Hyderabad during the decolonization period in India, and then for the French army in Algeria. He married several times and had two sons. Mary Jayne Gold never married. She died in 1997 at the age of eighty-eight.

Miriam Davenport

Miriam Davenport and her Yugoslavian husband Rudolph were divorced a year after their arrival in the United States. Miriam worked for a variety of organizations, including the International Rescue and Relief Committee, the NAACP, and the American Council of Learned Societies' Committee for the Protection of Cultural Treasures in War Areas. After the war, she directed the office of Albert Einstein's Emergency Committee of Atomic Scientists in Princeton. She met and married Professor William L. M. Burke, and the couple moved to the University of Iowa. There she undertook graduate work in art and began exhibiting her paintings and sculpture. After the death of her husband in 1961, she married Charles Ebel, an archaeologist and historian. She died on September 13, 1999.

Victor Serge, Laurette Séjourné, and Vlady

In Mexico, Victor Serge completed *The Long Dusk*, a novel based on his Marseille experience, and his *Memoirs of a Revolutionary*, as well as several other books and numerous articles. He carried on a long correspondence with George Orwell, who tried, without success, to get *Memoirs* published. The book was eventually published in 1951 after

Serge died. Laurette Séjourné and Serge's daughter Jeannine joined him in the winter of 1941. Serge's persecution by the GPU (Soviet Secret Police) accelerated in Mexico. A slanderous article appeared in the Mexican newspaper *Excelsior* claiming that Serge had been a Nazi agent working for Otto Abetz, Hitler's ambassador in Paris. Serge was often followed. Vlady remembered one occasion when gunmen fired at them from a passing car as they were walking in Coyoacán. In January 1942 one hundred thugs of the Mexican Communist Party, probably under the direction of the GPU, attacked a meeting where Serge was speaking. Though seventy people were injured, he was not wounded. Serge was too desperately poor ever to realize his dream of returning to France. On November 17, 1947, he died of a heart attack in the back of a taxi. Laurette Séjourné went on to become a prominent anthropologist specializing in Teotihuacan culture. Her many publications included *The Magic World of the Mayas*, illustrated by Leonora Carrington. Laurette died in a car accident at the age of ninety-two. After his father's death, Vlady studied art in France and Spain. He became one of Mexico's leading painters and muralists, and died in 2005.

André Breton, Jacqueline Lamba, and Aube

The painter Kay Sage found the Bretons a fifth-floor walk-up in Greenwich Village. Breton lived mostly in a French world of exiles, including Claude Lévi-Strauss, André Masson, Max Ernst, Kurt Seligman, and Marcel Duchamp, who arrived in June 1942. Handicapped by not speaking English, Breton lost a chance to teach at the New School for Social Research. He began a new surrealist magazine, *VVV*, and selected the young sculptor and photographer David Hare as editor. In March 1942 Breton became an announcer for the Voice of America. Produced by the Office of War Information and broadcast twenty-four hours a day throughout German-occupied Europe, the radio programs were designed to spur resistance to Nazism. The only constraints Breton imposed in his contract with the broadcaster were that he never be forced to utter the words *God* or *pope*. The writer André Thirion recalled that in France during the war, Breton's

familiar voice "resounded like an encouraging call."[6] Determined to concentrate on her own art, Jacqueline reverted to her maiden name of Lamba. She left Breton in October 1942 and went to live with David Hare, taking Aube with her. Breton was devastated, especially by the loss of his daughter. In December 1943 Breton met and soon married the Chilean pianist Elisa Claro. Though Germany conceded defeat on May 8, 1945, and the war in Europe came to an end, Breton waited before returning to France. The Communist Party had gained enormous influence through its association with the underground Resistance movements. On visits to New York, Albert Camus and Jean-Paul Sartre had warned Breton that the Stalinists were waging terror against the literary community. Given his long-standing opposition to Stalinism, Breton feared he might be at risk. However, on May 25, 1946, accompanied by Elisa and Aube, he returned to France and resumed his former life. Soon he discovered that his surrealist movement had been eclipsed by postwar existentialism. Eleven-year-old Aube returned to the United States in 1947 to live with her mother. Eventually both moved back to France, where Jacqueline Lamba established a significant career as a painter. André Breton died in 1966, two years before the student revolution in Paris that changed the geopolitical reality worldwide. Demonstrating students carried images of Breton and Rimbaud as models of the free mind.

Max Ernst and Peggy Guggenheim

When Max Ernst arrived with Peggy Guggenheim at LaGuardia airport on the fourteenth of July 1941, he was detained by immigration officials and transported to Ellis Island. It took three days to process his papers. Max was finally released into the care of his son. Jimmy's first view of his father was that of a "fragile, white-haired figure in a rumpled raincoat seated on a wooden bench."[7] After Pearl Harbor, Max, still holding a German passport, was subjected to interrogation as an enemy alien. He and Peggy Guggenheim married, but the marriage was brief. In 1942 Ernst held exhibitions in New York, Chicago, and New Orleans. Nothing sold. Still, Ernst quickly developed friendships among the American painters, including Jackson Pollock and Dorothea Tanning. In 1946 Ernst married Tanning and the couple

built a house in Arizona. In 1950 he made his first trip back to Europe, and soon returned with Tanning to live in France. In 1966 a German newspaper accused Ernst of failing to save his Jewish wife, Lou Straus-Ernst, by abandoning her in France. He was devastated and asked Danny Bénédite and Varian Fry to send sworn statements, made before lawyers, to the effect that they had witnessed Ernst's offer to remarry Lou Straus-Ernst. Both did so. Ernst died on April 1, 1976. Peggy Guggenheim opened her new gallery Art of This Century in New York on October 20, 1942. After the war she moved her collection to the Palazzo Venier dei Leoni in Venice, Italy.

CAS STAFF

Jean Gemähling

When the Resistance movements of occupied and unoccupied France were integrated, Jean Gemähling became one of the heads of intelligence for MUR (Mouvements Unis de Résistance). The network of about one thousand agents was called Katanga by General Charles de Gaulle's Central Bureau of Information and Action. Gemähling was arrested in 1943, but escaped just hours before the Gestapo came to collect him. He returned to underground work, sending information by clandestine radio transmissions to London, Geneva, and Algeria. After the war, he worked in journalism and publishing until 1955, when he became involved in nuclear research for the Commissariat de l'Energie. He died in France in 2004.

Marcel Verzeano (Maurice)

Upon arriving in New York in 1941, Marcel Verzeano found work as an elevator operator and then joined the U.S. Army. He was stationed in Italy, a lieutenant in the medical corps. At the end of the war, he was decorated by the Italian government with the Order of the Crown of Italy. In 1947 he worked as a researcher at the Harvard Medical School and the Massachusetts General Hospital. In 1954 he joined the Brain Research Institute of the University of California. He was visiting professor at the University of Lima and at the Sorbonne and

then professor of psychobiology at the University of California at Irvine. He died in 2006.

Albert Hirschman (Beamish)

Immediately on his arrival in the United States in December 1940, Albert Hirschman received a Rockefeller Foundation fellowship. He spent the next two years at Berkeley where he wrote *National Power and the Structure of Foreign Trade*. From 1943 to 1945 he served with the U.S. Army in Italy working in the intelligence section. In 1946 he took a job as a research economist for the Federal Reserve Board, working on Europe's postwar recovery. During an eminent career that included working in Bogotá, and at Yale University and Harvard, he published numerous books on economic development, particularly in Latin America. In 1974 he joined the social science faculty of the Institute for Advanced Study in Princeton, New Jersey. In 1995 he published A *Propensity to Self-Subversion*, which included autobiographical accounts of his wartime experiences. He still lives in the United States.

Bill Freier

CAS's forger, Bill Freier, and his wife, Mina, were arrested at the end of November 1940. She was released after two days, but he was held. Fry was unsuccessful in obtaining international visas for the couple. Freier was interned in Le Vernet, from where he was put on one of the last convoys to Auschwitz. He miraculously survived. He weighed only seventy-five pounds when he was liberated. Shortly after he was reunited with his wife in France, she suffered a mental breakdown. She died in an asylum in 1953.

Charles Wolff

Charles Wolff worked for the French Resistance relaying information between Spanish and French cells. Betrayed by a fellow agent who had revealed his name under torture, he was arrested in Toulouse in August 1944. He was beaten to death by the collaborationist Vichy militia, the Milice.

POST JUNE 1942: THE SECRET CAS

Paul Schmierer, Anna Gruss, and Jacques Weisslitz

Living in Antibes and then in the Auvergne with his wife, Vala, Paul Schmierer became agent P-2 of the Tartane-Masséna network of the Resistance movement Franc-Tireur. The Nazis never discovered his underground activities. Anna Gruss continued to serve as a courier, passing on names and money for refugees escaping to Switzerland. She was never caught. Jacques Weisslitz and his wife, both French Jews, had been denied a U.S. visa in 1942. Fry worked unsuccessfully on an appeal. The couple was deported to Germany in November 1944. They were never heard from again.

ASSOCIATES AND CLIENTS

Hans and Lisa Fittko

When the Fittkos reached Cuba in November 1941, they were immediately interned in the Camp Tiscornia with hundreds of other refugees. They were released after ten days. When Cuba sided with the United States after Pearl Harbor, all non-Jewish Germans were declared enemy aliens. Hans was arrested, but the Jewish owner of Máximo's Hotel where they were staying swore Hans's papers were false and he really was a Jew. With the additional help of a bribe, Hans was released. He learned the trade of diamond cutting and Lisa worked as a secretary. In Cuba they often encountered Nazi officers in flight to Latin America. In 1948 the Fittkos were admitted to the United States. Hans died of cancer shortly thereafter. Thirty-seven years later, Lisa Fittko published her memoirs *Escape Through the Pyrenees*.

Hertha Pauli, Carli Frucht, and Walter Mehring

Hertha Pauli landed at Hoboken, New Jersey, on September 12, 1940. A CAS member who had come to meet the ship identified her just as she was about to be sent to Ellis Island where undocumented refugees were held. She found work as a maid in New Jersey, but soon got a job

typing manuscripts. Eventually she became a well-known biographer and author of children's books. Through the intercession of Eric Sevareid, Carli Frucht sailed from Lisbon to Norfolk, Virginia. Immigration Services refused him permission to disembark. On the very day the freighter was set to sail back to Europe, a telegram reached Eric Sevareid, who ran to Western Union and sent further endorsements and money needed for Carli's release into the United States. The policy was to settle refugees away from metropolises and Carli was sent to work on a Quaker farm in Indiana. He joined the American army as a private and afterward established a career in international aid work. Walter Mehring made it to New York, via Martinique. He soon left for Hollywood and there he found lucrative work at MGM writing screenplays. In 1944 he published *No Road Back,* illustrated by George Grosz, and dedicated it to Hertha Pauli. In it he described their flight across Europe and his internment at Camp Saint-Cyprien. His masterpiece *The Lost Library: The Autobiography of a Culture* came out in 1951. He returned to Germany in 1953 and then moved to Switzerland. He died in a small hotel in Zurich in 1981.

THE SURREALISTS

Wilfredo Lam and Helena Holzer

Helena Holzer and Wilfredo Lam settled into a Havana apartment. The racism he discovered under the Batista dictatorship appalled him. He began integrating elements of Afro-Cuban culture into his work. In 1942 an exhibition of his paintings opened at the Pierre Matisse Gallery in New York. He and Helena were married in 1944. After the war, they traveled extensively, living in Cuba and France, with occasional trips to the United States. They were divorced in 1950. In 1981 the Cuban government awarded Lam the Félix Varela Order for his outstanding contribution to Cuban culture.

Benjamin Péret, Remedios Varo, and Leonora Carrington

Joining an expatriate community of Spanish exiles that included filmmaker Luis Buñuel, the three artists settled into Mexican life. They

initially thought that Mexico would be a temporary shelter. Varo and Péret moved into a ramshackle tenement house in the Colonia San Rafael district in the heart of Mexico City. Remedios filled it with cats and birds. She had drawings by Picasso and Ernst stuck with pins to the walls. Remedios and Leonora became close friends and collaborators. Benjamin Péret was eventually able to find work teaching French, but he did not adapt as well. He returned to France in 1947. Remedios Varo and Leonora Carrington became two of Mexico's most celebrated painters.

Other Surrealists Trapped in France

The painters Hans Bellmer, Victor Brauner, and Jacques Hérold never succeeded in getting international visas. All three survived the war by hiding out in the remote regions of Provence. Unable to get an international visa to leave France, the theater director Sylvain Itkine worked for the Resistance. He was arrested by the French police and turned over to the Gestapo, who tortured and killed him. In December 1944 Péret wrote a letter from Mexico to his friend the surrealist poet Robert Rius. He did not know that Rius had been shot six months earlier as he attempted to join the *maquis* in the forest of Fontainebleau. The surrealist poet Max Jacob died or committed suicide at the deportation camp of Drancy. Fellow surrealist Robert Desnos, arrested for activities in the underground press, ended up in the prison camp of Buchenwald. He died of typhus just days after his release.

CENTRE AMÉRICAIN DE SECOURS (CAS)

On August 14, 1940, Fry brought to Marseille a list of two hundred people that the Emergency Rescue Committee in New York determined were in danger of deportation back to Germany. In the early spring of 1942, six months after Fry's expulsion from France, Danny Bénédite wrote a summary report of CAS's achievements. Over a period of one and a half years, twenty thousand refugees had approached CAS for help. Stretching his mandate as much as he dared, Fry had extended the protection of CAS to more than four thousand people.

CAS had given direct financial support to six hundred refugees. It had helped fifteen hundred people to leave France, both legally and illegally. It had also assisted in one manner or another in the evacuation of about three hundred British officers and soldiers. CAS had set up a dozen communities around Grasse as well as woodcutting and charcoal burning enterprises in the Var forest that gave refugees not only employment but also a place to hide. From 1942 until the end of the war, the clandestine CAS was able to facilitate the escape from France of another three hundred people.

THE VILLA AIR-BEL

In 1970 the Villa Air-Bel was torn down. The surrounding forest was razed and replaced by an apartment complex to house recent immigrants, particularly from North Africa. Completed in 1972, Cité Air-Bel contains 1,165 apartments. Of the original Villa Air-Bel, only the pillars at the entrance, the terrace, and the three plane trees survive. The site is now occupied by a nursing home for the elderly. However, Dr. Thumin's house, La Castellane, still stands. It has been turned into a social center for the Cité Air-Bel complex. Funded by the French government and under the guidance of M. Antoine Dufour, young immigrant teenagers run a television studio that broadcasts programs throughout France. These young people are in charge of scripts and direction and run the control booth and cameras. The center also houses a day care facility. In the rooms where the children play hang mobiles with images of André Breton and Max Ernst, and in their art projects, children between the ages of three and five are taught to make sculptures like those of the surrealists who, during World War II, found temporary shelter at Villa Air-Bel.

ACKNOWLEDGMENTS

No author could undertake a work of this complexity without extraordinary support, and I am deeply grateful to all those who helped me.

I want to thank the Social Sciences and Humanities Research Council of Canada and the Canada Research Chair program for affording me release time from teaching at the University of Toronto and for financial assistance as I pursued my research. I would especially like to thank the Camargo Foundation for granting me a three-month residency in Cassis, France, which provided me with the opportunity not only to visit the sites that feature in my book, but also privacy and time to write.

Without the extraordinary diligence of librarians and access to library collections, authors could not engage in research. I want to thank Jennifer Mendelsohn, head of Reference, and Ian Crellin, director of Audio Visual Library collection, at Robarts Library, the University of Toronto, for their expert assistance; Maren Read of the United States Holocaust Memorial Museum for her unfailing generosity; and Jennifer B. Lee of the Rare Book and Manuscript Library, Columbia University, for her patience and kindness. I made use of many collections in my

research and would like to acknowledge their assistance: Manuscripts and Archives, Yale University Library; Irving S. Gilmore Music Library, Yale University; Beinecke Rare Books and Manuscripts Library, Yale University; Houghton Library, Harvard University; M. E. Grenander Department of Special Collections and Archives, State University of New York at Albany; the Getty Museum; and the Special Collections Department of the University of Delaware Library. I would like to thank the research centers and individuals in France who assisted me: Julia Mclaren of CPEDERF; the Archives Départementales, Bouches-du-Rhône; the Musée Cantini, Marseille; and the Centre Historique des Archives Nationales: Section du XX siècle, Paris.

In France, a number of individuals have proved exceedingly generous. Indicating her gratitude to that remarkable man Varian Fry, Aube Breton offered me permission to research the Breton papers at the Bibliotèque Littéraire Jacques Doucet and to quote from her father's works. Mme. Hélène Ungemach-Bénédite was equally generous in allowing me to quote from the letters of Theo and Daniel Bénédite and from his work.

Antoine Dufour, director of Centre Social d' Air-Bel, invited me to interview and be interviewed by the young people who participate in his center, as well as providing me with copies of the original plans of the Villa Air-Bel. Jean Bernard of the Atelier Bernard gave his time generously as we selected photographs for my book. Most important was the patience and kindness of Jean-Michel Guiraud, who answered my questions and offered me access to whatever material I needed. Marie Delord of the Université de Toulouse was unfailingly generous with her assistance and advice, and I am grateful.

I would like to thank Señora Kibalchich for her kindness. I also want to thank Leonora Carrington for offering me her memories of wartime France. Charles Ebel readily afforded me the right to quote from the memoir of Miriam Davenport Ebel, as well as the right to reproduce photographs. My greatest debt is to Annette Riley Fry for being so welcoming and so deeply kind. She shared her Varian Fry archives with me and gave me permission to reproduce the photographs from her private collection.

In the early stages of my research, a number of young undergraduate students, including Kristin Moriah and Rhonda Grintuch, enthusiastically assisted me in collecting research documents. I would also like to thank Jack Granatstein, Constance Rooke, Richard Teleky, Stéphanie Walsh, and David Mason for their help in reading the manuscript. My research assistants Anita Corsini and Alysia Kolentsis were invaluable and relentless as they undertook to answer my many questions. They were a pleasure to work with.

Finally, a book is as good as its editors. I want to thank the staff of HarperCollins, Canada, for their confidence in my book and all their hard work, particularly Rob Firing, Kate Cassaday, Debbie Gaudet, and Norma Cody. My longtime editor Iris Tupholme was wonderfully inventive in her ideas for my book and, as always, exacting and brilliant in her editorial comments. All writers should be so lucky as to have such an editor. I would also like to thank Eleanor Birne of John Murray Publishers for her keen interest and commitment.

I would like to thank the editorial staff of HarperCollins, New York, particularly Lauretta Charlton, Jonathan Burnham, Kathy Schneider, and Christine Boyd, for their hard work and unfailing good cheer. Most of all, I want to thank my editor, Claire Wachtel. Her vision of the book's potential, her extraordinary editorial expertise, and her great good humor made the whole experience of completing this book a deep pleasure.

I would like to thank my agent, Jackie Kaiser of Westwood Creative Artists, who encouraged me from the beginning to pursue this subject and supported me through the many stages of the book's evolution.

Arlene Lampert was my perfect reader. Her enthusiasm throughout this long project was that of a dear friend. I also want to acknowledge the patience and loving support of my family, particularly my mother, Leanore Guthrie Sullivan. Finally, I want to thank my partner, Juan Opitz, who provides the still center that makes the writing possible.

NOTES

THE ROAD OUT

1. Lisa Fittko, *Escape Through the Pyrenees*, trans. David Koblick (Northwestern University Press, Evanston, 1991), p. 108.
2. Ibid., p. 104.
3. Ibid., p. 103
4. Ibid., p. 109.
5. Ibid., p. 112.
6. Letter dated October 11, 1940, from Frau Gurland to Arkadi Gurland, reprinted in Gershom Scholem, *Walter Benjamin: The Story of a Friendship*, trans. Harry Zohn (Jewish Publication Society of America, Philadelphia, 1981), p. 225.
7. Ibid., p. 225.
8. Ibid., p. 226.
9. Fittko, *Escape Through the Pyrenees*, p. 115.

THE PHOTOGRAPH

1. *International Herald Tribune*, September 25, 1930:

Hitler Warns in Court
Berlin: The tragic scenes enacted in the Place de la Révolution (now Place de la Concorde) in Paris during the French Revolution when the guillotine swept hundreds of aristocratic heads into the basket, will be repeated in Berlin when the Fascists come into power, Adolph [sic] Hitler, the Fascist leader, promised before the criminal chamber of the supreme court in Leipzig today

during a further hearing of the trial of three Reichswehr officers who are charged with treason for attempting to establish Fascist cells in the German army. Not only the blood of the nobility will flow in Berlin when the "third Reich" comes to pass in Germany, according to the leader of the National Socialists, but Socialist proletarians and pacifist professors will also be massacred. In three years, Hitler predicted, his party would be the strongest in the country, and when the day of their triumph came the treaty of Versailles and the Young plan would be tossed in the wastepaper basket.

So sensational indeed was the nature of Hitler's remarks about what his party proposed to do in the event of its gaining power, that stocks on the Berlin and Frankfort markets, which had recovered in the last two days, broke again sharply today all along the line.

(Reprinted in International Herald Tribune, *September 26, 2006.)*

2. Author's interview with Leonora Carrington, Mexico City, July 7, 2003.

THE DINNER PARTY

1. Miriam Davenport, *An Unsentimental Education: A Memoir by Miriam Davenport Ebel (1915–1999)*, p. 63. Web page: www.varianfry.org/ebel_memoir_en.htm.
2. Mark Polizzotti, *Revolution of the Mind: The Life of André Breton* (De Capo Press, New York, 1997), p. 480.
3. Ibid., p. 22.
4. Ibid., p. 402.
5. Ibid., p. 5.
6. Victor Serge, *Memoirs of a Revolutionary*, trans. Peter Sedgwick (Writers & Readers, London, 1984), p. 361.
7. Susan Weissman, *Victor Serge: The Course Is Set on Hope* (Verso, London, 2001), p. 183.
8. William Wiser, *The Twilight Years: Paris in the 1930s* (Carroll & Graf Publishers, New York, 2000), p. 243.
9. Andy Marino, *A Quiet American: The Secret War of Varian Fry* (St. Martin's Press, New York, 1999), p. 213.

THE HEIRESS

1. Mary Jayne Gold, *Crossroads Marseilles, 1940* (Doubleday, New York, 1980), p. 25.
2. Wiser, *Twilight Years*, p. 151.
3. Gold, *Crossroads Marseilles, 1940*, p. 31.
4. Wiser, *Twilight Years*, p. 108.
5. Ibid., pp. 50–55.
6. Gold, *Crossroads Marseilles, 1940*, p. 32.
7. Ibid., p. 34.

THE YOUNG CLERK AT THE PRÉFECTURE DE POLICE

1. Gold, *Crossroads Marseilles*, p. 26.
2. Daniel Bénédite, *La filière marseillaise: Un chemin vers la liberté sous l'occupation* (Clancier Guénaud, Paris, 1984), p. 19.

3. Ibid., p. 46.
4. Wiser, *Twilight Years*, p. 37.
5. Francine du Plessix Gray, *Simone Weil* (Viking Penguin, New York, 2001), p. 63.
6. It is estimated that the first exodus of refugees from Germany after Hitler assumed the Chancelorship numbered about sixty-five thousand persons, of whom twenty-five thousand settled in France. See Christian Eggers, "Les émigrés des années trente, leur situation en 1940–41 et la demarche de Varian Fry," *Varian Fry: du refuge . . .* (Actes Sud, Marseille, 1999), p. 46.
7. Alexander Werth, *France in Ferment* (Harper & Brothers, London, 1934), p. 26.
8. Du Plessix Gray, *Simone Weil*, p. 61.
9. Gerald Holton, "The Migration of Physicists to the United States," *The Muses Flee Hitler: Cultural Transfer and Adaptation, 1930–1945*, eds. Jarrell C. Jackman and Carla M. Borden (Smithsonian Institution Press, Washington, D.C., 1983), p. 171.
10. Werth, *France in Ferment*, p. 26.
11. Holton, "The Migration of Physicists to the United States," p. 183.

AN EVENING AT THE APARTMENT OF ALEXANDER WERTH

1. Gold, *Crossroads Marseilles, 1940*, p. 35.
2. Werth, *France in Ferment*, p. 23.
3. Ibid., p. 25.
4. Janet Flanner, *An American in Paris: Profile of an Interlude Between the Wars* (Simon and Schuster, New York, 1940), p. 374.
5. Gold, *Crossroads Marseilles, 1940*, pp. 35–36.
6. "Werth, Alexander." Database: *Wilson Biographies*, H. W. Wilson, p. 3.

THE PARIS RIOTS

1. Wiser, *Twilight Years*, p. 112.
2. Werth, *France in Ferment*, p. 150.
3. Later statistics would put the number of injured at 2,329, with seventeen dead. See Herbert R. Lottman, *The Left Bank: Writers, Artists, and Politics from the Popular Front to the Cold War* (University of Chicago Press, Chicago, 1982), p. 76.
4. Werth, *France in Ferment*, p. 161.
5. Ibid., p. 173.
6. Ibid., p. 178.

UP IN THE CLOUDS

1. David Ogilvy, "1935: The Gull," *Shuttleworth: The Historic Aeroplanes* (Airlife Publishing, London, 1989). These were the days when many young women were addicted to flying. In 1927 a seventeen-year-old girl, Elinor Smith, became the youngest licensed pilot and gained notoriety the next year for flying under all four bridges spanning New York's East River. Young female pilots without money took to flying as stunt pilots in carnivals and circuses.
2. Gold, *Crossroads Marseilles, 1940*, p. 35.

THE CONGRESS AND THE CASE OF VICTOR SERGE

1. Victor Serge, *The Long Dusk*, trans. Ralph Manheim (Dial Press, New York, 1946), p. 302.
2. André Thirion, *Revolutionaries Without Revolution*, trans. Joachim Neugroschel (Macmillan, New York, 1975), p. 175.
3. Ibid., p. 173.
4. Lottman, *Left Bank*, p. 1.
5. Polizzotti, *Revolution of the Mind*, p. 418.
6. Lottman, *Left Bank*, p. 3.
7. Polizzotti, *Revolution of the Mind*, pp. 418–19. Conversation reported by Vítezlav Nezval, *Rue Gît-le-Coeur* (Editions de L'Aube, Paris, 1988), p. 21.
8. Ibid., p. 419.
9. Ilya Ehrenburg, *Eve of War 1933–1941*, trans. Tatiana Shebunina (MacGibbon & Kee, London, 1963), p. 72.
10. Ibid., p. 73.
11. Lottman, *Left Bank*, p. 85.
12. Ibid., p. 87. See also Alan Sheridan, *André Gide: A Life in the Present* (Harvard University Press, Cambridge, 1999), p. 479.
13. Lottman, *Left Bank*, p. 84.
14. Ibid., p. 85.
15. Polizzotti, *Revolution of the Mind*, p. 422.
16. Ehrenburg, *Eve of War*, p. 72.
17. Polizzotti, *Revolution of the Mind*, pp. 423–24.
18. Du Plessix Gray, *Simone Weil*, p. 67.
19. Lottman, *Left Bank*, p. 95.
20. Serge, *Memoirs of a Revolutionary*, p. 288.
21. Lottman, *Left Bank*, p. 96.
22. Serge, *Memoirs of a Revolutionary*, p. 322.
23. Ibid., p. 334.
24. Sheridan, *André Gide*, p. 510.
25. Serge, *Memoirs of a Revolutionary*, pp. 332–33.
26. Victor Serge, *The Case of Comrade Tulayev*, trans. Willard R. Trask (New York Review of Books, New York, 2004), xxi.

FRIENDS FOR LIFE

1. Weissman, *Victor Serge*, p. 254.
2. Victor Serge, *Men in Prison*, trans. Richard Greeman (Writers and Readers Publishing Cooperative, London, 1977), p. 1.
3. Serge, *Memoirs of a Revolutionary*, p. 1.
4. Ibid., p. 329.
5. Ibid., p. 332.

THE PARIS EXPOSITION

1. Arthur Chandler, "Confrontation: The Exposition Internationale des Arts et Techniques dans la Vie Moderne, 1937," *World's Fair* 8, no. 1 (1988): 1.
2. Ibid., p. 39.

3. Karen A. Fiss, "The German Pavilion," *Art and Power: Europe under the Dictators 1930–45*, eds. Dawn Ades et al. (Hayward Gallery, London, 1996), p. 109.
4. Ibid.
5. James D. Herbert, *Paris 1937: Worlds on Exhibition* (Cornell University Press, Ithaca, 1998), p. 39.
6. Alexander Werth, *The Twilight of France, 1933–1940* (Howard Fertig, New York, 1966), p. 129.

PICASSO AND THE DRESS REHEARSAL

1. Pablo Neruda, "Explaining a Few Things," *Tercera Residencia 1935–45* (Losada, 1951). Poem on the Spanish Civil War.
2. G. L. Steer, *New York Times*, April 28, 1937.
3. Herschel B. Chipp, *Picasso's Guernica: History, Transformations, Meanings* (University of California Press, Berkeley, 1988), p. 39.
4. John Russell, *Max Ernst: Life and Work* (Harry N. Abrams, New York, 1967), p. 120.
5. Du Plessix Gray, *Simone Weil*, p. 113.
6. Wiser, *Twilight Years*, p. 80.

DEGENERATE ART

1. Author's interview with Leonora Carrington, Mexico City, December 5, 2004.
2. Mario-Andreas Von Lüttichau, "Entartete Kunst, Munich 1937: A Reconstruction," *Degenerate Art: The Fate of the Avant-Garde in Nazi Germany*, ed. Stephanie Barron (Harry N. Abrams, New York, 1991), p. 45.
3. Ibid.
4. Ibid., p. 46.
5. Stephanie Barron, "Modern Art and Politics in Prewar Germany, 1937," *Degenerate Art: The Fate of the Avant-Garde in Nazi Germany*, p. 11.
6. David Grubin, *Degenerate Art: The Fate of the Avant-Garde in Nazi Germany*. Documentary Film, David Grubin Productions, 1993.
7. Barron, *Degenerate Art*, p. 17.
8. Alice Goldfarb Marquis, *Alfred H. Barr Jr.: Missionary for the Modern* (Contemporary Books, New York, 1989), p. 177.

THE ANSCHLUSS OR MERGING

1. Hertha Pauli, *Break of Time* (Hawthorn Books, New York, 1972), p. 9.
2. Ibid., p. 20.

THE CLIENTS OF VARIAN FRY

1. Joseph Roth, "Rest While Watching the Demolition," *Report from a Parisian Paradise: Essays from France 1925–1939*, trans. Michael Hofmann (W. W. Norton, New York, 1999), p. 239.
2. Heinrich Heine, *Almansor: A Tragedy* (1821). Used as an inscription on memorial at Dachau concentration camp.
3. Roth, "Rest While Watching the Demolition," p. 239.
4. Roth, "Europe Is Possible Only Without the Third Reich," *Report from a Parisian Paradise*, p. 227.
5. Pauli, *Break of Time*, p. 34.

6. Roth, "The Myth of the German Soul," *Report from a Parisian Paradise*, pp. 234–35.
7. Pauli, *Break of Time*, p. 79.

THE SHADOW CITY

1. Fittko, *Escape Through the Pyrenees*, p. 113.
2. Of the three million foreigners in France at the end of the 1930s, it is calculated that perhaps one-third were refugees from Fascist or Nazi dictatorships. See Eggers, "Les émigrés des années trente," p. 46.
3. Wiser, *Twilight Years*, p. 202.
4. Lottman, *Left Bank*, p. 40.
5. Mechtild Gilzmer, *Camps de femmes: Chronique d'internées, Rieucros et Brens 1939–1944* (Éditions Autrement, Paris, 2000), pp. 23–24. See Eggers, "Les émigrés des années trente," pp. 46–47.

REALITY UP FOR GRABS

1. Antoine de Saint-Exupéry, *Wartime Writings 1939–1944*, trans. Norah Purcell (Harcourt Brace Jovanovich, New York, 1982), p. 13.
2. Gold, *Crossroads Marseilles, 1940*, p. 23.
3. Ibid., p. 38.
4. Werth, *France in Ferment*, p. 40.
5. Gold, *Crossroads Marseilles, 1940*, p. 39.
6. Pauli, *Break of Time*, p. 62.
7. Gold, *Crossroads Marseilles, 1940*, p. 36.

AM I MY BROTHER'S KEEPER? THE FRENCH BORDER

1. Janet Flanner, *Paris Was Yesterday 1925–1939*, ed. Irving Drutman (Viking Press, New York, 1972), p. 201.
2. "Manifestations Socialistes," et "Pour l'aide aux réfugiés espanoles," *Le Populaire*, February 1 and 2, 1939.
3. Flanner, *Paris Was Yesterday*, p. 201.
4. Lottman, *Left Bank*, p. 119.
5. "Contre le dénuement des réfugiés espanoles Contre les camps de concentration," *Le Populaire*, February 15, 1939.
6. "28.000 miliciens et 10.000 civils ayant opté pour l'Espagne nationaliste," *Le Figaro*, February 14, 1939.
7. Werth, *Twilight of France*, p. 329.
8. Jacques Grandjonc, "L'émigration officielle: Les consulats," *Varian Fry: Mission américaine de sauvetage des intellectuels anti-nazi, Marseille 1940–42* (Actes Sud, 1999), p. 45.
9. Bénédite, *Filière marseillaise*, p. 288.
10. "Le general Franco définit les actes politiques coupables des républicains," *Le Figaro*, February 14, 1939.

DESPERATE TO PARTY

1. Flanner, *Paris Was Yesterday*, p. 220.
2. Ibid.
3. Wiser, *Twilight Years*, p. 224.

4. Flanner, *Paris Was Yesterday*, pp. 216–17.
5. Simone de Beauvoir, *The Prime of Life*, trans. Peter Green (Lancer Books, New York, 1966), p. 453.
6. Martica Sawin, *Surrealism in Exile and the Beginning of the New York School* (MIT Press, Boston, 1995), p. 66.

THE CALL
1. Sawin, *Surrealism in Exile*, p. 66.
2. Polizzotti, *Revolution of the Mind*, p. 476.
3. Ibid., p. 53.
4. Ruth Brandon, *Surreal Lives: The Surrealists 1917–1945* (Grove Press, New York, 1999), p. 157.
5. Polizzotti, *Revolution of the Mind*, pp. 54, 66.
6. Ibid., p. 29.
7. Christopher Robbins, *Test of Courage: The Michel Thomas Story* (Free Press, New York, 1999), p. 49.
8. Julian Jackson, *The Fall of France: The Nazi Invasion of 1940* (Oxford University Press, Oxford, 2003), pp. 26–27.
9. Bénédite, *Filière marseillaise*, p. 23.
10. Ibid., pp. 30–31.

LA DRÔLE DE GUERRE
1. Beauvoir, *Prime of Life*, p. 457/447.
2. For a study of the impact of the war on European museums see Lynn H. Nicholas, *The Rape of Europa: The Fate of Europe's Treasures in the Third Reich and the Second World War* (Vintage Books, New York, 1995).
3. Beauvoir, *Prime of Life*, p. 477.
4. Ibid., p. 502.
5. Jacqueline Bograd Weld, *Peggy: The Wayward Guggenheim* (E. P. Dutton, New York, 1986), p. 190.
6. Beauvoir, *Prime of Life*, p. 519.

SHAME
1. Eric Sevareid, *Not So Wild a Dream: A Personal Story of Youth and War and the American Faith* (Atheneum, New York, 1976), p. 97.
2. Eggers, "Les émigrés des années trente," p. 47.
3. Pauli, *Break of Time*, p. 113.
4. Beauvoir, *Prime of Life*, p. 476.
5. "France Copies Hitler," *New Republic*, January 15, 1940, p. 69.
6. Sevareid, *Not So Wild a Dream*, p. 120.
7. Ibid., pp. 121–23.
8. Pauli, *Break of Time*, p. 125.

ONE MAN'S NIGHTMARE
1. Peggy Guggenheim, *Out of This Century: Confessions of an Art Addict* (Andre Deutsch, London, 1979), p. 216.

2. Author's interview with P. K. Page, Canadian poet and painter, friend of Leonora Carrington, Victoria, B.C., April 10, 1994.

3. Julotte Roche, *Max et Leonora: Récit d'investigation* (Le temps qu'il fait, 1997), pp. 55, 75.

4. Max Ernst, "Biographical Notes: Tissue of Truth, Tissue of Lies," *Max Ernst: A Retrospective*, ed. Werner Spies (Prestel-Verlag, Munich, 1991), p. 319.

5. The policy of interning enemy aliens was not unique to France. The United States and Canada set up internment camps for people of Japanese heritage, including many who held American or Canadian citizenship.

6. Max Ernst, *Écritures* (Édition Gallimard, Paris, 1970), p. 61.

7. Jimmy Ernst, *A Not-So-Still Life* (St. Martin's/Marek, New York, 1984), p. 170.

8. Sawin, *Surrealism in Exile*, p. 17.

9. In one mural, called *The Last Supper*, the notorious glutton Henry VIII presides over a feast with John Wayne and an African chief; in another, sardines jump from a can and try to catch a ham that looks to be floating toward America. The images of food are almost deliriously rich. In another mural called *Aidez Moi*, farmers collect the grape harvest while caricature figures roll huge cheeses and sausages in a grand procession. Above the images are banner ribbons that comment on the scene with sufficient irony: "Allow our drawings to calm your appetite. . . . If your plates are not sufficiently garnished . . ." Author's visit to Camp des Milles, June 10, 2004.

10. Eggers, "Les émigrés des années trente," p. 48.

L'HUMOUR NOIR

1. Polizzotti, *Revolution of the Mind*, p. 482.

2. Ibid., p. 478.

3. Maud Bonneaud, "Notes sur une rencontre," *Profile Littéraire*, no. 15 (1943): 32. Author's translation.

4. Thirion, *Revolutionaries Without Revolution*, p. 182.

5. Bonneaud, "Notes sur une rencontre," p. 32.

6. Polizzotti, *Revolution of the Mind*, p. 480.

RETREAT: OPERATION DYNAMO

1. Antoine de Saint-Exupéry, *Flight to Arras*, trans. William Rees (Penguin Books, London, 1995), p. 27.

2. Gold, *Crossroads Marseilles, 1940*, pp. 39–40.

3. Sawin, *Surrealism in Exile*, p. 73.

4. Marino, *Quiet American*, p. 37.

5. Sevareid, *Not So Wild a Dream*, p. 143.

6. Jackson, *Fall of France*, p. 44.

7. Sevareid, *Not So Wild a Dream*, p. 142.

8. Bénédite, *Filière marseillaise*, pp. 31–32. Jackson, *Fall of France*, p. 77, corroborates that the British did not even possess up-to-date maps of France.

9. Bénédite, *Filière marseillaise*, p. 34.

10. Ibid., p. 36.

11. Jackson, *Fall of France*, p. 95. The British had contributed 700 vessels of all kinds and the French about 160.

12. Jackson, *Fall of France*, p. 95. Much to the bitterness of the French soldiers, the rescue craft had given British soldiers priority. "The retreat had been inevitable, and its execution heroic, but to Frenchmen it seemed that their British ally showed military verve only when it came to scuttling back to their island." Robbins, *Test of Courage*, p. 51.

THE FALL OF PARIS

1. Serge, *Memoirs of a Revolutionary*, p. 356.
2. Sevareid, *Not So Wild a Dream*, p. 145.
3. Jackson, *Fall of France*, p. 121. "By the spring of 1940 3,400 Communist activists had been arrested, and over 3,000 Communist refugees interned as foreign undesirables."
4. Serge had met Laurette Séjourné in Paris. His wife, Liuba, was permanently confined in a Paris mental institution. She had had a final breakdown and never recovered.
5. Serge, *Memoirs of a Revolutionary*, p. 352.
6. Serge, *Long Dusk*, pp. 74–75. This novel is Serge's account of the fall of Paris.
7. Wiser, *Twilight Years*, p. 248.
8. Jackson, *Fall of France*, p. 135.
9. Ibid.
10. Serge, *Long Dusk*, p. 86.
11. Serge, *Memoirs of a Revolutionary*, p. 358.
12. Saint-Exupéry, *Flight to Arras*, pp. 68–69.
13. Jackson, *Fall of France*, p. 174. "Starting with the arrival of the Belgian refugees in mid-May . . . the Exodus quickly spread to northern France: Rheims by 16 May, Soissons by 20 May, Compiègne by 28 May, Senlis by 29 May. In June it spread further south: Paris between 6 and 12 June, Chartres on 15 June. It is estimated that the population of Lille fell from 200,00 to 20,000, Tourcoing from 82,000 to 7,000, Chartres from 23,000 to 800."
14. Pauli, *Break of Time*, pp. 143–44.
15. Wiser, *Twilight Years*, pp. 256–57.
16. Ibid., pp. 266–67.
17. Marino, *Quiet American*, p. 51.
18. Jackson, *Fall of France*, p. 232.

FEAR

1. Serge, *Long Dusk*, p. 54.
2. Gold, *Crossroads Marseilles, 1940*, p. 49.
3. Ibid., p. 53.
4. Mary Jayne Gold, "Marseilles: Interview," June 2, 1988, Transcript #92, Audio #106B, MJ Gold Box 1/II Kaplan film, Exile Film Project Records, Manuscripts and Archives, Yale University Library.
5. Gold, *Crossroads Marseilles, 1940*, pp. 53–54.

THE CAPITULATION

1. Jackson, *Fall of France*, p. 143.
2. Bénédite, *Filière marseillaise*, p. 43.

POSTCARDS FROM THE ZONE LIBRE

1. Jackson, *Fall of France*, p. 180. Reports of the number of French casualties have varied widely, but "the available evidence has suggested . . . between 50,000 and 90,000 and tending towards the lower end."
2. Jackson, *Fall of France*, p. 144.
3. Robert Gildea, *Marianne in Chains: In Search of the German Occupation of France 1940–45* (Pan Books, London, 2003), p. 48.
4. Ibid., p. 49.
5. Claude Chabrol, *L'oeil de Vichy (The Eye of Vichy)*. Documentary film. TFI Films Production, 1992.
6. Jackson, *Fall of France*, p. 180.
7. Chabrol, *L'oeil de Vichy*.
8. Jackson, *The Fall of France*, p. 233.
9. Ibid., p. 188. The trial didn't open until February 1942 and was suspended before a judgment could be delivered.
10. Donna K. Ryan, *The Holocaust and the Jews of Marseille: The Enforcement of Anti-Semitic Policies in Vichy France* (University of Illinois Press, Chicago, 1996), p. 24.
11. Polizzotti, *Revolution of the Mind*, p. 481

SAVE THE CHILD

1. Jackson, *Fall of France*, p. 174.
2. Gold, *Crossroads Marseilles, 1940*, p. 55.
3. Ibid., p. 55.
4. Ibid., p. 59.
5. Ibid., p. 68.
6. Pauli, *Break of Time*, p. 168.
7. Davenport, *An Unsentimental Education*, p. 9.
8. Sheila Isenberg, *A Hero of Our Own: The Story of Varian Fry* (Random House, New York, 2001), p. 34.
9. Davenport, *Unsentimental Education*, p. 7.
10. Ibid., p. 12. See also "Miriam Davenport-Ebel," *Varian Fry: du refuge*, pp. 17–18.
11. Davenport, *Unsentimental Education*, p. 17. See also "Miriam Davenport-Ebel," *Varian Fry: du refuge*, p. 18.

MARSEILLE I

1. Author's interview with Leonora Carrington, Mexico City, July 7, 2003.
2. Arthur Koestler, *Scum of the Earth*, trans. Daphne Hardy (Victor Gollancz, London, 1941), p. 233.
3. Howard L. Brooks, *Prisoners of Hope: Report on a Mission* (L. B. Fischer, New York, 1942), p. 21.
4. Koestler, *Scum of the Earth*, p. 219.
5. Chabrol, *L'oeil de Vichy*.
6. Ryan, *Holocaust and the Jews of Marseille*, p. 11.

7. Pauli, *Break of Time*, p. 168. See also Varian Fry, *Surrender on Demand* (Johnson Books, Boulder, 1997), p. 20.
8. Brooks, *Prisoners of Hope*, pp. 140–141; Ryan, *Holocaust and the Jews of Marseille*, p. 129.

THEY GATHER

1. Serge, *Memoirs of a Revolutionary*, p. 362.
2. Du Plessix Gray, *Simone Weil*, p. 151.
3. Lion Feuchtwanger, *The Devil in France: My Encounter with Him in the Summer of 1940*, trans. Elisabeth Abbott (Viking Press, New York, 1941), p. 5.
4. Ibid.
5. Serge, *Memoirs of a Revolutionary*, p. 361.
6. Author's interview with Leonora Carrington, Mexico City, December 5, 2004.
7. Ernst, "Biographical Notes," p. 319.
8. Leonora Carrington, "Down Below," *The House of Fear: Notes from Down Below* (E. P. Dutton, New York, 1988), p. 164.
9. Guggenheim, *Out of This Century*, p. 228. There are several versions of the story of Carrington's loss of Ernst's house. This version is Guggenheim's, presumably told to her by Max Ernst.
10. André Breton, *Conversations: The Autobiography of Surrealism*, trans. Mark Polizzotti (Paragon House, New York, 1993), p. 154.
11. Pauli, *Break of Time*, p. 150.
12. Ibid., p. 168.
13. Ibid., p. 176.
14. Ibid., p. 194.
15. Ibid., p. 195.
16. Ibid., p. 197.
17. Ibid., pp. 197–199. Conversation based on Pauli's interview with Fry.

MARSEILLE II

1. Davenport, *Unsentimental Education*, p. 19.
2. Ibid., p. 24.
3. Ibid., 25.
4. Ibid., p. 28.
5. Ibid., 28.
6. Ibid., p. 29.

THE QUIET AMERICAN

The title of the chapter comes from Andy Marino's biography of Fry, *A Quiet American*.
1. Hans Sahl, "On Varian Fry," *Hitler's Exiles: Personal Stories of the Flight from Nazi Germany to America*, ed. Mark M. Anderson (New Press, New York, 1998), p. 155.
2. Fry, *Surrender on Demand*, p. 6.
3. Pauli, *Break of Time*, p. 134.
4. Marino, *Quiet American*, p. 36.
5. Ibid., p. 38.
6. *New York Times*, June 15, 1940, front page.
7. *New York Times*, June 24, 1940, front page.

8. Marino, *Quiet American*, pp. 41–43.
9. Thirty-five hundred dollars would be the equivalent of forty-six thousand dollars in terms of contemporary purchasing power.
10. Marino, *Quiet American*, p. 44.
11. Ibid., p. 46. See also Cynthia Jaffee McCabe, " 'Wanted by the Gestapo: Saved by America'—Varian Fry and the Emergency Rescue Committee," *Muses Flee Hitler*, pp. 81–82.
12. Marino, *Quiet American*, p. 46.
13. Ibid., p. 47.
14. David S. Wyman, *Paper Walls: America and the Refugee Crisis 1938–1941* (University of Massachusette Press, Boston, 1968), pp. 46–48.
15. Ibid., p. 48.
16. Ibid., p. 141. See also McCabe, "Wanted by the Gestapo: Saved by America," p. 80.
17. Marino, *Quiet American*, p. 49.
18. Gold, *Crossroads Marseilles, 1940*, p. xvi.
19. Marino, *Quiet American*, p. 7. See also "Editor Describes Rioting In Berlin," *New York Times*, July 17, 1935, p. 4.
20. Varian Fry, "The Massacre of the Jews," *New Republic*, December 21, 1942, pp. 816–19.
21. "Nazi Denies Fry Report," *New York Times*, July 27, 1935, p. 2.
22. Varian Fry, "What Hitler Is After: The Historical Background of German Foreign Policy, *Scholastic*, March 28, 1936, pp. 17–18.
23. Letter from Eileen Fry to Varian Fry, August 5, 1940. Box 3, Varian Fry Papers, Rare Book and Manuscript Library, Columbia University.
24. Letter from Mildred Adams to Varian Fry, Executive Secretary, Emergency Rescue Committee, August 3, 1940, *Archives of the Holocaust: An International Collection of Selected Documents*, eds. Henry Friedlander and Sybil Milton (A Garland Series, 1990), p. 1.
25. Marino, *Quiet American*, p. 52.
26. Letter from Eleanor Roosevelt to Varian Fry, July 8, 1940. Box 5, Fry Papers.

ENGLAND IS URSULA; FRANCE IS HEINRICH

1. Lord Moran, *The Anatomy of Courage* (Constable, London, 1945).
2. Marino, *Quiet American*, p. 58.
3. Doris Obschernitzki, "Varian Fry et le CAS—Essai de chronologie," *Varian Fry: Mission américaine de sauvetage*, p. 55. This date is disputed. Pierre Sauvage suggests August 14; Fry's biographers, Andy Marino and Sheila Isenberg, suggest August 15.
4. Davenport, *Unsentimental Education*, p. 36.
5. Alma Mahler Werfel, *www.alma-mahler.at/engl/presscorner/almaundlisboa_02.html*
6. Fry, *Surrender on Demand*. This conversation between Fry and Bohn is based on Fry's own account in *Surrender on Demand*, pp. 7–16. Parts of the dialogue have been condensed from the original.
7. Fry, *Surrender on Demand*, p. 15. See also Ryan, *Holocaust and the Jews of Marseille*, p. 144
8. Fry, *Surrender on Demand*, p. 16.

9. Ibid., p. 34.
10. Marino, *Quiet American*, p. 78.
11. Albert O. Hirschman, "Albert O. Hirschman, Albert Hermat [*sic*], Beamish," *Varian Fry: du refuge*, pp. 12–13.
12. Marino, *Quiet American*, p. 132.
13. Ibid., p. 120.
14. Letter from Varian Fry to Eileen Fry, September 7, 1940. Box 3, Fry Papers.
15. Davenport, *Unsentimental Education*, p. 36.
16. Marino, *Quiet American*, p. 5.
17. Isenberg, *Hero of Our Own*, p. 38.
18. Fry, *Surrender on Demand*, p. 36.
19. Isenberg, *Hero of Our Own*, p. 37.
20. Letter from Varian Fry to mother, November 3, 1940. Box 3, Fry Papers.
21. Pauli, *Break of Time*, p. 222.
22. Ibid., p. 203.

THE FITTKOS

1. Walter Benjamin, "Philosophy of History, Thesis VII." Inscription on the grave of Walter Benjamin in Portbou, Spain.
2. Lisa Fittko, *Solidarity and Treason: Resistance and Exile 1933–40*, trans. Roslyn Theobald (Northwestern University Press, Evanston, 1995), p. 73.
3. Marino, *Quiet American*, p. 84.
4. Fittko, *Escape Through the Pyrenees*, p. 118.
5. Ibid., p. 119.

CONNECTIONS

1. Letter from Dwight Macdonald to Victor Serge, November 14, 1939. Macdonald Papers, Box 46/27. Manuscripts and Archives, Yale University Library.
2. Undated letter from Victor Serge to the Macdonalds, quoted in Nancy Macdonald, *Homage to the Spanish Exiles: Voices from the Spanish Civil War* (Insight Books, New York, 1987), p. 55. All Serge letters translated from French by Marie Delord.
3. Letter from Victor Serge to the Macdonalds, August 19, 1940. Box 46/27, Macdonald Papers.
4. Letter from Nancy Macdonald to American Consul, Marseille, France, July 20, 1940. Box 46/27, Macdonald Papers.
5. Letter from Victor Serge to Nancy Macdonald, August 30, 1940. Box 46/27, Macdonald Papers.
6. Letter from Mildred Adams, Executive Secretary, ERC, to George Warren, September 12, 1940. Box 46/27, Macdonald Papers.
7. George Warren's reply quoted in letter from John Finerty to Francis Biddle, Solicitor General of the United States, October 8, 1940. Box 46/27, Macdonald Papers.
8. Letter from John Finerty to Francis Biddle, Solicitor General of the United States, October 8, 1940. Box 46/27, Macdonald Papers.

9. Letter from Henry Hart Jr., Special Assistant to the Attorney General, to John F. Finerty, October 10, 1940. Box 46/27, Macdonald Papers.
10. Letter from Nancy Macdonald to Victor Serge, November 6, 1940. Box 46/28, Macdonald Papers.
11. Serge, *Memoirs of a Revolutionary*, pp. 350, 365.
12. Letter from Victor Serge to Nancy Macdonald, August 26, 1940. Box 46/27, Macdonald Papers.
13. Letter from André Breton to Victor Serge, October 13, 1940. André Breton, Gen Ms 238, Box 1, No. 9. Beinecke Rare Book and Manuscript Library, Yale University.
14. Letter from Victor Serge to Nancy Macdonald, September 20, 1940. Box 46/27, Macdonald Papers.
15. Postcard from André Breton to Victor Serge, September 8, 1940. André Breton, Gen Ms 238, Box 1, No. 9. Beinecke Rare Book and Manuscript Library.

KILLER

1. Gold, *Crossroads Marseilles*, 1940, p. 85.
2. Ibid., p. 91.
3. Ibid., p. 95.
4. Pierre Sauvage, in his article "Varian Fry in Marseille," *Remembering for the Future: The Holocaust in an Age of Genocide*, eds. John K. Roth and Elizabeth Maxwell (Palgrave, London, 2001), p. 373, footnote 44, identifies Mary Jayne Gold's lover as Raymond Couraud. Couraud's biographer Colonel Roger Flamand, in *L'Inconnu du French Squadron* (Paris, La Forêt, 1983), tells the story of Gold's connection with Couraud and includes private correspondence from Raymond. In her memoir, *Crossroads Marseilles, 1940*, Gold identifies "Killer" by the name of Jacques Daunis, but this is clearly a pseudonym to protect Couraud's identity.
5. Gold, *Crossroads Marseilles*, 1940, p. 100.
6. Ibid., p. 103.
7. Ibid., p. 104.
8. The Battle of Britain lasted from July 10 to October 31, 1940.
9. Gold, *Crossroads Marseilles*, 1940, p. 134.
10. Davenport, *Unsentimental Education*, p. 29.
11. Ibid., p. 44.
12. Gold, *Crossroads Marseilles*, 1940, p. 153.
13. The Kundt Commission, a branch of the Gestapo, had the right to inspect French internment camps to search for Reichsfeinde (enemies of the state) and to oversee the "repatriation" of German citizens. Ryan, *Holocaust and the Jews of Marseille*, p. 108.

STATUT DES JUIFS

1. Telegram from Varian Fry to Eileen Fry, October 1, 1940. Box 3, Fry Papers.
2. Ryan, *Holocaust and the Jews of Marseille*, pp. 24–25.
3. Ibid., p. 26.
4. Ibid., p. 216. HICEM's own organizational files show that between the armistice and the end of 1942 HICEM helped 6,449 Jews escape France (Ibid., p. 138). See also Eggers, "Les émigrés des années trente," p. 57.

NEW STAFF AT CAS

1. Bénédite, *Filière marseillaise*, p. 18.
2. Fry, *Surrender on Demand*, p. 100.
3. Lottman, *Left Bank*, p. 155.
4. Ibid., p. 142.
5. Polizzotti, *Revolution of the Mind*, p. 483.
6. *Le jeu de Marseille: Autour d'André Breton et des surréalistes a Marseille en 1940–1941*. Exposition de 4 juillet au 5 octobre 2003, Direction des Musées de Marseille (Éditions Alors Hors du Temps, Marseille, 2003), p. 53. *La Grande Illusion* was made in 1937 and banned in 1939.
7. Sawin, *Surrealism in Exile*, p. 132.
8. Helena Benitez, *Wilfredo and Helena: My Life with Wilfredo Lam 1939–1950* (Acatos Publisher, Lausanne, 1999), p. 28.
9. Jean-Michel Guiraud, *La vie intellectual et artistique à Marseille: A l'epoque de Vichy et sous l'occupation 1940–1944.* (Édition Jeanne Laffitte, Marseille, 1998), pp. 123–24.
10. Polizzotti, *Revolution of the Mind*, p. 167.
11. Ibid., p. 485.
12. Ibid.
13. Ibid.

THE VILLA AIR-BEL

1. Davenport, *Unsentimental Education*, p. 61.
2. Ibid., p. 60.
3. Varian Fry letter to father, Arthur Fry, May 15, 1941. Box 3, Fry Papers.
4. Bénédite, *Filière marseillaise*, p. 56.
5. Ibid., p. 58.
6. Gold, *Crossroads Marseilles, 1940*, p. 243.
7. The phrase *Bucklicht Männlein* to describe the perpetual fear the refugee carries about with him or her is Hannah Arendt's. See Fittko, *Escape Through the Pyrenees*, p. 114.

SUNDAY AFTERNOONS: REBELLION

1. Roth, "From an Author's Diary," *Report from a Parisian Paradise*, p. 279.
2. Gold, *Crossroads Marseilles, 1940*, p. 250.
3. Polizzotti, *Revolution of the Mind*, p. 9.
4. Ibid., p. 43.
5. Brandon, *Surreal Lives*, p. 18.
6. Polizzotti, *Revolution of the Mind*, p. 89.
7. Marino, *Quiet American*, p. 224.
8. Mel Gooding, ed., *The Book of Surrealist Games* (Shambhala Redstone Edition, London, 1995), p. 25.
9. Polizzotti, *Revolution of the Mind*, p. 258.
10. Janet Kaplan, *Unexpected Journeys: The Art and Life of Remedios Varo* (Abbeville Press, New York, 1988), p. 80
11. Benitez, *Wilfredo and Helena*, p. 36.
12. Kaplan, *Unexpected Journeys*, p. 77.

ESPERVISA

1. Serge, *Long Dusk*, p. 84.
2. Serge, *Memoirs of a Revolutionary*, p. 364.
3. *Ersatz* was a German word used by Vichy propaganda to promote food substitutes. Museum of the Resistance, Fonatine des Vaucluse, France.
4. Bénédite, *Filière marseillaise*, p. 127.
5. Fry, *Surrender on Demand*, p. 115.
6. Gold, *Crossroads Marseilles, 1940*, p. 308.
7. Bénédite, *Filière marseillaise*, p. 121.
8. Gold, *Crossroads Marseilles, 1940*, p. 258.
9. Letter from Varian Fry to mother, Lillian Fry, November 3, 1940. Box 3, Fry Papers.
10. Letter from Varian Fry to father, Arthur Fry, May 15, 1941. Box 3, Fry Papers.
11. Isenberg, *Hero of Our Own*, p. 123. Isenberg interview with Stephane Hessel, March 20, 1999.
12. Isenberg, *Hero of Our Own*, p. 123. Isenberg interview with Maurice Verzeano, May 2, 2000.
13. Breton, *Conversations*, p. 188. The poem had a rough history. The Vichy censors refused Breton a permit to publish, but Léon Pierre-Quint, the Jewish director of Éditions Sagittaire then in Marseille, secretly printed five illustrated copies for the author's personal use on March 10, 1941. Later that fall, *Fata Morgana* appeared in an English translation by Clark Mills published by New Directions, and the first French edition was put out by Roger Caillois's Editions Lettres Françaises in Buenos Aries, Argentina, in 1942. Sawin, *Surrealism in Exile*, p. 125.
14. André Roussin, *La boîte à couleurs* (Éditions Albin Michel, 1974), p. 112.
15. Gold, *Crossroads Marseilles, 1940*, p. 255.
16. Author's interview with Leonora Carrington, July 7, 2003.
17. Serge, *Case of Comrade Tulayev*, p. 243.
18. Ibid., p. 268.

MARSEILLE III

1. Ryan, *Holocaust and the Jews of Marseille*, p. 93.
2. Brooks, *Prisoners of Hope*, pp. 29, 35.
3. Jean-Michel Guiraud, "La mission de Varian Fry: Le sauvetage des refugies dans une Europe en Guerre (1940–42)," *Livret pedagogique* (CRDP, Académie D'Aix-Marseille, 2005), p. 19. Andy Marino states that there were "120 concentration camps in Vichy France" (*Quiet American*, p. 235). The number is difficult to verify, as a full study of the camps has not yet been completed. According to Guiraud, between July 27 and August 30, 1940, the Kundt Commission enumerated ninety-three internment camps, including the camps of *"prestataires,"* in unoccupied France, without counting camps in the occupied zone. (Letter from Guiraud to author, March 26, 2006.)
4. Brooks, *Prisoners of Hope*, p. 149.
5. Guiraud, "La mission de Varian Fry," p. 20. Guiraud indicates that Vichy statistics were inaccurate by about twenty-one thousand. There were fifty thousand prisoners in internment camps in unoccupied France, not including the colonies.

6. Marino, *Quiet American*, p. 235.
7. Bénédite, *Filière marseillaise*, p. 132.
8. Ibid., pp. 133–35.
9. Gold, *Crossroads Marseilles, 1940*, p. 256.
10. Marino, *Quiet American*, p. 235.
11. Isenberg, *Hero of Our Own*, p. 85. U.S. State Department cable.
12. Isenberg, *Hero of Our Own*, p. 85. Isenberg interview with Miriam Davenport, May 16, 1998.

THE COMMANDANT

1. Marino, *Quiet American*, p. 256.
2. Gold, "Marseilles: Interview." April 30, 1985, Audio Cassettte Transcript #3, p. 14. MJ Gold Box 1/II Kaplan film, *Exile Film Project* Records.
3. Ibid., p. 7.
4. Gold, *Crossroads Marseilles, 1940*, p. 214.
5. Ibid., p. 223. See also Gold, "Marseilles: Interview."
6. Through Mary Jayne's intervention, Bögler, Lamm, Pfeffer, and Tittel were liberated from Le Vernet about October 5, 1940. For the fate of the prisoners, see Doris Obschernitzki, "L'émigration clandestine. Le CAS et ses filières," *Varian Fry: Mission Américaine*, pp. 50, 56.
7. Gold, *Crossroads Marseilles, 1940*, p. 262.
8. Gold, "Marseilles: Interview," June 2, 1988, Transcript #92, p. 10. Audio #106B, MJ Gold Box 1/II Kaplan film, *Exile Film Project* Records.

WE PROTEST AND RESERVE ALL RIGHTS

1. Bénédite, *Filière marseillaise*, p. 142. Se also Fry, *Surrender on Demand*, p. 135.
2. Bénédite, *Filière marseillaise*, pp. 142–43.
3. Ibid., p. 144.
4. Gold, *Crossroads Marseilles, 1940*, pp. 268–70.
5. Ibid., p. 270.
6. Fry, *Surrender on Demand*, p. 141.
7. Bénédite, *Filière marseillaise*, p. 145.
8. Fry, *Surrender on Demand*, p. 143.
9. Marino, *Quiet American*, p. 229.
10. Bénédite, *Filière marseillaise*, p. 147.
11. Gold, *Crossroads Marseilles, 1940*, p. 276.
12. Ibid., p. 275.
13. Bénédite, *Filière marseillaise*, p. 148.
14. Letter from William T. Stone to Eileen Fry, December 4, 1940. Box 3, Fry Papers.
15. Cable from American Consulate in Marseille to State Department, Washington, D.C. Box 11, Fry Papers.
16. Letter from Varian Fry to mother, December 8, 1940. Box 3, Fry Papers.
17. Letter from Varian Fry to Eileen Fry, December 8, 1940. Box 3, Fry Papers.
18. Ibid.
19. Letter from Varian Fry to mother, February 23, 1941. Box 3, Fry Papers.
20. Gold, *Crossroads Marseilles, 1940*, p. 271.

THE HONEYMOON

1. Flamand, *L'Inconnu du French Squadron*, p. 53.
2. Gold, *Crossroads Marseilles, 1940*, p. 289.
3. Ibid.
4. Ibid., p. 300.
5. Ibid., p. 283.
6. Ibid., p. 315.
7. Ibid.
8. Weissman, *Victor Serge*, p. 16.

POLICE REPORT

1. Letter from M. le Ministre, Secrétaire d'État à l'Intérieur et Directeur de la Police du Terriroire et des Étrangers to Monsieur le Prefet des Bouche-du-Rhône, December 24, 1940. 7292 P, Archives of the Bouches-du-Rhône, Marseille, France.
2. Report of Le Prefet des Bouches-du-Rhône à Monsieur le Ministre, Secrétaire d'Etat à l'Intérieur, December 30, 1940. 5 W 360, Archives of the Bouches-du-Rhône, Marseille, France. Author's translation. Published in *Livret pedagogique*, pp. 71–73.
3. Polizzotti, *Revolution of the Mind*, p. 491.
4. Letter from Victor Serge to Nancy and Dwight Macdonald, December 8, 1940. Box 46/28, Macdonald Papers.
5. Letter from Victor Serge to Nancy and Dwight Macdonald, December 14, 1940. Box 46/28, Macdonald Papers.
6. Serge, *Memoirs of a Revolutionary*, p. 364.
7. Gold, *Crossroads Marseilles, 1940*, p. 340.
8. Fry, *Surrender on Demand*, p. 150.
9. Isenberg, *Hero of Our Own*, p. 153. See also Marino, *Quiet American*, pp. 240–46.

DEEP FREEZE

1. Anna Seghers, *Transit Visa*, trans. James A. Glaston (Eyre and Spottiswoode, London, 1945), p. 122.
2. Serge, *Memoirs of a Revolutionary*, p. 363.
3. Brooks, *Prisoners of Hope*, p. 69.
4. Marino, *Quiet American*, p. 243.
5. Gold, *Crossroads Marseilles, 1940*, p. 285.
6. Cable from Frank Kingdon to Varian Fry, January 8, 1941. Box 4, Fry Papers.
7. Fry, *Surrender on Demand*, p. 170. See also Marino, *Quiet American*, p. 253.
8. Varian Fry's notes. Box 11, Fry Papers.
9. Weld, *Peggy*, p. 199.
10. Ibid., p. 198.
11. Guggenheim, *Out of This Century*, p. 220.
12. Ibid., p. 228.
13. Letter from Varian Fry to Eileen Fry, February 15, 1941. Box 3, Fry Papers.
14. Marino, *Quiet American*, p. 288. Marino notes that Allen was eventually released in August in exchange for a Nazi prisoner held in America.
15. Varian Fry's notes. Box 11, Fry Papers. See Marino, *Quiet American*, p. 271.

16. Letter from Varian Fry to Eileen Fry, February 3, 1941. Box 3, Fry Papers.
17. Cable from Ingrid Warburg to Varian Fry, January 30, 1941. Emergency Rescue Committee. Box 8, Fry Papers.

VISA DIVISION: DEPARTMENT OF STATE

1. Comment by William Blake as reported by James Ward. Letter from James Ward to George Raphael Ward, June 1855.
2. Cable from Jay Allen to Mrs. Allen, January 28, 1941. Emergency Rescue Committee, Fry Papers. See Isenberg, *Hero of Our Own*, p. 163.
3. Letter from Victor Serge to Macdonalds, January 5, 1941. Box 46/1129, Macdonald Papers.
4. Letter from Victor Serge to Macdonalds, January 16, 1941. Box 46/1129, Macdonald Papers.
5. Letter from Victor Serge to Macdonalds, January 27, 1941. Box 46/1129, Macdonald Papers.
6. Letter from Victor Serge to Macdonalds, February 5, 1941. Box 46/1129, Macdonald Papers.
7. Letter from Nancy Macdonald to Victor Serge, February 18, 1941. Box 46/1129, Macdonald Papers.
8. Letter from Dwight Macdonald to A. W. Warren, February 19, 1941. Box 46/1129, Macdonald Papers.
9. Letter from Victor Serge to Macdonalds, February 24, 1941. Box 46/1129, Macdonald Papers.
10. Letter from A. W. Warren to Dwight Macdonald, March 14, 1941. Box 46/1129, Macdonald Papers.
11. Letter from Edward Prichard to Dwight Macdonald, March 15, 1941. Box 46/1129, Macdonald Papers.

WAITING AT THE VILLA

1. André Breton, *Fata Morgana, Oeuvres completes* (Éditions Gallimard, Paris, 1992), p. 1187. Author's translation.
2. Marcel Jean, ed., *The Autobiography of Surrealism: The Documents of Twentieth Century Art* (Viking Press, New York, 1980), p. 384.
3. Bénédite, *Filière marseillaise*, p. 211.
4. Benjamin Harshav, *Marc Chagall and His Times: A Documentary Narrative* (Stanford University Press, Stanford, 2004), pp. 494–96.
5. Letter from Marc Chagall to Joseph Opatoshu, April 18, 1940. Harshav, *Marc Chagall and His Times*, p. 479.
6. Letter from Marc Chagall to Shmuel Nigger, September 1, 1940. Harshav, *Marc Chagall and His Times*, p. 483.
7. Letter from Hilla Rebay, Solomon R. Guggenheim Foundation, to Miss Dona [*sic*] Glanz, Fund for Jewish Refugee Writers, November 12, 1940. Harshav, *Marc Chagall and His Times*, p. 487.
8. Letter from S. R. Guggenheim to Miss Glanz, February 1, 1941. Harshav, *Marc Chagall and His Times*, p. 489.
9. Harshav, *Marc Chagall and His Times*, p. 489.
10. Letter from Victor Brauner to Varian Fry, October 3, 1941. Box 3, Fry Papers.
11. Sawin, *Surrealism in Exile*, p. 378.

12. Letter from Benjamin Péret to Kurt Seligmann, March 31, 1941. Houghton Library, Harvard University.
13. André Breton, "Jeu de Marseille," *VVV*3 (1943): 89–90, trans. Carole Frankel. See Stephanie Barron, *Exiles & Émigrés: The Flight of European Artists from Hitler* (Los Angeles County Museum of Art, Los Angeles, 1997), p. 106.
14. *Le Jeu de Marseille*, Exposition Catalogue, p. 85.
15. *Le Jeu de Marseille*, Exposition Catalogue contains all the drawings.
16. Some sketches from Villa Air-Bel are also housed at the Centre Pompidou in Paris.

SLIPPING THE NOOSE

1. The New School for Social Research was a center for adult education opened in 1919. From 1933, funded by the Rockefeller Foundation, its director Alvin Johnson had launched a plan to save German university faculty at risk. After 1940 its mandate was expanded to include émigrés from all European countries. See Xavier Affre, "Glossaire," *Livret pedagogique*, p. 142.
2. Marquis, *Alfred H. Barr Jr.*, p. 186. Barr helped Fry obtain visas for Marc Chagall, Jacques Lipchitz, André Masson, Jean Arp, and Wassily Kandinsky, among others.
3. Judith D. Suther, *Kay Sage: A House of Her Own* (University of Nebraska Press, Lincoln, 1997), p. 95.
4. Bénédite, *Filière marseillaise*, p. 190.
5. Letter from Walter Mehring to Varian Fry, December 22, 1941. Box 7, Fry Papers.
6. Benitez, *Wilfredo and Helena*, p. 50.
7. Letter from Victor Serge to the Macdonalds, March 6, 1941. Box 46/1129, Macdonald Papers.
8. Letter from Victor Serge to the Macdonalds, March 13, 1941. Box 46/1129, Macdonald Papers. See also Serge, *Memoirs of a Revolutionary*, p. 363.
9. Bénédite, *Filière marseillaise*, p. 191.
10. Claude Lévi-Strauss, *A World on the Wane*, trans. John Russell (Criterion Books, New York, 1961), p. 25. Shortly after the armistice, Lévi-Strauss was invited by the New School for Social Research to lecture in New York. He was also assisted by the Rockefeller Foundation's scheme to rescue European scholars "who might find themselves menaced by the German occupation." He'd been stationed on the Maginot Line and had made his way to Marseille.
11. Letter to Dwight Macdonald from Lemuel B. Schofield, Special Assistant to Attorney General, March 31, 1941. Box 46/1129, Macdonald Papers.

ART LOVER

1. Consuelo de Saint-Exupéry, *Kingdom of the Rocks: Memories of Oppède*, trans. Katherine Woods (Random House, New York, 1946) , p. 3.
2. Bénédite, *Filière marseillaise*, p. 218.
3. Ibid, p. 217.
4. Consuelo de Saint-Exupéry, *The Tale of the Rose: The Love Story Behind the Little Prince*, trans. Esther Allen (Random House, New York, 2001), p. 232.
5. Ryan, *Holocaust and the Jews of Marseille*, p. 31.
6. Guggenheim, *Out of This Century*, p. 229.
7. Weld, *Peggy*, p. 218.

8. Guggenheim, *Out of This Century*, p. 231.
9. Ernst, "Biographical Notes," pp. 281–85. Ernst wrote his autobiography in the third person.
10. Guggenheim, *Out of This Century*, p. 233.
11. Gold, *Crossroads Marseilles, 1940*, p. 355. See also Gold, "Marseilles: Interview."
12. Guggenheim, *Out of This Century*, p. 234.
13. Alfred Barr, Affidavit of Support for Max Ernst [undated]. Box 8, Fry Papers.
14. Ernst, "Biographical Notes," p. 319.
15. Bénédite, *Filière marseillaise*, p. 219.
16. Guggenheim, *Out of This Century*, p. 237.
17. Encouraged by André Breton and Pierre Mabille, Carrington would later write about the whole experience in a story called "Down Below" (published in *The House of Fear*), possibly one of the most lucidly hallucinatory accounts of madness that has been written. "When you go mad," she would say, "you find out what you are made of." Author's interview with Leonora Carrington, Mexico City, July 7, 2003.
18. Guggenheim, *Out of this Century*, p. 238.
19. Telegram from Varian Fry to Emergency Rescue Committee, April 19, 1941. "Ernst," Box 1, Fry Papers.
20. Ernst, *Not-So-Still Life*, p. 199.
21. Ibid., p. 220.
22. Note from Miss L. Loeb, Re: Max Ernst and Wife Mrs. Lou Ernst, Emergency Rescue Committee, July 3, 1941. Box 8, Fry Papers.
23. Note from Miss Lewinski, Cases: Max Ernst and Luise Ernst (ex-wife), Emergency Rescue Committee, October 7, 1942. Box 8, Fry Papers.
24. Ernst, *A Not-So-Still Life*, p. 237.
25. Ibid., p. 266.

BOULEVARD GARIBALDI

1. Sawin, *Surrealism in Exile*, p. 117.
2. Vala Schmierer, "Vala Schmierer," *Varian Fry: du refuge*, pp. 29–30.
3. Bénédite, *Filière marseillaise*, p. 191; Marino, *Quiet American*, pp. 269–70.
4. Bénédite, *Filière marseillaise*, p. 189.
5. Marino, *Quiet American*, pp. 263–64.
6. Fry, *Surrender on Demand*, p. 188.
7. Bénédite, *Filière marseillaise*, p. 224.
8. Harshav, *Marc Chagall and His Times*, pp. 501–05.
9. A bord du *Massilia*, 15/5/41, report. Box 11, Fry Papers.
10. Fry, *Surrender on Demand*, p. 208.
11. Letter from Eleanor Roosevelt to Eileen Fry, May 13, 1941. Box 4, Fry Papers.
12. Letter from Varian Fry to Eileen Fry, May 31, 1941. Box 4, Fry Papers.

ARRESTED

1. Marino, *Quiet American*, p. 127.
2. Bénédite, *Filière marseillaise*, p. 197.
3. Ibid., pp. 232–34.

4. Ibid., pp. 215–16.
5. Ibid., p. 235.
6. Ibid., p. 239.

MY BLACK HEART

1. Gold, *Crossroads Marseilles, 1940*, p. 358.
2. Ibid., p. 360.
3. Ibid., pp. 368–69.
4. Flamand, *L'Inconnu du French Squadron*, p. 57.
5. Ibid., p. 58.
6. Ibid., p. 139.
7. Gold, *Crossroads Marseilles, 1940*, p. 381.

TRISTE TROPIQUE

Triste Tropique (A World on the Wane) is the title of Claude Lévi-Strauss's memoir of his trip to Martinique and his times in Brazil.

1. Serge, *Memoirs of a Revolutionary*, p. 366.
2. André Breton, *Martinique: Charmeuse des serpents*, avec textes et illustrations de André Masson (Jean-Jacques Pauvert, 1972), p. 56.
3. Ibid., p. 60.
4. Lévi-Strauss, *Triste Tropique*, p. 26.
5. Breton, *Martinique*, p. 62.
6. Ibid., p. 65.
7. Ibid., p. 96.
8. Polizzotti, *Revolution of the Mind*, p. 498.
9. Benitez, *Wilfredo and Helena*, p. 58.
10. Sawin, *Surrealism in Exile*, p. 139.
11. Letter from Jacqueline Breton to Varian Fry, June 24, 1941. Box 3, Fry Papers.
12. Weissman, *Victor Serge*, p. 260.
13. Ibid.
14. Ibid., pp. 259–60. Under the Freedom of Information/Privacy Acts, I was able to obtain 331 pages of documentation on Victor Serge. Dating from 1940 to 1947, the material includes copies of Serge's private correspondence, summaries of articles by Serge, and agents' reports on Serge and his activities, making it clear that the FBI continued to keep Victor Serge under surveillance while he lived in Mexico until his death in November 1947.
15. Letter from Victor Serge to Macdonalds, May 10, 1941. Box 46/1130, Macdonald Papers.
16. Kaplan, *Unexpected Journeys*, p. 249. "Mexico intervened to seek help for the Spaniards, whom the French might have extradited back to Spain and Franco. On June 23, 1940, Licenciado Luis I. Rodríguez, Mexican Minister to Vichy, informed the French government that Mexico would offer hospitality 'to all Spanish refugees of both sexes resident in France' and if the French government agreed in principle, all Spanish refugees would be considered under Mexican protection."
17. Weissman, *Victor Serge*, p. 261.
18. Letter from Dwight Macdonald to Victor Serge, June 1941. Box 46/1131, Macdonald Papers.

19. Weissman, *Victor Serge*, p. 263.
20. Ibid.

WINDING DOWN

1. Letter from Varian Fry to Eileen Fry, January 5, 1940. Box 3, Fry Papers.
2. Danny Bénédite, "Administrative Report: The Stages of the Committee's Development," *Archives of the Holocaust*, Document 2, p. 15. Box 4, Fry Papers.
3. Fittko, *Escape Through the Pyrenees*, p. 161.
4. Fry, *Surrender on Demand*, p. 233.
5. Bénédite, *Filière Marseillaise*, p. 276. By the end of November 1941, even after Fry's departure, CAS had helped to establish a dozen communities involving about one hundred families, making everything from sandals and baskets to handbags, which they sold to keep alive. They also made crème de marron from local chestnut trees to send to concentration camps to feed internees. The committee furnished the tools and the materials for these ventures.
6. Marino, *Quiet American*, pp. 273–74.
7. Bénédite, *Filière marseillaise*, p. 241.
8. Ibid., p. 242.
9. Ibid., p. 248.
10. Ibid., p. 250.

END GAME

1. W. H. Auden, "Herman Melville," *Collected Poems* (Faber and Faber, London, 1991), p. 251.
2. Fry, *Surrender on Demand*, p. 223. See also Bénédite, *Filière marseillaise*, p. 255.
3. Marino, *Quiet American*, p. 306.
4. Bénédite, *Filière marseillaise*, p. 257.
5. Telegram from Hugh Fullerton to State Department, June 13, 1941. Box 8, Fry Papers.
6. Varian Fry, letters to Eileen Fry, August 14, 1941; August 17, 1941. Box 3, Fry Papers.
7. Marino, *Quiet American*, p. 245. Quoted from *Newsweek*, March 1, 1942.
8. Peter Schjeldahl, "Art as Life: The Matisse We Never Knew," *New Yorker*, August 29, 2005, p. 82.
9. Bénédite, *Filière marseillaise*, p. 260.
10. Isenberg, *Hero of Our Own*, p. 210. Interview with Gemähling, March 20, 1998.
11. Lucie Heymann report. Box 8, Fry Papers.
12. Fry, *Surrender on Demand*, p. 228.
13. Ibid., p. 230.
14. Ibid., p. 231.
15. Ibid., p. 232.

DECOMPRESSION CHAMBER

1. Fry, *Surrender on Demand*, p. 231.
2. Letter from Varian Fry to Eileen Fry, September 7, 1941. Box 3, Fry Papers.
3. Letter from Varian Fry to Theo Bénédite, September 14, 1941. Box 3, Fry Papers.

4. Marino, *Quiet American*, p. 313. Fry Notes, "September 1941." Box 11, Fry Papers.
5. Isenberg, *Hero of Our Own*, p. 219.
6. Letter from Varian Fry to Danny Bénédite, October 31, 1941. Box 2, Fry Papers.

EMPTY VILLA
1. Fry, *Surrender on Demand*, first draft. Box 11, Fry Papers.
2. Bénédite, *Filière marseillaise*, p. 283.
3. Kaplan, *Unexpected Journeys*, p. 80.
4. Polizzotti, *Revolution of the Mind*, p. 436.
5. Telegram from André Breton to AMSECOUR [CAS], September 16, 1941. Box 3, Fry Papers.
6. Unsigned cable from Amsecours (Marseille) to ERC in New York, International Rescue Committee Archives, State University of New York at Albany.
7. Kaplan, *Unexpected Journeys*, p. 82. This was the story Remedios Varo always told, and given the murderousness of the Marseille gangs, it was not unlikely.
8. Kaplan, *Unexpected Journeys*, p. 82.
9. Letter from Victor Brauner to André Breton, October 3, 1941. Box 3, Fry Papers.
10. Bénédite, *Filière marseillaise*, p. 296.
11. Letter from Varian Fry to Theo Bénédite, November 14, 1941. Box 3, Fry Papers.
12. Letter from Frank Kingdon to Varian Fry, February 13, 1942. Box 4, Fry Papers.
13. Letter from Varian Fry to Danny Bénédite, January 29, 1942. Box 2, Fry Papers.
14. Isenberg, *Hero of Our Own*, p. 231.
15. Letter from Varian Fry to Danny Bénédite, December 26, 1941. Box 2, Fry Papers.
16. Letter from Varian Fry to Theo Bénédite, December 18, 1941. Box 3, Fry Papers. It was Vlady who labeled the paintings. Bénédite, *Filière marseillaise*, p. 123.
17. Letter from Theo Bénédite to Varian Fry, March 12, 1942. Box 3, Fry Papers.
18. Ibid.
19. Letter from Danny Bénédite to Varian Fry, June 26, 1942. Box 2, Fry Papers.
20. Ibid.
21. Bénédite, *Filière marseillaise*, p. 297.
22. Ryan, *Holocaust and the Jews of Marseille*, p. 118.
23. Ibid., p. 114.
24. Bénédite, *Filière marseillaise*, p. 298.

RESISTANCE
1. Paul Celan, "Todesfuge." Author's translation.
2. Fittko, *Escape Through the Pyrenees*, p. 221.
3. Ryan, *Holocaust and the Jews of Marseille*, p. 134.
4. Bénédite, *Filière marseillaise*, p. 299.
5. Ibid., p. 300.
6. Ibid., p. 303.
7. Ibid., p. 310.
8. Ibid., pp. 327–28.
9. Letter from Danny Bénédite to Varian Fry, October 4, 1942. Box 7, Fry Papers.
10. Bénédite, *Filière marseillaise*, p. 333.
11. Fry Notes, Box 11, Fry Papers.

12. Jackson, *Fall of France*, p. 236. Mussolini's declaration of war against France, June 10, 1940, had earned him a tiny zone of occupation in southeast France.
13. Bénédite, *Filière marseillaise*, p. 341.
14. Ibid., p. 344.
15. Polizzotti, *Revolution of the Mind*, p. 510.
16. Fittko, *Escape Through the Pyrenees*, p. 220.
17. Quoted in Bénédite, *Filière marseillaise*, p. 349.

AFTERWORD

1. Pauli, *Break of Time*, p. 228.
2. Isenberg, *Hero of Our Own*, p. 252.
3. Ibid., p. 273.
4. Address by Jacques Lipchitz at the memorial service for Varian Fry, November 8, 1967, as recalled by Annette Fry. Isenberg, *Hero of Our Own*, p. 273.
5. Letter from Theo Bénédite to Varian Fry, March 16, 1946. Box 3, Fry Papers.
6. Thirion, *Revolutionaries Without Revolution*, p. 469.
7. Ernst, *A Not-So-Still Life*, p. 202.

BIBLIOGRAPHY

ARCHIVAL COLLECTIONS

Primary Archives

Varian Fry Papers, Rare Book and Manuscript Library, Columbia University, New York.
Dwight Macdonald Papers, Manuscripts and Archives, Yale University Library.
Exile Film Project Records, Manuscripts and Archives, Yale University Library.
United States Holocaust Memorial Museum Archives, Washington, D.C.
Police Files. Archives Départementales des Bouches-du-Rhône, Marseille.
André Breton Papers. Bibliotèque Littéraire Jacques Doucet, Paris.
Centre Historique des Archives Nationales: Section du XX siècle. Paris.

Secondary Archives

Alfred Barr Papers, Irving S. Gilmore Music Library, Yale University.
German and Jewish Intellectual Émigré Collection, M. E. Grenander Department of Special Collections and Archives, SUNY, Albany. Bemjamin Péret, Max Ernst Correspondence.
Getty Research Institute for the History of Art and the Humanities, Special Collections: Yves Poupard-Lieussou Correspondence; E. L. T. Mesens Papers: Robet Valancay Correspondence; Jan and Edith Tschichold Papers; Douglas Cooper Papers. André Breton, Benjamin Péret Correspondence, Max Ernst Folder.
Leon Trotsky Exile Papers: André Breton Correspondence; Sherry Mangan Papers: Péret Correspondence. Houghton Library of the Harvard College Library, Harvard University.

Emily Holmes Colman Papers, Peggy Guggenheim Correspondence. University of
 Delaware Library Special Collections.
Marc Chagall. Correspondence. Solomon R. Guggenheim Museum, New York.
U.S. Department of Justice: Federal Bureau of Investigation. In December 2004, under
 the Freedom of Information/Privacy Acts (FOIPA), I requested to see any FBI files
 on André Breton, Max Ernst, Miriam Davenport, Mary Jayne Gold, Benjamin
 Péret, Victor Serge, and Varian Fry. No "records pertinent to [my] FOIPA request
 were located by a search of the automated and manual files" for Miriam Dav-
 enport, Mary Jayne Gold, and Benjamin Péret. "Records which may have been
 pertinent" regarding Max Ernst were destroyed March 3, 2005. "The disposal of
 records is handled under Title 44, United States Code, Section 3301 and Title
 36, Code of Federal Regulations, Chapter 12, Sub-chapter B, Part 1228, issued
 by the National Archives and Records Administration." With regard to André
 Breton, records were also reported destroyed, though no date of the disposal was
 given. As regarding Varian Fry, thirteen pages were reviewed and eleven pages
 were released. The documents released consisted of nine letters between Varian
 Fry and J. Edgar Hoover, dated July 20, 1954 to August 5, 1954, regarding the
 death of Julian F. Sweeney, fourteen years old, "shot in the head, apparently at
 close range, by a patrolman of the New York Police Department." Still obsessed
 by perceived injustices, Fry was asking for a report on the FBI investigation. Three
 hundred and thirty-one pages of documentation on Victor Serge were received.
 Dating from 1940 to 1947, the material includes copies of Serge's private corre-
 spondence, articles by Serge, and agents' reports on Serge and his activities, mak-
 ing it clear that the FBI continued to keep Victor Serge under surveillance while
 he lived in Mexico until his death in November 1947.

BOOKS

Anderson, Mark M., ed. *Hitler's Exiles: Personal Stories of the Flight from Nazi Ger-
 many to America.* New York, New Press, 1998.
Bair, Deirdre. *Simone de Beauvoir, a Biography.* New York, Summit Books, 1990.
Barr, Margaret Scolari. "Our Campaigns: Alfred H. Barr, Jr., and the Museum of
 Modern Art: A Biographical Chronicle of the Years 1930–1944," *New Criterion:
 Special Issue,* Summer 1987.
Barron, Stephanie. *Degenerate Art: The Fate of the Avant-Garde in Nazi Germany.*
 Trans. Gerard Hopkins. New York, Harry N. Abrams, 1991.
——. *Exiles & Emigrés: Th Flight of European Artists from Hitler.* Los Angeles, Los
 Angeles County Museum of Art, 1997.
Beauvoir, Simone de. *The Prime of Life.* Trans. Peter Green. New York, Lancer Books,
 1966.
Bénédite, Daniel. *La filière marseillaise: Un chemin vers la liberté sous l'occupation.*
 Paris, Clancier Guénaud, 1984.
Benitez, Helena. *Wilfredo and Helena: My Life with Wilfredo Lam 1939–1950.* Lau-
 sanne, Acatos Publishers, 1999.
Benstock, Shari. *Women of the Left Bank: Paris, 1900–1940.* Austin, University of
 Texas Press, 1986.

Bloch, Marc. *Strange Defeat: A Statement of Evidence Written in 1940.* New York, W. W. Norton, 1968.

Block, Gay, and Malka Druker. *Rescuers: Portraits of Moral Courage in the Holocaust.* New York, Holmes & Meier, 1992.

Bonneaud, Maud. "Notes sur une rencontre," *Profile Littéraire,* no. 15 (1943): 31–34.

Brandon, Ruth. *Surreal Lives: The Surrealists 1917–1945.* New York, Grove Press, 1999.

Breton, André. *André Breton: Selections.* Ed. Mark Polizzotti. Berkeley. University of California Press, 2003.

——. *Communicating Vessels.* Trans. Mary Ann Caws and Geoffrey T. Harris. Lincoln, University of Nebraska Press, 1990.

——. *Conversations: The Autobiography of Surrealism.* Trans. Mark Polizzotti. New York, Paragon House, 1993.

——. *Martinique: Charmeuse des serpents* avec textes et illustrations de André Masson. Paris, Jean-Jacques Pauvert, 1972.

——. *Nadja.* Trans. Richard Howard. New York, Grove Press, 1960.

——. *Oeuvres completes.* Paris, Éditions Gallimard, 1992.

——. *Surrealism and Painting.* Trans. Simon Watson Taylor. Boston, MFA Publications, 2002.

——. *What Is Surrealism? Selected Writings.* Ed. Franklin Rosemont. London, Pluto Press, 1978.

——. *Young Cherry Trees Secured Against Hares.* Trans. Edouard Roditi. Ann Arbor, University of Michigan Press, 1969.

Brooks, Howard L. *Prisoners of Hope: Report on a Mission.* New York, L. B. Fischer, 1942.

Brooks-Pazmany, Kathleen. *United States Women in Aviation 1919–1929.* Washington, D.C. Smithsonian Institution Press, 1991.

Brownstone, David, and Irene Frank. *Timelines of War: A Chronology of Warfare from 100,000 BC to the Present.* Boston, Little, Brown, 1994.

Bury, J. P. T. *France: The Insecure Peace: From Versailles to the Great Depression.* New York, American Heritage Press, 1972.

Carrington, Leonora. *The House of Fear: Notes from Down Below.* New York, E. P. Dutton, 1988.

——. *Leonora Carrington: Textos de Juan García Ponce y Leonora Carrington.* Mexico, Ediciones Era, 1974.

——. *The Seventh Horse and Other Tales.* New York, E. P. Dutton, 1988.

Cartes à jouer & tarots de Marseille. Musées de Marseille, Éditions Alors Hors du Temps, 2003.

Caws, Mary Ann. *Surrealism.* New York, Phaidon Press, 2004.

Chadwick, Whitney. *Leonora Carrington: La Realidad de la Imaginación.* Mexico, Ediciones Era, 1994.

Chadwick, Whitney and Isabelle de Courtivron. *Significant Others: Creativity & Intimate Partnership.* London, Thames and Hudson, 1993.

Charlesworth, Monique. *The Children's War: A Novel.* Toronto, HarperCollins, 2004.

Chester, Eric Thomas. *Covert Network: Progressives, the International Rescue Committee, and the CIA.* London, M. E. Sharpe, 1995.

Chipp, Herschel B. *Picasso's Guernica: History, Transformation, Meanings.* Berkeley, University of California Press, 1988.

Cone, Michèle C. *Artists under Vichy: A Case of Prejudice and Persecution*. Princeton, Princeton University Press, 1992.

Davenport, Miriam. *An Unsentimental Education: A Memoir by Miriam Davenport Ebel (1915–1999)*. www.varianfry.org/ebel_memoir_en.htm

Dearborn, Mary V. *Mistress of Modernism: The Life of Peggy Guggenheim*. Boston, Houghton Mifflin, 2004.

Dortch, Virginia M., ed. *Peggy Guggenheim and Her Friends*. Milan, Berenice Art Books, 1994.

Du Plessix Gray, Francine. *Simone Weil*. New York, Penguin Putnam, 2001.

Du Pont, Diana. *El Riesgo de lo Abstracto: El Modernismo Mexicano y El Arte de Gunther Gerzso*. Santa Barbara, Santa Barbara Museum of Art, 2003.

Ehrenburg, Ilya. *Eve of War 1933–1941*. Trans. Tatiana Shebunina. London, MacGibbon & Kee, 1963.

El Surrealisme Entre Viejo y Nuevo Mundo. Quinto Centenario, Centro Altlantico De Arte Moderno.

Eluard, Paul. *Letters to Gala*. Trans. Jesse Browner. New York, Paragon House, 1989.

Ernst, Jimmy. *A Not-So-Still Life: A Memoir*. New York, St. Martin's/Marek, 1984.

———. *Jimmy Ernst*. Ed. Donald Kisput. New York, Hudson Hills Press, 2000.

Ernst, Max. *Beyond Painting and Other Writings by the Artist and His Friends*. New York, Wittenborn, Shultz, 1948.

———. *Écritures*. Paris, Éditions Gallimard, 1970.

———. *Max Ernst: A Retrospective*. Ed. Werner Spies. Tate Gallery Exhibition, 1991. Munich, Prestel-Verlag, 1991.

———. *Max Ernst: A Retrospective*. Intro. Diane Waldman. New York, The Solomon R. Guggenheim Museum, 1975.

Evans, Myfanwy. *The Painter's Object*. London, Gerald Howe, 1937.

Feuchtwanger, Lion. *The Devil in France: My Encounter with Him in the Summer of 1940*. Trans. Elizabeth Abbott. New York, Viking Press, 1941.

Fittko, Lisa. *Escape Through the Pyrenees*. Trans. David Koblick. Evanston, Northwestern University Press, 1985.

———. *Solidarity and Treason: Resistance and Exile 1933–40*. Trans. Roslyn Theobald. Evanston, Northwestern University Press, 1995.

Flamand, Colonel Roger. *"L'Inconnu du French Squadron."* Paris, La Forêt, 1983.

Flanner, Janet. *An American in Paris: Profile of an Interlude Between the Wars*. New York, Simon & Schuster, 1940.

———. *Janet Flanner's World: Uncollected Writings 1932–1975*. Ed. Irving Drutman. New York, Harcourt Brace Jovanovich, 1979.

———. *Men and Monuments: Profiles of Picasso, Matisse, Braque, and Malraux*. New York, Harper & Row, 1957.

———. *Paris Was Yesterday 1925–1939*. Ed. Irving Drutman. New York, Viking Press, 1972.

———. *Pétain: The Old Man of France*. New York, Simon & Schuster, 1944.

Friedlander, Henry and Sybil Milton. General Editors. *Archives of the Holocaust: An International Collection of Selected Documents*. A Garland Series, 1990.

Fry, Varian. *Assignment Rescue: An Autobiography*. New York, Scholastic, 1945. Revised as *Surrender on Demand*. Boulder, Johnson Books, 1997.

———. *Bricks Without Mortar: The Story of International Cooperation*. New York, the Foreign Policy Association, 1938.

———. *Livret pédagogique: Mission sauvetage: Varian Fry et le Centre Américain de secours (1940–1942)*. CNDP/CRDP d'Aix-Marseille, 2005.

———. *Varian Fry: du refuge . . .* Hôtel du Département/Marseille. Actes du colloque du 19 mars 1999. Marseille, Actes Sud, 1999.

———. *Varian Fry: à l'exile*. Hôtel du Département/Marseille. Actes du Colloque du 20 mars 1999. Marseille, Actes Sud, 1999.

———. *Varian Fry et les candidates à l'éxile: Marseille 1940–1941*. Galerie d'Art du Conseil Général des Bouches-du-Rhône/Aix-en-Provence. Actes Sud, 1999.

———. *Varian Fry: Mission Américaine de sauvetage des intellectuals anti-nazis Marseille 1940–1942*. Hôtel du Département/Marseille. Actes Sud, 1999.

Furst, Alan. *The Polish Officer*. New York, Random House, 1995.

———. *The World at Night: A Novel*. New York, Random House, 1996.

Gale, Matthew. *Dada & Surrealism*. London, Phaidon Press, 1997.

Gildea, Robert. *Marianne in Chains: In Search of the German Occupation of France 1940–45*. London, Pan Books, 2003.

Gill, Anton. *Art Lover: A Biography of Peggy Guggenheim*. New York, HarperCollins, 2001.

Gilzmer, Mechtild. *Camps de femmes: Chronique d'internées, rieucros et brens, 1939–1944*. Paris, Éditions Autrement, 2000.

Gold, Mary Jane. *Crossroads Marseilles, 1940*. New York. Doubleday, 1980.

Gooding, Mel, ed. *The Book of Surrealist Games*. London, Shambhala Redstone Editions, 1995.

Guggenheim, Peggy. *Out of This Century: Confessions of an Art Addict*. London, Andre Deutsch, 1979.

Guiraud, Jean-Michel. *La vie intellectual et artistique à Marseille: A l'epoque de Vichy et sous l'occupation 1940–1944*. Marseille, Édition Jeanne Laffitte, 1998.

Haffner, Sebastian. *Defying Hitler: A Memoir*. Trans. Oliver Pretzel. New York, Farrar, Straus, and Giroux, 2000.

Harshav, Benjamin. *Marc Chagall and His Times: A Documentary Narrative*. Stanford, Stanford University Press, 2004.

Haynsworth, Leslie and David Toomey. *Amelia Earnhart's Daughters*. New York, HarperCollins, 1998.

Hélion, Jean. *They Shall Not Have Me: The Capture, Forced Labor, and Escape of a French Prisoner of War*. New York, E. P. Dutton, 1943.

Herbert, James D. *Paris 1937: Worlds on Exhibition*. Ithaca, Cornell University Press, 1998.

Hirschman, Albert O. *A Propensity to Self-Subversion*. Cambridge, Harvard University Press, 1995.

Hobsbawm, Eric. *The Age of Extremes: The Short Twentieth Century 1941–1991*. London, Abacus, 1995.

Isenberg, Sheila. *A Hero of Our Own: The Story of Varian Fry*. New York, Random House, 2001.

Jackman, Jarrell C. and Carla M. Borden, eds. *The Muses Flee Hitler: Cultural Transfer and Adaptation 1930–1945*. Washington, D.C., Smithsonian Institution Press, 1983.

Jackson, Julian. *The Fall of France: The Nazi Invasion of 1940*. Oxford, Oxford University Press, 2003.

Jean, Marcel, ed. *The Autobiography of Surrealism: The Documents of Twentieth Century Art.* New York, Viking Press, 1980.

Jones, Gail. *Black Mirror.* Sydney, Picador, 2002.

Kaplan, Janet A. *Unexpected Journeys: The Art and Life of Remedios Varo.* New York, Abbeville Press, 1988.

Koestler, Arthur. *Darkness at Noon.* Trans. Daphne Hardy. London, Macmillan, 1941.

———. *Scum of the Earth.* Trans. Daphne Hardy. London, Victor Gollancz, 1941.

Levenstein, Aaron. *Escape to Freedom: The Story of the International Rescue Committee.* Westport, Greenwood Press, 1983.

Lévi-Strauss, Claude. *A World on the Wane.* Trans. John Russell. New York, Criterion Books, 1961.

Liebling, A. J. *Liebling Abroad.* New York, PEI Books, 1981.

Lottman, Herbert R. *The Left Bank: Writers, Artists, and Politics from the Popular Front to the Cold War.* Chicago, University of Chicago Press, 1982.

Lusseyran, Jacques. *And There Was Light: The Autobiography of a Blind Hero in the French Resistance.* Boston, Little, Brown, 1963.

Macdonald, Nancy. *Homage to the Spanish Exiles: Voices from the Spanish Civil War.* New York, Insight Books, 1987.

Malaquais, Jean. *Planète sans visa.* Paris, Edition Phébus, 1999.

Marquis, Alice Goldfarb, *Alfred H. Barr Jr.: Missionary for the Modern.* New York, Contemporary Books, 1989.

Marino, Andy. *A Quiet American: The Secret War of Varian Fry.* New York, St. Martin's Press, 1999.

Masson, André. *Les années surrealists: Correspondance 1916–1942.* Paris, La Manufacture, 1990.

Mehring, Walter. *No Road Back.* Trans. S. A. De Witt. New York, Samuel Curl, 1944.

Morton, Brian N. *Americans in Paris: An Anecdotal Street Guide.* Ann Arbor, Olivia & Hill Press, 1984.

Musées de Marseille. *Cartes à jouer & tarots de Marseille,* La donation Camoin. Musée de Marseille, Édition Alors Hors du Temps, 2003.

———. *Le jeu de Marseille: Autour d'André Bretons et des surrealistes à Marseille en 1940–1941.* Exposition de 4 juillet au octobre 2003, Direction de Musées de Marseille, Éditions Alors Hors du Temps, 2003.

———. *Marseille et les Américains 1940–1946.* Musées de Marseille, 1996.

———. *Marseille se souvient du temps des rafles.* Musées de Marseille, 1995.

Neruda, Pablo. *Tercera Residencia 1935–45.* Losada, 1951.

Nicholas, Lynn H. *The Rape of Europa: The Fate of Europe's Treasures in the Third Reich and the Second World War.* New York, Vintage, 1995.

Noël, Bernard. *La planète affolée: Surréalisme, dispersion et influence 1938–1947.* Paris, Flammarion, 1986.

———. *Une liaison surréaliste: Marseille—New York—a surrealist liaison.* Trans. Jeffrey Arsham. Marseille, André Dimanche, 1985.

Ogilvy, David. *Shuttleworth: The Historic Aeroplanes.* London, Airlife Publishing, 1989.

Pauli, Hertha. *Break of Time.* New York, Hawthorn Books, 1972.

Paxton, Robert O. *Vichy France: Old Guard and New Order 1940–1944.* New York, Columbia University Press, 1972.

Péret, Benjamin. *Benjamin Péret.* Ed. Jean-Louis Bédouin. Edition Pierre Seghers, 1961.

————. *The Elegant Ewe. The Automatic Muse: Surrealist Novels.* Trans. Terry Hale and Ian White. London, Atlas Press, 1994.

————. *Remove Your Hat or a Bunch of Carrots.* Trans. David Gascoyne and Humphrey Jennings. London, Atlas Press, 1986.

Polizzotti, Mark. *Revolution of the Mind: The Life of André Breton.* New York, Da Capo Press, 1997.

Regler, Gustave. *The Owl of Minerva: The Autobiography of Gustave Regler.* Trans. Norman Denny. New York, Farrar, Straus, & Cudahy, 1960.

Robbins, Christopher. *Test of Courage: The Michel Thomas Story.* New York, Free Press, 2000.

Roche, Julotte. *Max et Leonora: Récit d'investigation.* Cognac, Le temps qu'il fait, 1997.

Roth, Joseph. *Report from a Parisian Paradise: Essays from France 1925–1939.* Trans. Michael Hofmann. New York, W. W. Norton, 1999.

Roussin, André. *La bôite à couleurs.* Paris, Éditions Albin Michel, 1974.

Russell, John. *Max Ernst: Life and Work.* New York, Harry N. Abrams, 1967.

Ryan, Donna F. *The Holocaust and the Jews of Marseille: The Enforcement of Anti-Semitic Policies in Vichy France.* Chicago, University of Illinois Press, 1996.

Sahl, Hans. *The Few and the Many.* Trans. Richard and Clara Winston. New York, Harcourt, Brace & World, 1962.

Saint-Exupéry, Antoine de. *Flight to Arras.* Trans. William Rees. London, Penguin Books, 1995.

————. *Wartime Writings 1939–1944.* Trans. Norah Purcell. New York, Harcourt Brace Jovanovich, 1982.

————. *Wind, Sand, and Stars.* London, Penguin Books, 1995.

Saint-Exupéry, Consuelo de. *Kingdom of the Rocks: Memories of Oppède.* Trans. Katherine Woods. New York, Random House, 1946.

————. *The Tale of the Rose: The Love Story Behind the Little Prince.* Trans. Esther Allen. New York, Random House, 2001.

Sartre, Jean-Paul. *War Diaries of Jean-Paul Sartre: November 1939–May 1940.* New York, Pantheon Books, 1985.

————. "Paris Under the Occupation," *French Writing on English Soil: A Choice of French Writing Published in London Between November 1940 and June 1944.* Ed/trans. J. G. Weightman. London, Sylvan Press, 1945.

Sauvage, Pierre. "Varian Fry in Marseille," *Remembering for the Future: The Holocaust in an Age of Genocide.* Eds. John K. Roth and Elizabeth Maxwell. London, Palgrave, 2001.

Sawin, Martica. *Surrealism in Exile and the Beginning of the New York School.* Boston, MIT Press, 1995.

Schiff, Stacy. *Saint-Exupéry: A Biography.* New York, Alfred A. Knopf, 1994.

Scholem, Gershon. *Walter Benjamin: The Story of a Friendship.* Trans. Harry Zohn. Philadelphia, Jewish Publication Society of America, 1981.

Seghers, Anna. *Transit Visa.* Trans. James A. Glaston. London, Eyre and Spottiswoode, 1945.

Serge, Victor. *The Case of Comrade Tulayev.* Trans. Willard R. Trask. New York, New York Review of Books, 2004.

————. *The Long Dusk.* Trans. Ralph Manheim. New York, Dial Press, 1946.

————. *Memoirs of a Revolutionary.* Trans. Peter Sedgwick. London, Writers and Readers Publishing Cooperative, 1984.

———. *Men in Prison.* Trans. Richard Greeman. London, Writers and Readers Publishing Cooperative, 1977.

———. *Resistance* (Poems). Trans. James Brook. San Francisco, City Lights Books, 1972.

Sevareid, Eric. *Not So Wild a Dream: A Personal Story of Youth and War and the American Faith.* New York, Atheneum, 1976.

Sheridan, Alan. *André Gide: A Life in the Present.* Cambridge, Harvard University Press, 1999.

Shirer, William L. *The Collapse of the Third Republic: An Inquiry into the Fall of France in 1940.* New York, Simon & Schuster, 1969.

Signoret, Simone. *Nostalgia Isn't What It Used to Be.* New York, Harper & Row, 1978.

Stein, Gertrude. *Wars I Have Seen.* New York, Random House, 1945.

Stein, Louis. *Beyond Death and Exile: The Spanish Republicans in France, 1939–1955.* Cambridge, Harvard University Press, 1979.

Stephan, Alexander. *Communazis: FBI Surveillance of German Emigré Writers.* Trans. Jan van Heurck. New Haven, Yale University Press, 1995.

Suthers, Judith D. *Kay Sage: A House of Her Own.* Lincoln, University of Nebraska Press, 1997.

Tanning, Dorothea. *Between Lives: An Artist and Her World.* New York, W.W. Norton, 2001.

Thirion, André. *Revolutionaries Without Revolution.* Trans. Joachim Neugroschel. New York, Macmillan, 1972.

Tomkins, Calvin. *Duchamps: A Biography.* New York, Henry Holt, 1996.

Varo, Beatriz. *Remedios Varo: En el Centro del Microcosmos.* Mexico, Fondo de Cultura Económica, 1990.

Varo, Remedios. *Cartas, Sueños y Otros Textos.* Ed. Isabel Castells. Mexico, Ediciones Era, 1997.

———. *Remedios Varo: Catálogo Razonado.* Mexico, Ediciones Era, 1994.

Vlady (Vladimir Kibalchich). *Dibujos Eróticos de Vlady.* Mexico, Editorial Esquilo, 2000.

Waldberg, Patrick. *Max Ernst.* Paris, Jean-Jacques Pauvert, 1958.

Weissman, Susan. *Victor Serge: The Course Is Set on Hope.* London, Verso, 2001.

———, ed. *The Ideas of Victor Serge: A Life as a Work of Art.* Glasgow, Critique Books, 1997.

Weld, Jacqueline Bograd. *Peggy: The Wayward Guggenheim.* New York, E. P. Dutton, 1988.

Werth, Alexander. *France in Ferment.* London, Harper & Brothers, 1934.

———. *The Last Days of Paris: A Journalist's Diary.* London, Hamish Hamilton, 1940.

———. *The Twilight of France 1933–1940.* New York, Howard Fertig, 1966.

Wiser, William. *The Twilight Years: Paris in the 1930s.* New York, Carroll & Graf, 2000.

Wyman, David S. *Paper Walls: America and the Refugee Crisis 1938–1941.* Boston, University of Massachusetts Press, 1968.

INDEX

Grateful acknowledgment is made for permission to reprint from the
following works and collections:

*Not So Wild a Dream: A Personal Story of Youth and War and the
American Faith,* by Eric Sevareid; reprinted by permission of Don
Cogdon Associates, Inc.; copyright 1946 by Eric Sevareid, re-
newed 1974 by Alfred A. Knopf.
Surrender on Demand by Varian Fry; reprinted by permission of Big
Earth Publishing/Johnson Books, Boulder, Colorado.
Memoirs of a Revolutionary by Victor Serge; reprinted by permission
of University of Iowa Press.
Letters of the Préfet des Bouches-du-Rhône; reprinted by permission
of Archives départementales des Bouches-du-Rhône, Marseille.
Varian Fry Papers, Rare Book and Manuscript Library, Columbia Uni-
versity.
Dwight Macdonald Papers, Manuscripts and Archives, Yale Univer-
sity Library.
Exiles Film Project Records, Manuscripts and Archives, Yale Univer-
sity Library.
*An Unsentimental Education: A Memoir by Miriam Davenport Ebel
(1915–1999).* Web page: www.varianfry.org/ebel_memoir_en.htm;
reprinted by permission of Charles Ebel.